Utah Art

Since its founding in 1903, the Springville Museum of Art has been a strong advocate of the fine arts. The professional staff of the museum, its volunteer leaders, and the community of Springville, Utah, have made it one of the preeminent arts institutions in the western United States. Through its exhibits, its arts education program for youth and adults, and its acquisition of art works, the museum has enriched the cultural life of the state and the nation. This book marks the 88th anniversary of the Springville Museum of Art. Its publication is a milestone in the history of the visual arts in Utah.

*Special thanks to
the George S. and Dolores Doré Eccles Foundation
and Joseph Cannon of Geneva Steel.*

*Publisher's Dedication:
For my mother, Iola Heiselt Smith (1909–1991), a painter, a master of floral arrangement, and an advocate of the arts throughout her life.*

Utah Art is a Utah Centennial publication.

Utah Art

Vern G. Swanson Robert S. Olpin William C. Seifrit

with an introduction by William Gerdts

Published through the sponsorship of the Springville Museum of Art

GIBBS·SMITH PUBLISHER

PEREGRINE SMITH BOOKS

First edition

96 95 94 93 92 91 8 7 6 5 4 3 2 1

This is a Peregrine Smith Book,
published by Gibbs Smith, Publisher.
P.O. Box 667, Layton, Utah 84041

Book design by J. Scott Knudsen, Park City, Utah
Printed and bound in Korea by Sung In

Library of Congress Cataloging-in-Publication Data

Swanson, Vern G.

 Utah art / Vern G. Swanson,
Robert S. Olpin & William C. Seifrit
p. cm.
 "Published through the sponsorship of
 the Springville Museum of Art."
 Includes bibliographical references and index.
 ISBN 0-87905-385-2
 1. Art, American—Utah. 2. Art—Utah—Springville.
I. Olpin, Robert S. II. Seifrit, William C. III. Springville
Museum of Art. IV. Title
N6530.U8S94 1991
709'.792—dc20 91-4677

CIP

CONTENTS

PREFACE

Three years ago I gave a copy of Robert Olpin's *Dictionary of Utah Art* published in 1980 to John Sunderland, head librarian of the Witt Library at the Courtauld Institute of Art in London. Upon checking its date, Dr. Sunderland said, "Well, it's about time to start researching for a new volume on art in your state!" He recognized two important principles regarding art history: first, it takes an extended length of time to write books and second, we need perpetual reassessment of our cultural heritage.

Several major efforts have been made throughout the years to give a thoroughgoing account of Utah art. The first of these was Alice Merrill Horne's *Devotees and Their Shrines: A Hand Book of Utah Art,* printed in 1914. A classic, it dealt with most of the arts and artists up to that time. James Haseltine, director of the Salt Lake Art Center, then published his *100 Years of Utah Painting* in 1965 as a part of an exhibition reviewing Utah art from 1850 to 1950. And in 1980, the Salt Lake Art Center published *Dictionary of Utah Art*. Since 1980, the amount of available research materials has more than doubled. A new book assessing the visual arts in Utah is sorely needed. The advancement in quality and quantity of Utah art since 1950 has also inspired the present volume.

Given the state's unique rich history and current contemporary flowering, it is curious that the achievements of Utahns in painting and sculpture are not as well known as those made in some of the other fine arts. The state has obtained national recognition for the quality of its ballet, its symphony, and its opera. We hope this book will help residents and visitors alike appreciate the great tradition in painting and the plastic arts which enriches the cultural life of Utah. Perhaps the most interesting product of our research is the realization that among the twelve western states, Utah ranks very high in the visual fine arts—both in terms of tradition and current expression. Certainly California and New Mexico are bastions of the visual arts, with vital artists' colonies and healthy traditions of patronage. Utah has never attracted large numbers of wealthy patrons, nor has it ever been home to a major artists' colony; yet it has managed to produce art which competes in quality with that produced in these other western regional arts centers.

Having observed exhibition and marketing patterns for the past decade I would say that Utah, per capita, exported more art than any state in the United States. Even today, Utah is not a great market for art. Nevertheless, many artists choose to reside here, lured by the scenery, the cost of living, and the quality of life. No longer must artists live next to their sales galleries, nor must they move to either coast for the proper inspiration. Four years ago I noted in a publication on the artist's market that Utah was in the upper third of states in terms of the number of professional artists in the population. Building a solid base of artists, to the point of critical mass was, in Dale Fletcher's opinion, the only way an elite coterie of inspired artists could emerge. If Fletcher was right, then Utah should be ready to advance to the next level of artistic attainment.

Vern G. Swanson
Springville, Utah

ACKNOWLEDGMENTS

So many people and institutions have helped to bring this volume to pass. I would like to thank them all for the financial resources, time, interest, and expertise they contributed to the realization of this project. There are a few I would like to mention individually for their considerable contributions. Most of all I am thankful to the George S. and Dolores Dore' Eccles Foundation of Salt Lake City for their generous grant in 1988. Through the sympathetic efforts of Karen Gardner and Lisa Eccles of that foundation this project took shape and gained momentum.

The vision that crystallized the book was provided by Utah art collector David Dee, and art dealer David Ericson of Gallery 56 in Salt Lake City. We believed that a catalogue of the Springville Museum's collection of Utah art and a comprehensive survey text delineating our art history since 1847 should be made. Dr. Robert S. Olpin, Utah's dean of art historians, planted the idea that a more ambitious volume ought to be produced. He suggested that Gibbs M. Smith, Publisher, of Layton be contacted. An artist himself, Gibbs Smith was intensely interested in publishing a Utah art book.

The publisher's vision for the book was always expansive. He did not see it in its parochial sense, but rather as a national publication. He sought to produce a lasting memorial to past and present Utah artists. I am most thankful to Gibbs and his editor, Heather Bennett, for their untiring efforts to bring this volume to completion. I would also like to thank Elizabeth Watkins, Madge Baird, Catherine Smith and Dawn Valentine for much needed editorial assistance.

Scholars William Gerdts, Robert S. Olpin, and William Seifrit have contributed essays to the volume, insuring its factual and interpretive value. Manuscripts were read for content by Martha S. Bradley and Will South. Sherrill D. Sandberg, Pat Eyre, and Carol Nixon of the Utah Arts Council; Glen Leonard and Ronald Read of the LDS Museum of Church History and Art; Frank Sanguinetti and Charles Loving of the Utah Museum of Fine Arts; and Virgie Day of the Museum of Fine Arts, Brigham Young University have all advised on the illustrations, and allowed us to use pieces from their collections. Lila Larsen and other staff members and volunteers at the Springville Museum have been very helpful. To increase the size and scope of the project, Joseph Cannon of Geneva Steel in Orem donated considerable funds. The pages of this volume testify to his ongoing interest in promoting the art of our state.

Private collectors such as Kay and Alan Blood of Kaysville, Blake Roney and Steven Lund of Provo, Chris and Claudia Cannon of Mapleton, Joseph and Jan Cannon of Orem, David and Karen Dee, Theodore Milton Wassmer and Judy Lund of Salt Lake City, David and Bea Glover of Bountiful, F. Ed and Judy Bennett of Salt Lake City, and David and Karen Ericson of Salt Lake City have also contributed to this volume's success.

Vern G. Swanson
Springville, Utah

INTRODUCTION

I would like to preface this introduction with a disclaimer—I am not a Utahn and certainly not a specialist on the subject of Utah art such as Drs. Olpin, Seifrit, and Swanson, who are the authors of this incisive, remarkable text. I have been honored with the opportunity to contribute this short essay because of my researches and publications dealing with regional painting throughout this nation, in the hope that I might offer some observations concerning Utah painting and sculpture as it developed within the context of American art as a whole.

As I suggested in my study, *Art Across America,* the larger pattern that would seem to emerge from that treatise is that regional art in America yields no clear pattern at all. Of course, different communities, states and territories, and whole regions capitalized upon their most outstanding natural features, and art was often devoted to representing the primary occupations and concerns of their inhabitants and the characteristics of their distinct ethnic components. These often merged with both thematic attractions and stylistic developments that had appeared in the major urban cultural communities in the northeast or abroad.

But, as I have suggested, this interaction is not so simple or clear cut. Other factors come into play in order to account for the fascination with and extreme respect paid to miniature painting in Charleston, South Carolina, or the development of a unique emphasis upon historical painting in Texas in the nineteenth century. Artists in northern California painted endless renditions of Mount Tamalpais and Mount Shasta; those in Oregon constantly depicted Mount Hood; and those in Washington devoted their skills to Mount Rainier. But the spectacular scenery of Montana was relatively ignored by both resident and visiting painters in favor of a concentration upon American Indian themes. Old Lyme, Connecticut, on Long Island Sound, was probably the nation's most significant art colony of impressionist painters—but the artists there disregarded the obvious appeal of the sparkling, sun-filled shoreline and beaches; and when they painted such subjects, they tended to journey to Cape Ann in Massachusetts and Monhegan in Maine.

Art in Utah might seem, to some degree, to follow the norms of a national pattern of development, beginning with the one really "essential" concern: portraiture, as practiced by both resident artists such as William Warner Major and visitors such as Solomon Carvalho and

Enoch Wood Perry. These were generally rendered in an objective, naturalistic manner, as were the subsequent interpretations of the spectrum of regional landscape phenomena—Alfred Lambourne's Great Salt Lake panoramas, John Tullidge's and George Beard's pictures of the Wasatch Mountains, and, perhaps most spectacularly, Henry Culmer's dazzling pictures of the natural bridges in southern Utah. Likewise, genre painters such as C.C.A. Christensen, Danquart Weggeland, and George Ottinger documented the founding and growth of the urban communities. Later, more intimate and yet more ambitious figure painting, often dealing with domestic life, was the specialty of a number of European-trained Utah painters such as James Harwood and Mary Teasdel. John Willard Clawson's portraiture can be seen as a reflection of the international high-style manner which found its contemporaneous apogee in the work of John Singer Sargent. And just as the Hudson River school of landscape painting succeeded first to French Barbizon and then to French impressionist influences in the East, so the vistas of the Lambournes and Culmers were followed by the more intimate scenes of John Hafen and the sparkling, colorful views of Lorus Pratt. As the twentieth century developed, Utah painters were clearly aware, and their work was effectively reflective of, the regionalist concerns of the 1930s and the subsequent investigation of both the formal properties and the dynamic impact of abstract art.

Every major tradition is well represented in Utah—from portraiture, landscape, and still-life; through impressionism, fauvism, and abstract expressionism; to three-dimensional work in bronze, marble and wood. To the art historian, however, there are some conspicuous absences. Why, for instance, do we have no major nineteenth-century specialist in stilllife painting in Utah, despite the undeniable quality of the work of Martin Lenzi and also that of Harriett Richards Harwood? Why was the miniature painting revival of the turn of the century—with prominent representatives found not only in New York, Boston, and Philadelphia but in Birmingham, Atlanta, Chicago, San Francisco, and Seattle—only dimly reflected in Salt Lake City? Though, again, one should not fail to recognize the talents of Myra Sawyer, for instance, in this area. These are questions for scholars to investigate in the future.

One continuous theme treated by Utah artists of every generation has been the idea of man nurturing the land and seeing its fruits—and the progress of mankind—optimistically. This idea is reflective of Mormon history and beliefs but is practiced by Mormons and non-Mormons alike. It is implicit in Ottinger's and Christensen's individual easel paintings, in the latter's giant Mormon panoramas, and in Weggeland's documentation of neat, prosperous-appearing farms. It is explicit especially in the great series of harvesting pictures produced by the Utah "art missionaries" both in France and after their return from Parisian training: works such as Harwood's *Workers in the Field;* Lorus Pratt's *Harvest Scene, France* and his *Harvest in Cache Valley;* John B. Fairbanks's *Harvest;* as well as numerous works by Edwin Evans. The format and iconography of such pictures derive from the French peasant imagery introduced in the mid-nineteenth century by Jean-Francois Millet—his *Gleaners* and *The Angelus,* for instance—and continued by such French painters as Jules Breton, and by American expatriates such as Charles Sprague Pearce and Daniel Ridgeway Knight. But the Utah artists rejected the sense of hardship and despair in these images in favor of a sense of fruitfulness and optimism, as a reflection of the Lord's bounty. And this overriding image remained within the matrix of Utah art in later generations, as we see in Sam Jepperson's *Pasture near Provo;* in Donald Beauregard's *Artist's Father Clearing Sagebrush;* in H. Reuben Reynolds's *Load of Hay, Logan;* in LeConte Stewart's *Threshing Wheat at Porterville;* and even in Dennis Smith's contemporary sculpture, *Threshing.* This emphasis upon the rich yield of the land and man's productive relationship to his environment is tellingly implied also in Trevor Southey's *Eden Farm,* an image of birth, or perhaps rebirth, of a new Adam and Eve. This conception was prevalent in America almost two hundred years ago; it remains in Utah, and in its art, today.

Since the nineteenth century, each new generation of Utah artists has gone out into the world to bring back contemporary techniques, trends, and theories. And in each generation, artists trained elsewhere have come to live in this beautiful state. But as the state's population becomes predominantly urban, and as the isolation of the region is virtually ended, Utah has fully entered the mainstream of American art. One of the remarkable trends in our nation's history is the current vitality of regional cultural expression. Utah is now experiencing a renewed interest in the visual arts, and in its artists—past and present.

William H. Gerdts
Graduate School of the City University of New York

CHRONOLOGY

Autumn 1848 Portrait painter William Warner Major, Utah's first resident artist, arrives one year after the Mormon settlement of Salt Lake Valley.

1853 Frederick H. Piercy is commissioned by the Church of Jesus Christ of Latter–day Saints to illustrate *Route from Liverpool to Great Salt Lake Valley* (published 1855).

1856 Deseret Agriculture and Manufacturing Society (Utah State Fair) begins exhibiting art.

13 September 1857 Genre painter Carl Christian Anton Christensen arrives in Salt Lake City.

1860 Photographer Charles R. Savage arrives in Salt Lake City, establishes shop with Marsena Cannon.

Autumn 1861 Genre and landscape painter George Martin Ottinger arrives in Salt Lake City.

17 September 1862 Genre painter Danquart Anthon Weggeland arrives in Salt Lake City. He works at Salt Lake Theatre from 1862-73.

1863 Landscape painter John Tullidge emigrates to Salt Lake City.

1863 Deseret Academy of Fine Arts opens with Ottinger as its first president. It lasts only ten months.

1863 Noted landscape painter Albert Bierstadt first works in Utah.

1864 Sarah Ann Burbage Long of Salt Lake City paints *Brigham Young and His Friends*.

1865-66 Portraitist Enoch Wood Perry receives commissions to paint Brigham Young and his Apostles.

c.1865 Deseret Art Union (patterned after American Art Union) founded by Ottinger, Savage and Perry.

1866 Landscape painter Alfred Lambourne arrives in Salt Lake City, and soon begins to paint stage scenery.

1873 Noted landscapist Thomas Moran visits and paints in Utah for the first time.

1878 C. C. A. Christensen begins work on 23 large rolled murals depicting LDS church history.

1881 Utah Art Association is founded by Ottinger and others. It is the forerunner of the Utah Art Institute.

1882 Painter John Willard Clawson goes to New York to study at the National Academy of Design for three years. In 1889 he goes to Paris.

1882 Marie Gorlinski goes to Paris to study art. She is the first Utah artist to do so.

1887 Painter James Taylor Harwood opens an atelier, the Salt Lake Art Academy, to teach principles he has learned in San Francisco (1885-86).

1888-89 University of Deseret organizes a Department of Art, with Ottinger as principal.

1888 J. T. Harwood studies at Académie Julian in Paris. He stays there until 1892, spending only six months in Utah during that time.

1888 Sculptor Cyrus E. Dallin joins Harwood in Paris.

July 1890 Utah artists, John Hafen, John B. Fairbanks, and Lorus Pratt are sent by the LDS Church to Paris for art training so they can paint murals in the Salt Lake Temple. Edwin Evans and Herman Haag later join them. Hafen returns in 1891, while the others stay until 1892.

Autumn 1890 Utah State Agricultural College establishes its fine art department led by Karl Schaub.

1892 Harwood becomes the first Utah artist to exhibit at the Paris Salon with his *Preparation for Dinner* (UMFA).

6 April 1893 Mormon Salt Lake Temple is dedicated, with murals by Hafen, Evans, Fairbanks, Pratt, and Weggeland.

1893 World's Columbian Exposition is held in Chicago. Harwood, Clawson, Evans, and Dallin exhibit.

December 1893 Society of Utah Artists founded in Salt Lake City.

1897 Lewis A Ramsey studies in Paris, as do Mary Teasdel in 1899, Lee Greene Richards and Mahonri Young in 1901, A. B. Wright in 1902, and Donald Beauregard in 1906.

1898 Edwin Evans becomes head of the art department at the University of Utah (1898-1919).

1899 Utah Art Institute is established by the state legislature and led by Alice Merrill Horne. A mandate is given to the Utah Art Institute to hold an annual exhibition of Utah artists from which to purchase artworks for the state's fine art collection; first exhibition is held in December 1899.

March 1903 John Hafen and Cyrus E. Dallin donate art to establish the Springville Art Gallery Collection.

1908 Brigham Young University Fine Art Collection begins.

1909 J. Henri Moser studies in Paris, becomes enamoured with fauvism.

1913 LeConte Stewart studies at the Art Students League in New York City.

1913 Mahonri M. Young helps organize the Armory Show in New York City.

1914 Alice Merrill Horne's *Devotees and Their Shrines: A Hand Book of Utah Art* is published.

1921 Elbert H. Eastmond heads new College of Fine Art at Brigham Young University (1921-36).

1921 Alice Merrill Horne organizes sales exhibitions in the Tiffin Room of ZCMI and the Hotel Newhouse in Salt Lake City.

1923 Harwood becomes chairman of the art department at the University of Utah (1923-31).

Summer 1927 Lee Randolph is visiting instructor at BYU.

1928-30 Sven Birger Sandzen from Bethany College in Kansas, teaching during summers at Brigham Young University in Provo and Utah State Agricultural College in Logan, influences several Utah artists with fauvist technique.

11 June 1933 Art Barn (Salt Lake Art Center) dedicated after two years' work.

14 August 1934 Public Art Project (under FERA) initiated in Utah.

1934 Lee Greene Richards supervises the painting of murals for the dome of the State Capitol Building.

1935 Works Progress Administration (WPA) Federal Art Project initiated in Utah.

1936 Bent F. Larsen becomes head of the BYU College of Fine Art (1936-53).

4 July 1937 Springville Art Gallery's new Spanish style building is dedicated and becomes the largest art museum in the state.

1938 LeConte Stewart heads the art department at the U of U (1938–56).

25 November 1938 Utah State Art Center is established by Federal Art Project, in the old Elks Building at 59 South State Street in Salt Lake City.

September 1939 Farrell Collett comes to head the art department at Weber State in Ogden (1939-76).

1940 The conservative Associated Utah Artists (AUA) is founded.

15 July 1942 WPA Federal Art Project incorporated with War Services Program and Utah State Art Center renamed War Services Center.

1943 WPA support discontinued.

1947 Glenna Beesley establishes the Pioneer Craft House in Salt Lake City.

July 1947 Centennial Exhibition at Springville Museum of Art and State Fair.

24 July 1947 Mahonri Young's *This is the Place Monument* is dedicated.

September 1947 Avard Fairbanks returns to Utah to become the first Dean of the College of Fine Arts at the U of U (1947-65) and Alvin Gittins joins his faculty.

1951 The 52nd annual Utah State Institute of Fine Arts exhibit draws a line of demarcation between the conservative and modernist styles.

1951 The Utah Museum of Fine Arts is established on the University of Utah Campus.

8 May 1952 The Contemporary Gallery of Art at 60 Post Office Place opens.

1955 Don Olsen has solo exhibition at the Salt Lake Art Center of recent work done at the Hans Hofmann School on Cape Cod.

1955 George Dibble begins to review art for the *Salt Lake Tribune* and the *Deseret News*.

October 1959 (Berthe) Eccles Community Art Center founded in Ogden.

September 1960 Revival of Dixie College's art department with the arrival of Gerald Olsen.

4 July 1964 Clyde wing dedicated at the Springville Museum of Art.

1965 The Atrium Gallery in the new Salt Lake Public Library is dedicated.

1965 Phillips Gallery for the sale of contemporary art is founded by Denis and Bonnie Phillips.

1965 Tivoli Gallery founded in Salt Lake City by Dan Olsen.

October 1964 Harris Fine Arts Center at Brigham Young University is dedicated.

October 1965 James Haseltine's *100 Years of Utah Painting* is published by the Salt Lake Art Center.

October 1966 Don Olsen introduces hard-edge minimalism to Utah at his solo show in Phillips Gallery.

November 1966 Lee Deffebach introduces Pop Art to Utah at her solo show in Phillips Gallery.

1966 The Fairview Museum in Sanpete County is organized.

January 1967 E. Frank Sanguinetti becomes first professional director of the Utah Museum of Fine Arts.

September 1968 The Utah Museum of Fine Arts in the Park Building exhibits solo show of Wayne Thiebaud.

February 1969 The First Mormon Arts Festival is held at BYU.

1970 The North Mountain Artists Cooperative is organized in Alpine/Highland.

1970 Richard Murray is the first artist to move into the old Guthrie Bicycle Building in Salt Lake City.

1970 The Brigham City Museum-Gallery is founded.

September 1970 Art and Architecture complex—including the Utah Museum of Fine Arts—is dedicated at the U of U.

1972 Utah Museum Association is founded.

1972 First Annual All State High School Show at the Springville Museum of Art.

1973 The Alliance for the Varied Arts (AVA) in Logan is founded at old Whittier School.

October 1974 The Bountiful/Davis Art Center is founded.

1975 Nebo School District gives the Springville Museum of Art to the City of Springville.

1975 Gallery East is founded by Jim Young in Price at the College of Eastern Utah.

1975 Wasatch Bronzeworks, first in Vineyard (near Orem), then in Lehi, is founded by Neil Hadlock.

1976 Braithwaite Fine Arts Gallery at Southern Utah State College is begun by Thomas Leek.

1976 The Myra Grout Powell Gallery is created at the old Union Pacific Depot in Ogden.

1978 The Salt Lake Art Center moves from Finch Lane to new premises on the Salt Palace block in downtown Salt Lake City.

1979 The Salt Lake Council for the Arts takes over old Art Barn on Finch Lane.

1979 ArtSpace Inc. at Pierpont Avenue in Salt Lake City is founded.

1 August 1980 Vern G. Swanson begins as director of the Springville Museum of Art.

1980 Robert S. Olpin's *Dictionary of Utah Art* is published by the Salt Lake Art Center.

1981 Springville Museum of Art focuses on becoming a Utah art history museum.

1982 Nora Eccles Harrison Museum of Art is dedicated at Utah State University, Logan.

1983 LDS Church Museum of History and Art is dedicated in Salt Lake City.

1984 Utah Arts Council opens the Chase Home in Liberty Park for Visual Arts.

1985 One Percent for Public Art legislation is passed, allowing that one percent of the building costs for any public building may be spent on the purchase of art for display in the building and on the grounds.

1985 Visual Arts Fellowship Program is begun by the Utah Arts Council.

1985 Retrospectives, Inc. is founded by Marcia Price, Ruth Lubbers, Lila Abersold, and Ernest Muth in Salt Lake City.

1986 "Utah Art of the Depression" exhibit is held and catalog produced; sponsored by the Utah Arts Council, curated by Dan Burke.

1988 Salt Lake Art Center opens permanent gallery for display of modern art in Utah.

October 1988 Union Pacific Railroad Company announces donation of depot for purpose of housing State Fine Arts Collection.

18 October 1989 Governor accepts depot on behalf of the state.

1990 Legislature appropriates $2.3 million for Utah Arts Endowment Fund to endow all arts organizations, including Utah's museums.

18 October 1991 *Utah Art* is published by Gibbs Smith, Publisher.

In addition to standard and locally defined abbreviations, the following are used herein:

BYU—Brigham Young University; LDS—The Church of Jesus Christ of Latter-day Saints; MCHA—LDS Museum of Church History and Art; MFA/BYU—Museum of Fine Arts at BYU; p.c.—private collection; SFAC—Utah State Fine Arts Collection; SMA—Springville Museum of Art; U of U—University of Utah (name changed from University of Deseret, 1892); UMFA—Utah Museum of Fine Arts; USAC—Utah State Agricultural College (name changed to Utah State University, 1957); USU—Utah State University; ZCMI—Zion's Cooperative Mercantile Institutuion.

PLATE 1

PLATE 2

John Fery, American Fork Canyon; c. 1870s, oil on canvas, 67 1/2" × 102"; Utah Museum of Fine Arts, 1981-85, gift of Mr. and Mrs. Adrian H. Pembroke.

PLATE 3

Danquart A. Weggeland, Ontario Mill Park City; 1877, oil on paper, 16" × 30"; SMA, gift of Neal and Jane Schaerrer, Salt Lake City.

PLATE 4

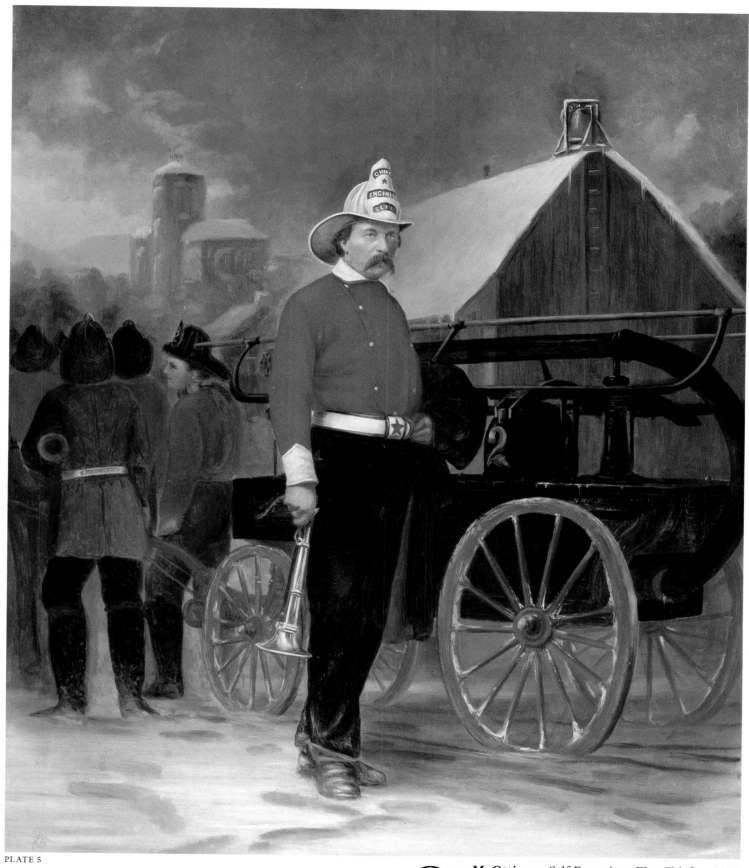

PLATE 5

George M. Ottinger, Self-Portrait as Fire Chief; *c. 1877,* oil on paper, 21 1/4" × 18"; SMA.

PLATE 6

*D*anquart A. Weggeland,
Bishop Sam Bennion Farm,
Taylorsville; *c. 1879, oil on canvas*
mounted on board, 21" × 31"; SMA.

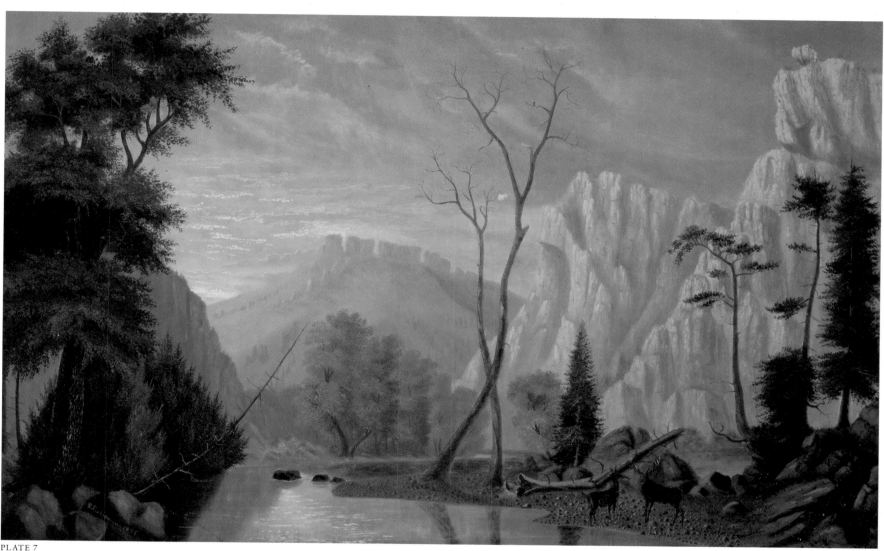

PLATE 7

*R*eID*uben Kirkham,* Sunset in
Blacksmith Fork Canyon,
Logan; *1879, oil on canvas mounted
on board, 29" ×45 1/2"; SMA, gift
of the Lund-Wassmer Collection.*

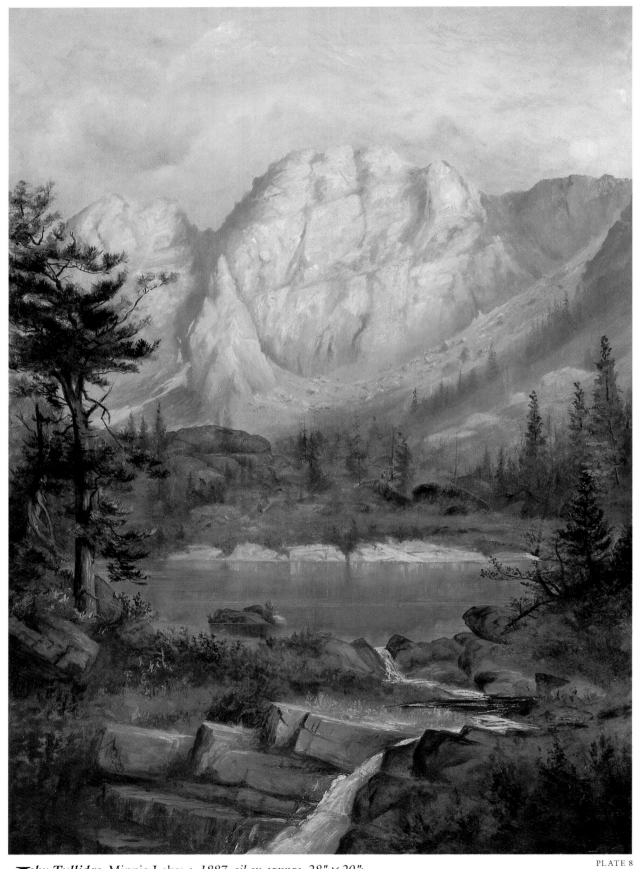

PLATE 8

John Tullidge, Minnie Lake; *c. 1887, oil on canvas, 28" × 20";*
SMA, gift of the Dr. George L. and Emma Smart Collection.

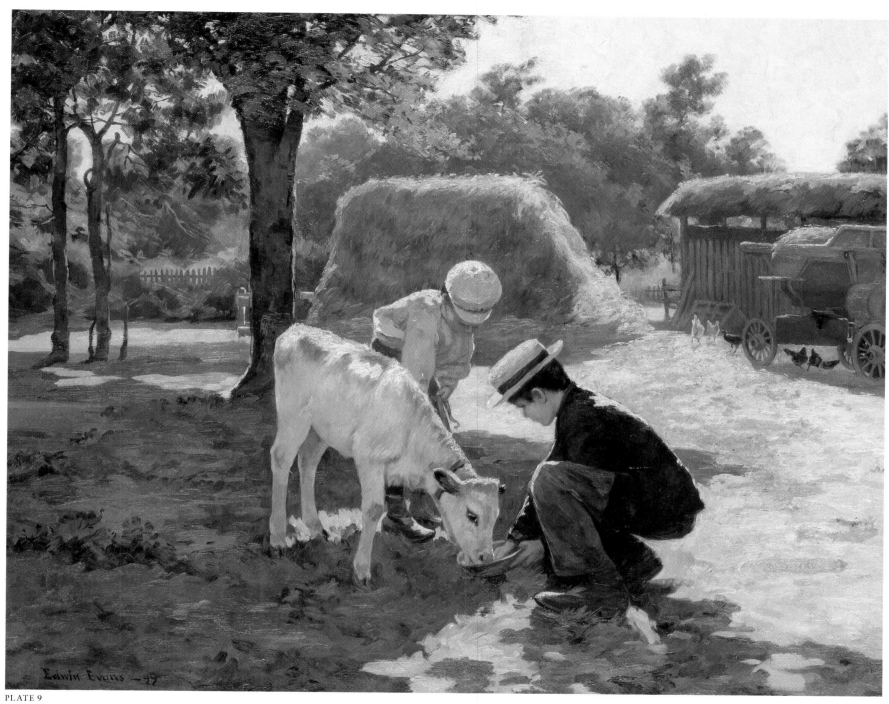

PLATE 9

Edwin Evans, The Calf;
1899, oil on canvas, 28" × 40";
BYU Museum of Fine Arts.

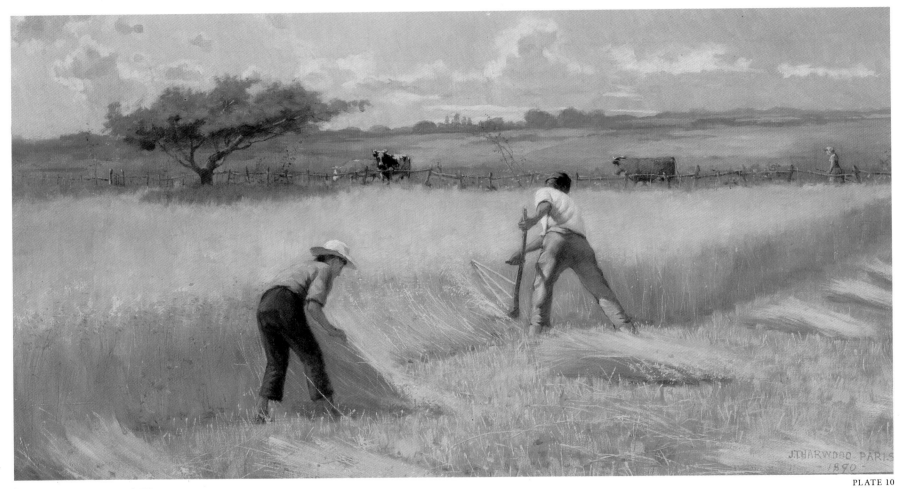

PLATE 10

James T. Harwood, Harvest
Time in France; *1890,
oil on canvas, 17 1/2" × 31";
SMA, gift of Blaine P. and
Louise Clyde, Springville.*

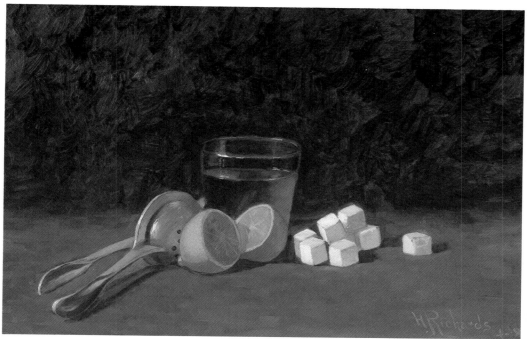

***H**arriet Richards Harwood,*
Lemonade Still Life; *1888,
oil on board, 12" × 18"; SMA, gift
in memory of Patrick O. Ward
(by exchange).*

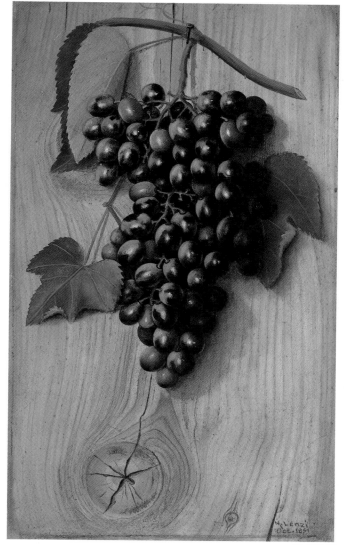

***M**artin Lenzi,* Still Life
with Grapes; *1891,
oil on board, 17" × 10"; SMA,
gift of a friend of the museum.*

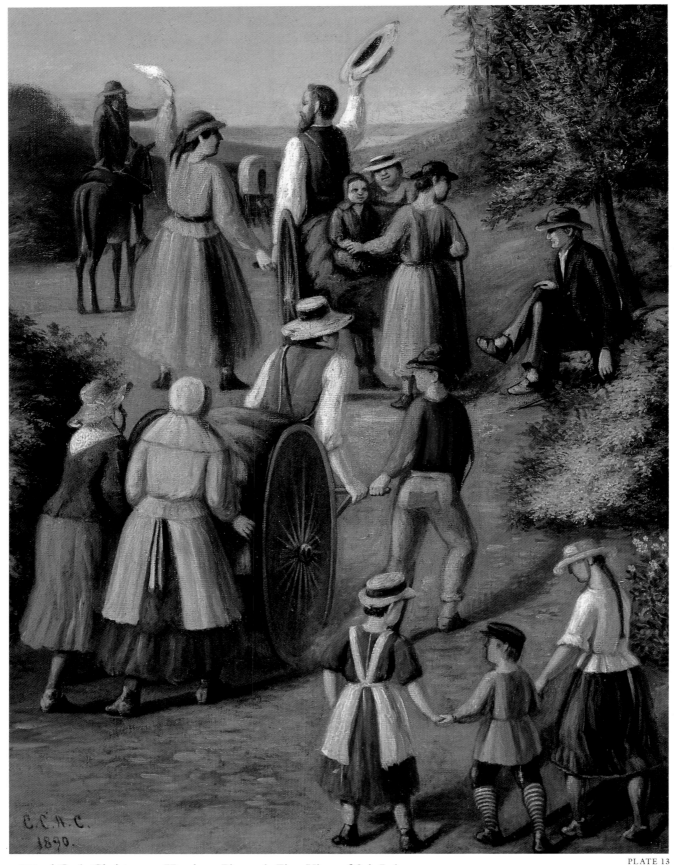

PLATE 13

*C*arl *C. A. Christensen,* Handcart Pioneer's First View of Salt Lake Valley; *1890, oil on canvas, 16" × 12"; SMA, gift of Neal and Jane Schaerrer, Salt Lake City.*

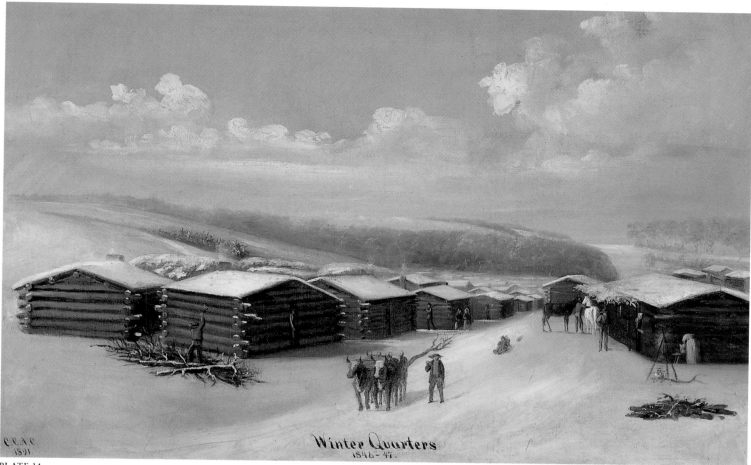

Carl C. A. Christensen,
Winter Quarters;
1891, oil on canvas, 14" × 22";
SMA, gift of the A. Merlin
and Alice Steed Collection Trust.

PLATE 14

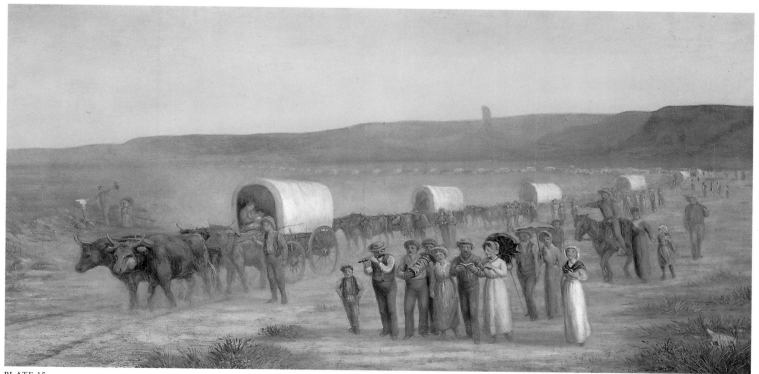

George M. Ottinger,
The Immigrant Train;
1897, oil on canvas, 20" × 40";
SMA, gift of the A. Merlin
and Alice Steed Collection
Trust.

PLATE 15

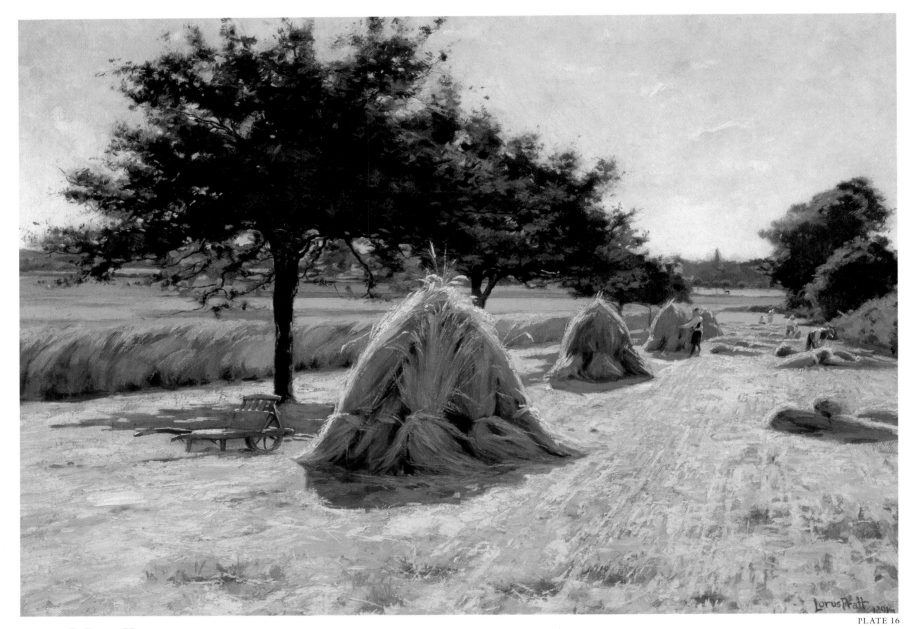

PLATE 16

*L*orus B. Pratt, Harvest
Scene in France; *1891,
oil on canvas, 22" × 31";
SMA, gift of Brent and
Diane Pratt, Salt Lake City.*

From Pioneer Painters to Impressionism
William C. Seifrit

Utah's art history after 1847 actually began elsewhere. Several of the figures who would play the largest role in framing Utah's artistic tradition were still young people living in various parts of the world and working at other occupations when the pioneers entered the valley of the Great Salt Lake in 1847. C. C. A. Christensen (1831–1912) was a sixteen-year-old toymaking student in Denmark. George Martin Ottinger (1833–1917) was being shunted from relative to relative prior to his running off to sea. Danquart Anthon Weggeland (1827–1918) had begun his limited art training in Norway and had completed an additional year of study in Denmark as the pioneers reached the valley.

FROM 1847 TO 1860

Perhaps more than any other American frontier community, early Utah had a strong affinity for the fine arts. Utah historian Edward Tullidge spoke in 1886 of an "early taste and love for pictures in the community" far in excess of what might be supposed from the newness of the country. He attributed this in part to the great number of citizens recently arrived from the "Old World," where they had often visited museums and galleries. Brigham Young, who had led the Mormon pioneers to the valley of the Great Salt Lake, was sensitive to the visual and performing arts. Missionaries to foreign countries were instructed to seek converts among skilled artisans. And experienced and significant painters did come, bringing their training and taste to contribute to the artistic community.

In the beginning, some early immigrant artists were put to work painting scenery for the Salt Lake Theatre, which opened in 1862. Portrait painting was often a source of income; and the land, so different from anything in most painters' experience, inspired much early work. The LDS church commissioned church building decoration and paintings of Mormon subjects.

Many of Utah's first artists arrived here with an understanding of art history that exalted such "old masters" of the time as Salvator Rosa, Quido Reni, and Joshua Reynolds. Utah's artists were also much more aware of the then "modern masters" such as Paul Delaroche, Sir Edwin Landseer, and William Kaulbach than of any artists from the more radical movements. But while Utah was isolated from the currents of world art, particularly until the coming of the railroad in 1869, it was not immune to outside influences. Through books and articles in newspapers and from artists who passed through the state, the local or "home" artists became somewhat aware of the Barbizon movement of the forties and fifties, the realism of the fifties and sixties, and impressionism in the seventies and eighties. By the turn of the century, Utah was enjoying the results of a season's study in Paris by several promising young artists.

However, from 1847 through to the end of 1860, the pioneers were understandably preoccupied with securing food, clothing, and shelter; and artists, consequently, had to take other jobs to make ends meet. As late as 1872, George Ottinger lamented in his journal the difficulty of subsisting as an artist:

> *In the last eight years I have painted 223 pictures which have been sold for $3,415, or a little over $15 each. Now deducting $7.00 each for supplies, . . . it leaves me*

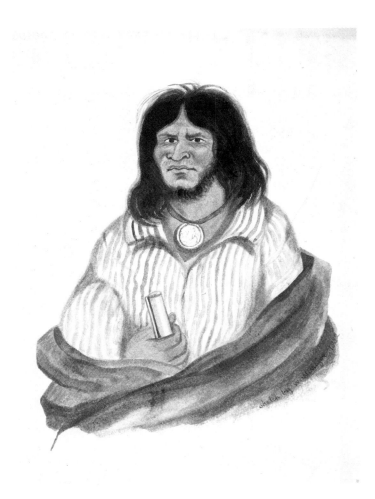

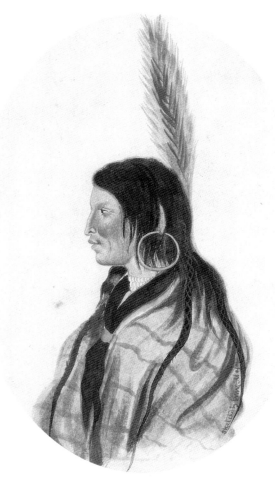

William Warner Major, *Rocky Mountains . . . Parishort or Leap of Elk, Chief of the Corn Creek,* May 1852, watercolor drawing, 8 1/2" × 6", SMA.

William Warner Major, *Wash'echick, Chief of the Shoshomas Tribe,* c. 1852, watercolor drawing, 7 1/2" × 5 1/2", SMA.

$1,752, or a little over half. My work is worth only $219 a year. When I look at my family and our wants I grieve.

Much of the art created in the region during the first "survival years" was done by itinerant artists rather than the pioneer inhabitants. The one notable exception was English painter and LDS convert William Warner Major (1804–1854), who accompanied an 1848 immigrant train to Utah and remained for several years thereafter, painting and sketching. He is best remembered for his portraiture, but legend has it that he also painted Utah landscapes and possibly some genre scenes. In 1852 he traveled with Brigham Young's party to the southern settlements and Indian tribes near Fillmore. There, according to Wilford Woodruff, "Brother Major our artist took the likeness of an Indian chief" (see *Parishort or Leap of Elk, Chief of the Corn Creek,* and *Wash'echick, Chief of the Shoshomas Tribe,* SMA). Major died in England while serving an LDS church mission. Few samples remain of what may have been a large body of work. The most outstanding

example of his work is a drawing-room oil of Brigham Young with one of his wives and their children, *Brigham Young, Mary Ann Angell Young and Family* (1845–51, Beehive House, MCHA).

Frederick Hawkins Piercy (1830–1891) is not generally thought to have been part of Utah's artistic heritage, yet he did contribute in his own way. Piercy was commissioned by the LDS church in 1853 to "paint the way west." He made his trek in 1853, took his sketches and notes back to England, and in 1855 his volume appeared: *Route from Liverpool to Great Salt Lake Valley.* While Piercy never lived in Utah, his scenic vignettes form a part of the widespread movement by American (and other) artists to describe visually the raw, empty, and beautiful West to the more populous East and to Europe.

Until the mid-1850s, the business of creating images in Utah was almost solely in the hands of photographers. Marsena Cannon (1812–1900) was probably the first (in 1850) to establish anything like a permanent studio. He was followed by one Robert Campbell. In 1854 John W.

Browning, assisted by S. A. Lobdale, established a "Daguerran Gallery." These photographers (and most of those who came after) specialized almost exclusively in small portrait "likenesses." "Particular pains taken with Likenesses of children," announced one advertisement. Cannon himself liked to use a popular advertising admonition of the time to stimulate photo sales: "Secure the Shadow Ere the Substance Fades!" Photographers of this period were almost compulsively mobile, staying in one locality for a few weeks or months and then moving on. No other Utah photographer was to last nearly as long in one place as Charles Roscoe Savage (1832–1909).

The year 1854 saw some major portrait painting done in Utah. After a nearly fatal trip to the Gunnison River territory with John C. Fremont, Solomon Nunes Carvalho (1815–1897) arrived in Great Salt Lake City and began painting portraits. Among his subjects were Wilford Woodruff and Abraham Owen Smoot. Wrote Woodruff, "I set today for the first time to have my portrait drawn by Mr. Cavalio [Carvalho] the Jewish artist that came with Mr. Freemont [Fremont]. He commenced one also for Brother A O Smoot." Few of Carvalho's known Utah paintings are extant, although the identities of many of his portrait subjects are known.

The tendency to paint portraits of leading citizens first, and then to work to secure commissions from other personages in the community, persevered throughout the nineteenth century. Rarely did itinerant artists arrive in Utah to paint bootblacks, barkeepers, schoolteachers, or grocers. Neither money nor fame could be had thereby.

Less than ten years after the first pioneers arrived, a group of Utah's new citizens organized themselves as the Deseret Agricultural & Manufacturing Society (DA&M Society), a forerunner to the state fair. The society was incorporated legislatively on 17 January 1856; it was at once an agency of territorial government and an instrument of the LDS church. The purpose of the organization was to showcase at territorial fairs the products harvested, processed, or created by residents.

The society's founders were reasonably quick to include an arts element in the fairs which they produced nearly annually. For most of the remainder of the nineteenth century, the fair was the one exhibition opportunity Utah artists could count on for displaying their art. At the first fair, in 1856, an unspecified number of works were exhibited. Among those were included at least two sculptures by William Ward—a bust of Brigham Young and, perhaps, a lion; photographs and a "case of Daguerreotypes" by Marsena Cannon; pencil drawings by

Henry Maiben (1855–1907) and Bathsheba W. Smith (1822–1910); an India-ink portrait by H. W. Wilson; and portraits in oil by Sarah Ann Burbage Long (1817–1878).

Of that group of prizewinners in the first DA&M Society fair only one artist has left a sample of work. Sarah Ann Burbage Long was a talented artist and teacher whose portrait work suggests a combination of clever naïvete coupled with the influence of William W. Major. Her *Brigham Young and His Friends* (c. 1863, MCHA) is a "must see." The variety and competence of William Ward's work has been described in Robert S. Olpin's *Dictionary of Utah Art*. It is quite possible that Ward's artistic achievements have been undervalued through the intervening decades. Perhaps the difficulties of reliably identifying his work have precluded a more comprehensive assessment of it. Henry Maiben was an energetic participant in the local Utah art scene throughout the last half of the nineteenth century. He was, variously, a singer, actor, and scene painter. No signed works by Maiben have been discovered. Bathsheba W. Smith's talents were recognized, but in fields other than painting. H. W. Wilson's drawings—indeed his identity—are lost to history.

It should be noted that, as these "prizewinning" Utah artists had lived in the territory less than ten years, they had brought whatever artistic talent they had with them from elsewhere. Further, each of these individuals was fully occupied in supporting both family *and* artistic creation. Through the nineteenth century, no Utah artist supported himself or herself solely by artistic production without a subsidy from family, teaching, or other income.

The DA&M Society began offering premiums, or prizes, for different types of home industry and manufacturing in 1857. The emphasis was on agricultural production initially, but the focus broadened to include the arts. Between the premiums published for "Best transparent window shades" and "Best table Cutlery" were the following:

Best Bird's eye View of Salt Lake City	$10.00
Best Landscape of Great Salt Lake Valley	$10.00
Best Oil Painting	$ 6.00

At the 1857 fair, Sarah Long again won the top prizes. A *Deseret News* reporter, W. G. Mills, offered a comment on Long's work:

We were struck with a splendid likeness of our friend J. V. Long . . . taken by his lady in oil colors. . . . The painting was highly and elaborately finished, and exhibited fine

talents in portrait painting. Other specimens of oil painting from the same artist were shown.

Through the end of the 1850s the DA&M Society's annual fair was the single event of the year where Utahns could publicly view art. The society, apparently anxious to make the art component of the fair more appealing, solicited not only locally produced art but also "antiquities and curiosities and rare specimens of the arts" to be exhibited.

September 1857 saw the arrival in Utah of Carl Christian Anton Christensen from Denmark, with the "Danish flag flying from his cart, his trousers flapping in tatters about his legs." In addition to studying toymaking, Christensen had spent five winters studying at the Royal Academy of Arts in Copenhagen. He became one of the first artists employed to paint scenery for the Salt Lake Theatre. "C. C. A.," as he would be called by historians in his later years and after his death, would become a quietly moving force in Utah's developing art history.

Meanwhile, the scarcity of hard currency, the absence of a liberal patronage, and political uncertainties all combined to make the life of an artist perilous. Consider Marsena Cannon's advertisement for photographs: "WANTED: Hay, Oats, Peas, Beans, Butter, Eggs, Fox and Wolf Skins and cash, for LIKENESSES." Trading for commodities seemed to be the rule rather than the exception in the new territory. It would be some time before Utah artists were paid in cash for their works.

At the fair in 1858, William Ward exhibited a life-size bust of Brigham Young; W. Pitt earned a second prize in oil painting following Sarah Long's first prize; Long's watercolor work was also praised. And a Mrs. Angell, probably Susan Eliza Savage Angell (1825–?), won a first prize for pencil drawing.

Works by Long, James Beck (1812–1866), Maiben, and Daniel Graves won awards in 1859. Awards in photography were divided between Marsena Cannon and the newly arrived firm of Sturgiss & Taylor.

At the end of the decade, Marsena Cannon continued to photograph people, places, and things as well as relocating his studio. Ed Covington & Co. opened a "First Class Picture Gallery" near the post office. In the territorial fair of 1860 James Beck won top prizes for pencil drawing; and Martin Lenzi (1815–1898) won a prize for best tinfoil painting.

Martin Lenzi was a Philadelphia cigar maker turned artist. Of all those associated with painting and sculpture during the first thirteen years of the territory's existence, Lenzi was one of the few who would continue to produce art until near the twentieth century (see *Still Life with Grapes,* 1891, SMA, **plate 12**).

Of the works known to have been created between 1847 and 1860 very few are extant; and of those almost none were created by so-called "home artists." Works by Major and Carvalho from this period are exceedingly rare, and extant works by local painters are even rarer. It is to be hoped that more works by the earliest Utah artists may surface.

THE 1860s

The 1860s were marked by an ever-increasing public awareness of art and artists. In addition, that decade saw the arrival in Utah of three figures whose influence would be felt at least until the end of the century and perhaps beyond. It may be helpful to place these individuals in their historic perspective as the decade opens.

Charles Roscoe Savage, an English-born LDS convert, had filled church missions for several years prior to beginning the practice of photography in New York City. He arrived in Salt Lake City in 1860. The twenty-eight-year-old Savage was, for a time, the partner of another photographer, Marsena Cannon; but by 1862 he had established his own business. For the next forty years Savage not only survived but triumphed over the various woes that beset most of the rest of Utah: Mormon-gentile conflict, economic depression, major losses by fire, and antipolygamy raids.

Savage's fame rests solidly on the volume and variety of his photography. He was also an active supporter (and frequently a member) of nearly every arts organization formed in Utah during the nineteenth century. Finally, his galleries, the Pioneer Art Gallery and, later, the Art Bazaar, were to become the principal exhibition sites for Utah's artists in the last half of the nineteenth century.

George Martin Ottinger arrived in Zion 12 September 1861. Then twenty-eight years old, Ottinger claimed: "I had walked every step of the way from Florence [Nebraska], a distance of 1079 miles, by my reckoning." His life and adventures prior to coming to Utah are recounted in his readily available journal. To support his painting and his family, Ottinger worked variously as a photo tinter, a theatrical scene painter, "chief engineer" of the fire department, assistant watermaster, and, late in the century, a lumber clerk.

Although he was basically an unhappy, envious man (a conclusion inescapable after reading his journal),

Ottinger was an artist worthy of mention here; his easel paintings contribute to Utah's artistic heritage. His *Self-Portrait as Fire Chief* (c. 1877, SMA, **plate 5**) is good portrait work; moreover, the painting preserves important historic detail. A number of other genre paintings issued from his brush and are prized because they are good paintings as well as important documents of the period. His marine paintings were drawn, no doubt, from his three years as a sailor. Ottinger is probably most often recalled for his remarkable "Aztec" or "Old America" paintings and Book of Mormon subjects. The scenes and events he portrayed on those canvases have various esoteric characteristics about them, and several of those paintings are described in detail later in this essay. A few of his Aztec paintings brought Ottinger a small measure of fame. Ottinger's influence in Utah's art history is weighted further by the instruction he gave several hundred students, both privately and as the first art instructor at the University of Deseret (now Utah) from 1882 to 1892.

Danquart Anthon Weggeland was thirty-four years old when he arrived in Salt Lake City on 17 October 1862; he was older and more experienced artistically than any other of what might be termed the "first generation" of Utah painters. His influence, like Ottinger's, extended through much of the remainder of the nineteenth century, weakening finally in the late 1880s when his visual acuity deteriorated. Weggeland was quieter and less flamboyant than his nearest contemporaries. His mural and easel paintings, executed for the LDS church (and for some of the church's leaders), form a large portion of his oeuvre. His privately commissioned paintings, such as *Bishop Sam Bennion Farm, Taylorsville* (c. 1879, SMA, **plate 6**) and *Ontario Mill, Park City* (1877, SMA, **plate 4**), constitute another body of significant work. Equally lasting was the influence his teaching had on the next generation of Utah artists.

The breadth and variety of subject matter in his paintings mark Weggeland as one of the more adventurous of Utah's early artists. Simply to say that he painted portraits, genre, and landscapes does him injustice. He was equally at home creating an eight-foot-high alchemist for the exterior wall of a drugstore or a modest still life. Other comparative examples are legion.

So, as the 1860s began, these three men prefigured strongly what the following decades would produce. There were to be other artists whose merit and influence would be felt, but these three—Savage, Ottinger, and Weggeland—formed the essential basis for an artistic

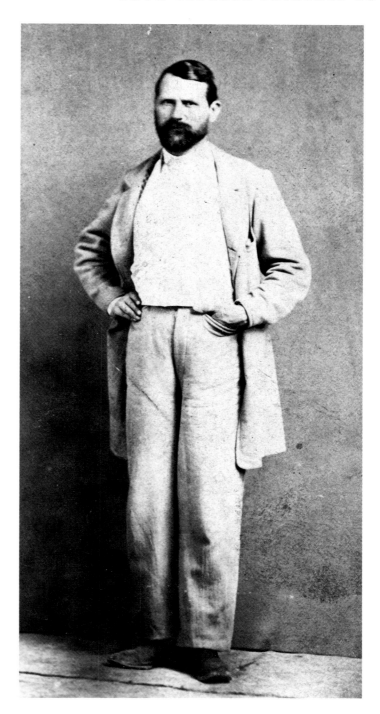

Danquart Anthon Weggeland, the "Father of Utah Art," shown when he was a young man, newly arrived in Salt Lake City from Norway via a season of study in New York. He became one of Utah's most beloved figures, the teacher of Harwood, Evans, Hafen, and Pratt. (Photo courtesy SMA.)

tradition that was to change and grow in exciting ways.

Utah art in the 1860s was much more energetic than in the preceding decade. Decorative painting became popular and was apparently quite well done. Fine artists whose work would both endure and have a beneficial influence on others continued to arrive in Utah. Artists traveled more frequently beyond the confines of the Salt Lake Valley to find scenes to paint. Itinerant artists visited to paint. Some local artists began to show their work more assertively. The teaching of drawing became a recognized course at the University of Deseret.

Awards committee members for the fine art division

of the 1861 territorial fair included William V. Morris (1821–1878), C. R. Savage, Edward Martin, and David McKenzie. That committee awarded first, second, and third prizes for oil painting to, respectively, George M. Ottinger, James Beck, and Martin Lenzi. C. R. Savage earned a first in photography, as did William V. Morris for "graining," the popular craft of painting hardwood grain onto pinewood.

In April 1862, Philo Dibble illustrated his lecture on early events in the history of the LDS church with his own paintings. Some of those works included representations of the martyrdom of Joseph and Hyrum Smith, Joseph Smith's last address to the Nauvoo Legion, and a skirmish between the Mormon Battalion and police officers.

Marsena Cannon continued to execute photographs that were favorably reviewed. The firm of Perris and Hopkins established a combination reception room and artist's studio for original paintings, copies, and Cannon's photographs.

By September 1862, Savage and Ottinger had established a partnership; they offered, among other things, "Photographs, plain and colored, Ivory types, Cartes de Visite, Ambrotypes, Crayon and Solar Pictures, Portraits in Oil, Water Colors, and India Ink." (See Ottinger's *Portrait of Eliza Thompson McAllister,* 1862, SMA.) In the territorial fair that year, Ottinger won a first prize for a copy of an oil painting, one of Sarah Long's oils won second prize, and a marine painting by James Beck won a prize. Savage's photographs and ambrotypes won first prizes.

The promising event of 1863 was the establishment of the Deseret Academy of Fine Arts, the first such school in the West. This association included Ottinger as president, William V. Morris as vice-president, E. L. T. Harrison as secretary, Charles R. Savage as treasurer, and Martin Lenzi as "Janitor." Other members included Danquart Anthon Weggeland, Henry Maiben, Ralph Ramsey, and William J. Silver (1832–?). Classes were to be offered in the George Romney building on Main Street in Salt Lake. The academy soon received gifts from Nat Stein (a portfolio of engravings) and William Jennings (an undisclosed cash donation). According to Alice Merrill Horne, "when wood hauling, agricultural pursuits, or public work prevented a teacher's attendance at the studio, his co-workers readily undertook to conduct his classes." After ten months, the academy withered away. Ottinger later suggested that its establishment had been "premature."

The mid-1860s showed a gradual increase in artistic activity. Sarah Ann Burbage Long painted *Brigham Young and His Friends* in 1863 or 1864. She advertised for pupils, offering "to instruct young ladies in pencil and water-color drawing" at a rate of five dollars per quarter. Classes were held each Monday from 10:00 until noon. William V. Morris and Henry Maiben formed a partnership to "execute PAINTING in all its BRANCHES." Edward Martin opened a portrait gallery: "Pictures taken; produce taken."

During the winter of 1865–66, Eastern artist Enoch Wood Perry (1831–1915) painted portraits in Salt Lake City. He arranged for studio space in the business location occupied by Savage & Ottinger. Ottinger groused in his journal about the money he thought Perry had made (over $11,000 in four months for portraits and landscapes), remarking that the local people "as a general thing like pictures and admire them but they have no money to spend for them, unless some stranger like Mr. Perry comes to the Valley." The *Deseret News,* however, saw Perry's presence as an opportunity:

> *Fine Portraits.—We stepped into Mr. Perry's studio, in Savage & Ottinger's . . . and saw some very fine portraits of Pres. D. H. Wells, the Twelve, Bishop Hunter and other leading citizens. Mr. Perry has produced some very good likenesses during the past winter, finished in a high style of art. . . . We understand they have been painted to meet a desire pretty generally expressed that good portraits of the Presidency and the Twelve should be preserved.*

Local artists were not idle during the mid-1860s. In early 1867 the *Salt Lake Daily Telegraph* reported that Daniel Graves of Provo had produced a large work, a "pen drawing," measuring four feet seven inches by three feet seven inches and representing the blessing of "the Twelve Tribes, with the two sons of Joseph, and their signs of heraldry." According to reports, this large work was completed in fourteen days. It was hung for a time in Mayor Wells's office. A newspaper reporter described it as

> *appropriately the representation of a Mormon family engaged in domestic duties and intellectual culture; the women spinning and otherwise employed, the children eye each other, and the father looking down with a protecting eye upon the whole. In the center is the Mormon coat of arms, splendidly executed.*

Other artists were enjoying successes as well. Ottinger painted two works in 1867 that depicted recent changes in both communication and transportation.

We were much gratified yesterday with a glance at two pictures recently painted by Mr. Ottinger of this city—the one, the Pony Express, the other, the Mail Stage, exhibiting in both the onward march of the luxuries of civilization westward. The Pony Express was the forerunner of the Daily Stage, the Telegraph and the Railway—and the paintings we allude to are very happy expressions of the past. The Pony is hurrying past Chimney Rock, at the head of which is a passing emigrant train, and the builders of the telegraph line are busy in the foreground. The Mail Stage is coming through the canyon with six lively greys, Jehu is swinging at his ease over the rough road, while an outside passenger hangs on with tenacity, while he views with some anxiety the rushing creek. The tunneling, bridge building and grading for the railroad are prominent objects, and tell us as directly as the telegraph wire, that the "slow day" is rapidly passing away.

Some of the very few works of Phineas Young (1847–1868) were also noticed in the press. A winter scene in Holland (purchased anonymously) and "a young lady in the bloom of early youth" were praised. The young painter died within a year of this notice, and few examples of his limited output are extant. He may well have been a talented copyist. His *Fortune Teller* (c. 1867, MCHA) is probably representative.

The mid-1860s saw a sad incident in Utah's art history—an incident that has since gone almost totally unremarked. Sarah Ann Burbage Long had won prizes and plaudits over several years for her oil paintings in the DA&M Society fairs; she had also taught drawing, painting, and music. But on 7 June 1866, her husband, J. V. Long, was excommunicated—together with his entire family—from the LDS church. And from that date till the day of her death, Sarah Long and her work were not mentioned again in the public press. Like one of Orwell's "unpersons," she simply disappeared from Utah society. Early in 1878, a notice of her death on January 9 was published in the *Women's Exponent* with this comment: "During the earlier years after the settlement of this city she did much towards the cultivation of music and painting among our young people." So, because of a husband's misfortune, Utah art history lost a bright early star.

As the decade continued, Ottinger received praise for his theatrical scene painting, and some of his paintings found favor with the *Montana Post,* which called them "noteworthy." This occasioned more favorable mention in the *Salt Lake Weekly Telegraph:*

We find the above chip [Montana Post's praise] floating on the art news current, and are glad to see it, not more as a recognition of Mr. Ottinger's claims as an artist, than that the West is no longer the mausoleum of oblivion to the talent that enters.

Of the joining of the rails at Promontory in May 1869, perhaps too much has already been written; yet an interesting sidelight of Utah's art history rises from that important event. Andrew Joseph Russell (1830–1902) was a nineteenth-century photographer who worked for the Union Pacific Railroad during 1868–69 following his service in the Civil War. He, with scores of other photographers (including Savage, of course), attended the joining of the rail lines. That may have been his first—or only—visit to Utah. Out of that visit came an oil portrait by Russell of George M. Ottinger. How the painting came to be done, what relationship may have existed between Ottinger and Russell, and when and where the painting was executed are all questions still unanswered. Russell was known for his photography; easel works by him in that period are generally unknown. Ottinger's journal is silent on the point. This enigmatic painting is owned by the Utah State Historical Society. Interestingly, Ottinger's *Self-Portrait of the Artist* (1869, SMA) also dates from that year.

In June 1869, Ottinger and Savage toured southern Idaho together for three weeks, sketching and "viewing." In the territorial fair that year, Ottinger won prizes for his *Last of the Aztecs* and for a landscape, a marine painting, and a watercolored photograph. Near the end of 1870 Ottinger managed to sell three recent paintings; he described the event in his journal: "I sold the pictures to the S. L. City Council for six hundred dollars but was not to draw the money for them for six months. The pictures sold were Last of the Aztecs $300.00, Washington at Trenton $200.00, and Cotton wood Lake $100.00." The local press praised the paintings and their purchase by Salt Lake City.

Dan Weggeland apparently concentrated on his family's survival during much of the decade, though he did receive the passing praise afforded several artists of the time. He spent a great deal of time coloring or tinting photographs with oil paint, sometimes in partnership with W. C. Gregg.

We . . . saw some excellent oil-painted photographs of some of our citizens, by Mr. [Marsena] Cannon, painted by Mr. D. Weggeland and framed by Mr. W. C. Gregg. Those of Mr. Philip Margetts and Richard McAllister are

equally as good as many executed by more pretentious artists at much greater expense.

In the fair that year, Weggeland won diplomas (a kind of honorable mention) for figure painting and (with E. Martin) for oil-tinted photographs.

Others whose artistic contributions were still in front of them began to be noticed near the end of the decade. John Tullidge (1836–1899) had worked for several years as an ornamental and decorative painter. In the 1869 fair he won modest prizes for his decorative skills. In the following fifteen or so years he would develop an attractive form of landscape painting (see *Minnie Lake*, c. 1887, SMA, **plate 8**).

Like nearly every other easel artist who came early to Utah, Alfred Lambourne painted scenery in the Salt Lake Theatre. He began such work while still a teenager, in 1866, and continued for several years. Then, as the 1860s closed, he was chided gently (for modesty!) for not submitting work to the territorial fair. He was also described editorially by the *Deseret News* as one of those men "of ability if not genius." These notices suggest that he had begun easel painting earlier than had been thought previously.

THE 1870S

The decade of the 1870s was a richly rewarding one in Utah's artistic history, as recognition, awards, sales, and adventures of various kinds all befell Utah's increasing numbers of artists. Visual artistic efforts in general received more attention. In many ways the 1870s were years of beginnings—of one-of-a-kind efforts or of preparation for what would come later in the nineteenth and early twentieth centuries. Before examining the progress of the major artistic figures of the seventies, a look at some of the unusual incidents of the decade may be of interest.

John Paternoster Squires (1820–1901) was a barber, a teacher in Salt Lake City's Twentieth Ward (prior to moving to the First Ward in 1881), and both an art supporter and progenitor. One of his sons was the artist Harry Squires (1850–1928), who was an uncle of Charles Clyde Squires (1883–?). J. P. was also the grandfather of Lawrence Squires (1887–1928), Charles Clyde's cousin. The patriarch's barber shop was the locale for a serious bit of decorative painting done by the firm of Morris & Sons. The painting was circular, six and one-half feet in diameter, done in oil on cloth (or perhaps canvas).

In its center is a bee-hive, and the balance of the space is divided into four compartments by ornamental scroll work, and in the compartments are the advertisements of each of the various departments of Z.C.M.I. The groundwork of the ornamentation comprises the various colors of the rainbow, artistically blended from the center outward. . . . Those who go to get shaved at Mr. Squires', instead of gazing vacantly upwards, can now divert their attention by minutely examining the devices and carefully reading the advertisements on this fine center piece.

Symbolic and institutional creations were described much more freely in the 1870s than would be the case in later years. The *Deseret News* published an account of the progress then being made on creating a baptismal font for the St. George Temple. The work was being done in the foundry of Davis, Howe & Co., Salt Lake City:

Six of the twelve oxen which are to support the baptismal font are completed, and two more are on the way. The animals are life size and were modelled in wood from a fine looking, genuine, live ox, and the modeller has done his work well, the imitation being excellent, and the castings are trim and neat.

The dimensions, weight, and other characteristics of the font were also supplied, together with the claim that "it will probably be the only one of the kind in existence."

A one-of-a-kind painter was the Scottish Mormon convert Nathaniel Spens (1838–1916). He arrived in Salt Lake City in 1865 and soon settled in American Fork, where he worked as a painter, decorator, woodcarver, woodgrainer, and farmer. He participated in the decoration of the Salt Lake LDS Tabernacle and Temple, and later carved part of the staircase in the Manti Temple. His powerful primitive narrative paintings were sometimes copied from the works or styles of others, but were unlike most of what was being done in the territory at the time. See, for example, his *The Deacon Jones' Experience* (c. 1876, SMA).

Throughout the early years of European settlement, many itinerant artists traveled through the Utah territory, painting both landscape and people. Albert Bierstadt (1830–1902), who gained great fame later in California and elsewhere, visited Utah several times. One early image is his *Salt Lake City, Wasatch Mountains, Uintah Range,* (1863, MFA/BYU). John Fery (?–1934), who lived briefly in Utah and several other western states, found the natural grandeur of Utah irresistible. He has

Nathaniel Spens,
*The Deacon Jones'
Experience* (after
Archibald Willard);
c. 1876, oil on paper,
16 1/2" × 22 3/4";
SMA.

Albert Bierstadt,
*Salt Lake City, Wasatch
Mountains, Uintah
Range;* 1863, oil on
canvas; MFA/BYU.

left a body of highly prized landscape work, of which one example is his *American Fork Canyon* (c. 1870s, UMFA, **plate 3**).

WEGGELAND IN THE 1870S

The early 1870s offered Dan Weggeland several opportunities for doing some important portrait painting. The portraiture Enoch Wood Perry had done during his sojourn in Utah over the winter of 1865–66 was afterwards used, occasionally, as a benchmark or standard against which to measure the skill of local artists. One of Weggeland's early portraits was so compared:

> *A Fine Piece of Work. A portrait of our city Marshal, J. D. T. McAllister, Esq., yesterday, from the pencil of D. Weggeland, Esq., took us by surprise. After viewing portraits of a number of our leading citizens, by Mr. Perry, we pronounce this a chef d'ouvre [sic], and one of the finest pieces of portrait painting we have seen in the city.*

By August 1871, Weggeland had begun teaching drawing at the University of Deseret but was still painting commissions privately. Two large works (now presumed lost) were ordered by a Mr. White. In the fair of 1873 his portrait of Brigham Young was lauded strongly, as was a portrait of Mr. B. G. Raybould (both c. 1873). The Brigham Young portrait had been commissioned by Joseph Hammer and perhaps Henry Dinwoodey with the intention of having the image reproduced by chromo-lithography and marketed at popular prices. Following is that "fine-art-to-mass-market" story:

> *Chromo Portrait.—Over six months ago, Mr. Joseph Hammer conceived an idea, which he, in connection with Mr. Henry Dinwoodey, has succeeded in carrying out very successfully. The idea alluded to was to obtain a good chromo portrait of President Brigham Young. . . .*
>
> *A splendid portrait was painted, expressly for this purpose . . . by Mr. Dan Weggeland. . . . The portrait was strikingly life-like, being in Mr. Weggeland's best style. In fact, connoisseurs in the east have stated that the painting was real gem of art, that would do credit to any living artist.*
>
> *Six months ago Mr. Hammer went on a business visit to the east. . . . While absent, he put the portrait . . . into the hands of Mr. Ketter[lous?], of Philadelphia, with an order to make an exact oil chromo counterpart of the original and strike off a thousand copies.*
>
> *Mr. Hammer brought those thousand copies with him on Sunday night, and they are now being mounted and will be ready for sale on Monday. It has already been stated that Mr. Weggeland's picture was a splendid portrait, and we need only say therefore that the chromo does it justice. The only fault that appears in any of the copies is that in some of them there is a slight tendency towards floridness of coloring in the face. The features, however, are well relieved and thrown out and the expression is quite natural.*

There are nineteen different shades of color in the picture, requiring, of course, the same number of impressions in the process of chromoing. The chromo-lithographs sold for four dollars in a "handsome oval frame" (although more expensive presentations were available). This was said at the time to have been the first chromo-lithographic representation of Young.

Weggeland was responsible for what must have been one of the most dramatic visual presentations of 1874; crowds of people gathered to watch the development of his "chemist" painting (no known title), painted on the north end of the Wasatch Drug Store and measuring sixteen by ten feet.

> *It is a basement room, fitted up as a chemist's laboratory. In the centre of the picture is a table, at which the chemist is seated, holding in his hand a glass partly filled with some decoction, with which he is apparently bidding defiance to "Death," while the latter standing in the opposite corner, holds in his fleshless hands a scythe and hour-glass. At the chemist's feet is a little dog, with a broken leg, sagaciously appealing for assistance, while in mid-air are two ethereal beings, the one with clasped hands, mutely praying for his success, the other about to crown him with laurels; and viewing all, with a demoniacal expression, is a mythical "fiend." A flood of light pouring down the steps through the entrance to the room is very effective.*

In the autumn, he joined with John Tullidge (and perhaps others) to sell a number of their paintings in an "art union drawing"—a raffle. Weggeland offered his own copies of old masters' paintings, his *Gypsy Group* (c. 1874) and his representation of the Crucifixion (1874). There is no indication how successful the drawing was for Weggeland or the other artists.

In March 1876, Weggeland exhibited his *Gypsy Camp* (also called *Campsite on the Mormon Trail*, c. 1874–75, UMFA), intended for the 1876 Centennial Exposition in Philadelphia, at William V. Morris's shop. A description of the painting was supplied:

> *It is a scene of a gypsy camp, in which the artist has brought out many beauties, and given the numerous figures*

that appear a wonderful variety of expressions. It is unpretentious, both in subject and in size, but it exhibits that glow and life which reveals the skillful hand of a true artist, while the drawing is nearly perfect.

One month later the artist (and the rest of the community) learned that the painting had been accepted—at least, it was listed in the exposition catalog. Later in the same year Weggeland presented Joseph Young with his *Crucifixion,* perhaps the 1874 work he had not been able to dispose of (or perhaps a new rendering).

Early in 1878, Weggeland finished images of Joseph A. Young and John W. Young. The first of these was done with Weggeland's own recollection and a small photograph to guide him. The *Deseret News* described it as a truthful likeness, so lifelike that "at first glance, a person is apt to imagine himself in the presence of the original."

The portrait of John W. Young was denigrated slightly because it had been copied from the work of an unnamed (or unknown) artist: "However it is an excellent copy of the picture from which it was taken."

Weggeland's painting in the then nearly completed Logan Temple has long since been lost. There is, however, a description of one of the murals he created there:

The most imposing feature . . . is the grand allegorical painting . . . which reached from the settee to the lower edge of the cornice above. It is an illustration of the ancient fable of the Scythian king, inculcating the doctrine and necessity of union, in the minds of his two sons; one of whom has a bundle of sticks, bound together in the attitude of vainly trying to break them over his knee, while his brother, with a similar bundle of sticks, takes them one by one, and readily shatters them into pieces. Underneath

Danquart A. Weggeland, *Campsite on the Mormon Trail;* 1874–75, oil on canvas, 23" × 36"; **UMFA X-117.**

23

the figures, in large, plain letters, is the motto: Union is Strength.

During the 1878 DA&M Society fair, Weggeland entered an unknown number of paintings; he won a bronze medal for a "portrait from life, in oil," of an unknown subject. He may have turned away a bit from oil painting as the decade ended. From March through December 1880, some half a dozen or so India-ink portraits came from his studio. The first two appeared in March—images of Eliza R. Snow and of a recently deceased one-year-old daughter of William C. Spence. Of the Snow portrait it was said: "The picture . . . makes the lady appear much younger than she is at present, which, however, may have been the intention of the artist." Priced at fifty dollars, the Snow portrait was exhibited in the *Women's Exponent* office, where some of the ladies were thinking of buying it. Weggeland showed a portrait of Eliza R. Snow again in September at Savage's gallery.

Weggeland used a solar enlargement of a photograph to complete the portrait of the Spence infant. "The parents are delighted with it, as it is but recently the little child died, and in this excellent portrait they have something to continually remind them of their departed darling."

LAMBOURNE IN THE 1870s

Alfred Lambourne's scenery painting continued to draw praise as the decade opened. Productions of such popular plays as *The Lost Ship* and *The Ice Witch* were enhanced by his scenes and other theatrical effects. Late in 1871 he exhibited the earliest of what would become a long, irregular series of views of and from the Great Salt Lake. The painting in this instance was titled *Salt Lake from Black Rock* (see also *Twilight near the Mouth of the Jordan*, 1872, SMA, **plate 1**). Lambourne had also begun to learn the benefits of good public relations with the press. His painting *Donner Lake, California* was presented to the *Salt Lake Herald*, whereupon that newspaper told its readers:

> *It is a delicacy of coloring and a happy blending of artistic points which constitute superiority in landscape paintings, and show that this young man has an artist's eye and soul of genius. Beautiful as the painting is, we appreciate it far more as a mark of esteem from a gifted young townsman than for its commercial value.*

Lambourne was to enjoy even more favorable public response to his entries in that year's DA&M Society fair. Drawing on his memories from earlier youth, when he migrated west with other pioneers, Lambourne

recreated a scene he may have sketched about 1866. One critic, in his review of the art offerings in the fair, wrote:

> *We now pass along to the collection of pictures by F. [sic] Lambourne, by far the most attractive and meritorious of which is "Sunset on the Platte River," in which a number of emigrant wagons, or prairie schooners, are represented as turning the corner of a rocky bluff, throwing the foreground into the shade, while the scenery in the background is illuminated by the rich glow of the setting sun. In this picture the artist has succeeded in infusing warmth into his subject, without which such art productions are dead and lifeless.*

His next publicly noticed and reviewed work was *Autumn by the Brookside*. The subject was suggested by some lines of poetry by Tennyson and it was described as a "clever piece of art, the lights and shades, with the rays of a golden sunset falling on the ruddy-tinted leaves, being all beautifully blended and worked in." Lambourne accompanied C. R. Savage on a nearly month-long tour of southern Utah, bringing home a number of excellent sketches of southern scenery which developed into paintings. He exhibited *A Nook of the Desert, Cactus Desert,* and *Scene in Little Zion Valley* at Savage's to good reviews. One critic described his favorite as

> *a scene in that part of southern Utah where the line is located which divides this Territory, Arizona, and Nevada. In the foreground is a lava bed, peculiar to that region, and a growth of several varieties of cactus. The details of the picture are boldly and judiciously rendered. . . . It is a "Dixie" picture.*

Lambourne was again painting scenery for Salt Lake's Eleventh Ward dramatic society and for the Salt Lake Theatre. In that effort he was joined by his near-contemporary Reuben Kirkham. Their professional relationship continued for several years; it included a business partnership and a venture into panoramas. Not only did this pair of young artists join efforts in the theater, but they also sketched and traveled together.

By early summer of 1875, Lambourne was sharing a studio with Kirkham and Arthur F. Mitchell (1837–1901), the latter a shadowy figure in Utah's art history about whom little is known. For much of 1875, Lambourne and Kirkham had been working diligently on a large, complex panorama titled *Across the Continent* (1876); an alternate title was *From the Atlantic to the Pacific*. A preview presentation of their panorama was received enthusiastically:

The pictures, which are all finished excepting a few, are twelve feet six inches long, and of proportionate height, save one, a view of Salt Lake City, which is twenty-five feet long. We have seen a number of the pictures, and, in our judgment . . . they are good. . . . The experience of the painters as scenic artists . . . enables them to execute the panoramic style, a leading quality necessary in which is boldness and dash . . . in which they have well succeeded in their present effort.

There were, moreover, several special effects incorporated into the panorama: "A contrivance will be arranged so as to have the water portion of the [San Francisco] view in motion, when exhibited, and a moveable full rigged ship will appear on the scene." Following a private exhibition of the panorama, one critic praised the scene painting generally but found fault with the perspective in the Salt Lake City and San Francisco views. The *Salt Lake Herald* advised that "if, in addition to the general pictures of this city, the artists would add one giving a view on East Temple Street, showing our prominent stores, banks, & c., it would greatly add to the interest and popularity of the panorama."

The initial public presentation in the Salt Lake Theatre was well received generally. Lambourne narrated as the sixty-odd scenes rolled before the audience. After singling out some merits and faults the *Deseret News* reviewer deemed it "well worth spending a spare hour to see." During December, January, and February 1876, Lambourne and Kirkham toured with their panorama through other locales before returning to Salt Lake City, where the panorama was presented at least twice in ward schoolhouses.

In mid-1876, Kirkham and Lambourne rolled up their sixty panels and, together with a "business agent" named George H. Dunford, headed east intending to "take in Cheyenne and Denver on the way eastward, and commencing at Omaha, visit a number of the cities and towns east of there. They intend visiting Philadelphia before they return." The two had apparently returned by October and were exhibiting easel work in Salt Lake.

Lambourne and Kirkham were not alone in the panorama business. C. C. A. Christensen, Dan Weggeland, Samuel H. Jepperson (1855–1931), and others also painted panoramas, which were a very popular art form in Utah as well as in the rest of the country during the nineteenth century.

Lambourne was soon off again, this time with C. R. Savage. They returned from a photo/sketching trip to Omaha in November. Lambourne's *Cliffs of Green River*

(p. c.), though not quite finished, was exhibited at Savage's gallery in December. And in June 1877 they made a three-week trip to Nevada and San Francisco, where they "feasted" their eyes on the art displayed in the galleries. They also visited several lakes—Tahoe, Cascade, Fallen Leaf, and Donner—and other scenic points in the Sierras, as well as the private Crocker gallery in Sacramento.

Morning in the Sierras and a dawn view of Donner Lake were among several California landscapes Lambourne produced over the next few years. He also showed a group of sketches of Big Cottonwood Canyon—"among the best productions from his pencil. They possess excellent merit, and, in the form of a portfolio, are most suitable to adorn the parlor or drawing room table."

OTTINGER IN THE 1870S

George M. Ottinger was a busy man in the 1870s. The firm of Savage & Ottinger, as their photographic operation was known during their several partnerships, gained recognition in the Pacific and in Europe. It was common practice during the last half of the nineteenth century for photographers to send scenic views to as wide a potential audience as possible. Having such unsolicited gifts acknowledged generally added to the home photographer's local and regional prestige:

A Royal Savage to a Noble Savage.—Our own Savage, the noted Charles R., our famous photographer, has received from that royal savage who presides over the destinies of the Kanakas, loving greetings and warm acknowledgements, to himself and Mr. Ottinger, for photographs received. Kamehameha V leads the emperor William of Germany, who will next acknowledge the receipt of Salt Lake Views.

In June 1871, Ottinger was finally paid for the three paintings he had sold to Salt Lake City six months earlier. Later that month he and Savage traveled through Nevada and California (presumably using Savage's lifetime railway pass). For a few days of this trip they moved themselves via a railroad handcar, pumping up gentle slopes, cruising down small slopes, "viewing and sketching" whenever they tired of working the two-man pump handle. The *Salt Lake Herald* described the episode more idyllically:

With a hand rail-car to pass up and down the road, which makes their art services truly labors of love, they can

go where they please on the line, catch scenes of loveliness from different points, and make pictures worthy of their reputation.

Upon their return to Salt Lake City the *Salt Lake Herald* noted that both men were "clean washed and looked anything but savage, albeit the Nevada Shoshones, through whom they passed, are not the most congenial souls in the world."

One of Ottinger's early Aztec paintings was reviewed in detail while being exhibited in Savage's Pioneer Art Gallery. The painting *Marini Deriding the Mexican War God* required ten months to complete. It was to be sent, together with two other Ottinger works—*Constance de Beverly* and *Columbia*—to a Philadelphia art dealer for consignment sale. The paintings were ultimately refused and returned. Of this rejection Ottinger wrote that the dealer had said "he has no room for my pictures, a polite way of telling me they are of little if any merit. . . . The blow comes easy as I am about used to it. . . . No Sale for my work at home or abroad." Yet just weeks earlier he had sold a Cottonwood Lake scene to William Jennings for one hundred dollars.

Ottinger continued painting despite his depressed attitude. His *Evening Gun* was exhibited to quite favorable reviews. After saying that the painting was "in every respect a fine picture," the reviewer went on to describe it as

a scene rarely witnessed in these days of steam and modern ship-building, the view being an imaginative one, marine in character, with an old fashioned three-decker belching forth "The Evening Gun," which is the title of the painting. The sun is setting in a hazy, lazy summer sky, the peculiar coloring of the piece having its chief beauty to those who have witnessed such sunsets in other climes.

Evening Gun was shown for a time with a Black Rock view of Great Salt Lake by Alfred Lambourne.

Between the unhappy years of 1870–71 and his triumphs in the following year's fair, Ottinger did manage to eke out a living of sorts. He wrote: "My principle income was from coloring Photo's, and painting a few portraits in oil, getting for 25 x 30 inch portraits $50.00 & $30.00, for 18 x 22 $20.00." After bemoaning his poverty and lack of acceptance, he observed that "Painting as a profession seems a hard hill to climb in an old country. Few know how hard it is in a new one like Utah."

However, the 1872 fair was nearly all Ottinger's. He won the gold medal for best group of paintings and a silver medal for the best landscape. Included in his entries were at least four works: a portrait of Brigham Young, completed just weeks before; an imaginary scene from the Book of Mormon entitled *Baptism of Limhi;* and two landscapes, *Canons Glory* and *Canons Gloom.* These four works are known to have been exhibited, but there may have been others as well.

The portraiture of Enoch Wood Perry was again invoked as a comparative standard when, in early September (less than a month prior to the fair), Brigham Young posed for Ottinger:

September 9th. Had another sitting to day by Prest Young. He pronounces the picture a far better likeness of him self, than the one painted by E. W. Perry, six years ago.

As an aside, it should be noted that Young apparently requested a trade in services for his portrait sitting after Ottinger had won honors in the fair: "Mondy Night Oct 7th. To oblige prest Young I played my old part 'Poindexter' in the Octoroon" (presumably at the Salt Lake Theatre).

In 1873, Ottinger used *Canons Glory* and *Canons Gloom* to help decorate the upper rooms of the city hall for the firemen's ball. In April 1873 these two paintings were sold to George Q. Cannon for two hundred dollars.

By late summer Ottinger had completed his Emma Hill Mine painting depicting the ravages of a natural disaster and fire in Alta some years earlier. The *Deseret News* called the work

a fine painting of the Emma Hill, Little Cottonwood Canyon. The view was taken from the divide between Little and Big Cottonwoods. The celebrated hill . . . is thrown out in bold relief. . . . A bird's eye view is given of the City of Alta.

Sometime in 1872 Ottinger had begun work on an idealized fantasy painting, suggested perhaps by some poetry of Byron. The painting was titled *Lashed to the Shroud* (1872) and depicts the corpse of a woman washed ashore after a shipwreck.

The artist has succeeded admirably . . . in depicting in the features that wonderful expression of peace which is so often seen on the faces of the dead shortly after the spirit's flight from its earthly tenement. The outlines of the figures are beautifully symmetrical, which combined with the exquisite and natural coloring, causes the eye to linger upon this portion of the picture.

This was Ottinger's last major painting of the year; he won a first prize for it in the October DA&M fair.

In February 1874, he began a series of public lectures on "How to Read a Picture." He was a popular public speaker, and his lectures drew good crowds on winter nights:

Mr. Ottinger is a most entertaining lecturer, and has the rare faculty of rendering, in a pleasing manner, any subject he undertakes to treat upon. He has always a fund of illustrative anecdotes on hand, and besides a general solid earnestness of manner, when the nature of the subject requires he is frequently irresistibly humorous.

Historical painting continued to be Ottinger's principal artistic thrust. His next such effort was a realization of Alexander Selkirk abandoned on the island of Juan Fernandez, an incident used by Daniel Defoe for his book *Robinson Crusoe*. Ottinger's painting was well received. One critic said the features of Selkirk's figure and face

indicate, as plainly as if written or expressed in words, a feeling of almost overwhelming despair, induced by a fearful sense of utter loneliness, mingled with the bitterness of anger, as he watches the ship which carries away from him his mortal enemy as well as his hopes of social intercourse with his fellow men. The sea, which is most beautifully painted, and the beach and distant bluffs of the island are delineated and modified so skillfully that the figure of the desolate mariner is made the absorbing point of the whole picture, and it is difficult for the eye of a person, viewing it, to dwell on any other part of it for any length of time.

The painting was also said to be "an excellent mate to that other one of 'Lashed to the Shrouds,' but is considered superior to it, being richer and more intense in interest." Ottinger considered it about the best picture he had painted so far. *Selkirk* was later sent to San Francisco for consignment sale. For the remainder of the year he occupied himself with sketching and painting "mostly small" works. It would be more than a year before another major historical or genre work left his easel.

The following winter Ottinger resumed his public appearances, but this time as an illustrator. C. W. Stayner gave a lecture on noses. "The diagrams of the various forms of this leading feature, designed by Mr. G. M. Ottinger, were a source of much amusement," said the *Deseret News* pointedly. Between his lecture illustrations on 7 January 1875 and the birth of his daughter, Sarrah Jane, on the twenty-eighth, he completed portraits of Thomas Williams, Mrs. [John?] Sharp, and H. Phelps. He also began a painting of John Howard Payne listening

to *Home Sweet Home*. His portrait of Thomas Williams was exhibited anonymously in Savage's gallery. The reason for the anonymity, according to a critic, was that "we desired that a good many people should see it, and form a judgment upon the merits of the picture previous to being made aware that it was the production of one of our home artists." The comment went on to suggest that merit alone should be the criterion for judgment of excellence, not the reputation of the artist nor an artist's residence outside Utah.

Ottinger's next major work, *Struck It,* was described in detail. "The great interest of the observer centres at once upon the two prospectors, who are so life-like that one fancies that he has seen lots of such looking men about this City and the mining camps in the vicinity." Ottinger responded to the reactions *Struck It* received by noting:

As usual those who know some thing of the merits of a picture Say little, admiring the good with modest praise and looking over [overlooking?] the many faults with charity; on the other hand the know-nothings Shower their lavished Econinims [encomiums?] in praise, or dam it as worthless.

At some point prior to October 1876, *Struck It* was acquired by Sharp Walker.

The remainder of the 1870s was marked for Ottinger by three important events: the centennial exposition in Philadelphia; his appointment as chief engineer of the fire department; and a trip to England. The first of these saw him scale heights of elation and plummet into despair. The second gave him, for the first time since his arrival in Utah, a modest, reasonably secure financial base. The England trip satisfied a dream of his adult life as an artist.

For much of the summer of 1875 Ottinger worked on a major painting designed and painted for the centennial; he titled the work *Montezuma Receiving News of the Landing of Cortez* (1875, MCHA). By 30 October the painting was "about finnished," and by 1 January 1876 he had completed it. After scurrying about trying to find money to pay for suitable framing, he exhibited the painting to large enthusiastic crowds at Savage's gallery. To cover the framing (and perhaps the transportation costs) he had the painting photographed and sold the prints, together with a lengthy printed description, for one dollar each. The painting represented Cortez's ambassadors encountering Montezuma in the midst of a sacrificial ceremony. It was peopled with figures Ottinger had apparently gathered from some of the many histories he had read,

including *The Fair God* by Lew Wallace. Ornamental and genre detail were plentiful.

In May Ottinger was notified, by receipt of the catalog, that his *Montezuma* had been accepted. Less than a month later, on 12 June, he recorded the text of a letter from a centennial official: "I am sorry that the committee saw fit to reject your picture, after first having passed upon it, which now I am advised was a mistake"

Ottinger raged. He wept. He fumed.

> *Can I do any thing but throw up the sponge. Were I a single man, never, I would fight it out to the bitter End, but situated as I am, with a large family depending, common sence prompts me to surrender, and go at some thing Else more likely and certainly, to bring flour and fuel to my little ones.*

And, when he thought his load was heaviest, his six-year-old daughter died.

Then, on 16 July, a letter arrived that ultimately offered a small hope. Ottinger had written to Lew Wallace complaining of what he saw as shabby treatment at the hands of the centennial jurors. Wallace responded that he (and others) had been unable to find the *Montezuma* painting! After searching unsuccessfully for the painting he talked with a Mr. Campbell (possibly the exposition secretary) who referred him to John Sartain, who confirmed to Wallace the rejection of Ottinger's painting. Wallace thereupon interested Campbell in renewing the search for the lost painting so that it could be returned to Ottinger. While so involved, Wallace learned that most of the jurors were New Yorkers who cared nothing for any art created outside their own circle (a comfortable, believable prejudice that is not directly provable).

Wallace and Campbell visited Sartain again and were told that after its rejection the painting had been shipped to Mansfield, Ohio. Sartain denied any responsibility for either the painting's rejection or its being sent to Ohio. At this point William Hayden and H. C. Goodspeed also interested themselves in the matter. These new friends of Ottinger's pressed Sartain again on the rejection of the painting and received from him assurances that once the work had been returned from Ohio it would be hung, somewhere. Hayden wrote to Ottinger in July finally, telling him, "Your picture is hung in the Pacific building, and is greatly admired."

The trauma of the accepted/rejected/lost painting having been soothed, Ottinger cast about for purchasers to buy several of his other paintings in order to provide sustenance for his family while he traveled with Savage to Philadelphia to see the centennial. He had already secured free transportation courtesy of the Union Pacific Railroad. Arriving in Washington, D. C., with Savage, Ottinger went straight to look at paintings. He saw two by Thomas Moran—*Grand Canyon of the Colorado* and *Yosemite*—and said: "I think them the two finest landscapes I have Ever seen." Later, in New York, he looked at some paintings by Corot and remarked: "If their is any merit in his misty, no not misty, indefinite work I Cannot for the life of me find it." He returned home on September 28. Of the fate of *Montezuma* at the centennial, C. R. Savage wrote: "G. M. Ottinger's painting is on exhibition, surrounded by American flags, but hung too high to be seen to advantage." In February 1877, Ottinger sold the painting to William Jennings for $250, a price far below what he had hoped to realize.

With his appointment as chief engineer of the fire department in 1876—a post in which he continued until 1890—Ottinger's finances improved slightly; his annual salary gave him a dependable twenty-five dollars per month. That, combined with the few hundred dollars a year he earned from coloring photographs and the sale of the occasional painting, gave him a marginally firmer financial footing. The waning years of the decade saw a gradual lessening of Ottinger's artistic output. After his return from the centennial he painted a few portraits and a large copy of Heywood Hardy's *Ulysses Plowing the Seashore* (1876, MFA/BYU) before the end of the year. The following year, 1877, he began several more Aztec paintings—*Gladiatorial Stone* and *Montezuma Notified of His Election to the Throne* among them. Of *Gladiatorial Stone* the press said: "We think it a more attractive picture than the Montezuma picture, bought by Mr. William Jennings, although somewhat in the same style." The painting remained unsold at the end of the year.

In May of that year he was visited by an old rival for the public's art dollar, Enoch Wood Perry. "We had quite a refreshing talk about Art Matters." And in June, Ottinger finished painting for James Dwyer, *Moroni Delivering the Plates to Joseph Smith*. He complained at the small fee—"I only received fifty dollars including frame"—but the LDS press praised the work.

At the 1878 DA&M fair, Ottinger's *La Noche Triste* won a gold medal for best historical painting. In all probability he was so busy with the fire department that he had little time and energy left for painting. He did offer one work (probably a copy) to be raffled for the benefit of one of his favorite groups, the Firemen's Mutual Aid Fund.

Ottinger and Savage had planned to take a trip to England during the autumn of 1879, and departure time was approaching. The city fathers had granted Ottinger a leave from his duties, and he set about selling off fifty or so paintings to help finance the trip. He installed several dozen works in Barratt's Furniture Warehouse and realized nearly three hundred dollars from their sale. Some of those paintings had been lying around his studio for several years. The *Deseret News* urged support for the sale.

> *Home art should be encouraged, and these paintings are priced very moderately. Many people pay higher prices for imported pictures far inferior to those of our home artist now on exhibition. Call at Barratt's and see the display.*

Both Ottinger and Savage lectured for profit through this period on "Pre-Columbian America" and "the scenic beauty of the West" respectively.

Once they had raised funds for the trip, Ottinger and Savage left Salt Lake City on 5 August; they sailed from New York City aboard the *Wyoming* on the nineteenth and arrived in Liverpool on the twenty-ninth. In England Ottinger traveled widely, visiting museums and galleries and even his wife's birthplace. He also visited a local fire station. He failed to make contact with several corresponding art friends, but he did manage to place three paintings—*Coatil, Lyncoya,* and *Quin Sabe*—with an art dealer in Liverpool. They returned to America on board the *Montana* and on 10 October passed narrowly through a severe gale that washed away lifeboats on the ship, together with a crewman and a passenger.

Prior to his departure for England Ottinger had arranged to have several of his paintings entered in the fair back home. When he returned he found that he had been awarded a gold medal for *Last of the Aztecs,* a silver medal for his landscape *Young's Peak,* a bronze medal for the "best painted banner or flag," and a diploma for another Aztec painting. He was welcomed royally upon his return home:

> *Mr. George M. Ottinger . . . returned home . . . last evening, and was met at the depot by the members of the local Fire Companies, dressed in complete uniform, with lighted torches, headed by the Tenth Ward Band. A procession was formed at the station, and the surprised and delighted fire chief was from there escorted toward Main Street . . . where the procession wheeled and proceeded to Firemen's Hall. An address of welcome was read by Mr. John Reading, and replied to by Mr. Ottinger, when the entire company proceeded up stairs, where a sumptuous*

> *banquet had been spread. . . . The feast was interspersed with toasts, sentiments and other expressions of welcome and good cheer.*

As 1879 drew to a close Ottinger painted a view of the *Montana;* the painting sold early in 1880. He sent *Gladiatorial Stone* to the art dealer in Liverpool. The fire department was taking ever-increasing blocks of his time and concentration, and in the final year of the decade he painted little. By his own account his output was limited to one portrait, a few landscapes, two titled Aztec pieces—*Flowers for Cotlantona* and *Mexico, 1520*—a Mormon history piece, and *Princess and the Pepper Seller.* He also reworked his *Constance de Beverly* and almost "wholly repainted" his *Marini Deriding the Mexican War God.*

For G. M. Ottinger, the 1870s had been a decade rich in both success and disappointment. He had lived through the birth and death of children, secured employment, been exposed at the centennial, made a trip to England, and had adventures in Utah and elsewhere. His year-end prayer sums up his decade:

> *. . . altogether I feel thankful for the kind providence, and blessing's that God in his goodness has given to me, and mine, and hope and pray I may deserve a continuance of the same divine care during the coming year.*

REUBEN KIRKHAM

The decade was also kind to Reuben Kirkham (1845–1886), an early Utah artist whose worth and merit are only now beginning to be evaluated. He first came to public notice for winning a minor prize for pencil drawing in the 1869 fair. Several years later he entered more ambitious works, prompting the *Deseret News* to tell its readers that "Mr. Kirkham's collection of oil paintings . . . is really creditable to that gentleman, especially the representations of scenes on the Yosemite." Others were even kinder: "In Mr. Kirkham's productions there is a marked improvement. . . . His views in the Yosemite are superb." He won a diploma for this group of paintings.

The year 1873 saw Kirkham grow firm in his friendship and artistic collegiality with the slightly older Alfred Lambourne. They collaborated on many scenes for the Salt Lake Theatre, and they toured nearby canyons sketching together. Later that year Kirkham entered the largest collections of anyone in the fair. His *Deserted Mill* (1873) was judged to be the best of the lot. Of some of his other works he was advised that his subjects may have been "a little too high for a young artist." The *Salt Lake*

Herald called the bulk of his paintings "crude." Undaunted (to his credit), he continued painting. New works—a foggy morning in Bountiful and *Sunset on the Weber River*—were praised.

In March 1874, Kirkham showed a painting of a scene in Holbrook Canyon that was admired: "It is the best picture from the brush of this rising young artist." Kirkham offered it for sale to earn means to pay for instruction in painting. More than a year later he joined with Lambourne and Arthur F. Mitchell in opening a studio in Salt Lake City and exhibited an unknown number of works in a "Fancy Fair" at Bountiful. During much of the summer he was apparently involved with Lambourne in the ambitious panorama project, *Across the Continent*. This was, in fact, Kirkham's principal occupation for over a year.

Kirkham's large (four-by-eight-foot) painting *Wilds of the Wasatch* (c. 1878–79, Salt Lake County coll.) was generally praised, although it might well have been a bit intimidating. But the work was called "bold and striking in conception. . . . Its greatest fault is a look of softness in the distance and there is a slight faulty perspective." Kirkham showed no more paintings until the fair of 1879, where he showed the impressive *Sunset in Blacksmith Fork Canyon, Logan* (1879, SMA, **plate 7**). Kirkham's paintings won a silver medal in that exhibition. Thereafter he reoccupied himself with the panorama and exhibited no further easel works until the Cache County Fair in 1880, where he showed two small "panel paintings" that went largely unremarked.

Early in 1881 Kirkham was painting again: "R. Kirkham . . . is engaged upon a landscape which will be a gem when completed. It is a view of Calder's lake and pleasure grounds . . . situated about three miles south of Salt Lake City." This may have been the work he exhibited in whiskey dealer George A. Meears's "business sample room" (about which more will be said) in March with two other landscapes: *Scene in Logan Canyon* and *Holbrook Canyon, Looking West*. In the fair that year Kirkham's scenes of Logan Canyon drew praise. He had five additional titled works in the fair, for which collection he was awarded a diploma; he also won a silver medal for "My Sketch Book" and a special five-dollar award. Shortly thereafter he became a founding member of the Utah Art Association.

From 1883 to 1885, Kirkham was apparently at work on subjects for a new panorama based on the Book of Mormon. During this period he either resurrected earlier easel paintings or created new ones. Two "very pretty little landscapes" were shown at Savage's. These may have been two northern Utah scenes later commented on by the *Salt Lake Herald*. After noting that Kirkham had recently been painting in the studio of Lorus Pratt (1855–1923), the *Herald* writer said (perhaps apropos of earlier criticism):

> He is not the only painter we know of who does not realize when to lay down his canvas. We remember recently seeing in Mr. Pratt's studio a beautiful little landscape by this same artist [Kirkham], which would not bear another stroke of the brush without injury, yet which he intended to spend much more time upon.

During the following month he showed "several excellent studies" in the second Utah Art Association exhibition; he apparently entered some additional works after the catalog had been prepared. In spite of this apparent confusion, one critic called Kirkham's *Narrows in Hard Scrabble Canyon* "nearer the standard of his better work, and . . . a picture that should find a place in some handsome Salt Lake drawing-room."

The early part of 1885 was devoted by Kirkham to his Book of Mormon panorama, which consisted of nineteen scenes. Kirkham exhibited it widely from 1884 to 1886; in the spring of 1885 he took it to Beaver, Nephi, and Provo. By May he resumed exhibiting easel paintings. A scene near Kaysville was shown at D. O. Calder's, and other landscapes appeared at Savage's. Late that summer he had begun taking scenic photographs. Views of Garden City, Joe's Gap, and the Logan Temple were mentioned. He turned his view of Joe's Gap into a painting early in 1886, and it was exhibited in Ogden at a furniture store during the time that Kirkham had his panorama showing elsewhere in that city.

The panorama was shown in Salt Lake City in February and March of 1886. A few weeks later Kirkham lay dying of pneumonia in Logan; he passed away 17 April. His loss was mourned widely, and commentators were uniform in acknowledging his exemplary life, his devotion to his church, and his occasionally successful struggles as an artist. The *Salt Lake Herald*, which had generally been fair—if not always kind—to Kirkham, recalled his last easel painting, *Joe's Gap*, noting:

> Take it all in all, it was his best and most pleasing picture, and moreover, it showed that his long study and application was at length bearing good fruit, and he was about to reap the benefits of careful sowing.

Reuben Kirkham's place in Utah's art history is

difficult to assess. The difficulty rises in part from his brief career and limited output. In the thirteen years between 1872 and 1885 he produced, by generous estimate, fifty easel paintings. Of these, perhaps six are known to be extant (including one that is unsigned but reasonably attributed). The difficulty is made greater by the largely uncountable theatrical scene paintings he created either alongside or in concert with Alfred Lambourne. Finally, there are the two panoramas, *Across the Continent* and the collection of scenes from the Book of Mormon.

Careful consideration of Kirkham's extant paintings available for viewing suggests that his nineteenth-century critics may have been fairly accurate in their estimation of his merit as an artist. Overly vivid colors, invention far above execution, and overattentiveness to some details and neglect of others equally important, all combined with a hasty rush to complete a canvas, may well be the marks of an artist struggling to overcome the lack of formal instruction while trying to learn what he could from those artists whose work he saw daily. Lambourne, Pratt, Christensen, Weggeland, and others were producing work that Kirkham surely saw. Yet his own easel works are certainly not derivative.

Kirkham painted as no other in his period. There is now opportunity, afforded by the passage of a century, to reexamine his extant work, most of which suggests a confident approach, an eye for detail, good composition, and an enthusiastically bright (if somewhat florid) palette. Placing his work on a wall together with representative works by his contemporaries suggests that Kirkham may have been not so much a poor painter as a different one. He simply did not paint in the same manner as those around him. This thought, in turn, suggests that Kirkham's greatest shortcoming may have been the absence of stronger, formalized training. At the minimum, Reuben Kirkham's extant works provide an interesting addition to the body of painting produced in nineteenth-century Utah.

OTHER ARTISTS IN THE 1870s

Around 1870, John Hafen (1856–1910) began studying art in Dr. Karl G. Maeser's "Twentieth Ward Academy." Hafen came first to public notice in 1873 with a landscape that was called "quite creditable, considering the age and inexperience of the artist." His next public recognition came five years later upon the completion of an oil portrait of Utah governor George W. Emery. Another portrait, a crayon likeness of George Q. Cannon,

appeared in 1880. Just less than a decade later, Hafen would be studying art in Paris.

Lorus Pratt (1855–1923) was a comparatively mature twenty-four years old when his painting efforts first came to public view. He showed an early portrait bust to a newspaper editor in 1879 and subsequently learned in that newspaper that:

> *The work is well done, and with study and practice Brother Pratt will very likely some day be a first class artist. It is the first time he has ever attempted to paint from life and we can confidently commend his effort in this line of work.*

In July of that same year he offered a painting (or a copy, very likely) of a pair of young lovers, the young man asking the hoped-for question while the young woman hesitates coyly. Entitled *Awaiting her Answer,* it was called "creditable." Another work, produced about the same time and also likely a copy, was an untitled household scene which was praised in similar fashion for the youthful work it was. Less than a year later a new painting by Pratt moved a writer for the *Deseret News* to predict that "with perseverance and practice he will develop into an artist of reputation." For the next several years Pratt continued painting in private, studying with Weggeland and Ottinger, and traveling abroad with his father, Orson.

Much about Carl Christian Anton Christensen's first years in Utah is but sketchily known. Many years passed following his arrival in 1857 before he allowed his paintings to be exhibited publicly, much less competitively. In the 1872 fair his painting of *Gleaners* earned praise and a silver medal. A few years later his friends and associates believed that Christensen's painting titled *Immigrants Crossing the Plains* had been accepted for exhibition in the 1876 Centennial Exposition at Philadelphia, but such was not the case. At the opening of the exposition, C. C. A.'s painting was still resting on his easel in Ephraim.

In 1878 Christensen's *Arrival of Poor Immigrants* earned a bronze medal in the DA&M fair, whereupon he threw himself heavily into finishing and then exhibiting his *Mormon Panorama* (1869–90, MFA/BYU). Probably his greatest achievement, this monumental narrative tells in twenty-two eight-by-twelve-foot scenes the story of LDS history, from Joseph Smith's vision in the Sacred Grove to the arrival of the pioneers in Great Salt Lake Valley. For convenience and portability, its scenes were attached in sequence as a continuous scroll on a roller. The artist and panorama toured in Arizona, Idaho, and Colorado as well

John Tullidge, a specialist in seascapes, and later in allegorical landscapes, was apprenticed as a decorative painter at the age of 14. Though he had little formal training, he taught classes in perspective, landscape, and life drawing at the Deseret Academy. (Photo courtesy SMA.)

he was associated with Danquart Weggeland in "art union distribution" schemes. His easel works continued to appear through the 1870s. In April 1877, two copies by Tullidge were praised and sold to W. S. Godbe. The following year he found patronage at the hand of Samuel Sharp Walker, who fancied a country scene painted by Tullidge. In the fair that year he won a bronze medal for "companion landscapes" and a diploma for "best general display of oil paintings."

In 1879 he served as an awards committee member during the fair and won a silver medal for animal paintings copied from old masters. Later that year he was commissioned by Walker Brothers to paint some Cottonwood scenes from original sketches. In 1880 he sold two Pennsylvania scenes to S. S. Walker. Said the *Salt Lake Herald* of these scenes: "In the handling of colors and in poetic effect, combined with a delicacy of touch, this gentleman ranks high." Just weeks after that review, Tullidge sent four landscapes to Owen Pierpont of Denver, who had purchased them on a recent visit to Salt Lake City. Pierpont became an important patron, as were members of the Walker family. By the end of the 1870s Tullidge was being ranked, locally at least, with Ottinger, Weggeland, and Lambourne.

Utah art in the 1870s was not limited to productions of a small handful of artists whose names are still well known. Other artists, local and itinerant, famous and obscure, were seen briefly and then dropped from sight—in Utah, at least. Their presence, however fleeting, might be noticed for whatever contribution their efforts, or their presence, may have made.

For example, Henry Wood Elliott (1846–1930) and William Henry Jackson (1843–1942) sojourned briefly in Ogden and Salt Lake City when they accompanied F. V. Hayden's Yellowstone exploring party in 1871. No paintings or photographs specific to the Utah portion of that expedition are known to exist. One year later, the then highly touted but now terminally obscure Charles H. Macpherson stayed a brief while. He claimed to have earned a silver medal for figure drawing in the Kensington School of Art; and he gave people to understand that he had just completed two years of study at the Royal Academy. While in Salt Lake City he executed portraits of M. Evans and Joshua Midgely—images that brought him praise. Then Macpherson disappeared, to turn up once again in a 1928 San Francisco city directory. One wonders at his adventures during the intervening fifty-six years.

Later, in 1878, through circumstances not yet fully

as within Utah. The pioneer experience was a favorite theme of Christensen's in smaller works as well. Typical are two paintings from the 1890s: *Handcart Pioneer's First View of Salt Lake Valley* (1890, SMA, **plate 13**) and *Winter Quarters* (1891, SMA, **plate 14**). He also worked on decoration for the St. George, Manti, and Logan temples.

John Tullidge (1836–1899) began his artistic life in Utah as a decorative painter in the employ of his father, or possibly in partnership with him. Through the late 1860s the younger John Tullidge had established a minor fame for workmanlike ornamental painting, lettering, graining, and marbling (the process of painting wood to resemble marble—like graining, a popular pioneer craft). In the fair of 1869 he exhibited landscapes "of merit." By 1872 he had begun selling his easel works; and by 1874

understood, a local Congregationalist minister, the Rev. Walter M. Barrows, received two paintings by James Fairman (1826–1904), the much-traveled, often-exhibited New York landscape artist, teacher, and critic. Barrows used the Fairman paintings to illustrate his own lecture on art; a year later they were exhibited noncompetitively in the fair. And in 1891 Fairman himself visited Utah.

Incidents such as the foregoing suggest that there was more artistic awareness and activity in the 1860s and 1870s than may have been thought. In addition, younger artists whose earliest efforts may have gone previously unnoticed were offering paintings for public scrutiny as the 1870s closed.

THE 1880S

The early 1880s saw several new developments in Utah's art history; these would stimulate both art and artists. A Utah businessman began to allow and even encourage the use of his walls for ad lib exhibition of the work of individual artists. The Utah Art Association was formed and enjoyed an active, if brief, life.

For some unspecified time prior to March 1881, George A. Meears, a whiskey wholesaler, had permitted local artists to hang their paintings on the walls of his "business sample room" at no expense; he took no commission on sales, nor did he charge rent for the space. By March 1881, a number of artists had availed themselves of the opportunity, among whom were Danquart Weggeland, George M. Ottinger, John Tullidge, Reuben Kirkham, Arthur Mitchell, and the young John Hafen. The essence of what Meears was attempting to accomplish is as follows:

> No expense attends this exhibition, and Mr. Meears respectfully invites all Utah artists to take advantage of this opportunity to place their works before a class of people whose attention is worthy of attraction. Mr. Meears would be pleased to dispose of these pictures, or to introduce possible purchasers to our local artists, whose merits are deserving of substantial encouragement.

In the spring of 1883, Meears opened a smallish storefront window in his liquor business for the same purpose; it was christened "the Easel" and quickly became popular both with artists and with the public. John Tullidge painted a drop curtain for the Easel, and it was launched on its bright, brief career.

The Utah Art Association was formed in the weeks following the 1881 DA&M fair. The founding artists included, at least, George Ottinger, William Armitage (1817–1890), Dan Weggeland, John Tullidge, Alfred Lambourne, Lorus Pratt, John W. Clawson (1858–1936), William V. Morris, Arthur Mitchell, C. K. Bowring, Reuben Kirkham, John Hafen, Harry Brown (?–1887), and C. C. A. Christensen. The name originally proposed was the Salt Lake Art Society, but this was changed a few days later. The stated purpose of the organization was to foster art appreciation in the community and to stimulate and help each member's artistic efforts. This organization was the precursor of the Utah Art Institute.

The members busied themselves with finding a place to meet, furnishing that space, and organizing themselves and an exhibition. William Jennings offered some rooms on the third floor over his Eagle Emporium. Furnishings were acquired through promised donations of paintings by members. David F. Walker offered fifty dollars to head a subscription list for the acquisition of an art library; Meears, Tullidge, and Ottinger were deputed to lengthen that list. Weekly, the members met to discuss art and to compete with drawings or sketches upon a given subject.

By November 1881 the Utah Art Association had completed its formal organization with its constitution and by-laws and had determined upon an exhibition to be opened in mid-December. An "art loan" feature was incorporated into the group's plan as well. There seems to have been a wealth of enthusiasm for the forthcoming exhibit. One commentator noted that "the members are very skillful with brush and pencil, and can draw almost anything except $1,000 checks, but expect to be able to draw the checks after the exhibition." Several weeks before the exhibition opened, the association successfully raffled paintings donated by its members and became debt-free. The ambitious group had also arranged for life-drawing studies with, perhaps, lectures by local physicians on anatomy and physiology.

The exhibition opened on 22 December and continued through 12 January 1881. Attendance was large, praise was plentiful, and there were occasional sales. Mining man J. R. Gilmer visited the gallery and asked the price of Tullidge's painting *Sunset;* it was offered at $125, and "Gilmer had the coin out at once." Said the *Salt Lake Tribune,* "There are hundreds of men in Salt Lake who will risk five twenties on the ace, and hesitate to invest a like amount in a good picture."

It is important to note that this exhibition was the first freestanding exhibition of Utah artists in the brief history of the territory; that is, the first exhibit organized,

designed, installed, and managed by the artists themselves, utterly independent of the fair, retail businesses, or any other organization or activity. In a little more than thirty-four years, Utah had become an art center with its first full-scale exhibition. So, as the 1880s began, new and exciting developments were occurring in Utah.

A formalized department of fine arts was organized in 1888 at the University of Deseret with George Ottinger as "Principal and teacher of freehand drawing and painting." Ottinger had begun teaching at the university in 1882. As a teacher, he (as well as Weggeland) urged students to pursue studies in the established art centers of the eastern United States and Europe. Several students of these two key teachers—including John Hafen, James T. Harwood (1860–1940), Edwin Evans (1860–1946), Lorus Pratt, and John W. Clawson—took that advice.

WEGGELAND IN THE 1880S

In the decade of the eighties, Dan Weggeland seemed to be even more serious about his easel work. He joined John Tullidge in a joint exhibition in January 1881; according to press reports, all the unspecified, untitled paintings were oils. Tullidge's illuminated shop was kept open at night, and several sales were noticed: "Some of the finest pictures have been carried off by liberal patrons whose refined taste and generous disposition have prompted patronage to these deserving artists."

Weggeland's portrait work was again noticed when Henry Grow, Jr., was sent to Cache Valley with what must have been reproductions of Weggeland's India-ink portraits. Grow carried with him portraits of Lorenzo Snow and Eliza R. Snow, as well as copies of a portrait of himself. By August, Weggeland had added a life-sized India-ink portrait of Edward Hunter to the portfolio of portraits being marketed by his friend Grow. It is unclear whether this was the Hunter portrait so lavishly praised in the fair later that year. During that summer Weggeland had also been busy creating some scenes for the St. George Temple.

In the fair that year he and Tullidge apparently combined their efforts on several canvases. Several "dog studies" were noticed and attributed to their joint efforts. Weggeland had a large number of paintings exhibited, including *Bishop Sam Bennion Farm, Taylorsville* (c. 1879, SMA), a portrait of a Mr. and Mrs. Peterson, and *Rosebank Cottage,* all done in oil. With Tullidge he exhibited *Spot on Duty* and *Douris and Spot,* both in oil. His India-ink entries included portraits of Bishop Hunter, D. Huntington, and F. Mousley. For all this work he won two silver medals, a diploma, and a special prize of five dollars.

George Meears wrote of Weggeland's *Rosebank Cottage* that it "evinces talent which is altogether too rare in this vicinity. It is a convincing reminder that the gentleman is at home in almost any department of painting." However, Meears had no praise for Weggeland's lack of financial acumen, observing: "What he can do, and what he cannot do, is illustrated by the price you pay him, or the figure he expects to realize."

> *Too much cannot be said of him as an artist; too little cannot be said of him as a financier. His lack of financial distinction, will hang to him through life, unless some convulsion of nature . . . wake him up thoroughly to a sense of his capacity to make money. . . . Dan ought to be, by this time, able to devote his attention to some great works, which would forever stand as a monument of his ability, instead of which, he is constantly struggling for the necessaries of subsistence.*

The 1881 fair included paintings by non-Utahns. Works by the California artist Julian Rix (1850–1903) and William Bradford (1823–1892) were exhibited noncompetitively. Bradford had visited Salt Lake City earlier in January and had left several of his paintings in the hands of new owners. In the days following the fair, as noted, Weggeland joined with over a dozen other Utah artists to form the Utah Art Association.

In the Utah Art Association exhibition, Weggeland showed several still-life works to praiseful notice: "The mountain trout look so natural, that they appear as if they could be lifted off the dish into the frying pan." As the year ended he was moved to make a gift to Meears of one of his best paintings; the work was said to be "equal to any piece of work on the Pacific coast. Mr Meears and his friends do not hesitate to say that it cannot be excelled by any one. It is now unpurchasable."

Weggeland had donated seven works to the drawing to help pay the Utah Art Association's expenses. These included *Sprites' Hall, Game, Windmill, Snow Storm,* and three untitled works—a lake scene, a marine painting, and an oriental landscape.

Weggeland's India-ink portraiture was noticed again in the spring of 1882. His rendering of Mr. D. J. Taylor was commissioned by a surviving brother, Richard J. Taylor. The skillful variety of Weggeland's multi-talented brush was next seen above the stage of the Walker Opera House. As that performance space neared completion, Weggeland was observed creating a "panel painting" in

which ". . . heavenly goddesses are portrayed in a dance together with Apollo, who has joined them. On either side of this panel painting are two cupids."

In the spring of 1883, Weggeland was one of the first to exhibit work at the Easel; he began with "a beautiful rural scene" and a painted medallion in black and white oils. An observer noted: "The representation of the bas-relief is so perfect that several have brushed it with their fingers to see if it was raised above the canvas." His *Norwegian Fish Girl* was called "a gem for its bold, free artistic and unconventional style."

In May, Weggeland was showing portraiture again. His India-ink portrait of Rev. G. M. Pierce was praised, as was his oil of Joshua Midgley. By the end of that summer Weggeland had gone to the Logan Temple to provide interior decorative work. While taking a break from such efforts he managed some nature sketches, including some flower and fruit pieces. These, too, were shown at the Easel. By mid-October he was back at work in the Logan Temple, this time accompanied by William Armitage. The subject of his last known easel work for the year was the Salt Lake City homestead of William Wagstaff (1883, p. c.), a talented gardener who had spent years cultivating and embellishing his property.

The year 1884 found Weggeland still painting in the Logan Temple. Upon his apparent return to Salt Lake City he found time to decorate the front of the Excelsior Bakery with a scene including flowers, a sheet of water with reeds and rushes, and a tall aquatic bird. He also finished three more India-ink portraits of three Mormon church officials who supervised the Logan Temple: Charles C. Rich, Lorenzo Snow, and Franklin D. Richards. These were to be hung in that temple.

For the next several years Dan Weggeland showed very little easel work. In 1885, for example, he is known to have shown only "scenery . . . of foreign design" on a baker's delivery wagon; he also prepared a "mammoth" portrait of U. S. Grant to be hung from the balcony of the Walker House Hotel in anticipation of Grant's visit to Salt Lake City. The next year found Weggeland credited with "elaborate scenery" in a production of *The Sea of Ice* in Ogden's Union Opera House. At the end of the year he showed at least one oil painting, a landscape, in what appears to have been a studio exhibition and sale put together by John Tullidge.

In January 1887 Weggeland exhibited several landscapes that were noticed. Later that month he showed portraits of Wilford Woodruff and David H. Cannon to Woodruff himself, who observed: "They were called

good. Cost $25 each." For some time Weggeland had been making pencil sketches of genre bits, artifacts, and other relics around Sanpete County and the Great Salt Lake; these were seen as an encouraging promise of future paintings. He also began a seven-by-fifteen-foot panoramalike scene of a fire on Salt Lake City's Main Street. Late in the year he participated in an art distribution scheme for the benefit of the recently deceased Logan sculptor Harry Brown. He contributed at least three paintings to that effort: *Apollo and the Muses, Ogden Canyon,* and *Utah Lake.*

Weggeland's next public notoriety came late in the year 1888, upon completion of a family-commissioned portrait of the deceased Brigham Young. The portrait stimulated reactions that did not focus on the work itself so much as they revealed the sociopolitical biases of the reviewing organs. Said the pro-LDS *Deseret News:* "It is a fine specimen of art, artistically worked up in detail. It is strikingly animated, and characteristic of the subject." Of the same portrait a *Salt Lake Tribune* reporter wrote:

> *[Weggeland] has quite a reputation for depicting the vegetable world, [and] has now on exhibition . . . an oil portrait of that giver of all good gifts, the Prophet Brigham. The saintliness of the face, its peculiar radish-like glow, and the root-like curves of the lines thereon, suggest that the transition from painting cabbages, radishes and garden sass generally, was too sudden and violent, and the texture of the beard indicates that the artist has been experimenting on painting wood.*

In the 1889 fair, Weggeland won a twenty-dollar prize for an untitled portrait. Two farm scenes were noticed politely. In 1890 he offered at least four works: *Great Salt Lake, Near Syracuse; American Fork Canyon; Christ Before Pilate* (after Munkasy); and an unidentified portrait. As the decades of the pioneer artists closed in 1890, Weggeland's art seemed to decline as he began painting more copies of "old masters" and multiple versions of his own work.

LAMBOURNE IN THE 1880s

The 1880s opened successfully for Alfred Lambourne. Collector J. R. Walker commissioned him to paint sunset and moonlight scenes of Silver Lake in Big Cottonwood Canyon, and the paintings were very successful. (See *Moonlight Silver Lake, Cottonwood Canyon,* 1880, SMA, **plate 2**). Lambourne's atmospheric effects, sometimes criticized for being garish or overripe, were praised in these paintings: "The sunset scene, to one

unfamiliar with the glory of a summer sunset in this air, might seem a little too fervid, but to a resident the first thought is, that the artist has caught and made perpetual an actual glory." Comments on the moonlight view were equally laudatory. Walker agreed to have the paintings placed on public view for several days prior to taking them home. Lambourne also exhibited, at Savage's Art Bazaar, a small view of Cypress Point, California.

During the summer of 1881 Lambourne may have given a young friend some useful instruction and encouragement in his own budding art career. H. L. A. Culmer (1864–1914) accompanied Lambourne "on a sketching tour among the isles of the Lake." This was very likely the first public notice taken of Culmer's painting inclination. This apparently brief trip may also help to establish more accurately the time of Lambourne's initial exploration of the Great Salt Lake. Dale L. Morgan has Lambourne visiting the lake "early in the eighties," with his first "cruises" coming in 1887. This Lambourne-Culmer tour may have been Lambourne's first sketching visit to the lake.

J. R. Walker appeared again as a Lambourne patron when he purchased *The Cradle of a Mountain Stream* and *The Bay of Monterey.* "The execution of both these exquisite paintings is beyond criticism, and would challenge the admiration of any connoisseur." The then twenty-seven-year-old Lambourne showed two more new works, *Quietude* and *Solitude* in September 1881. His talent and dedication were lauded:

> *This young man has the true spirit of genius. Nothing can quell his determination to excel in his line, yet his native modesty forces him to move cautiously. He is an indefatigable worker, and a constant student of nature. Alone in the hills and valleys of Utah, California, Arizona, New Mexico, and the wild spots of other states and territories, this young artist communes with nature in her wildest and roughest moods, seeking that inspiration which is the keynote of success.*

In the final months of 1881 Lambourne devoted much of his energy to theatrical scene painting in the Salt Lake Theatre. Many of these scenes, or "flats," were so striking that they were reviewed in the press prior to the opening of the plays themselves. In his scenes for *The Sea of Ice,* for example, he sought to reproduce "the reflections of the ever-changing lights on large and irregular masses of ice that result in color combinations found nowhere else in nature." He was successful in that effort "by frosting his work with powdered isinglass which under a strong lime light gives precisely the effect desired."

During this period Lambourne was also involved with the formation of the Utah Art Association. He showed two crayon sketches, *A Lonely Pool in the Wasatch* and *Headwaters of the Little Cottonwood,* in the association's gallery; in the first exhibition, he showed a number of works that had been seen (and sold) earlier. While praising Lambourne's paintings individually and as a group, a *Salt Lake Tribune* reporter took exception to the manner in which they were arrayed:

> *These pictures are hung in such a way that in many instances one kills the other. Had they been distributed about the room, instead of being hung in a line, they would have appeared in their full strength. In addition to neutralizing each other, they also have a deadening effect upon the pictures immediately above and below.*

Thus, in approximately a quarter of a century in Utah, the major question had changed from "Are there any oil paintings around that can be exhibited?" to "Why are these hundreds of paintings installed so poorly?" Not only was art more plentiful now than in the "survival on the frontier" days, but sensitivity to that art had become an affordable luxury.

Most of Lambourne's effort during the first half of the year was devoted to scenery painting, a class of work that routinely drew such comments as: "The piece is magnificently mounted, the first scene by Mr. Lambourne being worth the price of admission." Lambourne had been engaged to create scenery for the Walker Opera House as well as the Salt Lake Theatre, and his work there was also praised. By mid-May he had nearly finished a titled drop curtain, *Dream Land or Home of the Fairies.*

Easel work had been put aside temporarily, but Lambourne was engaged on new paintings from time to time. He had sold two Wasatch Mountain scenes to a W. F. Kirk of Chicago; about May 1881, Kirk commissioned two additional works: *Sunset after a Storm* and *Silver Lake, Wasatch Mountains.*

Lambourne told a reporter that the lonely solemnity of Utah scenery moved him and that he was trying to teach himself to paint directly from color tubes with little thinning or use of vehicles. During this time he also began writing poetry to express his worship of nature; poetry was an art form he felt was frequently more personally rewarding than painting.

Through the winter of 1882, Lambourne alternated between scene painting and easel works. A studio scene in the play *Esmeralda* was called, hyperbolically, "the best scene ever put on any American stage." And, as for the

Walker Opera House production of *Uncle Tom's Cabin:* "Mr. Lambourne has declared himself satisfied with the winter river scene, and with that success, all the rest is assured, because the garden scenes and other artistic pictures are perfect."

In January 1883, he exhibited a recent work, *Narrows of Ogden Canyon,* at Pierce's bookstore. It subsequently became the property of a Mr. Goodwin. A few weeks later Lambourne was presented with an artist's easel made of black walnut by an unidentified admirer. New images of Monterey and Tahoe were exhibited at the Easel. A large Salt Lake sunset was described in great detail just as it passed from Lambourne's hands to those of G. F. Culmer. In October, Lambourne showed a painting developed from one of his Uintah sketches taken the previous summer. *Sunset in the Uintah Mountains* was called an opportunity to "feast on the wonders and beauties which have been seen by but few white men."

> *The view is from a rocky ridge looking down a deep hollow, in which are several lakes surrounded by pine woods, while beyond stretch ranges of hills into the dim distance. The effect of sunset aimed at in the picture is what was witnessed, with the upper sky clear, while below were the golden line of clouds, the purple and the gray mist, through which the sun shines like a great red ball of fire. The painting was acquired by J. R. Walker.*

Later in the year Lambourne offered one of his earliest works sketched from the lake's interior, a view entitled *West Shore of Antelope Island,* which included the sun sinking behind Stansbury Island:

> *This is the artist's most successful style of picture, the glowing colors of sunset illuminating the heavens and lending a passing beauty to black mountain, lonely lake and craggy shore; and although he has been severely criticized at times on account of the bright tints he employs, the marvelous sunsets to which we have been treated during the past week, [show] how impossible it is for the artist to reach the brilliancy of nature.*

Late in January 1884, Lambourne wrote a small essay contrasting art (i.e., painting) and literature. His thesis seemed to have been that of the "three graces"—music, poetry, and painting—the last named being the least popular because it was the least accessible. Meanwhile, in his studio, Lambourne worked up two Tasmanian landscapes painted for Charles C. Burton from photographs Burton had brought with him when he returned from Australia several years previously. The

paintings were titled *Waterfall in Fern Tree Glen* and *Fern Tree Path* (both 1884). Later, he showed two Missouri scenes from sketches made years earlier: *Edge of a Wood* and *River des Pere,* which were acquired later by Ralph Savage. These paintings were joined in exhibition by a bust of Oliver Wendell Holmes by Cyrus Dallin (1861–1944).

Lambourne entered as many as ten paintings in the May 1884 exhibition of the Utah Art Association. Nearly all had been seen before, and several may have been borrowed from their owners for the exhibition. None was singled out in the various accounts of the affair. Just prior to the exhibition he had been sketching in California with Savage. Lambourne apparently spent the remainder of the year painting and sketching, generally in company with Savage. He paused, occasionally, to show a few paintings to friends who visited his studio. Those informal viewings nearly always resulted in praiseful mention in the press. Shortly after such a review he was off again; this time he and Savage went north to Yellowstone.

Just prior to their Yellowstone foray, Lambourne was visited by a *Salt Lake Herald* reporter who remarked on the number and variety of new paintings Lambourne had on hand. One in particular that found favor in the newspaperman's eyes was *Utah Lake from Springville:*

> *The foreground is a portion of the rugged, rocky canyon walls, the intermediate space being occupied with a mill, fields of grain, green meadows and a winding stream; in this happy, thrifty prospect a line of smoke denotes the railway train crossing the valley. It is a suggestive combination, giving an excellent idea of a peaceful thriving Utah scene. . . . A bit of that placid sheet, Utah Lake, is backed by the Goshute mountains, and the Tintic ranges of hills stretch away into the dim distance. The beauty and simplicity of the sky at once strikes the beholder, as well as the fine drawing and the harmonious coloring. . . .*

The painting was subsequently acquired by the *Salt Lake Herald* for use as a circulation-building premium.

Lambourne next arranged a small exhibit at Savage's Art Bazaar. He apparently showed only those works that had been seen and reviewed during the preceding months, but all of them were lauded. Almost simultaneously the account of his recent trip to Yellowstone was published. And so the year ended for Alfred Lambourne.

The year 1885 was a quieter one, with Lambourne less in the public view. In January he completed four Yellowstone paintings, all from sketches he had made during the previous summer. On that latter occasion he met

an Englishwoman, Mrs. J. L. Cox, who commissioned two Yellowstone paintings and showed Lambourne the actual scenes she wanted. These were *Scene in Upper Geyser Basin* and *Lower Falls, Yellowstone River.* He may also have sold her two other paintings earlier. In and among his easel painting efforts, he found time to paint stage scenery in Salt Lake City to be shipped to a theatre in Butte, Montana. Scenes from sketches made during yet another California sojourn next appeared: *Moss Beach, Restless Sea, Morning on the Coast,* and *Evening in the Bay.* These works subsequently became the property of Byron Groo, D. F. Walker, and (in the case of the latter two paintings) Gilbert Clements.

In both March and September 1886, Lambourne went traveling with Savage and returned with numerous sketches. He turned four of these into representations of the four seasons as seen on the River des Pere. He also painted two scenic views, *Glimpse of the Delaware* and *Storm Clearing the Golden Gate,* as "a couple of little gems intended for companion pictures . . . painted from sketches made on the very opposite sides of the continent."

Several major works deriving from his Great Salt Lake sketches appeared in 1886. At least five paintings resulted from cruises Lambourne made in June or July of that year. His *White Rock Bay* was called "striking." It represented

> *with pleasing effect a stretch of the northwest coast of Antelope Island, with the Elephant's Head cliff away in the distance. The White Rocks are in the near water from which are flying a large flock of the familiar seagulls. The Cambria is hove to in the bay, and her white sails, with the figure of a man at the helm, add a pleasing effect to what must ever be a very popular picture.*

Other views in this suite of Great Salt Lake paintings include *Moonrise on the Lake, Sunset on the Salt Lake, Black Rock from Garfield,* and *Storm on the 12th of June.* (See also *Black Rock, Great Salt Lake,* 1890, SMA.)

Later in the year 1886 Lambourne held his own "distribution" drawing. Twenty-one numbered ticket cards were sold at an undisclosed price. Each ticket entitled the owner to claim a painting carrying the same number.

Lambourne began 1887 by relocating his studio to the Emporium Building where, presumably, he taught and painted. After another visit to California with Savage he spent the summer painting and recovering from an apparently serious injury sustained when he was crushed by a freight wagon. By August he had recovered sufficiently to resume painting and to take a brief rest at Brighton.

In October he showed another suite of just-completed Great Salt Lake paintings: *Morning at the Sand Dunes, After-glow on the Willard Mountains, Cliffs at Promontory,* and *Looking Across the Davis Strait.* These were praised as fulsomely as his first suite had been in July 1886. These four paintings were later exhibited in Denver, where they generated much favorable comment.

In December of 1887, Lambourne made his annual appearance in Tullidge's exhibition while holding a studio exhibition of his own. To close the year, Lambourne's lengthy account of his 1884 exploration of Yellowstone was republished.

By May 1888, he was involved with several artists, including Dan Weggeland and H. L. A. Culmer, in the Utah Palace Exposition Car painting project. A railroad car, decorated to promote Utah, was used by the Salt Lake Chamber of Commerce to spread the word that Utah was a part of the United States. Lambourne contributed a view of a Great Salt Lake sunset at Garfield Beach, painted in oil on the railroad car. Weggeland painted clusters of fruit, garlands of grain, vegetables, and flowers to link the landscape views painted by other artists. The Exposition Car traveled over nine thousand miles to sixty cities throughout the country over a three-month period.

By midsummer his easel output was severely reduced. Indeed, for the entire year only about a dozen new canvases left his studio. Perhaps the death of his daughter, Edith, affected him profoundly; perhaps he would have begun turning to writing at this point regardless; perhaps still other factors caused him nearly to cease painting.

Still, Lambourne entered works in the 1888 fair. He won a special twenty-five-dollar premium for the "best and largest display of paintings," a silver medal for "palette knife work" in his *Restless Sea,* and a silver medal for Utah scenery paintings. This fair's works all but concluded Lambourne's oil painting for the next two to three years. Instead, he concentrated on black-and-white drawings, plaque paintings, and repetitive watercolors—all of a small size. He himself noted one oil painting during this period, *Sunset at Promontory.* The press noticed four others and praised them. Some of his black-and-white drawings appeared as etchings in *Pacific Coast Sketches* (1889). For most of the rest of the decade he concentrated on scenic and nature writing.

OTTINGER IN THE 1880s

The 1880s opened badly for George Ottinger. He had not sold a painting for some time, and he was pro-

foundly affected by a visit to Salt Lake City from one of the country's major artists, William E. Bradford. The admiration and respect paid Bradford, and the sales he enjoyed, engendered some envious feelings in Ottinger—much like those he had experienced fifteen years earlier during E. W. Perry's visit. Ottinger described Bradford's paintings as

> *painted very carefully in what I would call a starkly realistic manner . . . however, there is a similarity, or monotony, from which I should judge he does not posses that versatility and power that always will accompany true Genius. In fact, it is the novelty of the subject matter and not the artists handling or knowledge that makes his pictures interesting.*

Probably thinking of his own Aztec paintings, Ottinger seemed to reason that *any* new subject matter, dealt with adequately, entitled the artist who created it to honor.

By March, Ottinger had recovered sufficiently from the effects of Bradford's visit to have shown four works in Meears's "business sample room"; these included *Lane in Surrey, England; The Ruined Keep; Mutford Church;* and *Home of the O'Hara*, some or all of which may have been sketched during his recent trip to England. Later that spring he learned that all of the paintings he had placed on consignment in Liverpool, including *Gladiatorial Stone*, had been sold and that the consignee had absconded with the profits. Said Ottinger, "Well I have not broken my heart over it, but to tell the truth it has rather discouraged me, and dampens my ambition in no small degree." He did, however, continue working on *Princess and the Pepper Seller*, a Mormon Battalion work, and an Aztec incident, *Atala*. These, plus *East and West, Hardscrabble Canyon*, and *Mission of San Carmel*, he entered in that year's fair.

Much in the *Princess* painting was lauded: "The figure of the princess . . . is perfect in drawing and the coloring handled with happy skill." The figure drawing in his *Atala* was also admired, but some fault was found in other details. Another reviewer said of Ottinger: "He is a singular individual with the ability to depict with his artistic brush the idea of the real. He is poetic in one picture and practical in another." The same critic said of Ottinger's Aztec paintings that they "are more poetic and represent the ideal side of Mr. Ottinger's mind. They are very fine." For all this effort Ottinger won a gold medal for his three figure paintings, a silver medal for an historical painting, a diploma for one of his landscapes, and five dollars as an unspecified "special award."

Heady from all this recognition, he jumped into the formation of what would become the Utah Art Association. After declining to predict what benefit might accrue from the society's formation, Ottinger did offer a promise, of sorts:

> *This much I know, if we persue a course I have proposed to the society, I think we may all be benefitted, viz, a school for old and young with [work?] for Each others interests laying aside all selfishness and jealousy, working with harmony to create an interest, a love, and a desire to foster and improve the fine Art of our Territory.*

The weekly meetings of the Utah Art Association must have been interesting sessions. After having approved a constitution and by-laws, the members settled into a kind of friendly competition. Each week a topic or subject was agreed upon for the following week's meeting, and each member would sketch, draw, or paint his version of that subject. In early November 1881 the subject was "warmth." Fortunately, a published account of that meeting is available, and it offers an intimate look into the minds and working methods of some of the artists present that night:

> *W[illard] Clawson produced his Satanic Majesty in the midst of a sea of lurid flame. . . . G. M. Ottinger represented a tramp warming himself by a copious pull from a bottle of "Valley tan." A[rthur] Mitchell represented an elderly dame, imparting warmth to the physical structure of a refractory youngster with . . . the birch rod. D. Weggeland presented what appeared to be a donkey race in the region of the Egyptian pyramids. J. Tullidge got his ideas from the tropics, and produced a landscape. W. C. Morris [William V.'s son] produced a flaring picture of a furnace of the Ontario Mine. C. K. Bowring showed up an old lady warming her toes, and a big dog heating his nose by the glowing embers of a parlor fire.*

In late December Ottinger offered a number of works in the Utah Art Association's first exhibition. These included *Montezuma, Atala, Why Should the Spirit of Mortals be Proud, Cacique's Daughter, Evening Gun,* and *Beautiful Snow.* These were generally well received. Of his *Cacique's Daughter*, a critic said that the light and shade were well treated and that the drawing of the figures was bold and free. His *Evening Gun*, an earlier work, was said to have been "one of his best effects. . . . The water in the foreground, the light falling on the sails of the ships, the hues of the sunset in the sky and the shadowy forest of masts in the distance show rare skill." Yet another painting

was curtly dismissed: "'Beautiful Snow' is badly drawn, badly colored and beneath the consideration of an artist of Ottinger's reputation." Finally, a note on the esoteric subject and detail of his Aztec works was enunciated—a comment that may still have a measure of validity: "It was a mistake of the artist to have painted such a picture, because only such people as have informed themselves upon the subject can be interested in the work."

Late in January 1882, the association raffled paintings donated by member artists to help pay the organization's expenses. In addition to an Arctic scene, Ottinger contributed *Hardscrabble Canyon, Mission of San Carmel,* and an untitled landscape. Ottinger next showed some portrait work. His image of a fire department colleague, Frank May, was said to have been "very fine." By August of that year Ottinger was teaching in the University of Deseret; as many as fifty students were enrolled in his classes. In October many of Ottinger's more recent paintings and some pieces then in process were noticed. As the year closed he exhibited some landscapes at Savage's.

The year 1883 was a slow one artistically for Ottinger. It opened with the sale of two of his paintings; Francis Armstrong purchased *Tynemouth, England* and *First Snow in American Fork Canyon.* Later, he showed *Mutford Church* and *Silver Lake* to much praise. For much of the rest of the year he was largely, but not entirely, occupied with teaching and with water and fire department business.

In March 1884 Ottinger showed some Aztec works at Savage's and had a Wasatch Mountain scene in process. Another exhibition by the Utah Art Association had been announced, and Ottinger planned to enter. He also agreed to serve as a kind of registrar, or preliminary manager for works offered. In late May, when the exhibition opened, he showed at least six titled works: *After the Battle, Evening, Cacique's Farewell, John Alden and Priscilla, Arctic Moonlight,* and *Midnight Sun.* The *Salt Lake Herald*'s critic insisted that Ottinger's sea paintings were consistently his best effort: "Had he spent his life in the development of his splendid talents, he might have vied with the greatest marine painters, and made a world-wide fame." The painting *After the Battle* drew praise such as this throughout the exhibition:

> *The victorious ship is favored by the cheerful sunlight, while the defeated rests in somber shadow. The conception is poetic, and the sentiment has been beautifully seconded by the execution. It is such a marine as is rare among our local productions, and there can be no doubt of its capacity to find many admirers.*

It was not until July 1885 that more public notice was taken of Ottinger's easel work, when Levi W. Richards presented an American historical scene by Ottinger to the Brigham Young College in Logan. The subject was a Puritan family retreating to a blockhouse from some threat. Two Cottonwood lake scenes were shown at Savage's to many compliments. In May 1886, he showed two new paintings: *North Portal of Castle Gate* and a City Creek canyon scene. Both were praised, and both were sold to an unidentified buyer. Ottinger completed his teaching that year by awarding a small oil sketch to his best student, a Miss Lotty Webber. During the summer a *Salt Lake Herald* reporter visited Ottinger's Twentieth Ward studio and described a large quantity of works, many of which had not been seen by the public. *A Spanish Prisoner* and *Belle of Copan* were among the Aztec subjects. *In the Rolling Forties* and *A Sudden Squall* were described as "fancy subjects." In the former, a ship's doctor is seen paying close attention to an attractive female passenger; in the latter, two bathing girls were fleeing from a storm. Some marines, English landscapes, and Arctic scenes were also mentioned.

Kept busy by his fire department and water use duties, Ottinger had less and less time available to dispose of his increasing supply of easel work. A *Deseret News* reporter noted in June 1887 that Ottinger's Mexican, or Aztec, works were beyond counting. Landscapes from the Grand Canyon to Shoshone Falls filled his studio, as well as portrayals of scenes from English history and myth. By September he had returned to teaching. Later in the year he was one of several artists who organized a benefit auction for the family of deceased Logan sculptor Harry Brown.

By April 1888, Ottinger was at work on a large genre scene, *The Path to Glory,* depicting some firemen assisting one of their number who has fallen from a ladder. The DA&M Society fair of that year was an important one for Ottinger. He was paired with James H. Moyle to supervise what turned out to be a large number of entries. Ottinger's *Path to Glory* received much attention from the public, as well as a gold medal for the "best oil painting, any subject." He was also awarded one of the "special premiums" of twenty-five dollars tendered by the Deseret National Bank. The painting hung thereafter in the Firemen's Hall for several weeks, until Ottinger sent it, as a gift, to the New York Veteran Firemen's Association. So ended 1888.

In 1889 Ottinger was almost too busy with city duties to attend to any serious painting or art involvement. Indeed, between January and August he was barely noticed in connection with art. He was a pallbearer for William C. Morris's funeral; he praised a pastel portrait of Heber C. Kimball by J. W. Clawson; and he was reappointed to the University of Deseret faculty. His principal occupation that year was water—how to find it, channel it, and store it. At one point he was called upon to testify before a U. S. Senate Committee on Irrigation, and he "reeled off valuable statistics from memory . . . as fast as the stenographer could take them down."

By September Ottinger was involved with the fair again, in company with James H. Moyle. Of interest is the presence of H. E. C. Peterson, the Chicago portraitist, who served as chairman of the "hanging committee" by request of Governor Arthur L. Thomas. Ottinger won a gold medal for a large landscape, *American Fork Canyon*. Of this prizewinning painting the *Salt Lake Tribune* said: "There is something about the composition and coloring of this subject that suggests Turner, the great English painter, and a poetic sentiment pervades it that is charming." Ottinger's other paintings in the fair included *Arctic Seals, The Whale Boat,* and an English landscape, *On the Avon.*

By April 1890 Ottinger was out of office as fire chief, but he continued to teach in the University of Deseret and privately at home. He and Savage made a quick trip to the Oregon coast, exploring along the Columbia River. He was to use this experience for at least one of the paintings he entered in the 1890 fair, produced that October. Ottinger held some sort of supervisory position at the fair, as well as entering at least two Alaskan coastal scenes, the scene from Oregon, and an Aztec painting titled *Cabeza de Vaca.* For his efforts he won twenty dollars for *Cabeza* and a gold medal for his collection of marine paintings.

UTAH ARTISTS IN THE 1880s AND 1890s

The last years of the nineteenth century were marked by two events of general import for art in Utah. One was the passage of a bill in 1899 by the state legislature which funded the Utah Art Institute. Created through the efforts of Alice Merrill Horne, the institute's purpose was to encourage and promote the sale of art. Annual exhibitions and three hundred dollars in first-prize money were established. The present Utah Arts

Attributed to John Williard Clawson, *At the Acdémie Julian*; c. 1890, oil on board; collection of Gibbs M. Smith.

Council is a descendant of this organization.

The other and, without doubt, most notable event of the late 1880s and early 1890s in the lives of the younger "second generation" artists was the time several of them spent studying in Paris. Urged on by their teachers, particularly Ottinger and Weggeland, and by the departure of James T. Harwood for Paris in 1888, John Hafen, John B. Fairbanks (1855–1940), and Lorus Pratt, sponsored by the LDS church, and Edwin Evans, sponsored privately and later by the church, enrolled at the Académie Julian in 1890. Harwood was by then on his way back to Utah to earn money to marry fellow artist Harriett Richards (1870–1922) who had also come to Paris to study, but the "art missionaries" were welcomed by Cyrus Dallin and John W. Clawson who had also arrived in 1888 soon after Harwood.

In the spring of 1890, Hafen and Pratt had visited with George Q. Cannon of the First Presidency of the LDS church to inquire about obtaining church funding

This group portrait was taken in about 1891, probably in Paris. John Hafen is on the top row, second from the left. J.B. Fairbanks is the first seated man on the far right. (Photo courtesy SMA.)

for art study in France. The artists wished to become better prepared to paint murals in the Salt Lake Temple, which was nearing completion after being under construction for nearly forty years. It was determined that three artists (Hafen had included his friend Fairbanks in the venture) could subsist for a year in Paris for $1800, with an additional $360 to help provide for Hafen's large family of ten children in his absence. The three were set apart by the church as "missionaries with a special purpose."

At the Académie Julian, the artists worked intensively on drawing the human figure; painting was done on trips into the French countryside. Prior to this experience, few if any of these artists' works had been painted directly from nature; following their Paris study, they began to develop a more natural, spontaneous vision. Wrote Hafen, "Cease to look for mechanical effect or minute finish, for individual leaves, blades of grass, or aped imitation of things, but look for smell, for soul, for feeling, for the beautiful in line and color." Several paintings done in France during these years are illustrated in color herein: James Harwood's *Harvest Time in France* (1890, SMA,

plate 10), Harriett Richards Harwood's *Lemonade Still Life* (1888, SMA, plate 11), and Lorus Pratt's *Harvest Scene in France* (1891, SMA, plate 16).

By the end of 1892, all the art missionaries had returned to Utah, where work on the murals for the rooms in the Salt Lake Temple began in earnest. According to LDS church financial records, based on the amounts of money paid to each participating artist, Hafen did the greatest amount of work, followed by Pratt and Fairbanks, with Evans and Dan Weggeland receiving equal amounts. A minimal amount was paid to Alfred Lambourne for several paintings which were hung in the temple.

The Paris-trained artists also contributed much to art education and to various art organizations in the state. The Society of Utah Artists was reestablished in 1893 with Edwin Evans as president, John Hafen as vice-president, Herman Haag (1871–1895—a later art missionary to Paris) as secretary, John Clawson as treasurer, and James Harwood as custodian. Other charter members included Lorus Pratt, H. L. A. Culmer, George Ottinger, and J. B. Fairbanks. The society's exhibits were well

received by the public, who were even willing to pay an entrance fee. Arts activist Alice Merrill Horne later commented on the success of this "new" work: "Who does not recall the glory of those first annual exhibitions of real art . . . ? The town invariably turned out to see. And in those days people bought pictures."

Evans, Hafen, and Fairbanks all taught at Brigham Young Academy in Provo. Evans also, along with Harwood, taught at the University of Utah. Fairbanks served as the first supervisor of art education in the Ogden city schools. Hafen's interest in art education led him to donate a painting to the high school in Springville, where he had settled, and he encouraged other artists to do likewise. This collection grew to become the Springville Museum of Art (see "The Art Movement in Springville" in this volume).

During the 1880s, prior to his art mission in Paris, John Boylston Fairbanks had already come to public view in Utah's art history. When he was nearly thirty years of age, he and his longtime friend and sometime mentor John Hafen went sketching and viewing in the late summer and autumn of 1884 in and around Ogden and Logan. While thus sojourning, they took photographs of scenery and people for later enlargement into paintings. Fairbanks next appeared working as a photo enlarger for Springville's portrait photographer George Edward Anderson. In May 1886 a crayon portrait by Fairbanks of George Q. Cannon was said to possess "genuine merit." In March 1887 Fairbanks's portrait of Heber J. Grant, in crayon, was called "an excellent likeness, the best we have examined of the handiwork of the artist." Yet artistic acceptance was to continue to elude Fairbanks. Early spring of 1889 found him hustling newspapers for a living: "Mr. J. B. Fairbanks . . . was in town [Heber] the fore part of this week canvassing for the Salt Lake *Herald*."

Only fifteen months later, Fairbanks found himself as a subsidized student learning new approaches to painting with his friends John Hafen, Will Clawson, Lorus Pratt, and others in Paris. However, Fairbanks's months in Paris were less than satisfactory to him. He was moved by the experience; he saw what he might become; and he seemed to struggle sincerely. But success was not to be his. Of all the Utahns who studied in Paris in the years 1888–92, Fairbanks was the only one for whom artistic recognition remained elusive. Upon his return Fairbanks began almost immediately working with other church artists on decorating walls in the Salt Lake Temple. At one point, Wilford Woodruff was moved to note in his

journal: "We visited Br Fairbanks paintings which were very nice."

Although J. B. frequently assured his friends that he would enter work in the nearly annual fairs and the exhibits of the various art organizations that came and went, he rarely found critical or popular acceptance for his work. For example, of the five oil paintings he entered in the first exhibition of the Society of Utah Artists (SUA) in 1893, the *Salt Lake Tribune* told its readers: "A dainty bit of sunlight is seen in J. B. Fairbank's 'Evening,' and another good painting by the same artist is a 'A Muddy Lane.'" He fared even less well in the second SUA annual exhibition, entering several paintings and receiving harsh critical commentary. The *Salt Lake Herald*'s critic

John Boylston Fairbanks, *Old French Home;* **1892, oil on canvas; collection of the Fairbanks family.**

went to some length and into some detail concerning the flaws he saw in Fairbanks's work:

> Mr. J. B. Fairbanks has several landscapes painted in his own peculiar style. He is striving to render the difficult effect of evening twilight, and to our mind he has not yet acquired the mastery of color and technique necessary to that end. There is a hardness on the horizon and a lack of proper relation between earth and sky that are required in such subjects. His "Evening on the Summit," . . . is better in conception than it is in execution or expression. His "October Evening" . . . is in far better harmony and has many good points, but we would like to know what faint form it is in the center of the picture that spoils it and seems to hold no relation to the rest of it. The best thing he exhibits is . . . "A Scene Near Payson."

Fairbanks next exhibited on a smaller scale to a hometown audience and better reviews in Provo:

> If you haven't seen Artist Fairbanks' paintings at the book store of Skelton & Co., you should see them at once. His portrayal of Utah scenes is good. The harvest scene and a rainy day in Utah are particularly fine. His crayon sketches and meadow scenes are also very fine.

Attempts by Fairbanks to win critical and popular acceptance began to bear small fruit in 1895. In the third annual SUA exhibition he entered several small works; of these the *Salt Lake Herald* noted: "Two small, but much admired pictures by J. B. Fairbanks . . . are of such merit that they should meet with ready sale." The following year's SUA exhibition saw only a single painting by Fairbanks entered; and that single work, *A Foggy Day in November,* was barely noticed.

Still searching for a measure of success, J. B. and his son J. Leo Fairbanks (1878–1946) opened a two-week exhibition of their paintings in Provo; the local press noticed the exhibition but mentioned no sales. Shortly after this November 1898 exhibition, J. B. moved to Ogden to take the position of art supervisor previously held by John Hafen. He continued in that employment until his appointment to teach in the LDS College in Salt Lake City in August 1899. And in July of that year he was appointed to the board of the newly created Utah Art Institute—public recognition at last!

In the fair of 1899 Fairbanks submitted at least one oil painting, *Evening at Harvest Time,* which won him forty dollars, perhaps the first cash prize he had won competitively in the fifteen or so years that he had been painting. The art event of the season, however, was to be the first annual exhibition of the Utah Art Institute. Fairbanks was reported to have been "busily engaged" in readying paintings for the exhibition. His *Indian Summer* earned him an honorable mention.

As the century waned, Fairbanks began showing more work independently, not waiting to offer works in fairs or other group exhibitions. For example, an Ogden Canyon scene was noticed in February 1900; it was one of the few paintings by Fairbanks that evoked lengthy description:

> The picture measures about 40 x 48 inches and is a morning scene in Ogden canyon . . . in which the rising sun is just beginning to display its brilliance over the great hills, and the shadows in the canyon are suggestive . . . of nature's solitude. The deep green foliage and the blue and purple hills give the painting a singularly cool effect, suggestive of the canyon's breath at morn and the bracing breeze of a sunrise in the mountains.

In the fair that autumn Fairbanks entered an unknown number of works, none of which was publicly noticed. He resigned from the board of the Utah Art Institute, presumably to fill a mission for his church. In the second Utah Art Institute exhibition he entered at least one work, *Wheat Field,* which a *Salt Lake Herald* critic said was "better than his former work."

So ended John Boylston Fairbanks's nineteenth-century art career. He went on, in the twentieth century, to paint other works— to a somewhat better reception than he endured in the nineteenth. Several of his early twentieth-century works include *Moonlight on the Marshes in Springville* (1906, SMA), *Sunset on Utah Lake, Springville* (1909, SMA), and *Harvest in Utah Valley* (1913, SMA).

Another artist whose career was opening as the last decades of the century closed was Lorus Pratt, whose portraits received quiet praise in the opening review of the 1881 fair: "The portraits of Parley P. Pratt and Orson Pratt . . . are strikingly life-like. The young artist will, with careful training and practice, rank high in the profession." He won a diploma for the two portraits, an honorable mention for copies from chromo-lithographs, and a two-dollar-fifty-cent "special premium" in that fair. Shortly thereafter he became a founding member of the Utah Art Association.

Early in January 1882 Pratt donated a work, *Sunny Days,* for the benefit of the Utah Art Association. The remainder of that year saw numerous portraits leave his easel with praise. His portrait of Mrs. Margaret Pierce Young was called "strikingly life-like." A new version of

his Parley P. Pratt was called "very fine and artistic." By October, Pratt had opened a studio west of the Salt Lake Theatre where "those desirous of obtaining portraits in oil, water-colors, India ink or crayon can be accomodated." He was then twenty-seven years old.

The next several years were to be even busier for the young portraitist. From January through September he showed portraits of Angus M. Cannon, H. H. Hooper (twice), James Sharp, Feramorz Little, William C. Staines, and a son of J. P. Pascal. In 1884, notice was taken of portraits by Pratt of Horace S. Eldredge, a Mr. Booth, Alfred Solomon, William Jennings, and Andrew Jenson. In the 1888 fair he was awarded a silver medal for a portrait of a Mr. White.

By midsummer 1890 Pratt was on his way to Paris on his art mission. Early in 1891 he succeeded in having a drawing selected for the monthly student exhibition in the Académie Julian: "Bro. Pratt has succeeded in making a drawing last week good enough to take into the concour[s]. Johnny [Fairbanks] and Edwin [Evans] say it was an excellent drawing." Elated at his success, Pratt celebrated with his fellow Utahns: "Last night Lorus treated us to an oyster supper in honor of his last weeks success. We ate 7 dozen raw oysters between us four and some raisons and nuts." Pratt returned to Utah from Paris in the summer of 1892 to paint murals in the Salt Lake Temple. His work after his return from Paris met with mediocre success.

Hafen and Evans returned from Paris to work on the temple murals and to become teachers. Hafen's work was slow to be embraced by the public, and he struggled with extreme poverty all his life, although he is now considered the most appealing of any of the early Utah stylists and has been called "Utah's greatest artist" by Alice Merrill Horne. Hafen, big-hearted and eccentric, remained committed to his art, making frequent painting and selling trips through the remainder of his career. He was one of the earliest artists to work extensively in Monterey, California. A work from his post-Paris period, *Geneva Dance Hall and Resort* (1896, SMA, **plate 18**) shows his fine, impressionistic palette.

Edwin Evans won honors at the Chicago World's Fair in 1893 for his large oil *Wheat Field*. He did extensive mural work on the LDS temple in Cardston, Alberta, and became head of the University of Utah's department of art in 1898, a position he held for over twenty years. During his teaching career, he continued to paint (see *The Calf*, 1899, MFA/BYU, **plate 9**) and developed in his work an intellectual rigor which stressed arrangement,

balance, and specific detail wherein the parts fit into the purpose of the arrangement. He produced a significant body of painting.

The Harwoods—James and Harriett—returned to success in Salt Lake City, where they set up a private studio for painting and teaching. They returned to Paris many times in the early 1900s for "refresher" experiences. James taught art in the local Utah high schools and eventually succeeded Evans as head of the art department at the University of Utah.

John Willard Clawson stayed briefly in Utah after his return from Paris and then moved on to a highly productive and successful career spent largely in California.

Dan Weggeland's artistic output in the 1890s continued to be slow. He did not publicly exhibit easel work following the 1889 fair until the second annual SUA exhibition in December 1894. He then offered three oil

James T. Harwood as a young man, among the artifacts in his studio. He became one of Utah's greatest painters and most influential teachers. (Photo courtesy SMA.)

Lee Greene Richards,
Portrait of the Poet,
Alfred Lambourne; **c.**
1910, oil on canvas;
MFA/BYU.

Cloud-burst on the Side of a Utah Canyon, perhaps drawn from one of his own earlier paintings, was engraved for the frontispiece of the *Utah Monthly Magazine;* he also contributed text for that issue. In the fair of that year he showed a collection of black-and-white drawings called *Scenic Utah.* Said the *Salt Lake Herald*'s writer, "Mr. Lambourne's exhibit of drawings . . . is one of the finest collections in the gallery, and deserves a careful study." For his efforts Lambourne won a gold medal and a special premium of fifty dollars.

Lambourne's next major easel productions came months after an extensive sketching trip in the eastern United States. His *Hill Cumorah* and *Adam-Ondi-Ahman* were

paintings: *The Fisherman's Daughter; Clift House and Seal Rocks, San Francisco;* and *Near American Fork Canyon.* These were accompanied by pastel or watercolor sketches titled *Near Tintic Canyon* and *Old Mill, Manti.* All of these were politely noticed. In 1896 another watercolor sketch was noticed, and in the 1899 fair he won a twenty-dollar prize for an oil titled *Utah Lake.* He also entered the fair in 1900, but he received no special notice.

In point of his easel works, Weggeland's contribution to Utah's art history had probably ended effectively ten years prior to this. What is largely unknowable is the positive, practical influence he had on the scores of young art students he guided from the mid-1860s to 1900.

For Alfred Lambourne, the 1890s were not nearly as traumatic as they were for Weggeland and Ottinger. Indeed, it seemed that Lambourne simply put down his brush and picked up a pen in its place. For most of the decade his multifaceted mind was occupied with nature-writing reminiscences. Of his relatively few easel works, several were noteworthy. In January 1891, his drawing

hung in special rooms in the Salt Lake Temple. After these works were produced, Lambourne began concentrating almost exclusively on his nature writing until December 1898, when he showed still more black-and-white drawings in one of Kate Wells's numerous studio exhibitions. As the decade—and the century—closed, Lambourne enjoyed a pleasant visit from Thomas Moran, the famous itinerant painter, who apparently had known Lambourne fairly well when both were younger men.

Another itinerant, Christian Eisele (1854–1919), made several trips to Utah in the 1890s. He was known for his light-filled landscapes (see *Landscape in the Rockies,* 1896, SMA) and perhaps better known in Utah for his detailed cityscapes, especially the Salt Lake City view which hangs in the Salt Lake Masonic Temple, and his *Logan, Utah* (1892, MCHA, **plate 17**).

The final decade of the century was marked for George Martin Ottinger by a relentless decline in his fortunes economically, artistically, and perhaps spiritually. He painted a great deal, but much of his output was, by his

George Martin Ottinger, one of Utah's most colorful personalities, with palette in hand. In his youth, Ottinger had sailed around the globe, worked in a sugar refinery, and clerked in a fruit stand before he joined the Mormons. In Utah, his activities were equally varied. He was (among other things) partner in a photographic studio, theatrical scene painter, fire chief, and first professor of art at the University of Deseret. (Photo courtesy SMA.)

own account, little more than potboilers on the one hand or, on the other, desperate attempts to find a new genre or historical theme that would promise him a measure of success. Ottinger was employed for a time as a business census enumerator—a most unhappy calling. In his own words, "I never in my life undertook so disagreeable [a] job." Other responsibilities during the decade included chairing a review panel for artwork submitted from Utahns for possible exhibition in the Columbian Exposition in Chicago. Ottinger also served as adjutant general of the Utah National Guard and, finally, as a lumber store clerk. He was probably more economically insecure during this period than at any time during his years in Utah.

During the decade Ottinger painted a number of works, most of which may be presumed lost. His *Tlaloc, the Aztec Rain God* was uniformly praised and earned for the artist a gold medal in the 1891 fair. He also painted at least four other Aztec works and several American historical works—among them, *First Winter in Plymouth.*

The first exhibition of the SUA, after its formation in 1893, had two major attractions: the first, that many of the paintings shown in the Utah Building at the Columbian Exposition would be exhibited; the second, that the Utah artists who had been studying in Paris and who had now all returned would be exhibiting many of their freshest works. Along with a large number of other local artists (primarily the Paris-trained artists), Ottinger showed several paintings.

From 15 March 1894 until April 1895 Ottinger was preoccupied with his duties as adjutant general of the Utah National Guard. He traveled widely through northern and central Utah and painted but little. He did manage to sell *The Prospectors* and finally received payment for another painting sold on credit much earlier: "It is Evidently a poor plan to sell a picture on credit. I have been fleeced time and again and with it all I have given away more pictures than I Ever sold."

By September 1894 Ottinger was serving as supervisor for the fine art department of the fair. Among his own

paintings were *First Winter in Plymouth* and a portrayal of George Washington proposing marriage to Mary Phillips, a subject fictionalized by Washington Irving. Both paintings were noticed respectfully; neither won an award. Ottinger apparently had no work in the 1894 exhibition of the SUA.

The year 1896 was Ottinger's worst. Compelled to clerk in a lumber store many miles distant from his home, he had little time and less energy for putting paint to canvas. Following the loss of even that employment, he turned again to painting, choosing for his new subjects portrayals of heroic American women. Few such works ever received public notice. In the fourth annual exhibition of the SUA, held in December 1896, Ottinger offered four paintings, two of which were titled: *Chimney Rock, North Platte* and *Ranch, Summit County*. Both were politely noticed, although one critic found the figure drawing flawed.

Ottinger thereupon all but retired from exhibiting publicly. The bleakness of his mood is revealed in part of his last journal entry for the last day of 1896: "The work of forty years lays in my studio a pile of worthless trash, without merit or value or worth. My God, do not forsake me."

Ottinger next appeared in the Utah art world as one of the organizers for the first exhibition sponsored by the legislatively created Utah Art Institute. He served with Hafen, Harwood, and Culmer. He also offered several works for exhibition in what would turn out to be the last serious public display of his easel works in the nineteenth century: *Rejected, Montezuma Notified of his Election to the Throne, Buccaneers, Silver Lake, A Morning Call, American Fork Canyon, Children of the Sun,* and two works done of

Japanese subjects in what was said to be a Japanese style, *Meeting of Genzebo and O'Koyo* and *Parting of Rickiya and Konami*. These latter two paintings were the result of Ottinger's latest attempt to find a subject or theme he could paint with some hope of financial success. At the close of the exhibition Ottinger was named a life member of the institute for his painting *Children of the Sun,* one of the first paintings acquired for the newly named Alice Art Collection, which grew from purchase prizes awarded at the institute's exhibitions.

The 1890s were sorrowful years for Ottinger, whose experience mirrored that of other older painters faced with the new forms and impressionistic styles of younger men and women with better training. Certainly, part of the problem he and others faced as the century closed was that the art-viewing public was growing tired of fanciful "Old American" historical scenes, of dark European-styled portraiture, and, perhaps, of pioneer genre, though paintings like his *The Immigrant Train* (1897, SMA, **plate 15**) are still well loved. But for at least ten years Utahns had been growing increasingly fond of painting that found its way back to Zion from Parisian ateliers. As the trend grew, Ottinger's work looked correspondingly more reactionary.

And yet, to his great credit, Ottinger's pioneering spirit reasserted itself in his sixty-seventh year. Consider the very last words of his journal: "Individually I feel as Young and ambitious and desirous to push ahead as Ever, in spite of the years of discouragement and bad luck." Ultimately, this spirit of persistence in the face of adversity, revealed in the histories of so many of Utah's pioneer artists, has manifestly enriched the cultural heritage of the state.

PLATE 17

PLATE 18

PLATE 19

*J*oseph Kerby, Straw Hat
with Apples; *c. 1900,
oil on canvas, 20" × 30";
SMA, anonymous gift.*

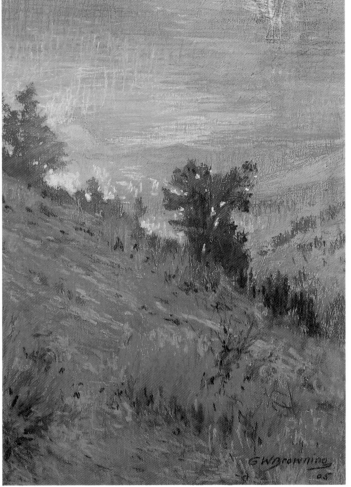

PLATE 20

*G*eorge Wesley Browning,
Sunset in the Wilderness;
*1905, pastel, 18 3/4" × 12 3/4";
SMA, gift of the Dr. George L.
and Emma Smart Collection.*

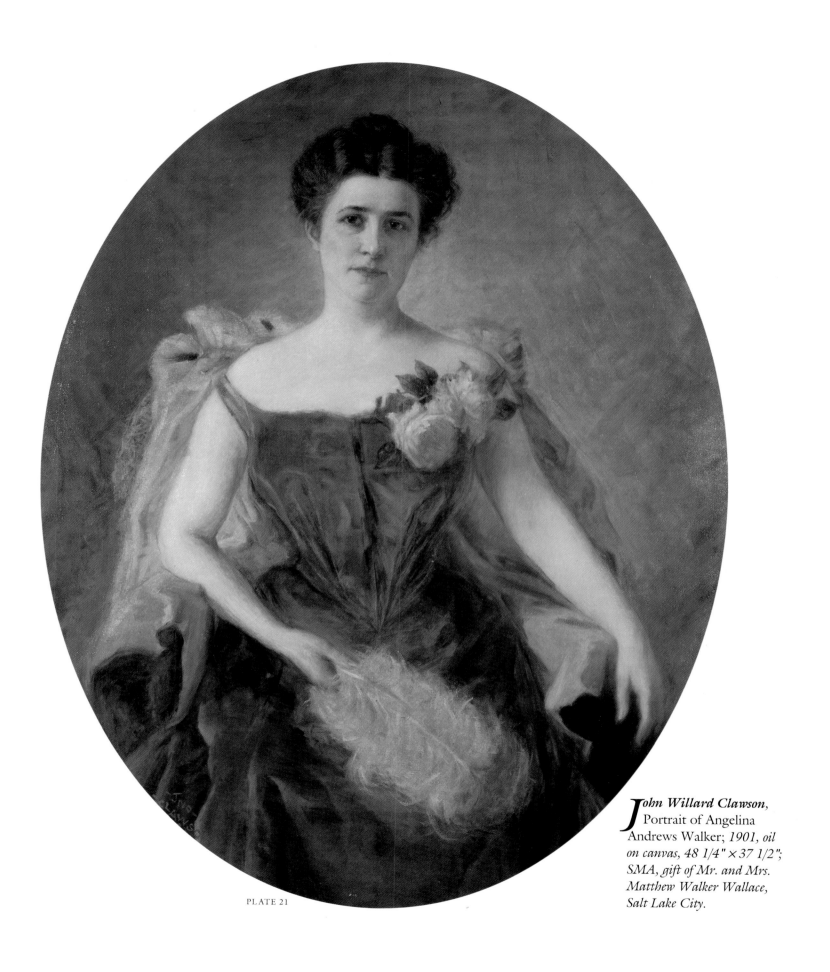

PLATE 21

*J*ohn Willard Clawson, Portrait of Angelina Andrews Walker; *1901, oil on canvas, 48 1/4" × 37 1/2"; SMA, gift of Mr. and Mrs. Matthew Walker Wallace, Salt Lake City.*

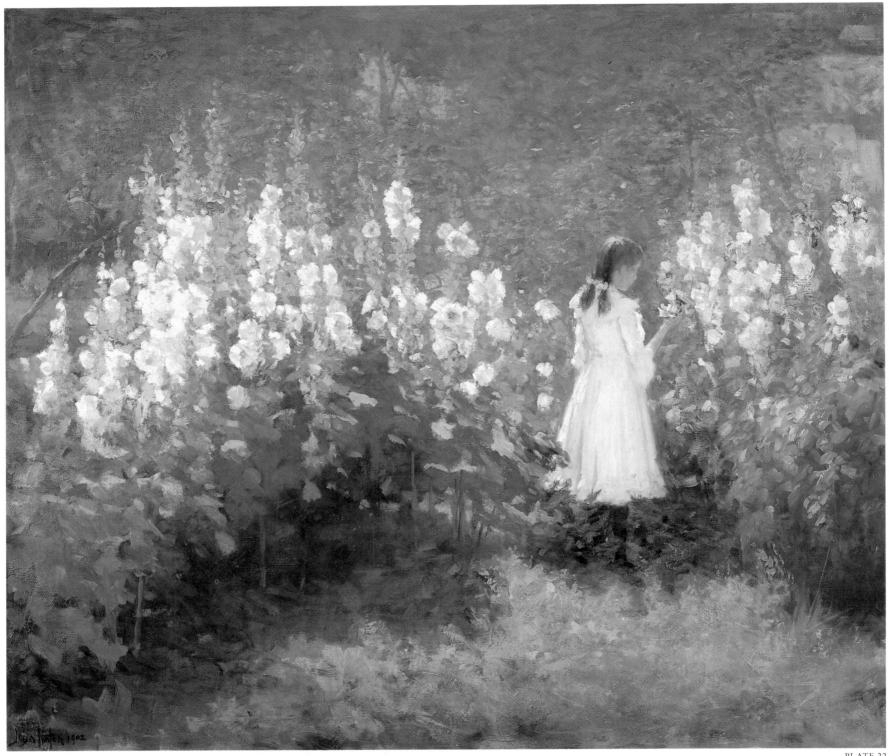

PLATE 22

*J*ohn Hafen, Girl Among
 the Hollyhocks; *1902,*
oil on canvas, 36" × 41";
LDS Museum of Church
History and Art.

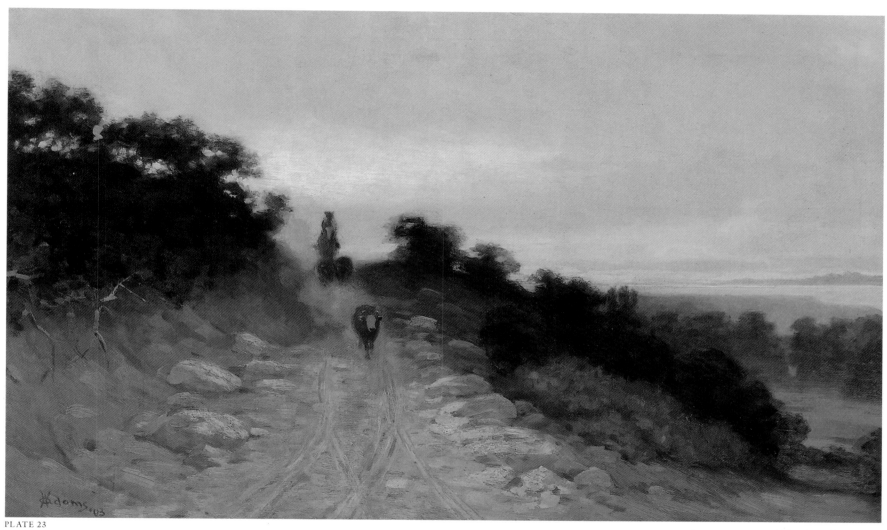

PLATE 23

Willis A. Adams, Evening; *1903, oil on canvas, 22" × 36"; SMA, gift of Frederick and Sherry Ross, New Jersey.*

PLATE 24

Cyrus Edwin Dallin,
Jane Dallin—The
Artist's Mother; *1904, marble,
22 1/2" × 18 1/2" × 10 3/4";
SMA, gift of the A. Merlin
and Alice Steed Collection Trust.*

PLATE 25

John Gutzon Borglum,
Conception; *c. 1904, marble,
18" × 9 3/4" × 12"; SMA, gift
of Dr. Kirke Van Nielsen,
Kalispell, Montana.*

PLATE 26

*A*vard T. Fairbanks, Mother and Child; *1928, Italian marble, 37" × 23" × 18"; SMA, gift of the artist.*

*H*enry L. A. Culmer, Approaching Salt Lake from City Creek Canyon; *c. 1906, watercolor, 7 3/4" × 14"; SMA, gift of the A. Merlin and Alice Steed Collection Trust.*

PLATE 27

*J*ohn B. Fairbanks, Harvest in Utah Valley; *1913, oil on canvas, 20" × 30"; SMA, gift of Blaine P. and Louise Clyde, Springville.*

PLATE 28

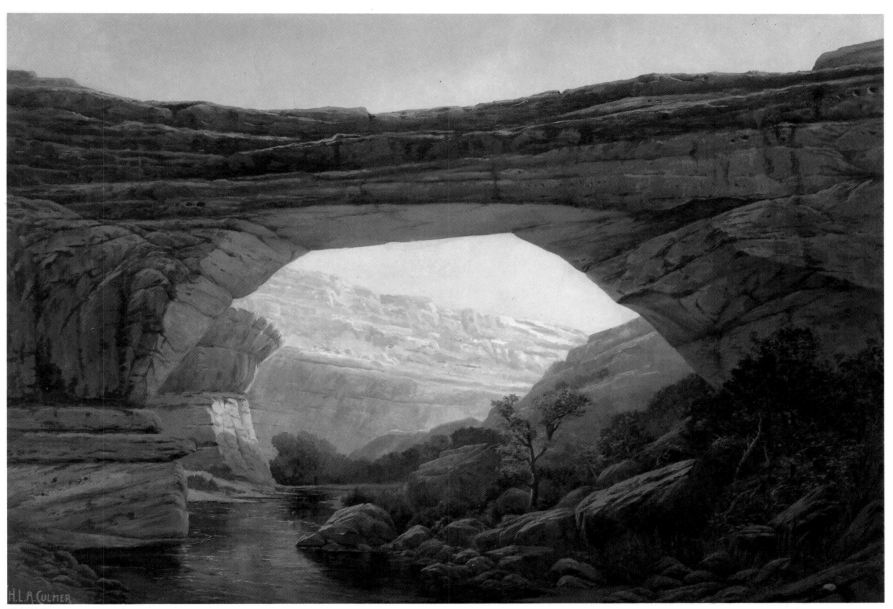

PLATE 29

H**enry L. A. Culmer,**
Augusta Bridge;
c. 1910, oil on canvas,
42" × 60"; Utah State Fine
Arts Collection, courtesy of
the Utah Arts Council.

PLATE 30

Donald Beauregard,
Working from Dawn
till Dusk, near Fillmore;
c. 1908, oil on canvas,
22" × 28"; SMA, gift of
David Dee, Salt Lake City.

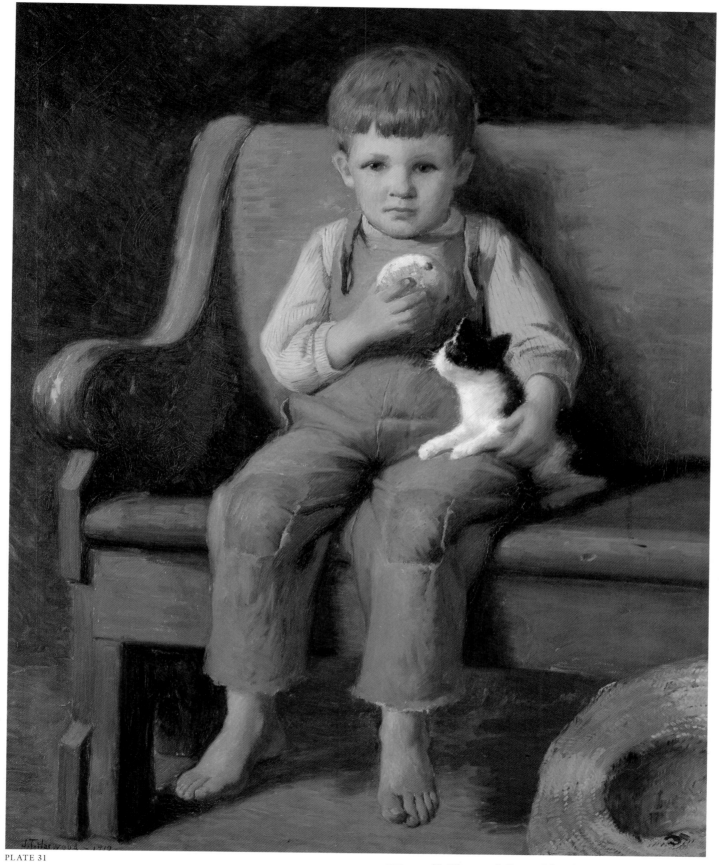

PLATE 31

*J*ames T. Harwood, Boy with a Bun; *1910, oil on canvas,
40" × 32 1/4"; SMA.*

orus B. Pratt, Fishing
Along the Jordan;
1916, oil on canvas,
16" × 28"; SMA, gift of
Blaine P. and Louise Clyde,
Springville.

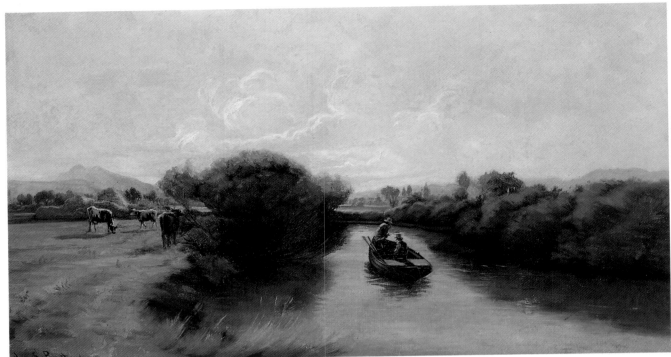

PLATE 32

amuel Hans Jepperson,
Goodbye Sweet Day;
1919, oil on board, 15" × 20";
SMA, gift of Vern G. and
Judy Swanson, Springville.

PLATE 33

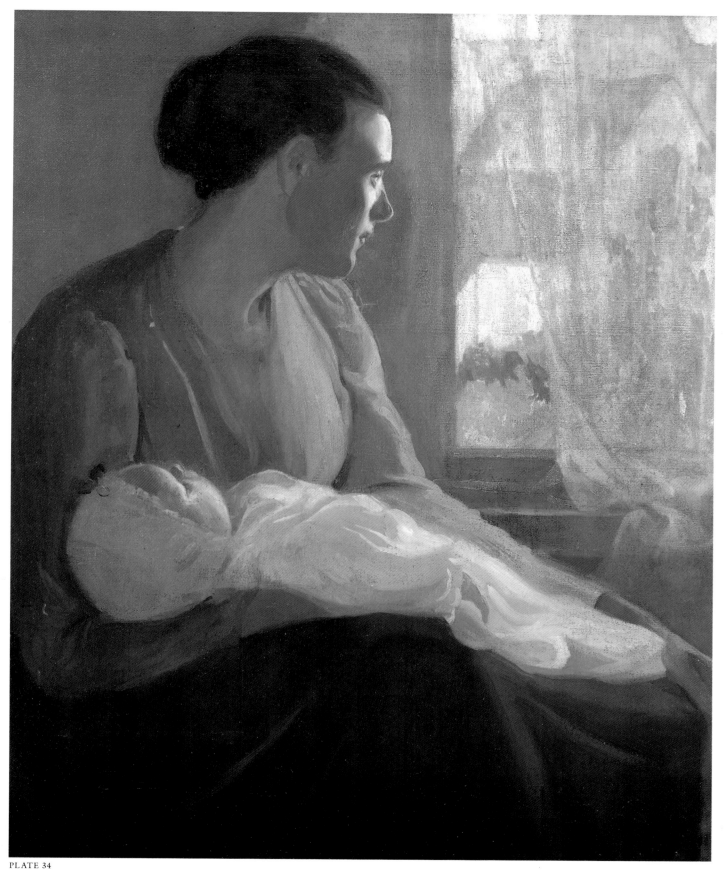

PLATE 34

Mary Teasdel, Mother and Child; *1920, oil on canvas, 31" × 60";*
Utah State Fine Arts Collection, courtesy of the Utah Arts Council.

Lee Greene Richards, Grandma Eldredge's House; *1922, oil on canvas, 21 1/2" × 28 3/4"; SMA, gift of Sheldon and Beverly Hyde, Salt Lake City.*

PLATE 35

Mabel P. Frazer, Sunrise North Rim; *1928, oil on canvas, 33" × 57 3/4"; SMA, gift of the Waldis Family (Madeleine, Dick, and Nettie,) Salt Lake City.*

PLATE 36

PLATE 37

John Held Jr., Ma Lives; *c. 1924, gouache, 7" × 6 1/4"; SMA, gift of the Dr. George L. and Emma Smart Collection Trust.*

PLATE 38

*W*aldo P. Midgley,
View of Park City;
*1924, oil on canvas, 20" × 24";
SMA, gift of F. Ed and Judy
Bennett, Salt Lake City.*

PLATE 39

*J. **Henri Moser,** Logan Canyon, Near Beaver Dam; 1926, oil on canvas, 25 1/4" × 32 1/4"; SMA, gift of the Lund-Wassmer Collection.*

PLATE 40

Alma B. Wright, Old
Farm in Coalville;
*1926, oil on canvas,
28 3/4" × 36 1/4"; SMA,
gift of the A. Merlin and
Alice Steed Collection Trust.*

PLATE 41

A*lma B. Wright,* Quai Pontoise; *1930, oil on canvas, 32" × 25 1/2";*
SMA, gift of the George L. and Emma Smart Collection Trust.

PLATE 42

Sven Birger Sandzen,
Moonrise in the Canyon,
Moab Utah; *1928, oil on
canvas, 40" × 48"; SMA, gift
of the Springville High School
Junior Class, 1928.*

PLATE 43

*F*lorence Ware, Breakfast in the Garden; *1928, oil on canvas, 36" × 30";*
Utah State Fine Arts Collection, courtesy of the Utah Arts Council.

PLATE 44

Calvin Fletcher, Wash Day in Brigham City; *1929, oil on board,*
24 1/2" × 27"; SMA, gift of F. Ed and Judy Bennett, Salt Lake City.

Frank Ignatius Zimbeaux, Catholic Mass, Decoration Day, Salt Lake Cemetery; *1928, oil on board, 8 1/2" × 13"; SMA, gift of Francis Zimbeaux, Salt Lake City.*

PLATE 45

Calvin Fletcher, Cache Valley Poplars; *1932, oil on canvas, 24" × 35 3/4"; SMA, gift of Leone Fletcher, Provo.*

PLATE 46

PLATE 47

*M*abel Pearl Frazer,
The Furrow; *1929,*
oil on canvas, 24" × 30";
LDS Museum of Church
History and Art.

PLATE 48

*J*ames T. Harwood,
Footsteps in Spring;
*1930, oil on canvas,
26" × 40"; SMA, gift of
Blaine P. and Louise
Clyde, Springville.*

PLATE 49

***P**hilip Henry Barkdull,*
Angels Landing; *1930,*
oil on canvas, 18" × 22";
courtesy of a private collector.

PLATE 50

P*hilip Henry Barkdull,* Designed Landscape: Symphony in Color;
1930, oil on canvas, 30" × 24"; SMA, anonymous gift from Mapleton.

PLATE 51

*L*ee *Greene Richards,*
Dreaming of Zion;
1931, oil on canvas,
32" × 39 1/2"; SMA,
gift of Springville High
School Class of 1935
(by exchange).

Gordon N. Cope,
Utah Hills, East
of Springville; 1937,
oil on board, 30" × 36";
SMA, gift of the
Springville High School
Junior Class, 1937.

PLATE 52

LeConte Stewart,
Private Car; 1937, oil
on canvas, 30" × 48"; LDS
Museum of Church History
and Art.

PLATE 53

PLATE 54

*R*anch Kimball,
Entrance to Zion;
*1934, oil mounted on
canvas, 29" × 35"; SMA,
gift in memory of Thomas
Rolo Kelly from Louise Kelly.*

Louise Richards Farnsworth, Capitol from North Salt Lake; *1935, oil on canvas, 15" × 22"; SMA, gift of the Lund-Wassmer Collection.*

PLATE 55

George Dibble, Marine #2; *1938, oil on board, 16 1/2" × 19"; SMA, gift of the artist.*

PLATE 56

D. **Howell Rosenbaum,** Children at Play in Mantua; *c. 1937, oil on board, 22" × 30"; SMA, gift of Paul Rosenbaum, North Ogden.*

PLATE 57

F. **rancis Horspool,** Utah Pioneer Home; *1939, oil on canvas and frame, 31 3/4" × 37 3/4"; SMA, gift of F. Ed and Judy Bennett, Salt Lake City.*

PLATE 58

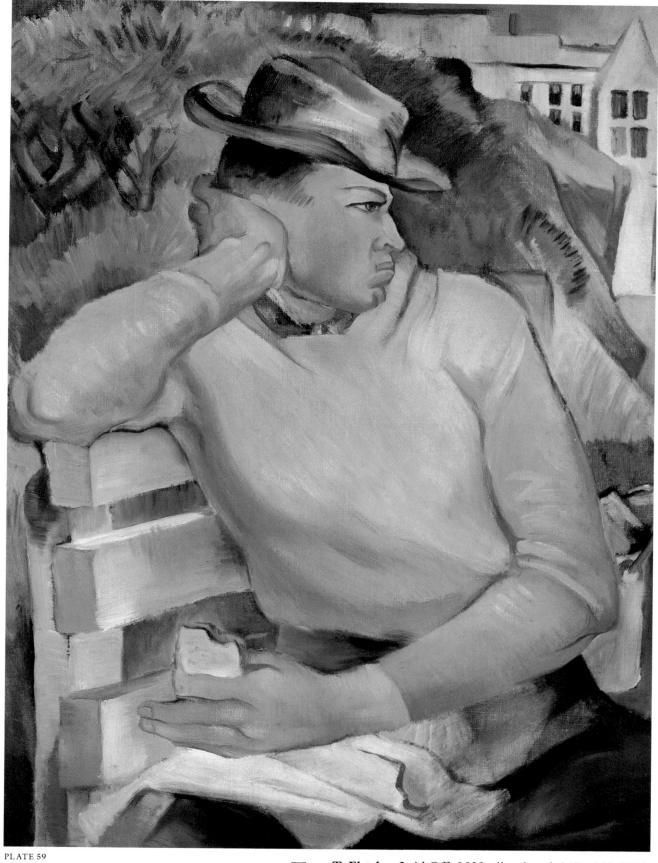

PLATE 59

***I**rene T. Fletcher*, Laid Off; *1938, oil on board, 24" × 18"; SMA,
gift of F. Ed and Judy Bennett, Salt Lake City.*

Minerva Teichert, Indian Captives at Night; *1939, oil on mounted canvas, 48" × 90";* SMA, *gift of the Lund-Wassmer Collection Trust.*

PLATE 60

H. Reuben Reynolds, Load of Hay, Logan; *1941, oil on canvas, 24" × 30";* SMA, *gift of Mrs. Zina H. Reuben Reynolds, Logan.*

PLATE 61

PLATE 62

L. Maynard Dixon, Road to the River, Mt. Carmel Utah; *1941, oil on board, 16" × 19 3/4"; SMA, gift of the Springville High School Class of 1935 (by exchange).*

PLATE 63

John Heber Stansfield,
Mt. Nebo, Early Spring;
1942, oil on board,
35" × 47 3/4"; SMA, gift
of the Springville Junior
High School Eighth Grade,
1942.

Tradition and The Lure of the Modern

Robert S. Olpin

BEFORE THE GREAT WAR: 1900–1913

Optimism was the key state of mind in Utah on 1 January 1900. Statehood had been achieved in 1897. The Salt Lake LDS Temple, designed by Truman O. Angell and William Ward had finally been completed. The tormented history of Deseret now seemed more filled with substantial social and economic development than hardship. In fact, during the period preceding World War I, Utah was generally in the vanguard of states with regard to social legislation; transportation; agricultural, mining, and manufacturing growth; commercial expansion; increased urbanization; and a very progressive sense too, of educational, cultural, and artistic development.

SCULPTURE: FROM BEAUX-ARTS TO THE AGE OF BRONZE

In its tastes for sculpture, the nation had turned away from the classical revivalists of the old expatriate "Italian School" workers in stone (Horatio Greenough, Hiram Powers, Thomas Crawford, and others) and toward the French-inspired romantic-realist works in bronze of Augustus Saint-Gaudens, Daniel Chester French, Lorado Taft, George Grey Barnard, along with the Utah-born and bred Cyrus Edwin Dallin (1861–1944), the Borglum brothers and others. One peculiar fact of Utah's art history is that all four of the Utah artists who have attained the highest levels of national recognition, Cyrus Dallin, Gutzon Borglum (1867–1941), Solon Borglum (1868–1922), and Mahonri Young (1877–1957), were sculptors.

C. E. Dallin of Springville, Utah and Boston was, by 1900, a teacher at the Massachusetts State Normal Art School, and the recipient of a contract for a monumental equestrian statue of Paul Revere destined for Boston's downtown. The sculptor, best known for his ennobling and classical realist depictions of the American Indian in bronze, such as *Signal of Peace* (1889–90, SMA) and *Medicine Man* (life size at Fairmont Park in Philadelphia and small bronze, 1899, SMA etc.), had begun work on the *Paul Revere* back in 1883. A first model, then a second, third, fourth and finally fifth (plaster and bronze castings, 1899, SMA) had followed through years of frustration, until 4 December 1899 when the commission approved his final version. It took another forty years to get the monument erected on Paul Revere Mall near Old North Church—this on 22 September 1940! The *Revere*, along with his *Jane Dallin* (1904, SMA, **plate 24**), *Scout* (1910, SMA, etc.) and *Appeal to the Great Spirit* (life size at Museum of Fine Arts, Boston and small bronze, 1912, SMA, etc.) are typical Dallin works of great generalized dignity.

On a 1903 trip to his home town, Cyrus Dallin was invited by superintendent Lars Eggertsen (1866–1927), Springville High School's first principal, to make an inspirational speech to the town's students; Dallin agreed and, during the lecture, became sufficiently moved by the example his own success could provide that he offered to donate the plaster-model for his fifth *Paul Revere* to the Springville schools.

Cyrus Dallin came back every now and then as he did for the unveiling of his *Moroni* atop the Salt Lake Temple in 1892–93, though not for the 1897 unveiling of his *Brigham Young* (which he found to be a very dissatisfying project) at the intersection of Salt Lake's South Temple and Main. Caught between his own aesthetic considerations

85

Cyrus Edwin Dallin, *Paul Revere (fifth model);* 1899, bronze, 37 1/2" × 36"; SMA.

brothers were known in their youth for table-top scale depictions of western subjects. Solon created very lively small bronzes of Indians, stampeding horses, and bucking broncos (some of these before Frederic Remington's works of the kind). Gutzon not only created excellent pieces in stone (*Conception*, marble, c. 1904, SMA, **plate 25**), but established his reputation first with such fine and powerful bronzes as *Mares of Diomedes* (1904, Newark Museum), a western stampede with a classical title. Finally, the elder Borglum attained a unique level of national recognition as the creator/engineer of two of the largest sculptural projects ever attempted—the *Robert E. Lee* at Stone Mountain in Georgia and the portraits of Washington, Jefferson, Lincoln, and Theodore Roosevelt at South Dakota's Mount Rushmore National Memorial.

Three-dimensional work had only a halting development within the first two decades of the twentieth century. A New York-trained sculptor and painter named Gavin Hamilton Jack (1859–1938) was active in Manti, Emery County and Salt Lake City. Jack learned to handle concrete effectively when he worked on the Panama Canal, and is best known today for the set of four *Lions* he did with the use of that material for the east and west entrances to Richard Kletting's Utah State Capitol Building.

Lewis A. Ramsey (1875–1941) was originally from Bridgeport, Illinois, but came to the Rocky Mountains with his family in 1887 as a Mormon convert. Settling in Payson, he had early lessons with painter, John Hafen but

in the design and those of a great many local citizens, Dallin had been, in the fervently sympathetic opinion of Alice Merrill Horne, confronted by a committee of "real estate agents" and "sausage grinders."

Yet elsewhere, this former Utahn pursued a rather happy artist's life, riding the crest of the popular vogue. He won a gold medal at the 1904 St. Louis Exposition for *Sioux Chief,* and about the same time designed the model for a large Revolutionary War *Soldiers and Sailors Monument* which won first prize in a 1906 competition.

John Gutzon de la Mothe Borglum was born in St. Charles, near Bear Lake in 1867, where his Danish parents had settled with the first Mormon immigrants in 1864. By the time Solon Hannibal Borglum was born in 1868, the family had moved to Ogden. Both Borglum

Lewis A. Ramsey as a young man. When he was a boy of sixteen Ramsey taught penmanship at BYU. Later he found work as a calligrapher in New York City, and finally, as a painter of celebrity portraits in Hollywood. (Photo courtesy SMA.)

86

was also interested in sculpture. In 1892, he left for study at the Art Institute of Chicago, and then trained in New York and Boston. After Ramsey took lessons with Douglas Volk, a pupil of John Singer Sargent, he joined Dallin in Paris. At the Académie Julian he pursued more training under portrait painting masters, and when he returned to Utah in 1903 he taught painting at LDS University for two years.

Meanwhile, Utah's greatest sculptor, Mahonri Mackintosh Young, was pursuing a similar course, in a very different style. While the lesser-known Ramsey was always something of a loner, Mahonri Young must be seen as the leader of his group of contemporaries. In fact, Young grew up on the same block as painters Alma Brockerman Wright and Lee Greene Richards. All three exhibited in early-century Paris salons and at the St. Louis Exposition of 1904, but while Young pursued a career largely outside old Deseret, his childhood companions opted for local involvement.

Mahonri studied first with J. T. Harwood and then obtained work as a staff artist for the *Salt Lake Tribune* and the old *Salt Lake Herald*. His painting pals were Richards, Wright and fellow "Trib" artist Jack Sears. Finally, in 1899, Young had saved enough for New York study under painter Kenyon Cox at the Art Students League. Returning to Utah in 1901, he worked at the *Herald* and saved his salary for training in France. With this money and a small inheritance from his grandfather Brigham Young's estate, he was able to leave for Paris within the year.

The Paris years were decisive for Young. He studied at the Julian, Delecluse, and Colarossi académies, and took criticism from both Raoul Verlet and Jean Paul Laurens. He quickly realized that as a painter he created linear action studies related more to sculptural, or etching designs than to any heartfelt color expression. Though he continued to paint and draw (*Portrait of John Hafen*, 1907 and *El on the Hudson River, 129th Street, New York*, 1909—both SMA), Mahonri would, from the first Paris period forward, think of himself primarily as a sculptor, etcher, and draftsman.

Having many Paris friends who were drawn in one way or another to modernism, Young, too, experimented with "non-realist" forms of expression. Essentially however, he remained in the realist camp. He demonstrated an ability to understand but disagree with such close associates as Gertrude and Leo Stein on art theory. Ultimately more impressed by Millet and Meunier than by Matisse, Young wanted to show the actions of anatomically believ-

able human figures. In this quest he was more like Ash Can artists John Sloan and George Bellows—or even his academically oriented colleagues from Utah (Richards, Wright, J. Leo Fairbanks) who were in Paris at the same time—than he was like such friends as Bernard Karfiol and "Alfy" Maurer. Working people engaged in strenuous physical activity were his individual subjects (*The Stone Mason,* c. 1907, or *The Carpenter,* c. 1911—both SMA), while his ongoing, more general goal was to capture the vitality of simple, contemporary action.

J. Leo Fairbanks, son of painter John B. Fairbanks and older brother of sculptor, Avard T. Fairbanks (1897–1987) was born in Payson, Utah the year after the birth of his friend Mahonri in Salt Lake City. Studying first under his father, Leo later went to Paris. Like Mahonri, L. A. Ramsey, and the others, he studied both painting and sculpture. When he returned to Utah in

1903, he secured employment as supervisor of drawing in the Salt Lake City schools, and as an art instructor up at LDS Academy in Ogden.

While Leo was only an average talent as a sculptor (*Portrait Bust of John B. Fairbanks,* 1906 and *Portrait Bust of John Hafen,* 1907—both SMA), his brother Avard Tennyson—the tenth son—Fairbanks was a youth with a very early and unique aptitude for three-dimensional conception and craft. He was taken to New York at the age of thirteen by his father to study at the Art Students League under the famed traditional sculptor, James Earl Fraser. Exhibiting that same year (1910) at the National Academy of Design, the boy was off to Paris in 1913 for work first at the Académie de la Grande Chaumière et Colarossi and then with Injalbert at the École Moderne. Impressive early as a sculptor of animal forms (*Buffalo,* both plaster and bronze castings, 1912, SMA), young Fairbanks became the youngest artist ever admitted to the French Salon in 1914. He was seventeen.

While Avard was in Paris, Mahonri Young was living the exciting life of a highly successful artist in New York City. In 1912—at the age of thirty-five—Mahonri was made an associate member of the National Academy of Design and given a commission to model life-sized groups of Arizona Indian figures by the American Museum of Natural History. Stopping by to visit Salt Lake City, Young was commissioned by the LDS Church to create the *Seagull Monument* for Temple Square. Having dreamed of such a hometown project since Dallin had done his *Moroni* and *Brigham Young Monument,* Mahonri Young finished the commission within a year! The artist attended the unveiling of his fine traditionalist monument in 1913. That same year he was significantly involved in preparations for the New York opening of the famous Armory Show. This exhibition offered the American public its first glimpse of modern art from Europe; most of the folks back home in Utah would have been appalled had they been aware of it.

PAINTING A BACKGROUND: PIONEERS AND THE ROCKY MOUNTAIN SCHOOL

At century's turn, the paintings of Winslow Homer, George Inness, A. H. Wyant, Homer D. Martin, John LaFarge, Elihu Vedder, John Singer Sargent, William Merritt Chase and Edwin A. Abbey were best known; while in Utah the oil and watercolor creations of the French-trained John Hafen, J. T. Harwood, Lee Greene Richards, A. B. Wright, John B. and J. Leo Fairbanks,

Lorus Pratt, and Edwin Evans gained greatest local recognition—alongside scenes by the older "pioneers," C. C. A. Christensen, Dan Weggeland, George M. Ottinger, Alfred Lambourne and H. L. A. Culmer.

Nearsighted, Christensen in later years used a cane and was hard of hearing. In his pictures of Mormon history he had wanted to get everything as accurate as possible. After painting his *Handcart Scene* (1900, MCHA)—with scrupulous, semi-primitive authenticity—he became a full-time volunteer worker in the church historian's office before his death on 3 July 1912.

George Martin Ottinger and Danquart Anthon Weggeland were, without doubt, Utah's most significant early painter/teachers. As second-generation artists began, toward the end of the century, to depart for further training in Europe, the careers of George Ottinger and Dan Weggeland commenced to close.

In 1900 Ottinger directed the construction of a *Fireman's Association* clubhouse, "Ottinger Hall," which still stands at the mouth of City Creek Canyon. Painting until almost the last, Ottinger died on 29 October 1917.

Weggeland created work for the LDS Temples in the 1890s. Afterward he painted on into his ninetieth year, creating straightforward and rugged little pictures of very uneven quality, both copies and originals. On 2 June 1918, this Norwegian convert to the Mormon Church, died amidst the unwanted inactivity of very advanced age.

The immense popularity of landscape painting that had existed in this country since the early-to-mid nineteenth century continued on into the first decades of the 1900s. The so-called Rocky Mountain School was essentially the romantic realist Hudson River School gone west with panoramic, naturalist, luminist and then tonalist and tonal-impressionist inclinations. Included under this heading (within the Utah context) are not only the well-known visitors, Albert Bierstadt (1830–1902) and Thomas Moran (1837–1926), but Ottinger, Weggeland, Alfred Lambourne, H. L. A. Culmer and George Beard.

A creative spirit literally bursting with expressive intent, the English LDS convert, Alfred Lambourne painted scene after scene in his highly romantic attitude. And yet Lambourne found the single medium of painting increasingly inadequate to his needs; he wrote more poetry and prose as time went by—fourteen books in his lifetime. The artist was one of the West's most enthusiastic trekkers, exploring the Rocky Mountain and Sierra regions (often in the company of Harry Culmer). Lambourne's depictions of nature both near and far from home continued even to such very late career examples as

Summer and *Autumn* (1921 and 1924, SMA).

He had a sharp, analytical mind, a great fund of information on many subjects which he shared openly and with great good feeling. In 1983, Waldo Midgley remembered visiting with him as a young man, "One evening he told us of a friend who came to him for advice. 'Brother Lambourne, my son wants to be an artist.' A pause, then a reply. 'Oh my God; have you tried to dissuade him?'—'Yes, but he won't listen.' Another pause. 'Then, my friend, take him up on the East Bench and gently, gently mind you, but firmly do away with him!' " When he passed away in Salt Lake City on 6 June 1926, Lambourne was well-loved not only by his children but by his many friends and acquaintances.

Lambourne's friend, Henry Lavender Adolphus Culmer, was another Englishman by birth who arrived in Utah at an early age because of Mormon missionary work abroad. Having attended the University of Deseret in the 1870s (possibly studying with Dan Weggeland there) he had lessons with Reuben Kirkham and Lambourne too, but developed a somewhat more reserved passion for painting the landscape than had his poetic associate.

Culmer had met Thomas Moran, a frequent visitor to Utah, in the 1870s and, as a result, developed a landscape approach that was (at least in his own mind) unabashedly based upon the better known artist's work. Culmer studied in both New York and California. As his art evolved, he also studied geology and botany extensively; these interests are strongly felt in the immediately popular but often rather dry oil painting of scenes such as Natural Bridges, Monument Valley, White Canyon and the Arches. Yet, this painter/scientist in his less ambitious works (*Sunshine and Shadow: Walker Lane, Salt Lake,* 1903, SMA) could demonstrate an admirable feeling for color in light and even a pleasing freshness.

Depicting landscape in both oil and watercolor (*Grand Canyon,* 1904, SMA and *Approaching Salt Lake City from City Creek Canyon* c. 1906, SMA, **plate 27**), Harry Culmer was arguably Utah's most popular painter (a fact which annoyed the younger, Paris-trained group). Large in view and done upon the basis of authentically-felt enthusiasm for the grand expanses of western lands (*Augusta Bridge,* c. 1910, SFAC, **plate 29**), Culmer works painted toward the end of his career were often purchased immediately after they were completed, especially by Colonel Edwin F. Holmes and his wife, Susanna Emery ("The Silver Queen"), the artist's most important patrons.

He wrote of painting "to please the public," yet the remarkable Harry Culmer usually relegated painting to a

Lee Greene Richards, *Portrait of H. L. A. Culmer;* 1908, oil on canvas; MFA/BYU.

Sunday, holiday and off-hour avocation, engaged in whenever the pressures of a life filled with a vast number of business, civic, cultural and literary endeavors permitted.

Then suddenly, on 10 February 1914, this self-made man died. As Alice Merrill Horne wrote soon afterward: "Mr. Culmer's recent death caused a shock to the entire community. He was a man of charming personality and made warm friends. His paintings hang in the homes of many of the wealthy citizens of Salt Lake City, as well as in public places."

One other artist who should be included here is George Beard (1855–1944) of Coalville. Another British convert to the LDS Church, Beard had come to Deseret with his family in the late 1860s as a teenager. Developing a naively precise landscape style in painting, he also served his community as pioneer doctor and nurse, school trustee, store keeper, mayor and state legislator. A wanderer too, Beard sketched, painted and photographed his way through the Uintah Mountains, and today he is perhaps best known not for his brush but

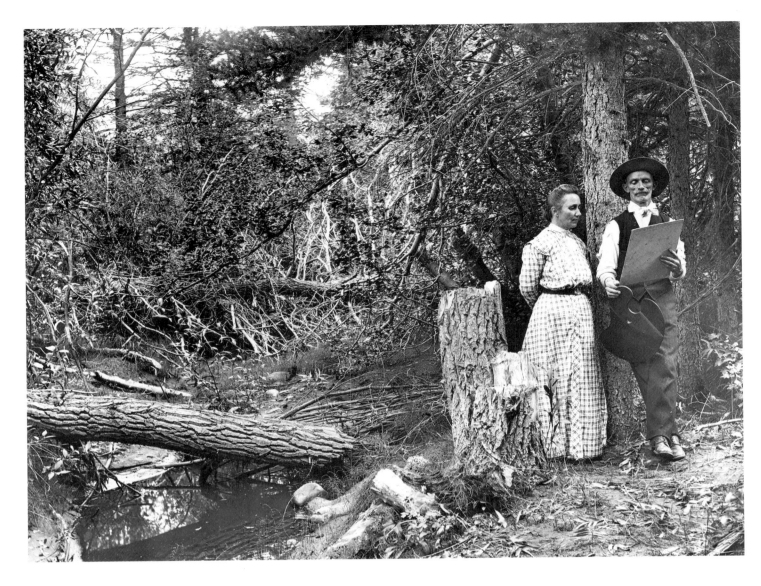

for his camera works. Living on into the 1940s, this local member of the Rocky Mountain School could, upon occasion, create paintings with an impressive sense of wide-open lighting and distance (*Tetons, Wyoming, from Lee Creek Divide,* 1911, p.c.).

THE IMPACT OF EUROPEAN TRAINING: PORTRAITS AND FIGURES

In the summer of 1888 James T. Harwood became the first major native-born Utah artist to sail for Paris. Cyrus Dallin joined him there within two weeks. Two years later in July, John Hafen, J. B. Fairbanks and Lorus Pratt arrived. Also enrolled at the Julian Academy by this time was John W. Clawson, and in the fall of 1890 Edwin Evans had joined the Utah group as the fourth artist member of the "French Mission." In 1891 Herman H. Haag, the fifth Mormon missionary painter, joined the others.

Called "pioneers in reverse," these men had first studied with Utah artists (Weggeland, Ottinger, John Tullidge, etc.), then in Europe, and finally in most cases returned home to impose on local culture first an academic purity, later moderated forms of impressionism and even, in a few cases, restrained suggestions of the modern. Indeed, within a broad turn-of-the-century time frame, the size of the group (locally born and/or bred artists who studied in Paris) was substantial: Harwood, Dallin, Clawson, and Avard Fairbanks, Richards, Wright and Young, plus Harriett Richards Harwood, Mary Teasdel, Lara Rawlins Cauffman, Maye Jennings Farlow, LuDeen Christensen, Louise Richards Farnsworth, Rose Hartwell, Myra Sawyer, Donald Beauregard, Ralston Gibbs, Gerard Hale and Henri Moser.

The Utah artists' migration across the Atlantic to Paris was part of the overall trend common to American artists at this time. The dominant element in this country's cultural growth during the last quarter of the nineteenth century was the compelling attraction of Europe for American artists and writers. For most Utahns the Parisian Experience represented draftsman-oriented training

James Taylor Harwood, *Preparation for Dinner;* **1891, oil on canvas, 37 1/2" × 50"; UMFA, Olpin Union Collection.**

within an aura of strict and traditional adherence to form. The European "faculty" associated with the training of Utah's artists during this time were solidly based, but unquestionably eclectic period academicians. The roster includes Berenaux, Bohn, Leon Bonnat, William A. Bouguereau, Boulanger, Chapu, Collin, Benjamin Constant, Fernand Cormon, Dampt, Doucet, Elonge, Fleuvier, Jean Paul Laurens, Jules Lefebvre, Mangiapan, Prenet, Rigelot, Simon, Triquigneaux and Verlet.

James Taylor Harwood (1860–1940) of Lehi, Utah, had studied with Virgil Williams at the California School of Design (San Francisco) in 1885–86, with Boulanger, Constant and Lefebvre at the Académie Julian (Paris) in 1888–89, and with Leon Bonnat at the École des Beaux-Arts (Paris) in 1889–90, all this before his marriage to painter Harriett Richards (1870–1922) on 25 June 1891 in Paris. Becoming the first Utahn to show in the Paris Salon (1892) with his wonderful genre painting, *Preparation for Dinner* (1892, UMFA Olpin Union Collection) Harwood returned to Utah to settle in Salt

Lake City with Harriett. Appointed art instructor for Salt Lake High School in 1898, this talented artist had also seen his landscape *Black Rock* (1899, SFAC) become the Utah Art Institute's first purchase prize winner in the old century's last year.

Once again in Paris some three years later, Harwood studied at the Julian early in the day and painted at the Louvre in the afternoons. By 1903 he was pursuing traditional academic realism leading to such genre works as *Blowing Soap Bubbles* (1903, UMFA) and *An Interesting Story* (1904, SMA). His son Willard and daughter Ruth Harwood posed for these paintings. When the Salon of 1904 rejected Harwood's *Adoration of the Ages* (1904, MFA/BYU) his most ambitious figure composition, the Harwoods departed Paris yet again.

Never really a portraitist, although he had all the skills to create such images of family members and friends, Harwood preferred to picture figurative "slices of life" or landscape. His best known genre works of the time are *Boy Pioneer* (1907 and reworked 1911 and 1925,

1904, MCHA; *Portrait of Elizabeth Winsor Smart*, 1906, SMA; also, *Portrait of Wilford Woodruff*, lithograph, n.d.), they tend to fade in memory because of the artist's more overtly joyous and emotional depictions of nature.

Not long before his passing, Hafen wrote that he had originally decided to study in Paris, not only because of advice from his pioneer teacher, Weggeland, but because "Harwood and Will Clawson also encouraged the idea." Having had, as he looked back at that earlier time, "no particular choice of subject," he'd "just drifted into the landscape" at first. Yet now, he admitted, "I believe that my main sympathy is with landscape," and for the rest (on the portrait and figure study side of art, in essence), he saw the pictorial as divided "into two classes at all times in history." On one side "are the painters." On the other "are artists." And "there are very great men on either side. On the side of painters I might class John Sargent, Anders Zorn and most modern impressionists. On the side of artists, Rembrandt, Whistler, etc." But it was Hafen's belief that "the tendency of the present age is strongly inclined to the painting side of art, and troubled seriously with commercialism."

Within this context, Hafen's fellow classmate in Paris, the popular portraitist, John Willard Clawson (1858–1936), had early cast his lot with "the painters" rather than "the artists." Born in the Beehive House, this grandson of Brigham Young had studied first with Ottinger at the University of Deseret. A remarkably gifted early talent, Will was advised to go east for further training, and though it is said that his father, Hiram B. Clawson, disapproved, William Jennings and some other Salt Lake businessmen offered to finance the adventure. Thus pressured into approval, H. B. Clawson paid his son's way back to New York City himself. The young man and his new wife (Mary Clark) set off in 1881; Clawson enrolled at the National Academy of Design soon afterward. After three years in New York, the artist came back to Salt Lake to open a studio. He always claimed to prefer landscape, but portrait commissions were what kept the business going.

At the end of the decade, having heard of the fortunate experiences abroad of Harwood and Dallin, Clawson too set out for Paris to study at the Académie Julian. Clawson also studied at the École des Beaux-Arts and in the atelier of Fernand Cormon, the teacher of Van Gogh, Toulouse-Lautrec, and Chaim Soutine. The gifted Utahn also had the rare opportunity of receiving criticism from Claude Monet; studying with the American painter, Julius Stewart for nine months in Venice; and spending a season

MFA/BYU) and his very fine *Boy with a Bun* (1910, SMA, **plate 31**). Life was dull and he yearned to do more with his art. Finally, in 1911, he arranged to go to the Europe ostensibly to buy furniture for the Salt Lake School Board. In Paris he had his newly reworked *Boy Pioneer* accepted at the Salon, painted a little, then came home to life back in Utah.

Perhaps more than any other single event, the death in 1910 of his old friend, John Hafen, hastened Harwood's feeling that his own chances to make an artistic mark were becoming fewer and fewer. The "artist's life" had been a tremendously difficult struggle for Hafen. Though his portraits can be fine in their dignity and sensitive probing of character *(Portrait of George Albert Smith,*

doing portraits in Britain before returning home in 1896 (*Portrait of a Gentleman*, 1894, SMA).

In Salt Lake again through the turn-of-the-century, the painter developed a buoyant and fluid brush performance through a Sargent-like "impressionist" approach. Commissions from local patrons were readily obtained, and remained frequent throughout Clawson's career, though he remained a Utah resident for only a few years after he returned from Europe. (See *Portrait of Angelina Andrews Walker*, 1901, SMA, **plate 21**.)

Moving on to San Francisco in the first decade of the new century, John W. Clawson became a rather well-paid portrait painter and newspaper illustrator until the 1906 earthquake and fire completely destroyed his studio and twenty portraits, valued at $80,000. Shocked at his misfortune, Clawson went to Los Angeles and then New York City until 1921, when he returned to Southern California where he was very successful.

Clawson's immediate replacement as Salt Lake's portrait painter in residence was L. A. Ramsey (*Portrait of Grandfather, Thomas Steed*, 1905, SMA). Returning from Chicago in 1906, that sculptor-turned-painter spent the next ten years working on various Mormon Church commissions including rather stiff portraits of LDS greats (*Joseph Praying in the Grove*, 1912, MCHA). Later it became clear that Clawson's real qualitative replacement at home in the field of portraiture was Mahonri Young's childhood friend, Lee Greene Richards (1878–1950).

Growing up together in the old Twentieth Ward in Salt Lake City, Young, Richards and A. B. Wright (1875–1952) had all, quite naturally, come under the early influence of George Ottinger. Richards and Wright, as young painters, made regular visits to Ottinger's neighborhood studio in the 1880s and 1890s. Richards had concluded his local training with J. T. Harwood (also a Wright and Young instructor), while Wright went to school, first at LDS College from 1892 to 1895, and then the University of Utah in 1895–96 (studying with Herman H. Haag). Wright worked as an instructor of art at Brigham Young College in Logan from 1899 to 1902, then left Utah for European training.

Lee Richards, on the other hand, had already been abroad as early as 1896 (on an LDS mission), and had also arrived in France as an art student the year before Wright. The two enrolled in the French capital with Laurens and Bonnat, at the Julian and École des Beaux-Arts respectively. Richards had his portrait of Hattie Harwood's father, *Dr. Heber John Richards* (1903, UAC) accepted and hung at the Societé des Artistes Francais,

Lee Greene Richards, *Lady with a Green Bag* (Blanche Richards); 1904, oil on canvas, 79" × 40"; UMFA, 1952-13.

and then his half-length portrait of another of Dr. Richards's daughters, *Blanche* (1903, MFA/BYU), shown at the 1903 Salon d'Automne. Invited to exhibit in the International Society of Painters, Sculptors and Etchers show in Great Britain in 1904, Richards was accepted too at both the St. Louis Exposition and the Paris Salon, where his portraits of Mrs. H. J. Richards (1903, UAC) and Blanche Richards (*Lady with a Green Bag*, 1904, UMFA) were presented. Winning honorable mention at the 1904 Salon for *Young Lady with a Green Bag*, he triumphantly returned home to Utah.

A talented bravura performer in both oils and water-color, Richards set up a studio in Salt Lake's Templeton Building alongside one used by Dan Weggeland. The younger artist put up a shingle announcing his intentions as "Portrait Painter;" almost immediately, commissions began to come in. (*The Girl in the Silk Dress,* 1904, SMA; *Cyrus E. Dallin,* 1908, SMA; *George M. Ottinger,* 1910, UMFA, Olpin Union Collection; *William M. Stewart,* 1912, UMFA), plus a long line of more generalized portraits and accompanying figure paintings of very high quality.

While Richards had launched his professional career in 1903, Wright moved from study under Laurens at the Julian to the taking of criticism at the Colarossi Academy (*Profile of a Young Girl,* 1902–04 and *Figure Study*—both SMA). Developing a rather admirable "Whistlerian" portrait style (*Blanche Richards*), 1903, SFAC), he exhibited work at the Autumn Salon in both 1903 and 1904 and then won the Utah State Prize with his *Blanche* in the latter year. He won similar prizes at state competitions in 1905, 1908, and 1910.

Alma Wright was not only an able portrait and figure artist (*Portrait of Weston Vernon,* 1905, SMA), but a good landscapist and a championship fencer as well! Having won the intermountain title with the foil first in 1897, this well built little man with an immaculately groomed and trimmed mustache (*Self-Portrait,* 1905, SMA) went

on to defend his title for years to come. A sparkling conversationalist, he was considered attractive by the ladies—both before and after his marriage to Alice May Cooper in 1899.

Wright had one of his portraits accepted at the Paris Salon in 1913 and then spoke with Alice Merrill Horne regarding his very high ideals. "The portrait is to me a psychological rendering of personality," he said. "While I think a great deal of the material of things I feel that materiality is only a means to a higher end—the spiritual significance of the sitter." Mrs. Horne was very obviously taken with A. B. She concluded her comments regarding his career to that time by calling Wright "clean and upright in his life and habits, sincere in his work, self-sacrificing for the sake of his calling, thoughtful and helpful to students and lovers of the beautiful." Horne here makes Wright and his work seem the logical outcome of Parisian training in art that had initially been combined with Mormon missionary work.

Lorus Pratt (1855–1923) was a son of the remarkable Utah scholar and Mormon leader, Orson Pratt. Having studied with Weggeland, he also trained a bit on the East coast, then traveled to Great Britain with his father in the 1870s.

He lived on into the early 1920s and died poverty-burdened but rich in family (a huge tribe, including the painters, Lorus Orson Pratt, and Louis Hand, a grandson). His work—including some lovely impressionist landscapes—was left either in the hands of sympathetic relatives or in the possession of his creditors.

In some ways an equally dismal fate awaited John B. Fairbanks. Among his contemporaries, Fairbanks suffered most from a certain archaic quality that the Paris years did little to alleviate.

Moving around with great frequency after his return from Europe, he worked in Arizona, St. George, Provo, Ogden and South America, always looking for more success with his art than either the fates or his own talent would allow. He lived in Provo for some time after his Salt Lake Temple mural obligation was completed, teaching at Brigham Young Academy and running his own photographic studio. His sculptor/painter son, J. Leo Fairbanks helped support the family.

Following the death of his first wife in 1898, Fairbanks moved his large brood to Ogden to take a job as the first art supervisor for the public schools of that community. He took off in early 1902 with the Benjamin Cluff archaeological expedition through Mexico and Central America to Colombia. While the father was thus

The Templeton Building, constructed in 1890, housed the studios of many early Salt Lake City artists, and served as an informal art center and school. (Photo courtesy the Utah State Historical Society.)

Lee Greene Richards in his studio (possibly in the Templeton Building). Richards was without peer among the local portrait painters in the first half of this century. (Photo courtesy the Utah State Historical Society.)

employed as director of "art and photograph" on that Brigham Young Academy attempt to prove the *Book of Mormon,* J. Leo Fairbanks worked on in Ogden to support the family. After J. B. returned, his faithful son finally set out on his own career with that initial sojourn in Paris.

In 1905, Leo and young Avard helped their father (who had "given up" painting) move to the province of Alberta, Canada, in order to homestead 250 acres of wheat and cattle range. But, soon afterward, John Fairbanks became ill and received "in a dream" a mandate to continue his painting back in Deseret. J. B. subsequently put most of his artistic efforts into "copying" famous paintings (he had done some of this before, as in *The Prairie,* a copy after Edwin Gay, c. 1902, SMA), along with some portraits, landscapes and quite a good number of Book of Mormon theme paintings.

It was in fact a meager living and by 1910 J. B. and Avard moved on to New York. There, the Provo Chamber of Commerce was to pay five dollars a month toward the $130 price of a John B. Fairbanks "old master copy" after Rosa Bonheur's *Horse Fair* (1910 Provo County

Collection) in the Metropolitan Museum. The scheme failed and J. B. decided to come back to Utah to promote Zion Park through his sketches and paintings. But these sold about as well as his old master copies had, and so Fairbanks became a window dresser to get by, though he kept his studio space at Social Hall in Salt Lake City.

Fairbanks did earn some rewards for his tough life. On one of his many painting trips to Zion he met a girl named Florence Gifford who consented to marry him around 1915. By that time Fairbanks was sixty, but eventually, Leo and Avard had five more brothers and sisters to worry about. And yet the boys loved their dad, and as Leo put it in a speech during his early Salt Lake career, "father's attitude, his willingness to sacrifice everything to his art—this has been an inspiration to me."

J. Leo took his academic studies very seriously, and it was his activity in the academic realm which led him out of state. Eventually, he became chairman of the art department at Oregon State University.

Like Mahonri Young, John Septimus "Jack" Sears (1875–1969) had begun the study of painting and drawing

under J. T. Harwood. Having won a local competition silver medal in 1892 "for the best oil painting for those under eighteen," he then studied for a year at the Mark Hopkins Art Institute in San Francisco under William Keith, Arthur B. Matthews and others. Back with Harwood in 1895–96, Sears sold frog legs to a Salt Lake hotel, merchandised a "tub-full" of medals he had won as a cyclist, and even played some baseball in an effort to raise enough for art school in the East.

He made it to New York the next year, attending classes at the Art Students League taught by Douglas Volk, George De Forest Brush, William Merritt Chase and Ernest Knaufft. He also worked at William Randolph Hearst's *Journal* as a "joke drawing" artist in order to stay in school. Taking on additional work for the *Deseret News* in 1897, he continued draw cartoons in Utah and Chattanooga, Tennessee until he found a job as a reporter for Bradstreet's Mercantile Agency (later Dun & Bradstreet), back in New York City. Later, he took jobs as an illustrator for the *New York Morning Telegraph,* and again the *New York Evening Journal,* in 1904. In his spare time this journalist-artist studied the oil technique with Dan McCarthy. Sears was in New York with his old *Salt Lake Tribune* mate "Hon" Young, and the two were both swept up in the excitement of a new and energetic era in American art.

In 1907–08, they studied with the great teacher, Robert Henri, easily one of the most forceful advocates of the early-century American thrust toward illustrative "social realism". Sears joined Young during the period in a romance with the new and bustling core of an artistic urban awareness which had great influence in the country's ongoing cultural development (M. M. Young, *The El at Hudson River at 129th Street, New York City*, 1909, SMA; Sears, *Eugene Ysaye, the famed Belgian violinist as he played at concert,* 1912, SMA; Sears, *Bum on a Bench* or *Old Man Sitting,* c. 1912, SMA).

THE IMPACT OF THE YOUNGER GENERATION: IMPRESSIONS OF THE LAND

John Hafen was the central figure among the Utah landscape painters who went beyond the pioneering Rocky Mountain School. Today he is regarded by many as the most naturally appealing of the early Utah stylists, but extreme poverty was his most constant companion in life. When he died of pneumonia in 1910, he was working away from home, in Indiana. Hafen was intelligent, talented, dedicated, sensitive and enchantingly eccentric.

Certainly Alice Merrill Horne liked him, both in life and in memory. Indeed, she was quite in awe, and summoned Whistler's "Ten O' Clock Lecture" in her description of his influence: "Where the Artist is, there Art appears, and remains with him . . .; and when he dies she sadly takes her flight . . ." She continued, "John Hafen has laid all upon the altar of sacrifice for art's sake . . ."

Returning home from Paris in 1891—after a year of travel and study—Hafen made Springville his home base. A confirmed landscapist in the tradition of Barbizon, the artist favored such painters as Rembrandt, Millet, Corot and George Inness, and saw his work in the lineage of sweeping *tone poems*—visions of nature initiated in seventeenth century Holland, carried forward by eighteenth and nineteenth century English and French painters, and "discovered" in the mid-nineteenth century by such American artists as Inness, Wyant and Martin. Hafen's carefully-loaded brush and lighter "Corot-like" touch (*Sawmill up American Fork Canyon,*" pastel, 1898, and *Indian Summer,* c. 1900, both SMA) were not particularly appreciated by local viewers. One of the artist's contemporaries later wrote that the work was "too chaste, too subtle, too delicate in the manipulation of values to suit a western audience, whose inclination ran to spectacular subject and photographic likeness."

After his temple-painting work, Hafen traveled yearly to California. There were some few acknowledgements of his talent locally, and upon those occasions Hafen and his large family celebrated. In 1900 and 1903, the artist won purchase prizes at Utah Art Institute shows. He was, though, always more successful away from home. After he returned from an extended sojourn in California in 1901 (*The Mission,* 1901, SMA), the Mormon church agreed to subsidize his work for a year at $100 per month. He spent much of the rest of his last decade away from home—with some success. He studied and painted in Boston and other East-coast cities and finally moved to Brown County, Indiana, with his son Virgil in 1907. With the patronage of a wealthy Indianapolis industrialist, he won important commissions for portraits, ironically, not landscapes. Hafen's works were on view at museums in Chicago, Philadelphia, St. Louis and Indianapolis during his lifetime.

A $500 first prize at the Utah State Fair in 1902 and a $300 prize for best landscape at the Illinois State Fair in 1908 not only helped feed his brood, but serve to highlight the beginning and end of his finest period of painting. His *Girl Among the Hollyhocks* (1902, MCHA, **plate 22**); *Landing at Geneva, Utah Lake* (1905, SMA); and

Mount Timpanogos (1907, SMA) are some of the finest paintings ever executed by a Utah artist. Hafen's sense of color in light and air, his use of close values, and his Wyant-like intimism (often displayed in enclosed scenes sensitively and silently observed) are at the core of his tonal-impressionist aesthetic.

Hafen was a generous man, who nurtured the talent of others. He influenced Joseph Kerby (1857–1911), an English-born primitivist who lived and worked in Heber Valley and Provo. Kerby painted oils (*Straw Hat with Apples*, 1900, SMA, **plate 19**); did interior decoration, including drop curtains for the Park City Opera House; designed costumes; wrote poetry; did carpentry; and farmed.

Samuel Hans Jepperson (1855–1931), also of Provo, made many friends including Hafen, Weggeland, Lambourne, Harwood, J. B. Fairbanks, and especially George Henry Taggart (a portraitist from New York City who came to take the mountain air as treatment for his lung ailment). Jepperson came with his family from Copenhagen to Utah as an infant in 1857. He showed early talent in the arts, and at seventeen began to take lessons from the Provo portrait and theatrical scene painter, Henry Maiben. Though in the end he created over 1,000 paintings, Jepperson remained a provincial artist. See *Goodbye Sweet Day* (1919, SMA, **plate 33**) and others from the twenties.

Hafen also befriended Willis A. Adams (1854–1932), a non-Mormon pioneer of Park City. A native of Goshen, Indiana, Adams was originally a photographer. He had become interested in the painter's life and studied at the Chicago Art Institute while his brother, Charles, remained in Goshen to tend to the family photography studio. When they decided (in the way of Bierstadt, W. H. Jackson and others) to go west, it was late in the 1870s (thirty or so years after the original Utah pioneers).

Having arrived in Ogden by rail almost ten years to the day after the creation of Charles Savage's historic Promontory pictures, Charles Adams had immediately set up as a photographer in that town, while partner Willis (Adams Brothers Portrait and Landscape Photographers) moved quickly on to Park City to establish a second family photo gallery. The new silver immigrants soon swamped Willis with requests for both photographic and painted likenesses.

Seeking artistic companionship, Adams eventually numbered H. L. A. Culmer, J. T. Harwood, Lee Richards, A. B. Wright, Edwin Evans, LeConte Stewart and especially John Hafen among his friends. Being almost the same age and of very similar temperament,

Hafen and Adams enjoyed traveling together on various sketching trips. Indeed, it was Hafen's Barbizon-inspired approach to landscape that most influenced Adams's very consistent and high quality handling of mountain valley and woodland interior views (*Evening*, 1903, SMA, **plate 23**). The Adams approach is joyful nature worship, balanced by innate reserve. And the proof that Willis Adams knew precisely what he was doing can be found not only in his painting, but upon the tiny pages of his journals:

> *Color notes—An observation of yellow foliage will convince any observer that the compliment of that color is*

Jack Sears, *Sketch of John Hafen*; 19 June 1907, pen and ink, 6 1/2" × 4 3/4"; Harold Christensen collection (courtesy SMA).

purple . . .Tone and Concentration—whether in sketching or easel work, it is good practice to work on a respectful reserve of color and shade values, holding the highest colors and brightest lights where they will be of greatest assistance . . .

Of the "Tonists" (we would call them "tonalists" today) he writes,

> *. . . we [must] paint our canvas with reference to a unifying tone—not waiting for the action of time to make perfect what should be the later of the present moment . . . Each part of a picture is a blood relation to every other part, and glaring contrasts should be avoided. . . . Why do painters . . . Corot or any other great . . .tone down the blue sky or green of grass, but to make the elements in his picture all pull together . . .*

This excellent painter was almost completely overlooked until a 1982 retrospective at the Salt Lake Art Center. But at least Adams himself seemed not to suffer as a result of the general lack of notice his paintings received throughout his career. He was busy with many things. The same could not be said for Lorus Pratt. Pratt had a minor role in the post-Paris murals undertaken by the "mission" painters back home in Utah, and his role as a painter on the local scene remained minor throughout his career.

It is not clear why that was true. Apparently feeling sorry for Pratt in her 1914 *Hand Book of Utah Art,* Alice Horne wrote that he "had ready sale for the pictures he painted before his study abroad, . . .[but] " the public was neglectful of him and lost interest when he entered a more advanced field of art." Considered a proficient portraitist in his early years by such a local pundit as Edward Tullidge, it is often said that his later work became rather too "detailed" or "linear" or "severe"— especially when compared to the brushier, more intimate views gaining popularity at the time. And yet, there are charming, intimate, not overly fussy, indeed rather painterly Pratt studies of rivers, vales, farms and such from this later period (*Shepherd and His Flocks,* c. 1893, *Harvest Time in Cache Valley,* 1913, and *Fishing Along the Jordan,* 1916, **plate 32**—all SMA).

Pratt's friend, John B. Fairbanks has also been underrated as a landscape painter. He was, in fact, a painter of nature with a quite distinctive point of view. Like Pratt, J. B. was a student of Rigelot (who was a student of Palon, who was a student of Corot). When the "Paris painters" all got home to paint in the Salt Lake Temple, Fairbanks

received a larger part of the assignment than Pratt. While Hafen devoted his talents to the *Garden of Eden Room,* with Pratt and project foreman, old Dan Weggeland, doing foliage and animal bits respectively, Edwin Evans and Fairbanks painted the *Lone and Dreary Room* as a team, collaborating on design and execution.

As a result of his *Lone and Dreary* experience (so Alice M. Horne alleged), J. B. Fairbanks developed a "moody" and tonal orientation to scenery in which the artist searched "for evening effects" and/or "harvest scenes" and/or "misty water," or "tree subjects." And the later critic, James L. Haseltine states that Fairbanks "retained throughout his life an ingenuousness which belied his Paris training," and further that "diagonals often rush in from the sides of his canvases, being resolved as if by magic, if they are at all." And yet, as that same writer goes on, "there are an obvious love of the land and a tender treatment of it," as in *Harvest in Utah Valley,* (1913, SMA, **plate 28**), or in the State Collection's *Moonlight* or BYU's *Farm House and Barn.*

Edwin Evans (1860–1946), was the same age as J. T. Harwood, and they both had grown to manhood in Lehi, Utah. Yet young Evans, unlike his colleague, hadn't really considered painting as a profession until he was nearing thirty. Evans had a little work with Ottinger and Weggeland before joining the French missionary group. He studied with Laurens and Constant at the Julian and was later credited by Harwood as having advanced "more rapidly during his two years abroad than any of the other artist students."

A work like *American Fork Canyon* (c. 1900, SMA) shows this painter's lifelong search for essentiality. His mastery of light is also in evidence here, from a deeply shadowed foreground the eye is led by a strong diagonal up a road to deftly modeled rocks and trees silhouetted against misty light in the distance. The best of Evans's painting shows a rare depth of inquiry and seriousness of intent, which attitudes would be his legacy to students like Donald Beauregard, A. B. Wright, Mabel Frazer, and LeConte Stewart.

Donald Beauregard (1884–1914) was a rancher's son from Fillmore, Utah. He had taken his first art lessons at eleven years of age from an "Eastern teacher" who was visiting central Utah at the time, and perhaps from this early example developed an urge to travel that would turn his path toward artistic discovery. Beauregard's first works were "drop curtains" for local plays, but what has been called his first oil painting (a view entitled *The Fillmore Flour Mill*) is now exhibited at the old Territorial Capitol

in the artist's hometown.

As Beauregard developed his painting skills (*Still Life with Lemon*, c. 1900, SMA), he decided to leave town. He wandered a bit in 1900 and then entered Brigham Young University in 1901. After two years in Provo, the young painter went on to Salt Lake City and the University of Utah for three more seasons under Edwin Evans. Becoming Evans's assistant in 1904, the student won first prize in the 1905 Utah Art Institute show. He was a "brilliant student," according to Evans, and toward the end of his first year of work at the university, Beauregard proved his versatility by winning first place in an oratorical contest in Lawrence, Kansas, and going on to a second prize at the St. Louis State Fair Interstate Collegiate Debate in June of 1904. Two years later Beauregard graduated from the University of Utah, then took a laborer's job in order to gain enough money for the inevitable study abroad.

His early work showed extraordinary potential (*Artist's Father Clearing Sagebrush*, c. 1906, SMA), and he signed up at the Julian for work with Laurens in late 1906. He spent his summers in various sketching tours throughout western Europe and won first prize (and a place in the school's permanent collection) for "technical composition" during his initial year in Paris.

On sketching tours, Beauregard displayed a particular liking for Flemish coastal and country landscape and genre scenes, while the Julian sketch books reveal a raw strength in the rendering of nude figures. Indeed, when he wrote in one of his essays (on Rodin's *Thinker*) about "tension" in drawing, he might also have been speaking of his own painted work of the time. The artist discovered Monet and the Impressionists, too, in Europe, and elements evident in the French and Flemish studies would later appear in western American views (*Working from Dawn till Dusk, near Fillmore*, c. 1908, SMA, **plate 30**).

Returning home in 1908, he became supervisor of art for the Ogden schools from 1909 to 1910. In the summers, he studied archaeology with Professor Byron Cummings of the University of Utah, and he was with Cummings in the Arizona-New Mexico area when he met Edgar L. Hewett, director of archaeological exhibits for the Panama-California Exposition planned for 1915 in San Diego. While studying early Spanish colonial remains with Hewett, Beauregard also came into contact with Frank Springer, an art patron who became very interested in the painter's work.

Springer offered to support Beauregard in further European study, so the artist was off to the Old World

Donald Beauregard with a cart full of his possessions in Paris, c. 1907. Six of his large murals of St. Francis of Assisi are now in the Museum of New Mexico. (Photo courtesy SMA.)

again, this time painting landscapes and still lifes in Spain, France and Germany. Fascinated by the accomplishments of Gauguin and Cézanne, the Utahn incorporated cubist feeling and rich color into thrusting and boldly painted expressions.

His works sold well to Americans and Europeans alike, and Beauregard was commissioned by Springer to do six murals for the San Diego Exposition. Researching and painting furiously, first in Washington, D.C. and then Spain, he was able to finish two of the works and establish preliminary designs for the rest by 1913. The artist fell ill that same year, and though he worked on the project until was physically incapable of continuing, Donald Beauregard died in his parents' home in Fillmore on 2 May 1914. As Dorothy T. Dulle of Santa Fe's Museum of New Mexico has written: "Tragic irony confronts the critic who would evaluate the work of Beauregard—Tragic, in that a career so full of promise should be so early ended. "

In her *Devotees and their Shrines,* Alice Merrill Horne gave an individually subtitled, full-page, illustrated section to the landscapist, and Sunday painter, George Wesley Browning (1868–1951). Horne wrote that though "the painter had been denied the privilege of art study abroad, . . . his intense love of nature and close powers of observation have served him . . . his charming personality,

kindliness, gentleness, and dignity, have found their way into his pictures." (*Sunset in the Wilderness,* 1905, **plate 20**; *The Storm,* 1911, *Wasatch Mountains in Early Spring,* 1920s—all SMA).

A businessman, amateur botanist, and entomologist, as well as a painter, Browning was one of Utah's most active arts organizers. A member of the Utah Art Institute since 1899, Browning was also one of the first non-charter members of the Society of Utah Artists—a local reflection of the Society of American Artists, which had been founded some years before as an alternative to the very conservative National Academy of Design.

The charter members of this influential society in Utah included Edwin Evans, John Hafen, Herman Haag, John Clawson, J. T. Harwood, Lorus Pratt, and J. B. Fairbanks. Lewis Ramsey, Leo Fairbanks, Lee Richards, Alma Wright, Hon Young, and Wesley Browning all joined between 1904 and 1907.

"OVER THERE" AND "BACK HOME": 1913-1930

The U. S. Congress declared war against Germany on 6 April 1917, and called for draft registration two months later. Eleven thousand Utahns were eventually drafted. Thirteen thousand more volunteered for duty, and many found their way into the bloody combats of the War to End All Wars. One such was the painter, Lawrence Squires (1887–1928).

A Salt Laker, Squires was but one product of the artistically-inclined Squires clan. John P. Squires, Lawrence's grandfather, had been a "tonsorial artist," and his father, W. C. kept the family's well-known barbershop in the Deseret Bank Building for many years.

Another of the barber's sons, Willard Squires, was "a singer on the stage" and father of C. (Charles) Clyde Squires (1883–1970), the noted New York City-based illustrator-painter. Studying first with J. T. Harwood and Jack Sears, Clyde later pursued the study of illustration with the famous Howard Pyle, and went on to drawing and painting classes at the New York School of Art with William Merritt Chase, Robert Henri, Frank DuMond, and others. Squires was a charter member of the Society of Illustrators and frequent contributor of sentimental work to such publications as *Life, American Magazine, Argosy, Collier's, Harper's,* and *The Ladies' Home Journal.* Highly successful as illustrator and painter of obvious subjects, Clyde Squires remained in New York—with a sojourn or two in Utah upon occasion—exhibited his works internationally, and with one painting entitled *Her Gift,* created a work which sold record numbers in reproduction through the 1950s.

The whole Squires clan "a close-knit family with intellectual inclinations," lived on the lower Avenues in Salt Lake City—the same part of town in which such artistic lights as Mahonri Young, Lee Richards, and Alma Wright, and later George Watson Barrett, Taylor Woolley, Waldo Midgley, Clifford Evans, John Held, Jr., Harold Ross, Hal Burrows, and William Galbraith Crawford all developed!

Among the younger artists, there was much camaraderie, and they all looked up to Mahonri Young. As Waldo Midgley recalled it later: "Then Hon returned from Paris" (via his 1905 teaching stint in New York at the American School of Sculpture). His arms were "full of work," and he was "flooding . . .with nostalgia of the world of art." Young then "started a life class where we (Lawrence Squires, Hal Burrows, Johnny Held, and some others) worked two evenings a week." There was difficulty in Salt Lake City finding models to hire, so much so in fact that: "Once we tried to get a 'lady of the evening' to pose. She was shocked but not speechless."

Often they sat "in the back room of Lollin's saloon" to "talk of art." Ingres, Courbet and Degas were particularly remembered by Midgley as major artists figuring in those discussions. All were exquisite draftsmen. " 'But Ingres is cold,' one of us remarked. 'You don't know the difference between cold and white heat!' [said Hon]."

After Mahonri's departure, Lawrence Squires continued to help his father in the barber shop, but the spark had been ignited. By 1907, the twenty-year-old finally got his chance to move in the direction of his dreams, a "mission call" from the LDS Church appeared. In the French Conference of the Swiss-German Mission, Squires had the opportunity to take in the artistic sights of France and Switzerland. He proselytized, sketched and gallery-hopped his way across Europe and then asked his mother for enough financial support to travel another six months with Uncle Harry in France, Austria, Germany, Holland and Italy.

Back home in May of 1910, Squires spent the next two years practicing with the brush and saving his money for study in New York City. Following the footsteps of other, slightly older Salt Lake artists (by now including cousin Clyde and friend George Barrett), Lawrence enrolled at the Art Students League for study under George Bridgeman, Boardman Robinson and Kenneth Hayes Miller. He met fellow Utahn, LeConte Stewart, at the League, and persuaded him to join one of Miller's classes with him.

He remained in Utah between trips to the Veteran's Hospital in Palo Alto, California, through 1923. A successful autumn exhibition of thirty Squires oils and watercolors was held by the Utah Art Institute that year, but his health took a turn for the worse the following winter, and in 1924 he was forced to move to the Tucson, Arizona area. Yet, Lawrence managed a painting trip with Uncle Harry Squires to Mexico, where new views, of villages, ruins, churches, and desert woods were done. Returning to Salt Lake City in 1925, Squires and his widowed mother planned and then helped build an apartment house to rent and live in, while Lawrence prepared for an Ogden Palette Club exhibition held in 1927.

Mahonri Mackintosh Young, *Man in Visor Sketching a Nude Model;* **n.d.; collection of Gibbs M. Smith. Young's pencil sketch shows his interest in the athletic form. It is also an example of a chaste nude—the kind acceptable to Young's Utah audience.**

They were settled and ready to pursue a quiet life that was sure to stabilize his respiratory weakness. But, on 28 January 1928, a week following the move to their new home, Lawrence Squires simply passed away in his sleep. Outlived just a few months by his ancient Uncle Harry and eulogized by fellow artists, Jack Sears, Ranch Kimball, Florence Ware, Alice Merrill Horne, and others, the artist received further posthumous tribute in March with a "Memorial Exhibit" at Hotel Newhouse sponsored by the "Association for Appreciation of Utah Art."

CAREERS ONGOING AND WOMEN ARTISTS WITH IDEAS, TALENT, AND DETERMINATION

Having taken his Revolutionary War monument to Paris for casting in 1906, Cyrus Dallin was probably not back in this country long before the death of his old friend, Augustus Saint-Gaudens in 1907. That great man's passing was a watershed, and afterward Dallin's

Then, in the spring of 1917, Lawrence decided to enlist. In fact, as his aunt would later report, though the young man was no great physical specimen, "he hoped he would get by the tests" because he was "so anxious to get back to Europe to visit the art galleries again!" It took Lawrence Squires two tries to get into the army, but he eventually saw combat in Picardy, Somme and Flanders, where a dose of poison gas ruined his lungs. Within weeks Squires was on his way home and away from his dreams of painting and theatrical successes in the East. The ultimately hollow postwar prosperity, mixed with regional depression, proved a sad echo of Squires's last years—a mesh of artistic accomplishments, mixed with continual physical decline.

similar work in a Beaux-Arts tradition of "idealized realism" would be seen increasingly as representative of an older sculptural school. By 1908 Dallin was involved in the creation of yet another "noble savage," and completed the original *Appeal to the Great Spirit* (Museum of Fine Arts, Boston) the next year. A replica of this work is in the Springville Museum, along with other bronze creations of the subsequent period such as Dallin's excellent *Chief Washakie* (1914, SMA).

Another major Dallin work had been started in the late teens, and completed in 1921 for Plymouth, Massachusetts. *Massasoit,* perhaps the noblest of all of that sculptor's Indian subjects, overlooks historic Plymouth Bay. The tall, standing figure of the eastern American chief is a dominating plastic force. A plaster cast of *Massasoit* is now located, on loan, in the Springville Museum. Another casting of the figure—it is said that the sculptor used a black wrestler as model for the torso and an Indian woman's features for the face—is handsomely silhouetted against the State Capitol Building and looks out upon the vast panorama of Salt Lake Valley.

The sculptor, like his *Massasoit,* was a man with two homes, and the post-twenties period brought honors for the venerable Dallin in both. In 1923, he received a master's degree from Tufts College, and in 1936, Boston University bestowed an honorary doctorate upon the "American Old Master."

Meanwhile, in June of 1925, the local chapter of the Daughters of Utah Pioneers met in Springville's city park to decide upon an appropriate monument in memory of the town's "Pioneer Mothers." Dallin was contacted in Boston, and he was in Utah the next month to say that if money for materials could be raised, he would create a bust of the *Pioneer Mother* free of charge. It took a few years, but by the afternoon of 25 July 1932, the town had in its park a dramatically dedicated, meticulously and sentimentally rendered sculptural remembrance of (as the inscription reads): "Pioneer Mother by Cyrus E. Dallin, In Honor of the Noble Women who Braved the Wilderness . . ."

Though not all Utah artists received such support, not all of the unrecognized were desperate. Palmer Torsten Jansen (1873–1948), one of the most fascinating of the painter/personalities of this period was born in Odalen, Norway. Jansen, who called himself Paul Fjellboe, was a soloist with a choir in his home country, then came to America in 1905. Once in Salt Lake City, he became a member of the local Norwegian Chorus and was increasingly well-known for richly painted, albeit formulized views in oil of Utah's mountain and valley landscape (*Black Rock*, 1910s, SMA, and *Logan Canyon*, 1920s, SMA). Always avoiding other employment, the dapper Fjellboe seemed to live out his Utah career as artist via payment-by-paintings for his numerous creditors, and by managing never to pick up the check after lunch!

Another resourceful artist was L. A. Ramsey. Returning from the Midwest not long after the turn-of-the-century, Ramsey spent the next few years working on certain LDS Church commissions including some portraits of Mormon leaders, and illustrations for books the likes of William A. Morton's *From Plowboy to Prophet* of 1912. He spent eighteen months in Hawaii beginning in 1916 doing murals for the Mormon temple there, and was back in Utah from 1918 to 1930. Painting some landscapes *(The Grand Canyon,* 1919, SMA) and more portraits, he finally left the state for Hollywood, California, and a new career of painting art card scenes and movie-star portraits.

Never a great force in the general development of Utah artistic expression, Ramsey did landscapes that can be freshly brushed, although he often (to some extent like Fjellboe) worked from a rather unexciting formula and his pictures are frequently marred by too-sweet colors. Not without color and contradiction himself, this illustrator of such themes as *The Visit of the Angel Moroni* and *The Angel Moroni Showing the Plates of the Book of Mormon to the Witnesses,* also made wedding presents of paintings showing "red-headed nymphs cavorting in the forest." He died in southern California in 1941.

In the years 1930–33, Ramsey shared Los Angeles with his talented (and far more successful) colleague from Utah, John W. Clawson. Returning to California from New York in 1921, Clawson stayed in Los Angeles for twelve years, including the frightening year 1929, when he suddenly lost his sight. It was soon discovered that an incorrect prescription from the pharmacist had resulted in the temporary condition.

Affecting a rather sweetened sentiment and bright, warm palette in many of his works, Clawson developed a flattering and highly commercial technique. Indeed, he was an excellent technician who performed admirably and prolifically in oil, pastel, and other media. Painting an occasional California landscape scene for fun, like the Springville Museum's rather nice plein-air *Landscape of Southern California,* (1925) or *Windy Day, California Shore,* (1928,) Clawson was also fond of Sargent-inspired gypsy and Spanish dancer images done with the use of a broad and simplified impressionist formula. His sobriquet,

Cyrus E. Dallin with his *Massasoit,* 1920. The artist appears in classic smock and goatee. The statue of the famous Indian chief (1920) stands in Plymouth, Massachusetts. Another casting is at the Utah State Capitol Building. (Photo courtesy SMA.)

Cyrus E. Dallin, *Appeal to the Great Spirit;* 1912, plaster, 40 1/2" × 39 1/2" × 24 1/2"; SMA. Dallin gave this piece to the Springville schools; it is shown as it was displayed at the high school. (Photo courtesy SMA.)

"the Sargent of the West" is an overstatement almost by definition, but John Willard Clawson was a fine and talented brush-wielder nevertheless. He painted portraits of many of the nation's celebrated screen personalities, succumbing once again to the lure of Utah late in his career. At his death in 1936 (while doing a portrait "remembrance" of Joseph Smith) he left several thousand works. And he'd probably made more money by painting than any other Utah artist of his time.

The portrait market in Utah had been, for some time, Lee Greene Richards's almost exclusive province. Indeed, before he was done, Richards's portraits lined the halls and galleries of Salt Lake City government, Utah State government, and the Church of Jesus Christ of Latter-day Saints. And few have achieved finer figurative results than he did in his prime. Witness his very effective *Dreaming of Zion* (1931, SMA, **plate 51**). Then too, Richards continued to be an admirable landscapist of a painterly type throughout the twenties and into the next decade, as seen in such exquisite views as Springville's *Big Cottonwood Stream* (1932) and *Grandma Eldredge's House, Salt Lake City* (1922, **plate 35**).

Both J. Leo and Avard Fairbanks had worked on a variety of projects in the late teens. In 1916, J. Leo won a commission for the sculptural component of the new Mormon temple in Laie, Oahu. (Leo was involved in sculpture throughout this period—whenever it suited his entrepreneurial purposes.) Avard went with him to collaborate on the commission, and together they worked out an ambitious plan which included the traditional baptismal font supported by a dozen life-size oxen, and a free-standing sculpture called *Lehi Blessing Joseph,* in addition to the decorative high-relief panels and friezes.

When J. Leo made his move to Corvallis, the younger Avard Fairbanks was also in Oregon, teaching at the University of Oregon in Eugene (1920–24). Then, as Avard transferred his activities to the Yale School of Fine Arts (B.F.A., 1925) in the fall of 1924, J. B. went back with him. Building a studio for the old man in Highland Park, New York, Avard was off to Italy two years later to continue his life's work (*Scuola Florentina di Pittura,* 1927–28). J. B. and his Florence (Gifford Fairbanks) finally found permanent settlement in the East. He became an LDS Church Patriarch in the 1930s, painted a bit more, and finally passed away on 16 June 1940 at the age of eight-four. (J. Leo Fairbanks outlived his father by only six years, dying on 3 October 1946 while still at Oregon State's art department helm.)

Avard's idealized figural group *Motherhood* (*Mother and Child,* marble, 1928, SMA, **plate 26**) dates from his Italian period. Unlike so many of the works modeled by Fairbanks for casting in bronze during subsequent years, it exhibits a soft and subtle quality of serene surface and spirit, and is perhaps his finest marble.

But such a creation was only a moment in this energetic monument-maker's life in the arts and education, and soon he was fully involved in the development of models for two of his finest memorial sculptures (*91st Division Memorial*, 1928, Fort Lewis, Washington and *Pioneer Mothers Memorial,* 1929, Vancouver, Washington). With the conclusion of his fellowship, Avard went west again, this time to pursue an M.F.A. degree at the University of Washington in Seattle. He taught classes for the Seattle Institute of Art, and then in 1929, degree in hand, he took a job as associate professor of sculpture and sculptor-in-residence at the University of Michigan, Ann Arbor. There he worked and prospered for eighteen years—before the inevitable return to his native Utah.

Mention of Dallin's *Pioneer Mother,* and Fairbanks's *Mother and Child* (or *Motherhood*) should bring to mind women artists as well as women subjects for art. The treatment of female artists by the Springville Museum mirrors their treatment throughout the state and the nation. Emma Stoltz Smart (1862–1924), wife of Springville Museum co-founder, Dr. George Smart, had contributed some of the first oil painting to the collection. But, although Mrs. Smart—who was originally from Buffalo, New York—"studied art in New York before coming west," she was not "a professional painter." Rather, Emma Smart "painted a good many pictures because of the enjoyment she found in doing it."

And that has, of course, been the assessment of "women artists" from the beginning of time to the present day, at least within the context of western civilization. They have (it is assumed) simply painted or sculpted to amuse themselves. Before 1920, only Smart and Harriett Richards Harwood were represented in the permanent collection of the Springville Museum of Art; 1939 saw the inclusion of a work by Corinne Adams; a painting by Florence Ware was added seven years later; then one by Bess Gourley in 1947; and, finally, three more works by women were acquired in the 1970s.

In his catalogue essay for a 1984 exhibition entitled, "Women Artists of Utah," Springville director Vern Swanson promised to "survey" and acquire the work of our first generation of Utah women artists, especially Mary Teasdel (1863–1937), Rose Hartwell (1861–1914), and Myra Louise Sawyer (1866–1956).

Indeed, among them, Mary Teasdel was one of the most interesting and talented Utah artists ever to study in Paris. A more flamboyant brush handler than J. T. Harwood, her major teacher at home, she could, in early genre works, evoke a sense of calm similar to that achieved by Harwood in his treatments of parallel subjects.

A subtle colorist, she demonstrated a love of the painterly approach in many later landscapes, as well as still-life scenes. She was also an able portraitist upon occasion. Teasdel became proficient early in oils, watercolor, and pastel. She was also a talented interior designer and eventually planned several residential ensembles punctuated by her own pictorial creations.

Within the context of Salt Lake City's well-heeled upper middle class into which Mary Teasdel was born, it was acceptable for a young lady to take a few art lessons; but to go off to Paris for several years as a painting student was quite another matter. Yet young Mary had wanted this very much, and so it was in 1899, she and two close artist friends, Lara Rawlins (later Cauffman) and Maye G. Jennings (later Farlow) departed for art training in France. Joined soon afterward by LuDeen Christensen

of Gunnison, Utah; this second Paris group—Harriett Richards Harwood and Marie Gorlinski (later Hughes) had preceded them—would be followed within a few short years by a number of other female artists from Utah.

Among this group of four Paris women, only Teasdel can claim lasting significance. Maye Farlow did little more with her art back in Salt Lake, while Lara Cauffman (a daughter of U. S. Senator, Joseph L. Rawlins) was mentioned by Alice Horne in 1914 as an adequate portraitist residing on the West coast. Actually, when Horne visited the four in Paris in 1902 (shortly before the girls returned to Salt Lake), it had been LuDeen Christensen she'd gone there to see. Christensen went home to Gunnison, continued her painting there, finally moving to San Diego, California, where she found a career as a public school supervisor of art.

Teasdel remained in Paris for a three-year period, while spending summers sketching and painting in Normandy. She eventually studied with Benjamin Constant, Jules Simon and even the celebrated Whistler. Becoming the second Utahn (after J. T. Harwood) and the first woman painter from Utah to exhibit in the French Salon, her work was also shown in the International French Exposition. When she returned to Utah in 1902, she found she had become something of a local arts celebrity: Governor Wells appointed her immediately to the governing board of the Utah Art Institute.

Finding employment in the Salt Lake schools as an art teacher, Teasdel set up a private studio within her new residence on C Street, thus to begin a long career of success and service to her community. She retired eventually to Los Angeles, and, in 1937, died almost exactly five years after a Utah retrospective showing of some 35 of her works was held in a Salt Lake City gallery operated by her old friend, Alice Merrill Horne. Like Horne, she had lived a good, long life in the arts. Never married, she has been called "the first woman painter of Utah," and it is difficult for the student of American art history not to think of her in connection with the great Mary Cassatt, especially when viewing something like Teasdel's early *Mother and Child* (1920, SFAC, **plate 34**). Teasdel was later and Cassatt was greater, but both were Paris-trainees in their times; both broke with tradition to assume the professional artist's life; both were called "spinster" by an unforgiving society; and both led the way for women thereafter.

Although Rose Hartwell was two years older, with talent at least equal to Teasdel's, this pioneer woman

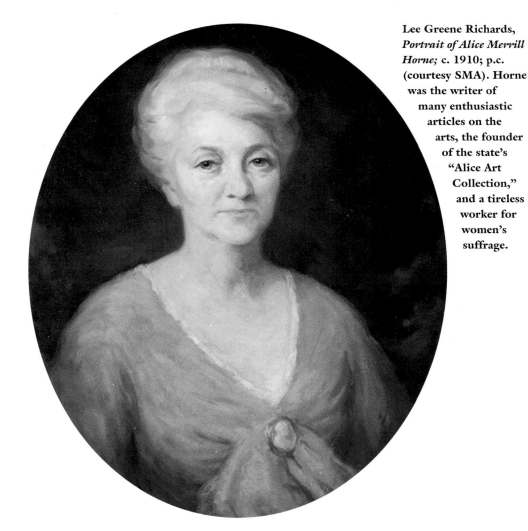

Lee Greene Richards, *Portrait of Alice Merrill Horne;* c. 1910; p.c. (courtesy SMA). Horne was the writer of many enthusiastic articles on the arts, the founder of the state's "Alice Art Collection," and a tireless worker for women's suffrage.

painter was not so fortunate in either longevity or local fame. Hartwell's debut in the Paris Salon had occurred in 1903, just following Teasdel's first departure from the French scene. Having also studied with J. T. Harwood (and Clawson) in Utah, Hartwell came, as they advised, to the Julian Academy, and also studied under the critic/teacher, Castelucho. In France, Hartwell developed a rather richer coloristic technique than Teasdel. She spent two years in France and another eighteen months in Italy in the early years of the century.

Returning to Utah only occasionally afterward, Hartwell didn't exhibit much within the state, though Alice Horne celebrated her work in *Devotees and Their Shrines,* published shortly before Rose Hartwell's premature death in 1914.

Hartwell's friend, the talented Myra Louise Sawyer, lived a long life. Having gone for study to France in the early 1900s, Sawyer spent over six years there in addition to traveling in Italy, Holland and Spain. She made copies after Velasquez south of the Pyrenees, joined Hartwell for sketching and painting near Monet's home and, at that

Rose Hartwell, *Jewel Box;* oil on canvas; SFAC (courtesy SMA). This world traveler stayed in Europe for many years and exhibited little in Utah. "In Paris and in Florence I am more at home than in Salt Lake City."

placing her watercolor work in a 1913 exhibition presented at the Corcoran Gallery in Washington, D.C. Then, working quietly on into later decades, Myra Louise Sawyer finally died far away from her home state—in Peoria, Illinois—in 1956.

Such are the central lines of so many stories lived out during these years by women artists. Examples are many: Aretta Young (1864–1923) was a well-respected art instructor at Brigham Young in Provo; Mary Bastow (1871–1918)—an early teacher of the well-known painter-critic, George Dibble—was the same slightly later at Brigham Young in Logan; and Corinne Damon Adams (1870–1951) practiced in Ogden for many years as both a public-school teacher and an interesting flower still life painter (*Hollyhocks*, 1928, SMA).

Of course, other women made their mark in the arts, sometimes without teaching: Springville's great photographer, Elfie Huntington Bagley (1868–1949); Salt Lake City crafts specialist, Margaret May Merrill Fisher (1872–1946), along with her colleagues, Emma Frances Daft and Louise E. Jennings; the muralist, Edna Ensign Merrill Van Frank (1899–1985); and the remarkable craftsperson-turned-mystical-illustrator, Ruth Harwood (1896–1958), a daughter of the painters, J. T. and Harriett Richards Harwood.

Ruth Harwood was born in Salt Lake City and, as a child, she was her father's model for numerous works done in Utah and in Europe. She entered the University of Utah around 1916 and graduated with a degree in English in 1920. In that year she won a prize at the university for "the best poetry of the year 1919–20."

After graduation she moved with her parents, younger brother H. James, and sister June to Berkeley, California. In 1921, Ruth began graduate study at the University of California, Berkeley, and that year she "won the Emily Chamberlain Cook Prize . . .for the best unpublished group of poems." Shortly thereafter she won a prize "for writing an outstanding one-act play," but she graduated with a master's degree, around 1923, in Graphic Art! Indeed, at that time, J. T. and Hattie Harwood's eldest daughter was primarily interested in painting and drawing (*Nude Study*, 1926, SMA).

Most of the works she created were either in poster paint or in an ink spatter medium she developed herself. They were illustrations to her writings and heavily symbolic in their mystical themes. Ruth Harwood also published a book on graphic design and won the Browning national poetry contest, along with many other honors. She continued painting into the 1930s, mostly in

time, was fortunate enough to observe the master at work.

Sawyer developed a more delicate, softer approach than either Teasdel or Hartwell. Her forms are typically integrated by a broad, but sometimes too light painter's touch (*Girl Among the Hollyhocks*, n.d., p.c. and *Helen Kimball*, n.d., SFAC). Having returned to Utah, the sensitive young lady went to work under Edwin Evans in the University of Utah's Department of Art from 1907 to 1909. This teaching experience was followed by work of the same kind with the girls of Salt Lake's Rowland Hall School. She exhibited in Paris in 1910 (in the American Girls' Club Show of that year) and in the American Society's show of 1912. At the same time, Sawyer had two miniatures accepted at the Pennsylvania Academy of Fine Arts in Philadelphia, and she also succeeded in

Berkeley, and formed a partnership with Lois Atkins for the purpose of selling a line of artistic gift cards. Harwood also continued to write poetry, which she illustrated and published herself on a handpress in her Berkeley home. She illustrated the poetry of famed modern dance pioneer, Ruth Saint Denis (*Flame Meditation* and *Lotus Light*, published by Houghton-Mifflin). Eventually, during the 1940s and '50s, she came to reside in Santa Barbara where she died in 1958.

THE LURE OF NEW YORK (AND ELSEWHERE)

Out-migration was the rule, not the exception for Utah's younger artists through these years, and the early career of E. Merrill Van Frank offers one example among many. Little Edna Ensign Merrill first appeared in this world on the campus of Utah State Agricultural College in 1899. Her father, Lewis A. Merrill, headed the Extension Division of USAC at the time.

Allen Dodworth, former director of the Salt Lake Art Center, summarized Merrill's migration pointedly in an appraisal report written in 1986. "Dissatisfied with the limits placed on art training at . . . [USAC], particularly their refusal to allow drawing from nude models . . . in 1920 she persuaded her friends Nancy Finch and Helen Kearns to enroll with her at Columbia." She "continued her studies [there] in a more open-minded environment," along with the other girls and "her mother, Effie Merrill" (who had accompanied the young women as chaperone). Then, as Dodworth continues, "Miss Merrill showed considerable talent for the figure and for fashion illustration," and "she was soon employed by Bergdorf-Goodman in Manhattan as an artist." She "was married to Leslie Van Frank in December, 1922," and following a trip to Utah (*Home for the Holidays: Centerville, Utah,* c. 1923, SMA) the couple moved up the Hudson to Newburgh, New York, where "Merrill (she didn't care for her real first name very much) . . . continued to work as a freelance fashion illustrator for various firms in New York." The Van Franks resided in Newburgh for the next quarter century.

The artist's subjects were often fashion-related, but also included New York landscape, Depression-era cityscape, outdoor themes, certain "historical" presentations and, finally (following her move to Utah in 1943) western landscapes. She went to work then for Auerbach's, one of Salt Lake City's two major department stores, where she executed her most famous local works, several large historical murals commemorating the Utah Pioneer Centennial in 1947.

In 1948, Van Frank moved on to ZCMI (the other major department store). She produced some costume history murals there before switching to interior design in 1956. Later, she worked with independent designer Sharon Mulholland until she retired in 1973.

Virgil Otto Hafen (1887–1949) was another exemplary pioneer youth who left Utah. This painter had studied with his father, John Hafen, then later at Brigham Young University with E. H. Eastmond before going on to additional training at the Herron Art Institute in Indianapolis. He painted with his father in Indiana's

Ruth Harwood, *Wisdom;* 1930s, etching; SMA. Harwood's stylized, magical creations were only one evidence of her many talents. She was also a poet and a craftswoman.

107

Brown County Art Colony; went on a Mormon church mission in Europe; studied at the academies in Paris; and worked as an instructor in the school of Architecture and Allied Arts at Avard Fairbanks's alma mater, the University of Oregon

There were, after all, many destination points in the West, Midwest and the East. But for most younger Utahns of this period, New York City was the place—if you had the courage to try it. Waldo Park Midgley (1888–1986) and his pal, Harold (Hal) Longmore Burrows (1890–1965) tried it. As Midgley would later recall in Shakespearian terms: "There is a tide in the affairs of men which, taken at the flood, leads on to fortune—and Hal and I were sure we were floating on that tide when we boarded the train that autumn morning in 1907 for New York." He'd saved his money working for his father, the sign painter Joshua Midgley, but that morning he "went to the station [to meet Hal] all alone. Nobody came to see me off." Even in his ninth decade, he remembered that lonely leave-taking.

They arrived at Hoboken, across the Hudson from midtown Manhattan. "Had to take the ferry across . . .we had the address of a boarding house . . . Well, anyway, we arrived at Mrs. Miller's . . .on West 20th Street . . . settling in—two rooms on the top floor . . ."

The next morning they went to see the Art Students League. But Burrows and Midgley "didn't think much of it." Then, "up to the Henri School on 80th Street," and there they found what they were looking for. As Midgley would remember it much later, "Hon Young taught me drawing. Robert Henri taught me painting."

Henri urged his group "to immerse themselves in the vigorous metropolitan atmosphere, to enjoy the flavor of its masses of humanity, and to paint this world with freedom and spontaneity." This was a very appealing orientation to many students in his classes, including young Waldo Midgley and Hal Burrows. Midgley especially had been painting Utah (of all places!) that way since 1905. When he was asked, "Who do you think was the most important teacher to you?" Waldo responded, "Oh, Henri. . . . he was not only a great teacher, but he was a great man." When Midg and Hal came to watch the Henri gang in 1907, the work of some of their predecessors could still be seen. "Portraits on the locker doors of students; painted by Bellows, Ireland and others, when they were students there. The place was bubbling like the Hot Pots at Heber. . . . It was full, and every student was hard at work. There was no fooling at all."

From that point began a huge patchwork of artistic activity for Midgley during the remainder of a rich ninety-eight-year life. As a painter, he was a student of (off and on) and in association with Henri, Sloan, George Bellows and even the Armory Show enthusiast-modernist, Walt Kuhn up and into 1912. From 1908, he worked as a sign painter, and then illustrator-designer for the Mannheimer Company, C. J. Gude Co., the Blackman-Ross agency, and as a freelance artist for Condé Nast Publications.

A very active participant in professional groups and schools, too, in addition to his powerful use of the oil brush and pencil, Midgley also developed into an adept and expressive printmaker (etchings), watercolorist, and master of other media. (See *View of Park City,* 1924, SMA, **plate 38**.)

Lucille Midgley, Waldo's first wife, really didn't approve of many of his artist friends except Hon Young, who was (after all) a grandson of the great Brigham. This used to irritate Young, who was one of the most famous artists in the country, all on his own! Beginning in 1916 a career of teaching at his old school, the Art Students League, Young continued in that capacity, on and off, until 1943. His wife Celia died in 1916 and he remained single until 1931, when he married the painter, Dorothy Weir, daughter of another painter, J. Alden Weir.

But before that, in 1923, Young went back to Paris in connection with one of the most important large commissions of his career. Working with Bertram Goodhue, the well-known eclectic architect, on a *Monument to the Dead* for the American Pro Cathedral there, Young found the environment and the project so rewarding that in 1925 he returned to France with his children for a stay of two-and-a-half years. In this very productive period, away from the pressures of teaching and large-scale commissions, Mahonri Young's essential realistic style matured.

Increasingly fascinated by the drama and energy of the boxing match, he created works of compelling physicality like *Groggy* (Whitney Museum) and *Right to the Jaw* (Brooklyn Museum).

After his return from Paris, his show at Kraushaar Galleries in New York was not only the most successful he ever had, but was important in establishing him in the popular awareness. Having kept a studio on 59th Street while abroad and in Salt Lake, he continued his teaching involvement at the nearby League. Sculpting construction workers and prize fighters and etching the American scene with pal Harry Wickey, Young was at the height of his powers artistically and socially. He often attended "the fights" with a group of friends, including Charles Dana

Gibson, the illustrator best known for his "Gibson Girls." Young was in a marvelous whirl.

And Hal Burrows's career was going well. Burrows was a life member of New York's watercolor club. He exhibited fluid works in this medium in Brooklyn, New York and Philadelphia. During World War I, he joined the service as a staff artist for the original *Stars and Stripes* in Paris, won a citation (presented by General Pershing himself) for his work there, and then eventually returned to New York to find career-long work with Metro-Goldwyn-Mayer.

In 1918, the Midgleys returned from Chicago to New York, where Waldo resumed his long-time Condé Nast association. Burrows was so successful with MGM that he could even throw a little work from that enterprise in Midgley's direction: "eight large decorative panels for the lobby of the Capitol Theatre; two boards each for outside, etc." And with that great job in the motion picture industry, Hal also felt he could support a wife. He married Miss Minnie Abrams of New York City in 1920, and took his bride to live out in Manhasset, on Long Island.

Like Waldo, Hal split his time between work (as art director at MGM) and play (sketching and painting on his own). His painting was good enough to be represented in many New York City private collections; and in the Utah State Fine Arts Collection, the Springville Museum, the Utah Museum of Fine Arts, and elsewhere. He mounted a one-man show in New York at Harlow-McDonald Galleries in 1928, and again at Grand Central Art Galleries in 1945. He died of cancer on 26 July 1965.

John Held, Jr. (1889–1958) was born the same year his father, John Held, Sr. formed the fifty-member "Held Band" which became a Saturday-night fixture on the Liberty Park bandstand. His mother, Annie Evans Held was an actress on the stage of the old Salt Lake Theatre, so young "Johnny" came by his artistic inclinations honestly.

It was reported in *Vanity Fair* that Held, Jr., as a youngster had "spent his time drawing in a studio above his father's shop or making sketches and paintings in the theater where his mother was performing."

John Held, Jr., attended the University of Utah during the years 1907, 1908, and 1909, and while there illustrated the Utonian, the university [yearbook]. He was also sports cartoonist for the Salt Lake Tribune. In 1910 , with $4 in his pocket, John went to New York to make his fortune in commercial art.

WITH WHICH IS COMBINED LESLIE'S WEEKLY

Copyright, 1923, Judge, New York

John Held, Jr., *Judge* magazine cover, 1923. Held's famous one-eyed flapper is shown in her heyday, (courtesy Gibbs M. Smith).

Living first in New York with his friend Mahonri Young, Held found jobs easy to come by at the outset of his career on that larger stage. He designed streetcar posters to start, but advanced quickly to art work for Wanamaker's. Some rougher times were ahead in the mid-teens, but his escape from "Cockroach Glades" (as he and his six roommates called their three room flat on West 37th Street) came with an enlistment in the wartime U. S. Navy. After the war, the artist continued his college studies at Princeton. His best known cartoon character, "the flapper" began to evolve in drawings during those days. Held was voted "Favorite Artist" at Princeton before he left, and by the end of 1920 a rather pudgy, single-eyed "cutie" had appeared upon the pages of *Judge*. She experienced several metamorphoses through her various appearances (along with her bell-bottomed boyfriend in the raccoon coat) in such publications as *Judge, Life,* and *Collier's,* in a syndicated newspaper strip called

Margy, and finally in a famous 1927 issue of *College Life.* As she became a major visual personification of the Jazz Age, this creation made the illustrator a rich man and a widely known personality throughout the country.

Held continued to work at more personal "easel art," (*Ma Lives,* c. 1924, SMA, **plate 37**). Much of this work didn't really surface until after his death.

For John Held, Jr., the crash of 1929 signaled not only "the demise of the flapper," but the destruction of his personal fortune at the hands of the Swedish "Match King" Ivar Kreuger. When Kreuger's various businesses finally began to fall apart in 1930–31, Held and countless other American investors went down with them. Yet, though Kreuger himself committed suicide in Paris in March of 1932, the buoyant John Held, Jr. survived. The money gone and his most lucrative cartoon character all washed-up, Held simply turned to other, previously untapped talents.

This self-proclaimed "Parsley Hater" and "Three-Bottle Baby turned Three-Bottle Man" went to Hollywood in the mid-thirties, and hung out a shingle that read: "Open for screen-writing after four years of experience in Hollywood." In that same year he was in Utah giving talks on personal aesthetics at the Art Barn and the Hotel Newhouse. While Held was in the state, a friend and fellow artist, Roscoe Grover, asked the New Yorker what his favorite color was. "Plaid," he answered. He died on 2 March 1958 in New Jersey.

Another cartoonist, Bill Crawford (1894–1978) was born on Apricot Street at a time when a lot of the neighborhood kids (Hon Young, Al Wright and Lee Richards, for example) were already beginning careers of great significance. His introduction to the visual arts came through the illustrations he saw in magazines his parents had around the house.

Eventually it was the work of Charles Dana Gibson, and the work of Wallace Morgan which most impressed the youngster. Unlike most others up to this time, Crawford went to Brigham Young University for his art training, and that decision brought him under the tutelage of B. F. Larsen.

He studied at the Art Students League before he joined the army during the Mexican War. Dubbed a first lieutenant in the cavalry when America got into World War I, Crawford transferred from the First Cavalry Division to Artillery School and then Air Reconnaissance for the duration. Serving in France, he was there with some old Brigham Young buddies who later reported that Bill Crawford was known to his service comrades as a "sparkling wit and vivid personality." Following the war, he came home to Utah for work at a local advertising agency and some more art study, this time with Jack Sears.

In about 1919, Sears suggested that Crawford (who had started signing his work "Galbraith" to avoid confusion with another Bill Crawford) join the Utah artists' colony in New York City which included Mahonri Young, John Held, Jr., Hal Burrows and Waldo Midgley. First Crawford decided to study a bit at the University of Mexico (c. 1922), returning to the region where he had been in the service "south of the border" before World War I. Then, it was off to New York City again, where he studied at the League, worked as an illustrator, and joined Hal Burrows in the New York-based art department of Metro-Goldwyn-Mayer in 1928. His projects there included designs and drawings for *Hollywood Review of 1929, New Directions 1930, Broadway Melody, Dynamite, The Mysterious Island, The Vikings,* and *The Greatest Show on Earth.* He also did cartoons (including covers) for *Harper's, The New Yorker, Cosmopolitan, Redbook, Vanity Fair, Saturday Evening Post, Stage,* and other magazines. In 1939, he began his nationally syndicated cartoon, *Side Glances.* Crawford's career spanned half a century until heart trouble forced him to slow down his output.

TEACHERS

John S. ("Jack") Sears was, as it turned out, a "teacher's teacher!" How amazing that seems since he hadn't been headed for a career in teaching at all. He had certainly proved himself competent in the world of commerce. In New York, Sears was associated as artist with the late famed newspaper writer, Arthur Brisbane, and he did freelance work "that appeared frequently in *Judge, Puck, Leslie's Weekly,* the old *Life Magazine, Everybody's Magazine, Literary Digest, Vanity Fair, Metropolitan, Harper's, Saturday Evening Post,* and *Cosmopolitan* . . . [And] while working for the *New York Telegram* he sketched a cartoon of a little-known cowboy entertainer named Will Rogers and helped him on to his career as a famed humorist."

Always interested in the philosophy and practice of teaching, Sears had, early in his career, organized at least one independent art school in Salt Lake City, a "Modern School of Illustration." He ran it in partnership with a former student, Clyde Squires, from rooms in the city's Hooper Block.

Before he returned to teach at the University of Utah in 1918, Sears had worked for such papers as the *Salt*

Lake Tribune, the *Deseret News*, the *Salt Lake Telegram*, the *New York Telegram*, the *New York Journal*, the *American Journal Examiner* Sunday section, the *Chattanooga Times-News* and *Southern Star*. In 1920, the artist rejoined the *Deseret News* staff.

He had been at the university only a year when Edwin Evans resigned from the art department chairmanship leaving only three teachers there to cope (Evelyn S. Mayer, Florence Ware and Sears). In that male-dominated era, much of the responsibility of running the school's art program thereafter fell to Jack Sears.

That period finally came to an end four years later with the beginning of J. T. Harwood's chairmanship. All that "traditional" studio stuff could be left to the older master and others, while Sears organized a "commercial art department" within his own former teacher's art department. He had Chairman Harwood's blessing in this, although for reasons that could have been a bit galling to the illustrator-designer-cartoonist-calligrapher, (even if Jack Sears never said so). Harwood saw his fine artist's calling as a higher one, something he made quite clear in a May 1925 article for *Utah Educational Review* entitled "Some Real Objectives in Art Education."

> . . . *Some of the commercial fields open to the artist are: advertising in magazines, on billboards, on street car cards, and in newspapers; professional millinery, weaving, costume designing; textile, linoleum, wall paper, and rug designing . . .; the making of gift cards, murals, and the other crafts, including jewelry, pottery . . . and leather work. . . . Finally there are those smallest groups of all professional artists, the easel artists and sculptors. . . . They are the ones whose mission is to start the next generation out on their artistic journeys, and to instill in their minds a real and growing love for all things beautiful.*

Painters have perhaps always felt the way Harwood did regarding the other arts (including sculpture, if the truth were known). Nevertheless, Sears loved his job and thought it was important, and so did his students. George Dibble for example said, "Everybody took Sears's lettering class. . . . He said 'of course you're all going to go east. You're going to go back there and get your feet wet at least. One thing you'll need is lettering.'"

This recollection delights Dibble even to this day, for as he says now, "Sears was prophetic! The one thing that I made more money with was lettering." And Dibble adds that the trait he appreciated most about Sears, and Professor Mabel Frazer too, was that they allowed him to "develop my own style." That was fortunate for the

"modernist" Dibble. Sears also initiated the art department's first intensive activity in printmaking (etching, engraving and lithography at least).

Sears painted landscapes and portraits as well, but as Richard Oman of the LDS Church Museum of History and Art stated in the 1970s, "it is his sketches that represent the most unique and creative aspect" of his work. Indeed, as his *Tribune* obituary notice in 1969 remarks, by 1948 the artist "estimated he had completed 25,000 drawings and sketches." George Dibble wrote in 1979: "Jack Sears always ended letters to his students with the encouraging reminder, 'sketchingly yours'. . ."

Sears remained an "instructor," the title he would always have under Harwood, then A. B. Wright

Advertising flyer for the "Modern School of Illustration" conducted by Sears and Squires in the early years of this century, (courtesy Gibbs M. Smith).

(1931–38), and finally LeConte Stewart (1938–56)—painters to the man—at the university until his retirement in 1946. After that, he kept a studio in the Judge Building in downtown Salt Lake City. In partnership with Paul Clowes and Fielding Smith, who together called themselves and their space the Intermountain School of Art and Commercial Art Studio, he gave private lessons into the fifties. Though he gave up his staff job at the *Deseret News* in 1924, he continued with his regular cartoon feature. Sears also worked for the prominent Salt Lake advertising firm of Stevens and Wallace during later years.

After the death of Joseph A. F. Everett (1883–1945), his friends formed the Everett Guild. Throughout the remainder of the forties and on into the fifties, that active association's membership averaged around sixty painters, each of whom was deeply indebted to his mentor's teaching efforts and/or direct example in some memorable way. Years later, Everett was recognized by George Dibble as "perhaps better known than any Utah painter because his works have been widely distributed and enjoyed."

In an account of her father's life, Blanche Freed has written, "[Miss Elva B. Godbe, his art teacher] arranged for him to have art lessons from J. T. Harwood in a class that included Mahonri Young and Lee Greene Richards. After three years with J. T. Harwood, he studied with John Hafen at the LDS College." And so it was that young Everett, in around 1897, found his way into an ongoing stream of influence and teaching that had its beginnings some fifty years before with the arrival of Utah pioneers.

Certainly, by the time Harwood and Hafen (especially) were through with him, Everett was a fully committed and painterly tonal-impressionist student of the landscape. He later painted with both Lee Richards and L. A. Ramsey.

In 1905, he accepted an LDS mission call to England, and departed (when he had found enough money) early in 1906. There he came to know Heber J. Grant, who presided over the Latter-day Saint British and European Missions. In subsequent years Grant (as a member of the Quorum of the Twelve and then as president of the LDS Church) became one of Everett's "most ardent patrons and benefactors."

Released from his obligation in 1908, the young Utahn was able to study watercolor with E.A. Smith at the Kensington School of Art, and then go on to Paris for further training of a more general sort. Before his return home, he traveled extensively throughout Europe, visiting art galleries, museums, and art salons, where he concentrated on the galleries of Holland and Belgium. Though he spent much time in the Hague and in Brussels, Everett was particularly fond of the works of Sir Joshua Reynolds, John Singer Sargent, and Winslow Homer.

Returning to this country, he enrolled for a few lessons with the New York-based painter, Kenyon Cox, before heading home to Salt Lake City where he took a job as an assistant pharmacist with Schramm Johnson Drug Store. But by the time he married Miss Josephine Morris on 28 June 1911, he had found work with the railroad. Joseph worked as draftsman in the engineering department of the Oregon Shortline. Of course, there was never enough time to paint. He soon became frustrated with his job, according to Alice Merrill Horne, because "he didn't have time to indulge his passion for art." She advised him to paint during his lunch hour in nearby City Creek Canyon. Indeed, it wasn't long before the artist "had developed his innate ability to see art in the common, everyday subject." He had a way of quickly sketching people, buildings, the flowing stream, and weather on the move.

University of Utah president, John A. Widtsoe, asked Everett to assume chairmanship of the art department sometime between 1919 and 1921. However, wanting to spend his time painting instead of administrating, Joe Everett declined. J. T. Harwood, Everett's old teacher, took the job in 1923.

Everett was commissioned many times to do scenery for the old Salt Lake Theatre, where he worked alongside many others. When the theatre was razed in 1929 "so great was his consternation (that) he went daily to sketch the various stages of its demolition."

In 1932, the Oregon Short Line transferred its offices to Nebraska and, at forty-nine years of age, Everett retired, in order to co-found his own school (in the LDS-owned Lion House) and, of course, to paint. Blanche Freed remembers that while the family had very little money, "he could always pay for piano lessons, dental work, or even groceries with his paintings."

A member of the Associated Utah Artists (AUA), a conservative group of painters based in Salt Lake City, Everett exhibited with them at the Art Barn (the Salt Lake Art Center) in the summer of 1943. During this general period he was also invited to exhibit for the Biltmore Gallery in Los Angeles, and Gump's in San Francisco. Yet, if those who remember him well were forced to state the most memorable aspect of Joe Everett's work, it would be his contributions as a teacher.

The two Utah-based teachers who were most central to the life of the arts community in Utah through 1930 however, were Edwin Evans and James T. Harwood.

The university art offering had been left in 1895 (with the death of Herman H. Haag) to be operated as an adjunct to the Department of Engineering, and Evans was not hired until 1898. Called "a stimulating, exacting and sometimes unmerciful teacher," Evans was remembered later by one student, Mabel Frazer, as an instructor "demanding the utmost of effort, honesty and originality. . . . He believed in art as a life-long form of growth and expression." In his long career, Evans held many positions in teaching and art administration, including the presidencies of both the Society of Utah Artists (1895–1906) and the Utah Art Institute (1904–16). He taught at the LDS Church School, Hammond Hall, the YMCA, BYU, the Art Barn, and in his private studio in addition to his twenty years as head of the University of Utah Department of Art (1898–1919).

Lauded afterward by LeConte Stewart, a pupil at the university and future art department chairman there, as "the man who made possible a department of art," Evans was a chief advocate of the arts in Utah. He organized annual Society of Utah Artists exhibitions that attracted unprecedented numbers of the Salt Lake citizenry, and later worked for the state's purchase of the "Alice Art Collection." Seeing attempts in early century to impose a "mechanical" drawing system upon the training of art students in the public schools, Evans fought for three years against it and won.

Despite this activity, Evans did not abandon studio work. There were projects, exhibitions, and awards large and small. He was one of the Salt Lake Temple mural painters upon his initial return from Paris. Eventually, he filled nine more walls at the LDS Cardston Temple in the Canadian province of Alberta and completed eight murals commissioned by the Veteran's Administration for its hospital in Salt Lake City. During his tenure at the university, he worked with other drawing and painting instructors like Virginia Snow Stephen, Myra Louise Sawyer, Evelyn S. Mayer, Frances Saunders Kempster, and Charles W. Brown. Florence Ware also began her long career in teaching with an appointment as instructor of art in the department in 1918 under Evans; while Kempster was left "in charge" of the program during the 1915–16 and 1916–17 school years when Evans went east to study again, first in Paris and then in New York City.

Back in Paris again for two years of research from 1920 to 1922, Evans exhibited oils and watercolors at the

The stern and demanding Edwin Evans at the University of Utah. "The unintelligent mind will never see anything except that which is shown." (Photo courtesy SMA.)

Salon Francaise, Salon d' Automne, and the Salon de la Nationale during that period.

In the original "French Mission" context, many of Evans's colleagues had seen great potential in the work of this artist who had started later than they had, and final proof of the worth of that original opinion is found in the painter's mature works. From the late teens to the early forties, many Edwin Evans works can be seen as the result of the artist's one dictum that "arrangement, balance, and specific examples are most important. The parts fit into the purpose of the arrangement . . . most of our art has been based upon literalism and reality. . . . Subject never made art . . ." His watercolor output is particularly rewarding. Some, like James Haseltine, would go so far as to credit the body of Evans's late work in this medium as "the most significant" product of this state's entire painting development.

Many of Evans's oils show well-thought-out and "virile" colors, forms, and restrained linearity. Such elements were converted back into the gifted teacher's philosophy to be imparted to students, friends, and critics alike. As Alice Horne said in 1914, "because he has had the fearlessness to hew a line and to say, 'This is art and that is not art,' he has made strong friends and strong enemies." Quick to condemn a painting for over-detail, Evans demanded "one paramount idea with all else subordinated."

Returning to this country to begin his sixth decade of life, Evans kept busy with painting, etching, and some travel. His art was even more totally committed to landscape in later career. He often investigated different lighting effects, and the works show an intellectual bent for problem solving, though the basic conservatism of Evans's style remained intact. In Salt Lake City, a retrospective of Evans's work containing 141 paintings and drawings was organized in April of 1941. Five years later, in California, the old man insisted upon completing a watercolor one evening before going to bed. This done, he consented to rest and died in his sleep on 4 March 1946.

Evans's childhood playmate from Lehi, James T. Harwood had, after his return from Paris, become a teacher and painter too. In the period 1907 to 1910, Harwood's interests had turned toward a more coloristically oriented and somewhat broader watercolor approach. Horne felt this approach produced Harwood's "most noteworthy work . . . a collection of twenty-five watercolors, painted within one year's time [1907–08] . . . all in and about Liberty Park representing "the actuance of the seasons." Mrs. Horne continued, "all the artists agree that in this collection Harwood has best realized his powers." Three of them were shown at the Paris Salon. Alfred Lambourne selected a verse, or composed a stanza, to suit the theme of each picture, and Harwood was so proud of the group, he refused to sell one from this collection, which he recognized as his most representative work.

In 1920, Harwood decided to move his family to California. There were several reasons, but two or three of the most important have been described by art historian, Will South.

In Salt Lake City, Harwood entered the competition held to design and execute murals for the recently completed State Capitol Building. His design was of Sea Gulls, but it was rejected in favor of the work of his former pupils, Lee Greene Richards and A. B. Wright. A large-scale, one-man exhibit was held of Harwood's work at the

Webster School in 1917, and in catalog notes written by J. Leo Fairbanks, the continued frustration felt by J. T. is captured in a few telling lines:

. . . "His hope was to have his name on a mural painting in Utah's State Capitol. We are sure he would have been successful. Artists cannot paint what they do not know well. Mr. Harwood has the skill of an artist besides an intimate knowledge of Utah, and has grown up with the West. We could have pointed to his works with pride."

The loss of this mural commission, the slow sales, and a hunger for the old enthusiasm all contributed to the decision to start all over. The choice of a new location was simple; it had to be California. Ruth could attend Berkeley, and the two younger children would adjust. It was hoped that the artist could develop an entirely new market for his work. Harriett was, as she had always been, entirely supportive of her husband's plans.

. . . The contentment found with this new life was brief. Early in 1921, Hattie fell seriously ill. She was suffering from a thyroid condition, commonly referred to as a goiter. By April, the "little mother" was neglecting to water the flower that graced her bedside, and she no longer asked for notes from the children. Her husband was by her side on the 28th when she died.

James Harwood was devastated by the loss of his wife. The house [in Oakland] was unbearable for the artist, and he returned to Salt Lake City in the summer, where he was appointed to head the art department of the University of Utah.

Assuming his new University of Utah post in 1923, Harwood was department head for eight years. The faculty included Florence Ware; Maud Hardman; Jack Sears; Mabel Frazer; Harvey E. Gardner; Mary Moorhead; Rhea Brain; and Caroline Parry.

In the subsequent "Harwood years," the program included painting, printmaking, sculpture, commercial art, arts and crafts, pottery, art appreciation, art education, and art history. Later department head LeConte Stewart remembered Harwood as an idealist who emphasized an essential drawing foundation and craftsmanship in the development of art students. Those emphases have been carried forward at the University of Utah through subsequent chairmanships from the 1930s to the 1990s.

In 1925 Harwood's third and last Salt Lake City studio was built, on Lake Street, and he used it, when in town, for the next fifteen productive years. Also in 1925, while visiting Ruth at her home in the Berkeley Hills of northern California, Harwood painted a scene showing

Art class at the
University of Utah
c. 1920s. During
Evans's and Harwood's
tenures, the university
set high standards
which made it the
premiere art school in
the state. (Photo
courtesy the Utah State
Historical Society.)

the place with the San Francisco Bay in the background. It is a charming scene, vibrant in color wherein Harwood displays the essence of his latest, and very consistent, painting manner—a form of postimpressionism, usually termed "neoimpressionism."

Within this approach to painting, several options are available. One might maintain fanatically the precision of it all, or, as in the case of Paul Signac and others, convert Georges Seurat's original dots back toward more decoratively-inclined and larger, separated color splotches. That way can produce absolutely joyous, though somewhat "surfacey" visual excursions (as in some fauvist works), and of course these run very much counter to Seurat's original intent. The variation used by the essentially conservative Harwood was to relax the uniformity of pointillism and thus create something in between the art of Monet and that of Seurat. Harwood remained a sensitive creator of images in softened colors which only gradually intensified over the years, with a continuing eye for good design combined with careful and loving subject selection (*Footsteps in Spring, Liberty Park,* 1930, SMA, **plate 48**).

Also, as Will South adds:

By December of 1927, a sudden change had come over James Harwood. In an article of that year, he is quoted as follows: "I've struck my pace again. I feel young and strong again. I've just completed my finest piece of painting. See—the paint is still wet. I'm into the fight again!" The source of his new-found enthusiasm was a young university art student, Ione Godwin. A literature major, Ione fit into the artist's lifestyle, and, more importantly, shared his ideology. They fell in love, and their relationship, while somewhat scandalous by local standards because of their age difference (nearly forty-seven years), was irrepressible. She became for him "Loving Eyes," and he monogrammed all future paintings with initials to that effect. The two were married on the first of June, 1929.

Taking in 1929 a sabbatical leave, Harwood and his bride spent their honeymoon in France and Italy while a retrospective showing of his work was being planned back home. He resigned from the university in 1931 (at the age of seventy) to spend more pleasurable time in France, where he continued to exhibit in the Salon. With the increasing threat of war in Europe in 1939, J. T. and

Ione decided to bring their own two young children home to Utah.

According to Ione Harwood, during the ten years following their marriage, her husband's painting, drawing, and color printmaking "became recognized not only at home but in the art museums of Europe." Harwood was an extremely gifted printmaker (*Sand Market at Cannes, France,* etching, 1927, SMA). His wife has written "you will note it is 'color etching' as Jim wrote it, not as some people say 'colored etching'. The first refers to color applied to the plate before printing; the second is color applied after printing. The first is first quality. Jim always uses it correctly."

Harwood died in his Salt Lake home on 16 October 1940. A student scholarship established by Ione Harwood in J. T.'s memory required "that the applicant must work hard to express in his own way high ideals in art, and must have a fine character and high morals."

A much warmer personality than Edwin Evans, Harwood was called "a patient, loving teacher," even though he shared with his childhood friend an interest in the relentless pursuit of "accurate" drawing. Also called "Utah's strenuous painter," Harwood was a big fellow ("a magnificent type of manhood," Alice Horne called him) who "figured out how to utilize every waking moment of time in work, and study and play. . . . Versatile, conscientious, and truthful, full of integrity . . . noble in his conduct . . .," Horne lauded, while the artist merely said of himself: "My hobby, I am a farmer; profession, an artist; religion, a church with one member."

Harwood's successor as art department chairman at the university in 1931 was one of his former students and an excellent teacher in his own right—A. B. Wright. Having taught at LDS College in Salt Lake City until the end of 1912, Wright took a "sabbatical" with his family in San Francisco through the next school year (1912–13). Then, continuing to paint adept traditional portraits and figure studies (especially *Lady in Black*, 1919, SMA), this talented artist began to increase his production of sophisticated landscapes (especially *Old Farm in Coalville, Utah,* 1926, **plate 40** and *Quai Pontoise,* 1930, **plate 41**—both SMA).

In 1912, Wright painted a mural for LDS College's Barrett Hall (which received "rave" notice in Alice Horne's *Devotees*). He executed another LDS mural commission in 1915, in Laie, Hawaii; then returned to Utah the next year to paint (with his friend, Lee Richards) an additional work of the kind in the senate chamber of the new State Capitol Building. An overwrought article in the *Deseret News* described the work as "a picture that needs only the stamp of approval by renowned critics to be classed among the world's foremost achievements of brush and palette." Traveling and painting between the years 1917 and 1919, Wright then went to Cardston, to paint another mural in the LDS temple there (1920–24). When that work was done, he was off to Mesa, Arizona, on the same kind of commission.

The Canadian murals, in particular, exhibit stunningly bright, direct and cunningly stylized figures forming friezes of Bazill- to Puvis-de-Chavannes-like classical quality, while the backdrops are painted in a Seurat-inspired "pointillist" manner. These vivid and clarifying illustrations of biblical connections with Mormon theology, are in sharp contrast to accompanying work by Wright's student, LeConte Stewart, which is much more subdued.

Finished with the Arizona temple project in 1925, Wright turned to easel painting as usual until 1929 and another Paris term (now at the Grande Chaumière), followed by private lessons in Belgium under Professors Pros de Wit, Luce, and Jean de Boton. He returned in 1931 to the U as associate professor and heir apparent to the chair of his old teacher, J. T. Harwood.

Other interesting careers in art education were developing simultaneously in other parts of the state. For example, Orson Dewsnup (O. D.) Campbell (1876–1933) of Provo pursued a career as a professional artist/teacher. Born in the centennial year in Fillmore, Campbell studied at BYU where he taught briefly before moving on to New York in 1908. Campbell spent a year painting under J. Walter Taylor, Frank DuMond, and Kenyon Cox at the Art Students League before a return to Provo for more teaching at Brigham Young.

Though he developed a sometimes subtle tonalist approach to landscape and cityscape early, Orson Campbell probably did his best work during his years at BYU. He left that institution in 1915 to go to work as an art instructor in Idaho at Ricks College, another LDS school. He remained there until 1918, then spent two years in St. George at Dixie College. Returning to Provo in 1920 as art supervisor for the city's school system, Campbell lived there until his death in 1933.

Fellow teacher-painter (and print specialist), Elbert Hindley (E. H.) Eastmond (1876–1936) was also born in the centennial year—in American Fork. Studying first at the Art Institute of Chicago (1901) and then at Pratt Institute in New York City (1902), he crossed the continent to continue his work under John Lemos at Stanford University from 1903 to 1904. Then it was off to

B. F. Larsen conducting a painting class, probably in Provo Canyon, c. 1930s. A dedicated teacher and local historian, Larsen defined the BYU art department for many years. (Photo courtesy Gibbs M. Smith.)

Europe. Eastmond spent time in a number of continental centers before the outbreak of the First World War. Back in this country by 1912, he went to work first under the direction of the faculty at the California College of Arts and Crafts, then transferred to the art department at Berkeley the next year. Eastmond returned home to Utah during these years, but went back to the University of California and then the University of Washington in the early twenties for further study. He became the master of many techniques, and well known in Utah as a scenery designer and pageant master.

A stronger printmaker than painter, the artist had, by this time, also become a very effective teacher, and in 1921, Elbert H. Eastmond was named head of the art department at Brigham Young University, a position he held until his death in 1936.

Yet, the central BYU art teacher forever more—in a "spiritual" sense at least—is Professor Bent Franklin (B. F.) Larsen (1882–1970). Born in Monroe, Utah, Larsen

went on to become a varied contributor to the state's artistic tradition, not only as a robust landscape painting stylist but as a pioneering art educator and prolific local "art historian" as well. Having studied first at Snow College, and then at BYU—this while holding down a number of local jobs (as a Provo public school principal between 1901 and 1906, Springville Schools art supervisor in 1907–08 and finally director of art at the Brigham Young Training Schools from 1908 to 1912)—Larsen was awarded an M.A. degree from the U in 1922.

The painter took more studio work at the Art Institute of Chicago immediately thereafter, and by 1924 he was in Paris for a year at the Julian (*Belgian Fields,* 1924, SMA). One of the last Utahns to be involved in lengthy European study, Larsen came back from France in 1925 only to return in 1929 for another year-long Paris sojourn, this time at the Académie de la Grande Chaumière, Colarossi, and Académie Andre L'hote. His teachers there included A. Deschnaud Paul, Albert

Laurens, Jules Pages, Henri Royer and L'hote. To the last belongs the credit for developing in Larsen an understanding of abstraction in art.

The Utahn remained, in his own work, a representational painter of landscape as he had been since his studies with the American artist George Elmer Browne. Yet, an amalgam of influences developed in Larsen's visual thinking to produce works that were landscape scenes, but additionally imbued with a quality of energetic painting abstraction (especially *Uzerche Tannery, France,* 1929, SMA).

Appointed associate professor of art at the Y (in 1912), Larsen returned to his teaching in 1930–31, after his second Parisian experience, to bring a slightly less conservative view to the art training there, which was still headed up by Elbert Eastmond. Larsen was appointed to succeed Eastmond as chairman of that department in 1937, where he continued until 1953. (See also *County Fair,* 1943, SFAC, **plate 67**.)

Calvin Fletcher (1882–1963), head of the art department at Utah State Agricultural College, had, in 1927, traveled south to Provo for a session of painting. He joined B. F. Larsen, who was working and studying there at the time, in a course under Lee R. Randolph, then a visiting instructor at Brigham Young. A San Francisco-based artist, Randolph was concerned about the rather traditional artistic approaches the vast majority of Utah artists were then pursuing, and mentioned this concern to Fletcher. Fletcher agreed with Randolph's appraisal, and resolved to do something about it. Returning to Logan at the end of the term, Fletcher conferred with H. Reuben Reynolds and others of the USAC staff, and it was determined that a number of visiting artists or "artists-in-residence" should be invited to the campus starting the next year.

Birger Sandzen of Kansas came to Utah in 1928 as the first of these visitors, followed within the subsequent decade by Otis Oldfield and Ralph Stackpole of San Francisco, Randolph again, B. J. O. Nordfeldt of New Mexico, and Ralph Pearson of New York. The caliber of the Logan program improved decisively through the period.

Increasing receptivity to the non-traditional was the overall effect of the visiting artist series at Utah State. Fletcher, Reynolds, and the somewhat younger Everett Thorpe, in particular, felt the impact of resultant "fresh breezes" of "modernism. (See *Moonrise in the Canyon, Moab, Utah,* 1928, SMA, **plate 42**.) Yet, among all these (locals and visitors alike), it is Professor Calvin Fletcher who holds the historian's interest most as the one whose mind was constantly open to new ideas and change.

As a child, Fletcher was interested in sculpture, but Charles and Elizabeth Fletcher had pointed their shy, gifted child in the direction of drawing and painting in school. Then, in the winter of 1896, they were able to secure lessons for him with J. B. Fairbanks, who at that time had a studio in Provo.

Entering Brigham Young Academy the next year, Fletcher received "a certificate in normal drawing" in 1901, and then entered BYU. Two years later he graduated from the school with a B.S. degree and a certificate in Fine Arts. By that time Fletcher was already an "assistant professor of art and manual training" at Brigham Young. He continued to teach there for one more year before leaving Utah for training in New York's Pratt Institute.

He had married Sarah Ann Herbert the previous August, and the two of them were in the East for a year before the artist accepted an offer to head the art department at USAC in Logan. Sarah Fletcher passed away in 1909 after the birth of two children, and Calvin took a sabbatical in 1912 for further painting study with both Charles F. Binnes of Columbia University and, in a night class, under Robert Henri. Hungry for varied training, Fletcher stayed in New York only one term before moving on to London for work with the eminent painter, Sir William Rothenstein, and then study at the Central School of Arts and Crafts with J. M. Doran, a textile designer.

By May 1913 Fletcher, along with five other artists, had rented a studio in Paris for the summer. He stayed until October, then returned to the U. S. where he planned to take a teaching position at the Art Institute of Chicago for the upcoming year. Instead, that fall, he picked up his appointment as art chairman in Logan and held that position of leadership for more than three decades.

Fletcher stayed at home (aside from short term outside sojourns) for the remainder of his career. Joined at Utah State first by Reuben Reynolds in 1923 and then by Everett Thorpe eleven years later, he had, at first, carried on a literal orientation to nature, which gradually changed through further study and contact with visiting artists. He wrote, "I did not understand Cézanne because he was not naturalistic enough. I did not understand Matisse for the same reason. I had the mistaken notion that it was unethical for an artist to change the landscape in any way, once he had found the spot which challenged him."

As James Haseltine has written on the subject of this

artist's evolving expression, "the result of these diverse influences was to make Calvin Fletcher a man without a developed style." Yet, the man was a marvelous teacher largely because of these same searching qualities combined with an authentically compassionate nature. (See *Wash Day, Brigham City,* 1929, **plate 44**; and especially *Cache Valley Poplars,* 1932, **plate 46**—both SMA.)

In the end, Calvin Fletcher was honored not only for his long service to the Utah State art department (lasting far beyond his retirement year), but as an LDS churchman and long-term scouting leader as well. His presence on the local art scene and as a representative from Utah on the national level was mammoth. A prodigious award winner within the state, he also showed, on occasion, outside of Utah; and, in a career that stretched from before the turn-of-the-century to his death in 1963, Fletcher's contribution was unique in its daring and profound in its endurance.

Toward Modernism in Conservative Utah

One example of Calvin Fletcher's remarkable influence is the artistic accomplishment of a young Hooper, Utah, widow named Clara Irene Thompson, who was Fletcher's star pupil in 1925–26. In fact, her "personality endeared her to everyone, especially to the teacher." Zettie Fletcher, the professor's second wife, had died giving birth to her sixth child, and with Sarah's two children that made eight—until 24 December 1926 when Calvin Fletcher and Irene Thompson were married, and her six children brought the total to fourteen!

Irene Thompson Fletcher (1900–1969) had also taken classes from Harry Reynolds, and she would study (in summers) with Floyd Cornaby, Gaylen Hansen, Nordfeldt, Oldfield, Pearson, Randolph, and Sandzen. Like her husband she developed a thoroughgoing understanding of "modern" style and an admirably controlled and often gracious sense of artistic interpretation. Exhibiting throughout Utah and, in 1932, in San Francisco too, Irene Fletcher was chosen as one of five Utah representatives at the Third Annual National American Art Show in New York in 1938. She had a solo show in the Logan Public Library in 1940; painted a mural for that building's interior; did another one for the LDS Seventh Ward Chapel in Logan; won a purchase prize at the Utah State Institute of Fine Arts exhibition of 1947; and was given a retrospective (along with her late husband) at USU in June of 1965 (*Laid Off,* 1938, SMA, **plate 59**).

It was often the women artists who led the way in the very slow development of modernism in conservative Utah during these years. Women didn't get to lead much in the traditional sense in Utah (or the world for that matter, in those days or these) and so they were used and then left pretty much alone to experiment more freely than their male counterparts. While the gents carefully ran the show, many women in subordinated positions worked hard and had more creative ideas in a week than some of their supervisors or directors/protectors and/or chairmen actually had in a lifetime.

Of them all, Mabel Frazer (1887–1981) was unquestionably the most interesting personality. As her sister once wrote:

> I wonder if anyone really knew and understood her. At once caring, and thoughtful. Then in the blink of an eye all that was changed and she became impatient, crisp, almost unlovable, demanding to be left alone with her work, "since it is far more important than listening to meaningless babble." A statement she made to a nurse in the hospital the day before she died pretty well sums up her character. She had been giving the nurse a bad time, and feeling a little remorseful for not having been more cooperative she suddenly grasped the nurse's hand and said, "I really have a lot of love in my heart, but I also have a lot of damn-it-to-hell." Being somewhat taken aback the nurse replied, "Well, you're really human; so have I," and gently stroked back Mabel's hair.

The versatile Frazer was a mainstay on the University of Utah art faculty from 1921 until 1953. She remained a female assistant professor for some forty-two seasons before being promoted to associate professor just three years prior to her retirement at the age of sixty-five.

Born near Salt Lake City in West Jordan, Utah, she grew up in the town of Beaver to the south. She taught in Beaver in 1910–11 but was back in Salt Lake Valley at the U to study under Edwin Evans in her twenties. Graduating from that institution in 1914, she took a teaching job at Lewis Junior High in Ogden in the fall of that year, which lasted until 1916 and a New York sojourn of study at CCNY, the School of Industrial Art (under Carl Tefft), and the Art Students League with Frank DuMond. Returning to Utah the next year, she eventually taught at Cedar City's College of Southern Utah in 1918–19, in order to gain sufficient means for another New York stint, this time at the Beaux-Arts Institute of Design. She began her career at the university soon afterwards

Going on to paint murals in both the Salt Lake Temple and that city's 33rd Ward Chapel, she exhibited many times in her long career—in Utah, and in New York, Washington (D.C.), San Francisco, and Portland as well. Given "one-man" shows at the U in 1924, 1930, 1933, and 1949, Frazer also spent periods of study abroad from 1930 to 1932 (Europe) and again from 1949 to 1952 (Latin America). By 1980 the busy Mabel Frazer was still an active Salt Lake artist at the age of ninety-two.

Her former student, George Dibble describes her painting:

> Spurning paths that might lead to popular art she evidences in her work a solid disdain for trite, maudlin or sentimental ideas. She essays sterner tasks. . . . Unlike many who attempt to paint the Grand Canyon, she posed a fiery slit between two somnolent land masses—a rift in a volcanic crust. Asked why she didn't treat more of the major theme she replied, "I can't take on the whole Grand Canyon at once." Typical of the artist's restraint and studied discipline. . . .
>
> "An artist," she reminds, "must have something to say. Art is just another language and the would-be painter should at least learn the rudiments of that language—color, composing, drawing etc. . . ."

When the modernistically-inclined Dibble was at the university as a student (he got his teaching certificate in 1926, and then returned to take additional art classes there in 1928), Harwood was in charge. But Dibble purposely avoided taking courses from Harwood. "I didn't respect him as much as I do now," he says with a smile. "He was academically inclined, requiring his students to imitate him."

Dibble did admire the work and teaching method of Professor Mabel Frazer: "She had a kind of easy, free watercolor approach, and encouraged this. . . . [She also] decried anybody's compulsion to hold to rigorous detail. Frazer was a challenging teacher: 'So you want to make a statement. Go out and paint a pile of lumber and see what you can do with it.'" (See especially Frazer, *Sunrise, North Rim, Grand Canyon*, 1928, SMA, **plate 36**; *Venice Canal*, 1930, SMA; and *The Furrow*, 1929, MCHA, **plate 47**.)

Back home at the U though, neither Chairman Harwood nor many others, especially LeConte Stewart, the later art department chair, thought Frazer was much of a painter or painting teacher at all. This allowed her to pursue painting experimentally—and it seems it also made her angrier and angrier with each passing year.

Born on April 15, 1891 in Glenwood, Utah, Stewart moved with his family to Richfield in 1893 and then to Rexburg, Idaho, in 1907. He attended Ricks Academy in that latter town, worked on a farm, and studied lettering and the painting of signs in his eighteenth and nineteenth years. Moving to Murray, Utah, in 1911, he found a teaching job, continued to study art, and painted his first oils. With Edwin Evans at the U in 1912, he also took private lessons with A. B. Wright before going on to the Art Students League in New York. He studied initially with J. F. Carlson and Walter Goltz at the League in the summer of 1913, then, in subsequent months, under Frank DuMond, Ernest L. Blumenschein, Edward Dufner, Thomas Fogarty, George Bridgeman and Kenneth Hays Miller.

Returning to Utah in June of 1914, Stewart worked for a Salt Lake engraving company, painted signs and billboards in the area, and then found a job teaching for the Davis County Schools. In Laie, Hawaii (with other artists previously mentioned) by 1916, he supervised decorations for the Mormon temple. Stewart was at work there until 1919, when another assignment from the LDS Church took him to paint temple murals in Cardston. (He also completed a mural for the Mesa temple in 1925.) Finally, he settled permanently in Kaysville. He was hired as an art teacher at East High School in Salt Lake City and then a year later went to Ogden High as head of the art program there. Steadfastly refusing to succumb to the lure of European training throughout his career, Stewart went in the summer of 1924 to study at the Pennsylvania Academy of the Fine Arts with George T. Pierson, Daniel Garber and George Harding. He returned to his job at Ogden High in the autumn of 1925 where he continued until 1938 when he was appointed department head at the University of Utah.

Stewart remained a realist throughout his career. By the 1920s, he was largely in tune with his times, as that period was marked, on a national level, by a general reaction away from the "modernism" that had so enchanted American artists of the previous two decades. Later however, his appeal as a landscape painter would be—as it is today—that of a tonal impressionist whose views evoke a rural quiet not often accessible to most of us.

Two other University of Utah art instructors of note were Florence Ellen Ware (1891–1971) and Caroline Keturah Parry (1885–?) Like Mabel Frazer, both women had been students of Edwin Evans at the U in the teens. Later, while Ware was in Chicago studying for three years

at the Art Institute, Parry attended several sessions at the University of California at Berkeley. Ware went on for further training with the brush in Laguna Beach, California while Parry reversed the process—moving to New York for study in painting and sculpture at Columbia University (1924), with Mahonri Young at the American School of Sculpture (1925), and at the Art Students League (1926). Winning a scholarship at Cooper Union in 1927, Parry also returned to New York for study under Leo Lentelli at the Art Students League in 1935–36.

Both Ware and Parry had mastered many means of artistic expression. Parry became a member of the National League of American Pen Women and practiced both painting and sculpture throughout a career of teaching on the elementary, secondary, and college levels of education.

Florence Ware began her long career in teaching with an appointment as instructor in the University of Utah's art department in 1918. There she stayed until 1923 when she moved to a position as art teacher with the University's Extension Division. Continuing her education with two four-month sessions under Charles Hawthorne at Provincetown, Massachusetts, she spent two years traveling and studying in Europe and the Near East. At last, Florence Ware returned—as "lecturer"—to LeConte Stewart's department in 1952, where she remained until the beginning of Alvin Gittins's chairmanship four years later.

Ware designed costumes and scenery for many theatrical productions in Kingsbury Hall, and is probably best remembered today for the two WPA-sponsored murals she painted on either side of that theater's main stage. She was active in local organizations through the years (first president of the Associated Utah Artists, art representative for the Altrusa Club, etc.); functioned as "supervisor of art" for the Utah State Fair in the 1940s and 1950s; and juried local shows throughout her extended career.

Ware was most effective with small, quiet renderings of fragile, sensitive, and rather romantic tonal nuances frequently dealt with in terms of "close" value relations (*Breakfast in the Garden*, 1928, SFAC, **plate 43** and *Nature's Embroidery*, 1945, SMA).

Very interested in interior decoration as well, Ware once wrote that, to her, "probably the most interesting phase of art [was] the subtle beauty of color as it is shown and developed in pictures. Interiors, fabrics, gardens, and nature I should like to arrange, so far as I am able, the perfect setting for a work of art."

Rosine ("Rose") Howard Salisbury (1887–1975) was

Florence Ware at work on the murals in Kingsbury Hall, c. 1937. Ted Wassmer assisted and modeled for her on this project, which depicts the whole history of the arts in the western world. (Photo courtesy the Utah State Historical Society.)

another of that generation of women who received local recognition for a career spent creating paintings in an essentially traditional style. Rose Salisbury originally came from New Brunswick, Canada. She studied with Harwood, L.G. Richards, Evans and Frazer early in the century, and also took classes at the Art Barn and then at the Schaeffer School in San Francisco in 1928. Salisbury taught at Irving Junior High from 1922 until the year of her departure for California. Upon her return to Utah the next year, she began a twenty-three-year teaching career at Rowland Hall School for Girls in Salt Lake City. She exhibited widely and won, among numerous other awards, purchase prizes in the Institute of Fine Arts show

of 1926 and at the Utah State Fair in 1932 and 1946.

Married to fellow art teacher and painter Cornelius Salisbury, Rose Salisbury retired from Rowland Hall in 1952 to pursue full time a somewhat broader approach in painting than that of her husband's landscape and figure work. (See *Night Blooming Cereus,* 1930s; *The Artist's Model* or *Reclining Lady,* 1936; and *Purple and Gold,* 1961—all SMA.)

Cornelius Salisbury (1882–1970) a Richfield, Utah native, began his art study in 1904 under John F. Carlson, then moved on to the U art department the next year. The years 1907–08 saw him under Eastmond at the Y and then with William Dufner in New York at the League. Going on to classes at the Pratt Institute and, in 1916–18, at the Corcoran Gallery in Washington, D.C., Salisbury also attended the Broadmoor Art Academy in Colorado Springs in 1927—this in the midst of a full career teaching art in Salt Lake. He offered private art lessons in his studio but also taught at BYU, Lewis Jr. High, Jordan Jr. High, the University of Utah Extension Division and West High School.

Salisbury specialized in the painting of winter scenes and pioneer Utah homes, and like J.A.F. Everett and Irwin Pratt, he painted for the old Salt Lake Theatre, where he also performed as an actor. (See *Blue Mountain,* 1929; *The Source of Our Daily Bread,* 1926; and *Curtain Time Pioneer Theatre, Salt Lake,* 1947, **plate 65**—all SMA.)

A theatrical bent also characterized Minerva Teichert (1888–1976). Born Minerva Kohlhepp in North Ogden, she had grown up in the vicinity of American Falls, Idaho, where her family went early to homestead a farm. She had begun sketching as a child with the encouragement of her father, but by the time she took a job teaching school in Davisville, Idaho, she had developed an "indomitable will to succeed and excel in the field of art." Seeking counsel, she went to see the photographer, Charles Savage, in Salt Lake City, who advised her to pursue art studies in Chicago as soon as possible. Young Minerva went back to Idaho, teaching school until she had saved enough money, but when the time came to make plans for the trip east, her father wouldn't let her go alone. The answer was to "call and set her apart" as an LDS missionary so that she could travel with a church group to the Midwest. Thus Minerva became the first known female artist to go forth essentially for painting lessons with the specific and official blessings of the LDS hierarchy.

Studying at the Art Institute of Chicago and later in New York at the Art Students League under George Bridgeman, her most important training came when she transferred in the next year to lessons with Robert Henri. She studied off and on with Henri into the 1920s, and sometimes, when the money ran low, the petite (5'4", 110 lbs.) Minerva (or "Miss Idaho" as she was sometimes called by Henri) used skills learned at home to put on "a roping act on the New York stage"!

Henri and his student became close friends in time, though her approach to subject matter was very different from his own. Steeped in Mormon lore from youth, the young Idahoan wished not only to record that history in figurative work, but also leaned toward animal themes or at least rural and outdoor scenes. Henri told Minerva to "go home and paint the Mormon story," shortly before her marriage to Herman Adolph Teichert of Pocatello in 1917. Splitting her time between life in the West and "the Eastern lures of art study" for a few years beyond her wedding day, Teichert became quite well known as a muralist. Her work is on the walls of buildings from Ellis Island to Manti, Utah. Minerva gave birth to five children, and named her second son Robert Henri Teichert in honor of her beloved teacher.

Borrowing aspects of Henri's bravura technique for her broad, brushy, and vigorous style, Teichert painted pictures of trekking west, pioneer farms and other western subjects, as well as religious themes from the Bible and the Book of Mormon and a number of floral arrangements for her closer friends, these on a multitude of surfaces including "plywood, canvas, brown paper grocery bags, ivory, velvet or whatever." For many years a rancher's wife in Cokeville, Wyoming, Minerva spent her last days in Provo, Utah, where she had sent all of her children for college work at BYU (*Indian Captives at Night,* 1939, **plate 60** and *Jesus Christ is the God of that Land,* 1940s—both SMA).

In America, no post-impressionist movement occurred. The result was that when modernist directions were "discovered" in Europe by our country's artists after the turn-of-the-century, the Americans tended to leap without transition from realist and impressionist forms into the middle of a formal language of abstraction. Many early-century American modernist developments were therefore tentative—and were met with bewildered hostility by the public. The early center of influence was Paris, and the so-called American Expressionism which resulted was inspired by the French Fauves. Max Weber and Alfred Maurer studied with Matisse in 1907–08, and John Henri Moser (1876–1951) of Logan, Utah was in Paris the next year.

In the words of James Haseltine, "Utah has produced only three artists (of an earlier generation) who might be called expressionists" and "all were associated with the Logan group: Henri Moser, Everett Thorpe, Howell Rosenbaum." (When he wrote his great *100 Years*, one assumes he hadn't yet seen the work of Louise Richards Farnsworth.)

Moser came originally from Wabern, Switzerland. His parents (John and Elizabeth) had become converts to the LDS Church in the 1880s while living in Bern, and in 1881 the family emigrated to America. Settling in Payson, Utah, the Mosers later moved to Logan where young Henri worked at farming. The youth developed an early interest in the visual arts, found work in a printing shop in Enterprise during his teens, and then, in 1898, he returned to Logan to tell his parents he'd decided to attend college and was going on up to the Gilt-Edge Mine in Montana to earn enough money to begin his studies.

Studying engineering at Utah State, Moser excelled in drawing, and old Professor Stoddard of that discipline persuaded his student to pursue a vocation in the arts. Married to Aldina Wusten in 1905, Moser quit the USAC in favor of work at Brigham Young College in Logan under A. B. Wright from 1906 to 1908. Wright was conservative and the training was traditional, but among Moser's fellow students were J. B. Powell and Calvin Fletcher. Like Fletcher a few years later (1913), the young Mormon artist from Switzerland was sent back to Europe in 1908, "with the encouragement and a loan" from USAC President John A. Widtsoe. He enrolled at the Colarossi under Marcel Berenaux and also at the Académie Delecluse upon his arrival, and continued his studies at the Carri and Miller Academy through to 1910. Studying with both Laurens and Simon, he also met and became a friend of Pablo Picasso, another young artist in Paris at the time.

Yet Moser's was not an analytical nature, and though he would (like Picasso) produce many works (1197 pieces recorded), this painter's appeal lies in the strong emotion he could intuitively harness from time to time within the outpouring of an uneven brush. Asked about the twisting path of Picasso's achievement in later years, Moser said, "I knew him well; he painted beautiful things then. Today, he paints to advertise himself and laughs at the credulous public. He has wonderful talent and ability." Implying scorn, the statement ends with praise—and this was essentially the way of Henri Moser. He positively loved his work, but, unable to evaluate his own painting, he often missed the mark. "He would exclaim, 'Isn't that beautiful!' when viewing almost any of his painting or any aspect of nature."

Returning to Logan in 1911 to teach (as Widtsoe had hoped), Moser turned his back on previous academic training to create a positive explosion of otherworldly form and intensified color. Often using thick, alla-prima applications on canvas, Moser usually shunned local color in favor of an expressionist conjuring of hues.

Moser's career at USAC lasted only a year. By 1915 he was in Cedar City for a two-year teaching stint at the Branch Agricultural College. In 1917–18, he went north again to homestead a farm in Idaho. Later, he purchased a ranch in Malad, Idaho. Farming and painting for about eight years, Moser won a purchase prize at the Utah State Fair in 1926 and, two years later, exhibited his work in Oakland, California. That same year he was invited to San Antonio, Texas, by the Art League there to enter a "competition for the painting of Texas wildflowers and scenes." He stayed for a year of very successful painting and exhibition activities before returning to Utah in 1929 to begin a twenty-year association with the Cache School District as art supervisor.

Henri Moser exhibited often through the thirties and forties, and had his last one-man show in 1950, the year before his death at the age of seventy-four. (See especially *Logan Canyon, Near Beaver Dam*, 1926, **plate 39**, *Golden October-Quaking Aspens*, 1932; and *Early Spring in Cache Valley*, 1930s—all SMA.)

Perhaps the acute observer James Haseltine (in a 1963 catalogue for a Moser retrospective at the Salt Lake Art Center) said it best:

> *At first viewing, these are, to many people, painful pictures. Some appear to be simply vignettes: trees sometimes march in awkward columns across the canvas, viridian lakes gash the landscape, magenta cliffs wound the mountains. Yet, the visual disturbance is only transitory. Somehow all the elements seem to fall back into place. Through the artist's integrity, the consistency and passion of his vision, and his orchestration of color, we are finally convinced that these paintings work. The intense, unexpurgated, often naive, art of Henri Moser demands a sophisticated viewer. Every Wolfe needs his Perkins.*

Moser was a pioneer in painterly abstraction in this area, and yet he was too much an independent to generate a local sphere of influence. He did however, manage to lure one of his Paris compatriots back to Utah.

While Henri Moser had struggled to follow the

precepts of his masters and extract principles from the works of certain other artists of that time and place, it was difficult for such a buoyant and individually imaginative person. He took solace in a friendship established with a fellow American painter, Frank Ignatius Seraphic Zimbeaux (1860–1935) of Pittsburgh, Pennsylvania. Zimbeaux was almost sixteen years older than Moser, but the two had much in common, especially kindred artistic "visions." As painterly romantics of the nineteenth century had often prefigured fauvist expression, so too did a nocturnal tempest by Zimbeaux suggest the coming of the "incandescent, high noon" light often seen in later Moser works.

Zimbeaux's aesthetic was darker than Moser's, but equally emotional—more like the neoromantic echoing of an Elshemius or a Ryder or even a Turner responding to natural and spiritual forces. A remarkably independent, wholly committed painter, Zimbeaux had known Matisse and others of the "great ones" in Paris and London during his residence in those capitals. He had married the concert pianist Lillian Clotilda Wehlisch, and had (with world war coming on) decided to return to the U. S. in 1914. In New York and then Carthage, Missouri, through the teens and early twenties, Zimbeaux finally decided to join Moser "out West" where the land was more inspiring. In 1925, he arrived in Salt Lake City, a place that would be his final home.

Zimbeaux painted a series of street scenes of such Salt Lake City landmarks as the Salt Lake Theatre, which he finished on the spot and sold for a few dollars. He would join Moser at the ranch in Malad for periods of painting. Like his friend's works, the romantic landscape/mythologies of Frank Zimbeaux never found a direct student following, except of course as echoes of that charming, unusual imagery can be sensed in the art of his son, Francis Zimbeaux. (See *Catholic Mass, Decoration Day, Salt Lake City Cemetery,* 1928, SMA, **plate 45.**)

Louise Richards Farnsworth (1878–1969) was a spirit in sympathy with both Moser and Zimbeaux. She became one of the most forceful expressionist painters ever to come out of the ranks of Utah artists.

A Salt Laker and daughter of Joseph and Louise Richards, she was, like Hattie Harwood, a cousin of Lee Greene Richards. But, unlike her locally famous cousin, Louise Richards became a landscape specialist, and her work evolved as a rather wonderful amalgam of the L. G. Richards *and* Henri Moser approaches to the apprehension of nature on canvas (*Capitol from North Salt Lake,*

An early photo of Louise Richards Farnsworth shows an angelic countenance and belies her role as one of the more powerful Utah expressionists. A *New York Times* critic said of her work, "Here is no facile naturalism, sugared with the specious of the studio." (Photo courtesy SMA.)

1935, **plate 55**; *Springtime,* 1935; and *Haystacks,* 1935— all SMA).

Farnsworth studied at the Art Students League and later in Paris, where she exhibited in the Paris Salon. As Richard Oman of the LDS Church Museum writes:

. . . *In general she [Farnsworth] avoids a point of view which subscribes to the conventional picturesqueness of grand vistas and concentrates instead upon the simplicity of the mountain masses which prove sufficiently interesting in themselves. . . . Her work has a freedom of brush that takes on a life apart from the scene being depicted. The texture of paint and brilliance of color take on a unique life of their own. . . .*

From the tonal mysticism of Zimbeaux to the post-impressionist, cubist, and fauvist directions of Calvin Fletcher, Henri Moser and Louise Richards Farnsworth, this first-phase discussion of modernist directions in Utah can be concluded with a look at the life and work of Philip Henry Barkdull (1888–1968). This painter\teacher from Hatton, Utah, has received recent scholarly attention. As Vern Swanson of the Springville Museum writes:

Long forgotten and completely ignored, this talented artist has been relegated to the minor names of Utah art of the 1920s. . . . Never robust, he developed his talent in art rather than [doing] the heavy chores on the farm. Barkdull's father was a grain farmer in Meadow, Utah, and since there were no high schools in the immediate area, the youngster remained on the farm until he was already an adult. Then, at the age of twenty-three, he left, traveling north to Provo. Entering Brigham Young High School, . . . he studied art [and] graduated in the spring of 1914.

The next fall Barkdull started college at the Y. There he studied art under Eastmond, Campbell, Larsen and his favorite teacher, Aretta Young. Swanson continues:

Philip studied at the BYU full time until 1917, when his old boarding mate in college, Hugh Woodward became the president of Dixie Normal College. Woodward was familiar with Barkdull's work and invited him to St. George to teach school. Barkdull began his art education career in the fall of 1917 at Dixie. He taught until the spring of 1918 when he was inducted into the army. When he reported to the family doctor after his release for medical reasons, the physician exclaimed, "This three months has put you back (in health) three years!"

Barkdull accepted a post in September of 1918 as an art teacher at Hurricane High School in Washington County. During his teaching stint at Hurricane he married on June 3rd, 1919, Evelyn Woodbury [Barkdull-Stoddard], who eventually bore him four children. During the summer of 1919, he attended three art classes at the University of Utah with Jack Sears. Barkdull taught at Hurricane until the spring of 1920. That autumn the position of "instructor in art and shop work" opened at Dixie Normal College.

Thus Barkdull was back in St. George by September of 1920. In 1923, art was dropped from the curriculum by a new president and the painter moved to Millard High in Delta, Utah. He taught painting in the evenings at the high school and then "woodwork and

Philip Barkdull on a Provo street in 1929. His bold experiments with fauvist color seem incongruous in light of a gentle demeanor and fragile health. (Photo courtesy Barkdull family.)

farm related crafts" for the town's "Smith-Hews Fence-Building Farm" in the afternoons.

But Philip Barkdull persevered. During the summer of 1924, he continued to work toward his bachelor of science degree at BYU. Leaving Delta, he moved to Provo where he painted (and studied summer terms 1925 and 1926) through the year until an art appointment was his at Provo High alongside Orson Campbell.

Barkdull also attended BYU during that summer session of 1927, when Lee Randolph made such an impact on the artistic thinking of Logan's Calvin Fletcher and caused him to invite Birger Sandzen to Utah State the following year. Sandzen's *Moonrise in the Canyon, Moab, Utah,* was the purchase prize winner at Springville's April Salon. Barkdull took lessons with the Kansan in Logan at that time. As Swanson writes:

No other artist had a greater influence on Philip than [Sandzen] . . . Barkdull's paintings from this prolific period in his life all bear the mark of Sandzen's thick impasto, raw

color and regional . . . scenery . . . the next summer Sandzen
returned and again Barkdull attended the sessions. . . .

When the opportunity of taking the place of B. F.
Larsen at the Brigham Young University became avail-
able for the 1929–30 school year, Barkdull left the Provo
School District. Larsen was taking his sabbatical in
France and he probably chose Barkdull as his replacement.
. . . It was as a teacher of design that Philip Barkdull
made his greatest contribution to Utah art history.

Probably because of the acquaintances made during
these summer classes in Logan, Barkdull went north in
the fall of 1930. He hadn't made any applications, for he
already had his job with the Provo School District back.
One day as he was just about ready to leave his house a
letter came from Lewis Petersen, the school district supervi-
sor in Logan, asking him if he could be released at Provo
in order to become the "supervisor of arts and crafts of the
Logan schools" and teach art at the high school in the
afternoons. Although there were some people upset that he
and not a local person got this important position,
Barkdull taught from the fall of 1930 until his retirement
in the spring of 1954, for the Logan School District.

After his retirement, necessitated by his ill health,
money problems forced him to teach private art classes. He
did not paint much after 1930 because of his teaching
duties and low energy level. He turned to watercolor the
last years of his life and painted many florals. On
November 6, 1968 the artist died in Logan, Utah.

Barkdull's paintings shine out like a beacon amidst the
"foggy grey" of many of his contemporaries. (See especially
Seagulls on Utah Lake or *The Gulls,* 1930, SMA; *Angel's
Landing,* 1930, p.c., **plate 49**; and *Designed Landscape:
Symphony in Color,* 1930, SMA, **plate 50**.)

GREAT ART IN THE GREAT DEPRESSION: 1930–1942

Despite Herbert Hoover's efforts and some local
programs, the worst depression in history just
got worse. In the election of 1932, Franklin
Roosevelt crushed the incumbent with over 57% of the
vote—and in Utah, another Democrat, Henry H. Blood
was elected governor by about the same margin.
Governor Blood stayed in office until 1941, and under
his leadership Roosevelt's New Deal flourished in Utah.
The WPA (Works Progress Administration and later—in
1939—Works Projects Administration) operated here
from September of 1935 until the end of 1942, and dur-
ing this period, built or improved an incredible quantity
of parks, roads, sewers, water lines, pools, privies, air-
ports, and public buildings—including the Springville
High School art gallery (1932).

First came the Public Works of Art Project (PWAP)
in December of 1933. As arts administrator, historian and

former director of the Salt Lake Art Center, Dan E. Burke, has written: "The PWAP in Utah was part of the women's division of the Utah Civil Works Administration. . . . Helen Sheets and Taylor Woolley [of Hon Young's old gang] were appointed directors . . . [and in] 1934, Sheets announced that ten projects had been assigned to Utah artists."

These original ten were: (1) Lee Greene Richards—"decoration of a 260 foot circular space, 12 feet high in the Capitol rotunda"; (2) Edwin Evans—"removable murals for the Veteran's Hospital"; (3) J. T. Harwood—"two gallery pictures of early Utah life"; (4) Millard F. Malin—"Sculpture and sketches of early Indian life"; (5) Florence Ware—"pictorial map of early Salt Lake Valley"; (6) Caroline Parry—"sculpture and sketches of early Indian life"; (7) Henri Moser—"triptych depicting Utah life of today"; (8) Ranch Kimball—"sketches of activities of various governmental branches"; (9) Gordon Cope—"sculpture and sketches of early Indian life"; and (10) Carlos Anderson—"sketches of places historically important." Helen Sheets insisted that, "although financed by the public work administration," these projects were not to be considered relief work. "On the contrary, it is the government's attempt to ascertain what artistic material we have in America." Sheets's emphasis underscores the difficulty Americans—particularly Utahns—had accepting government help in the 1930s. Many in that generation had been raised with a pioneer ethic of frontier individualism. And yet, the necessity was there, and the majority partook.

As Dan Burke points out, several assignments were made in addition to the initial ten. Irene Fletcher "painted a mural for the Logan Library," Howell Rosenbaum "created a mural proposal for Box Elder High School," and Everett Thorpe—in a moment when the lines between church and state were blurred—"designed a mural for the Logan-Cache LDS Stake Tabernacle. . . . Other artists, including James T. Harwood and Elzy J. Bird produced paintings for Utah Schools and state buildings."

The PWAP program came to a close on 30 June 1934, while the Federal Emergency Relief Administration (FERA) existed in Utah from 1 April 1934 to 1 July 1937. The state's Public Art Project was approved on 14 August 1934, and administered by Judy Farnsworth Lund (1911–), the state art supervisor (later, state art director). Also a painter, Judy Lund was, at that time, working toward her master's degree in art at the University of Utah.

FERA's major accomplishment in the eyes of the community was the completion of the murals in the Utah State Capitol. Planned by Lee Richards, with the assistance of Gordon Cope, Henry Rasmusen, Ranch Kimball, and Waldo Midgley, the murals—on 4500 square feet of canvas—were painted at the state fair grounds and later transported to the capitol dome. In his column for the *Deseret News* on 11 August 1934, Gail Martin claimed that Mr. Richards and his assistants were "devoting practically every waking moment to the task"—even though under regulations of the public works of art project, artists were to work five six-hour days each week.

When I asked Waldo Midgley in 1983 if this great public works project were an enchanting experience, he said, "No!. . . It was a pain in the neck! Lee Richards was the whole show. He just sat in his studio and made all the drawings, and the boys down at the fair grounds copied them. So they didn't rate much [even so] they [the project people] wouldn't let me do any of that. All I did were the borders. . . . I worked there for two weeks, and then I said 'ah to hell with this, I'm going to go painting!' Helen Sheets gave me an extra two weeks . . . when I quit."

But other committee painters stayed to the completion of the project. Burke describes one of the lighter moments: ". . . when the murals were mounted . . . and the scaffolding taken down, it was discovered that a paint-stained cloth had been left on a shelf at the base of the dome. Cope, armed with a long fishing rod, spent the greater part of a day at casting before the undecorative object was landed."

One other project sponsored by the FERA was an exhibition held at the Union Building, University of Utah, in October 1934. Another of Gail Martin's "At the Galleries" columns describes it: "At this exhibit, it is the intention of those in charge to have not only paintings, sculpture, (and) wood-blocks, done as part of the Public Works of Art Project. . . . but examples of recent work done by all of Utah's living artists."

The exhibit included not only works by Lee Greene Richards, Gordon Cope, and Henry Rasmusen, but other creations by J. T. Harwood and E. J. Bird, Florence Ware, Minerva Teichert, Cyrus Dallin, Ranch Kimball, Carlos Anderson, Frank W. Kent, Cornelius and Rose Howard Salisbury, Joseph A. F. Everett, A. B. Wright, LeConte Stewart, Richards, Cope, Mahonri Young and Waldo Midgley. (See Carlos Anderson's later *Snake River, Near Bliss,* 1942, SMA, **plate 64.**)

The stated purpose of the exhibit was "to help create an atmosphere in which the younger generation of artists can grow and attain to greatness in artistic lines." This

high purpose did not prevent the *Deseret News* of 27 October 1934 from complaining that the quality of the exhibit was mixed due to the inclusion of the "inept" among the "good."

Apparently this was a problem all over the country as the establishment—on 14 October 1934—of the Section of Painting and Sculpture (later, Section of Fine Arts) attests. Founded under the Treasury Department "to resolve the issue regarding quality," the section tended to focus on nationally-recognized artists from the eastern states, and no Utah artist ever received a commission.

President Roosevelt announced the creation of the Works Progress Administration on 6 May 1935. The Federal Arts Project (FAP) within that organization concentrated on the visual arts, music, drama, and literature. FAP was administered through the women's project, and was directed first by Judy Lund, then Elzy J. Bird, and finally Lynn Fausett, who served until the program was terminated in January of 1943.

The Federal Arts Project has three stated goals: "the creation of Art, [the fostering of] technical research, and [the encouragement of] Art applied to Community Service and Art Education." The program produced a lasting legacy. In all, the Utah State Institute of Fine Arts acquired 113 pieces of art during those few years—everything from murals to wood carvings. The program was very helpful to a number of individual artists and served the community at large. As Dan Burke writes:

> Probably the most far-reaching application of art to community service was the Art Project's extensive system of community art centers where art classes as well as traveling exhibitions were presented in rural communities. Of all the programs of the Art Project, the community art centers were probably the most effective attempts to integrate the arts with the life of the community. . . . The precedent for taking arts to the community had actually been established . . . with the integration of the Salt Lake Art Center. . . .

The Salt Lake Art Center, affectionately called the "Art Barn" had its origins in the depth of the Depression. WPA funds, along with a land grant, and $1,000 from the city fathers made it possible. The original site was to have been a barn at South Temple and K Street, where art lovers and artists could mingle in an "informal camaraderie." After various fund raising events under the direction of Mrs. John Jenson and fifteen of her women friends, the cornerstone was finally laid by Governor George Dern on 7 December 1931 in Reservoir Park on the southeast corner of South Temple and University streets. Also in the dedication year the "Salt Lake Art Center School" under the leadership of Mrs. W. W. Ray began its operation.

Since its beginnings the Center and its associated school have provided a vital—often more liberal—alternative to collegiate art training. An enormous number of talented artists have been associated with the center as students, exhibitors, and teachers over the years. Some university instructors taught there as well. The list of teachers through the thirties and early forties includes Joseph A.F. Everett, Millard F. Malin, Douglas Donaldson, Caroline Parry, Edwin Evans, Waldo Midgley, Henry Rasmusen, Maurice Brooks, Gordon Cope, Norman Jacobsen, Cornelius and Rose Howard Salisbury, and Michael Cannon.

Gordon Cope was director of the center from 1939 through 1941 while Evans and Brooks were certainly there in WPA days, and Michael Cannon probably served on the center's faculty for the longest time (1942–60). Other artists on the Art Center teaching faculty in the forties were Gertrude Teutsch, Dan Leahy, Mary Kimball Johnson, Jack Vigos, and Lynn Fausett. In short, the "Art Barn" has provided employment, exhibition opportunities, and companionship for artists from its inception—and, under the auspices of the Salt Lake City Arts Council—continues to do so today.

CAREERS ONGOING: PAINTERS AND (ESPECIALLY) SCULPTORS

How to make money as an artist in Utah? Waldo Midgley (who had decided to spend some period in Utah during the Depression) exhibited at the Art Barn in 1936, and used that forum to reintroduce himself to the community. He also taught an evening life class there, as well as a weekly evening class at BYU, where B. F. Larsen had become chairman. He exhibited also (with Alice Horne as his agent) in such venues as the ZCMI Tiffin Room, Beesley's Music Store, and the Newhouse Hotel.

Midgley had applied for work at both the University of Utah and Utah State Agricultural College. But although Utah State had an artistically innovative program under Calvin Fletcher, it was a small department, and, in those days, geographically isolated. The U of U art department, headed by A. B. Wright, was expecting a vacancy at the end of the 1937–38 school year due to retirement of Professor Maud Hardman. All Waldo could do was wait.

Alma B. Wright,
Myrtle, the Artist's
***Model;* c. 1937,**
oil on board,
10 3/4" × 16 3/4";
SMA.

In the meantime, he was becoming more and more involved in Salt Lake City's artistic society. An active teacher at the Art Barn still, he had by 1938 joined Alice Merrill Horne's "Utah Art Colony" organization and was also a card-carrying member of the Utah State Institute of Fine Arts. In early 1938, Waldo seemed very much like a confirmed Salt Laker in every way.

On the U art staff (in addition to Wright and Hardman) were Jack Sears; the crafts expert, Harvey E. Gardner; Bernice Magnie; and Mabel Frazer. Frazer was (after she almost lost her own job over it) instrumental in the departure of Chairman Wright for France—for the rest of his life—after a secret campus investigation of Wright's conduct around departmental models, and just preceding the appearance on campus of an irate, life-threatening Salt Lake City husband. (See *Myrtle: the Artist's Model,* c. 1937, SMA.)

Two faculty slots were therefore open for the 1938–39 school year. Primary candidates for the chairmanship were: Frazer (who had wanted it for a long time, but had no chance at all); Salt Lake's leading portraitist,

Lee Greene Richards (who had the backing of certain high-ranking LDS Church officials); the talented younger landscape painter, and Ogden High School art teacher, LeConte Stewart (who was supported not only by Governor Blood, but by numerous other civic, academic, social and Church leaders as well); and Waldo. The Midgley candidacy, with its scattered backing from certain former Utahns of consequence now living in New York City (or thereabouts), had in its favor also the fact that he was an experienced artist-teacher who could bring a whole new set of contacts and freshness of approach.

But University of Utah President George Thomas was extraordinarily careful this time, mainly because of the Wright affair. Waldo recalled that at "the interview he [Thomas] said he thought I was excellent material for the job and that I would hear from him. [Then I was] taken to a concert where I met the president of BYU [Franklin Harris], who was cordial and seemed in on the know." In the meantime, Alice Merrill Horne came to see Midgley, and "said that [a certain female teacher at the university] . . . told her [that Waldo] was a drunkard." Mrs. Horne then

Mahonri M. Young, *The Farmer and The Laborer*; c. 1939, plaster; MFA/BYU. Concentrating on figural sculpture of athletes and workers in his later years, Young became one of Utah's best-known native sons. His work is in over fifty museum collections across the country.

11 April 1938 letter to LeConte Stewart, one may read that: "On Friday, April 8, the Board . . . appointed you teacher of art with the rank of assistant professor and head of the art department." The president went on, "within the next few days, we hope that you can come to the University and arrange for the work for the next year. Please do not make any commitments to members of the department until you see me. Some of them want certain work, and I think that should be gone over. . . ."

It would not be easy for Stewart. His faculty, almost to a person, resented his appointment, especially the department's most senior female member. Meanwhile Waldo was left without a job. Alice Merrill Horne tried to persuade him to take the job at Ogden High School, and eventually an offer did come in from USAC in Logan, but Waldo went back to New York, just in time to see one of the paintings in his Old Utah Home series exhibited in the third annual National Exhibition of American Art under the sponsorship of the New York City Municipal Arts Committee.

In the meantime, the famous Cyrus Dallin had finally received membership in the old and conservative National Academy of Design in 1930 (Solon Borglum received the same honor nineteen years earlier).

In 1943, at the age of eighty-two, the artist died at his home in Arlington Heights, Massachusetts—three years after the placement of his *Paul Revere* near the Old North Church in Boston. He had called the erection and dedication of the Revere his "swan song," and so it was. The sculptor is today often remembered in Utah for the following words delivered on his final trip west in 1942: "I have received two college degrees . . . besides medals galore, but my greatest honor of all is that I came from Utah."

And Utah's other most famous expatriate artist often felt the same way. Mahonri M. Young spent the Depression teaching at the Art Students League and doing some of the finest work of his career (*Frontier Scout,* bronze, c. 1932 and *The Factory Worker,* bronze, c. 1938—both SMA). In 1939, the famed sculptor gained one more major commission—from Utah.

This Is the Place Monument at the mouth of Emigration Canyon was finally constructed in 1947—the centennial year of the Mormon colonists' arrival. This monument is a fitting culmination to Mahonri's career, though, in the final analysis, Mahonri's best and most justly remembered works today are the smaller figures of active workers and athletes. At the 1932 Olympic Art Exhibit he was awarded first prize in the sculpture division

said that he had "better tell Dr. Thomas that this was circulating around." When Midgley did report the story to the president, "Dr. Thomas . . .[declared] that 'I don't think you're a drunkard, you don't look like a drunkard.' "

According to another source, Thomas went so far as to visit (unannounced) another candidate and his family at home (it wasn't Waldo), to see how they lived, what they read, whether they had a "proper" life style. Then, as Midgley tells it, "the board of regents met, the governor, an ex-officio member, with them. Next morning, I see by the paper, that [the governor's] neighbor . . . had been appointed head of the department of art." In Thomas's

for a piece entitled *The Knockdown* (various locations). Elected a member of the American Academy of Arts and Letters in 1948, Young spent the last ten years of his life as an honored elder statesman of the arts.

Besides Ramsey, Ward, Dallin, the Borglums, Young, and the Fairbankses there were other sculptors. Torlief Severin Knaphus, for example (see especially *Sleep,* plaster, c. 1936, SMA). Originally from Norway, Knaphus (1881–1965) took his early training at the King's Academy in Oslo with Lars Utne (1913), at the Julian in Paris, and with Harriott Barker. Coming finally to Utah as a Mormon convert, he worked in LDS temples in Arizona, Canada and Idaho, and he held teaching jobs at both BYU and the University of Utah. Knaphus was an entirely realistic worker in the third dimension—his handcart group on Salt Lake's Temple Square is well known locally, while another of his pieces can be seen at Hill Cumorah, near Palmyra, New York.

Knaphus's career probably benefited in the early middle years of the century from Avard Fairbanks's absence from the state. While Fairbanks was at the University of Michigan, he did some of the best work of his life. His *Rain* (a nude female figure in bronze of 1932, acquired by SMA, 1981) is a marvelous period stylization of a curvilinear nature. After his triumphal return to Utah in the mid-forties, although he became a rather well-known traditionalist sculptor, he never attained the degree of fame achieved by the Borglums, Dallin, or Young (with whom he unsuccessfully competed for the *This Is the Place* commission).

Solon Borglum had died early in 1922. But in the thirties, Gutzon was involved in America's largest sculptural commission at Mount Rushmore (to be completed in 1941 by Lincoln Borglum seven months after the death of his famous father). Though the Borglums were among the first to do small "Wild West" pieces in bronze, few in their home state pursued this genre for many years. The style was popular in surrounding states, but no particular tradition for "Western art" (of the "Cowboy and Indian" variety) in *any* media, existed for many years in farmer-founded Deseret.

The mainstream sculptural work in Utah during the middle decades was done by Knaphus, as well as Maurice Edmund Brooks and Millard Malin. Brooks (1908–) tended to split his time between smaller works and large architectural decorations in Salt Lake for the Cathedral of the Madeleine, the Daughters of the Utah Pioneers Museum, and the LDS Relief Society Building. He also assisted Millard Malin on the sculptural work for baptismal

fonts in the LDS temples at Bern, London, and in New Zealand, and on an Angel Moroni for the Los Angeles Mormon temple.

Maurice Brooks's teacher and older colleague, Millard Fillmore Malin (1891–1974), had been a pupil of Edwin Evans at the University of Utah 1914–15, studied at the National Academy of Design under Herman A. MacNeil in 1917, and worked with Gutzon Borglum as assistant on the Stone Mountain project in 1920. He created the Sugarhouse Pioneer Monument in 1930, taught at the Utah Art Center in 1939–40, and was also a teacher for the Navy School at Gonzaga University during the second world war. (He did the commemorative plaque for the battleship *Utah.*)

THE YOUNGER GENERATION AND CERTAIN MORE INDEPENDENT TYPES

Having grown up in Price, Utah during a time when Carbon County was a strange blend of staunch Mormon settlers and rough-tough miners, Lynn Fausett (1894–1977) studied art at Brigham Young Academy in Provo from 1910 to 1912. He began his college studies at BYU a year later, then transferred to the University of Utah as an engineering major. In 1916, he joined the wartime Navy and, when he emerged from the service in 1921, he had enough experience as an electrical engineer to obtain a good job with Utah Power and Light. He wasn't happy in his work however, and a year later he opted for the insecurities of an artist's life. His goal was to study at the Art Students League; he hitchhiked to San Francisco and shipped out on a freighter, finally arriving in New York in 1922, with $100 in his pocket.

Fausett found a job with the Fifth Avenue Bus Company as a night report clerk. For the next four years, he studied art by day and worked nights to support himself. At the League he studied with nine different instructors and discovered that "in no other place in the world was the opportunity so great and varied for a student to find himself—to discover his own capabilities."

The opportunity, in Fausett's view, lay in the quality of the faculty, but also in the structure of the League. The students registered by the month and studied with whomever they chose, changing classes at will. In effect, they hired their own teachers. There were no entrance requirements, and the only motivation to attend was the desire to become an artist.

Fausett flourished in this liberal environment. Some of his cohorts were the artists Isabel Bishop, Edward

William Dean Fausett, *Nudes;* n.d., wash drawing; SMA. The Fausett brothers of Price did much to bring freshness and consistent quality to Utah art in the wartime and postwar period. Lynn came home, while Dean stayed on the East coast.

concepts of classic design, sculptural form, three-dimensional space, and the integrity of the picture plane.

Fausett remained under Miller's direct influence until 1927, when he embarked upon a career as a working artist. He became an assistant to muralist Hildreth Meiere and for the next ten years was involved with large commissions for the decoration of buildings in New York, Baltimore, Chicago, Kansas City, and Omaha. He also served on the Board of Control of the League from 1927 to 1932, at which time he was elected president of that school. During the four years of his presidency, the faculty grew faster than it ever had before.

Having married Helen Wessels in 1925, Fausett continued to work with Meiere into the thirties on such projects as mosaics and stained glass windows at numerous locations around the country. He went to Europe in 1928 for further study, and then returned to continue his career as a Meiere associate and arts administrator at the League.

Lynn Fausett left New York in 1938 primarily because of the divorce that ended his thirteen-year first marriage. He went immediately to Depression-stricken Utah, and for the next four years—almost without break—was involved with mural projects under the sponsorship of the WPA. His initial commission was done in his hometown of Price, and it remains the most successful of his large-scale works—despite the obstacles to its creation.

Price Mayor J. Bracken Lee (later governor of the state and mayor of Salt Lake City) was initially opposed to the idea of a federally-sponsored mural. The painting (which depicted a pioneer history) finally included no less than 82 figures. It was unveiled in 1941 to generally favorable notices. Some members of a Price family objected to seeing one of their ancestors in the mural nursing her baby, but Fausett was able to paint in a piece of lace which averted the crisis. Even Mayor Lee liked Fausett's work when it was done. According to Elzy J. Bird in a 1973 article entitled "Birth of an Art Center," Lee's stand against federal projects of the kind was so softened by his continuing friendship with Fausett, that later, in 1940, he gave full support to a motion for the setting up of an Art Center for Price.

Community pride in Lynn Fausett's Price accomplishment was warranted. The work is only four feet high, but in James Haseltine's words it is an "unusual blend of Rubenesque form and Piero della Francesca mood and color." Other effective murals followed, such as a slightly later work for the Farmington Ward Chapel and the so-called Barrier Canyon mural of 1941, as well as many smaller easel paintings in a final, hard, and rather dry style.

Laning, Kimon Nicolaides, and Reginald Marsh, while another fellow student, Lloyd Goodrich, eventually found his future niche as art historian and director of the Whitney Museum of American Art. The League's faculty of the twenties was impressive. The roster included Robert Henri, John Sloan, and George Luks, plus such other notables as Whistler-student, Joseph Pennell, the famed teachers, Boardman Robinson and Kenneth Hays Miller, the American "modernist," Max Weber, and Mahonri Young.

Kenneth Hays Miller soon became Fausett's main teacher, and from Miller, Fausett learned the traditional

Fausett married Fiametta Rhead of Coalville in September of 1940 and continued to garner major local commissions for mural work.

With the outbreak of World War II, he became art director for the Special Services Branch, Ninth Service Command at Fort Douglas and was employed by the government through 1946. Appointed assistant state administrator for the Utah WPA Art Project in its last days, Fausett presided over the closing down of that enterprise on 30 June 1943.

In the summer of 1947, Fausett taught at BYU. Later he also became an Art Barn instructor for a brief period. That particular association did not have a happy outcome. Though liberal within a Utah context and without strict entrance requirements, the Art Barn was nevertheless essentially traditional in its structure in terms of faculty/student relationships and the enrollment of students in courses for the duration of each seasonal session. In the late 1940s additional regulations were imposed on any school attended by veterans under the G.I. bill.

Fausett's support of the more liberal approach epitomized by the Art Students League was well known, and in the words of Don Hague (who also took courses with Fausett at that time), some of the students "asked him to help them formulate a plan for a similar independent approach to teaching which would permit a more selective choice of classes." Essentially, they wanted to run their own school. When the board of directors became aware of the plan they discharged Lynn without a hearing. The furor died down quickly and a year or so later, according to Lynn, the Art Barn board asked him to direct the school again—an offer he declined to accept.

Fausett's career continued to cut a substantial swath through the late forties and fifties. By 1951, he was an extremely well known and well appreciated Utah artist. His works were owned by numerous influential local collectors and associates including old friends, Governor and Mrs. J. Bracken Lee. Through Lee's influence, Fausett was commissioned to execute a mural in 1951–52 for the Kennecott Corporation which ended up in the Chrysler Building in New York. He then painted a piece for the information building at Mahonri Young's *This Is the Place* monument.

He was active in local associations throughout the fifties and eventually founded a "Fausett League of Art Students (or Utah Art Students League) in 1955. The Fausett League met two nights a week for the next five or six years at the Acme Quality Paint Store in Sugarhouse before an automobile accident in 1961 cut short the master's

ability to teach on such a scale. After the dissolution of the league in 1962, the "Fausett manner" was carried on especially by Nina Kingston and Vyrl Baker. (See *Rainbow Arch,* 1960; *Flaming Gorge Dam under Construction,* 1961; and *Angel's Arch,* 1962, **plate 72**—all SMA.)

Fausett's method was based not only upon a liberal approach to studio training but upon a special oil-tempera medium initially developed by Dean Fausett in the thirties. The specifics of the medium remain a secret described only as "an emulsion of oil, damar varnish, turpentine, and a solution of gelatin suspended in water." According to Lynn, the oil-tempera mixture was "a medium with which you can do anything you can do with oil paint and anything you can do with tempera paint."

Lynn's brother William Dean continues to use and improve the medium he invented today. Dean was born on 4 July 1913. He studied early at BYU, following this training with work at the Art Students League under Kenneth Hays Miller and at the Colorado Springs Fine Arts Center. Eventually he developed a much freer and more open stylistic approach than his brother's. Dean carried on a highly successful career as a painter, printmaker, and teacher outside of Utah, and today resides in Vermont.

Other painters working in the thirties and forties included Howard Kearns (1907–1947), a musician and landscapist; Esther Erika Paulsen (1895–1978) of Logan; Lura Redd (1891–), who taught at Box Elder High School and worked on the restoration of the Salt Lake Temple murals; Maud Hardman (?–1981), a long-time art educator at the University of Utah; Bessie Eastmond Gourley (1886–1961), a sister of E. H. Eastmond, who specialized in flower painting; Edgar M. Jenson (1888–1958), a life-long art educator and college administrator; Florence Frandsen (1908–), a teacher, painter, and wood-engraver; Mary Kimball Johnson (1906–), an exceptionally talented painter and teacher in Salt Lake City; William J. Peters (1901–), a designer; and Hilma Mole Payne (1901–1973) of Ogden.

One often overlooked talent was Alpheus Harvey (1900–1976), who taught in the Ogden city schools for thirty-seven years. Harvey studied art in Utah under Calvin Fletcher, J. T. Harwood, Mabel Frazer, and with Ralph Pearson. Often he produced landscapes depicting the mountains east of Kaysville where he lived. George Dibble has noted that Harvey's management of geometric force in his painting suggests Cézanne's studies of Mont Sainte Victoire.

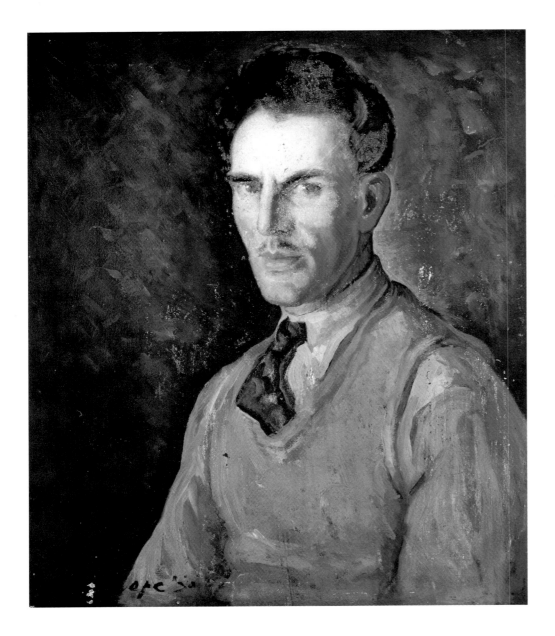

Gordon Cope, *Portrait of Ranch Kimball;* 1930, oil on board, 23 1/2" × 27 1/2"; collection of Ranch S. and Josie Kimball.

The artist who took over for Judy Lund as Utah's Federal Arts Project director on 1 August 1937 was Elzy J. ("Bill") Bird (1911–). He was born in Salt Lake City, but spent much of his childhood on the family farm in Layton, Utah, as well as on cattle ranches in Swan Valley, Idaho. Back in Salt Lake, he studied art at West High School under Cornelius Salisbury and went to the University of Utah where lessons from Harwood and Sears were available. In 1933, he moved to Los Angeles where he studied at the Chouinard School of Art and worked with his teacher, Don Graham, at the Walt Disney Studios.

Returning to Utah (*City Creek,* 1934; *Mill Creek-Autumn Morning #1,* 1934—both SMA), Bill Bird became an active Utah artist just in time to come to the attention of area arts administrators. Eventually watercolor became his most favored medium (*Old Barn,* 1936,

SMA); he went on to attract critical acclaim at the 1939 World's Fair in New York for a work entitled *Takin' Five.*

Dan Burke describes some of Bird's activities in arts administration:

These two projects [the Salt Lake Art Center "Art Barn" construction of 1931–33 and the new Springville Museum of Art facility dedicated on July 4, 1937] . . . had great success in bringing art to the community. However, the arts would reach an even broader audience through the Federal Art Project. Under the aegis of the Utah State Art Center, four additional art centers were created in Salt Lake City [in the old Elks Building at 59 South State Street], Helper, Price and Provo.

Among those who exhibited through FAP-sponsored traveling exhibition program was William Jensen Parkinson (1899–) from Hyrum, Utah. Though primarily self taught, he began as a student of A. B. Wright in 1924 (*My Friend, Paul Smith Reading,* c. 1930; especially *Within the Ancient Underground Temple of Oude,* c. 1945; and *House Wife,* 1961, **plate 80**—all SMA). One of the few Utah artists to create what can be termed surrealist works, Parkinson held a number of teaching, administrative, and other positions through a career as a very independent painter and sometime decorator in Salt Lake City.

The accrued signs of his dedication to the arts can be seen in his early mural for McKinley School; shows at the Oakland Art Museum and of work executed for the Index of American Design in Hyde Park, New York, and elsewhere; a one-man-show at the Salt Lake Public Library; top awards from the Utah State Fair and the Institute of Fine Arts; and representation in various collections in Utah.

S. (Sidney) Paul Smith (1904–) of Salt Lake, William Parkinson's 1946 partner in the decorating business, carried on a similar independent career. He began with study under Lawrence Squires and A. B. Wright—followed by a period with Leon Kroll at New York's League between 1932 and 1934. He taught at the Utah Art Center (from 1936 to 1941) and subsequently pursued a freelance career of design and painting commissions from the late forties to the present.

The husband of Ogden-born Ruth Wolf Smith (1912–1980), Paul Smith became best known for his watercolor landscape work (*Wilderness West of Salt Lake,* c. 1936, SMA).

Both Smiths received a number of awards for their

D. Howell Rosenbaum,
Self Portrait; **c. 1952,
oil on board, 14" × 17";
SMA.**

works, Paul Smith's painting in particular gained local and national notice through solo shows at the Hotel Newhouse (1932), the Lion House (1933), Ferargil Gallery, NYC (1933), the Art Barn (1934), the Unitarian Church in Salt Lake City (1936), the Utah Art Center (1940), and elsewhere.

The career of Ranch Shipley Kimball (1894–1980) of Salt Lake City was unique. After early training at the Y (1912–13), at the Art Institute of Chicago (1914–16), and at the League in New York, Kimball returned to Utah. He regularly exhibited his paintings at the Utah State Fair between 1920 and 1930, and at the Art Barn for the next five seasons. He worked for the PWA in 1934 and finally earned a position on the board of the Utah State Institute of Fine Arts from 1940 to 1944. In the 1930s he became a painter of distinctive "stylized" landscapes (*Entrance to Zion,* 1934, SMA, **plate 54**). Kimball

was also the juror for many exhibits during a long career that led him first into graphic design and illustration, then toward a business career. Eventually the president and general manager of both the State Amusement and Lagoon corporations, Kimball became an art collector and a patron of the local arts in subsequent years.

During the 1930s a number of the most exciting expressionist images in Utah were done by another independent, David Howell Rosenbaum (1908–1983), an artist often associated with the so-called Logan group. Originally from Brigham City, Rosenbaum had studied with Fletcher in Logan in 1931, then painted and developed on his own until 1938 as an effective and unique figure painter and landscapist of controlled emotion. A wonderfully bold colorist of thoughtful composition, he created highly imaginative landscape flights (*Children at Play in Mantua, Utah,* c. 1937, SMA, **plate 57**).

In 1938 Rosenbaum entered the American Artists' School in New York to study under Sol Wilson, Moses Soyer, Mivon Sakile, Jean Liberta, and Sidney Laufman, and by 1941 he was back in his home state teaching at the Utah Art Center for the WPA. In March of 1942 Rosenbaum joined the Seabees and was sent to Guadalcanal. He returned to Utah after the war, where he continued to paint, though his years as an innovator were behind him.

It would be different for Gordon Nicholsen Cope (1906–). He resides today in San Francisco, but Cope began his training as a youth with A. B. Wright and LeConte Stewart, and also worked with Lawrence Squires in Arizona. The young painter went to study the "old masters" in England, France, Switzerland, Italy, Belgium, and Holland from 1924 to 1928, and studied at the Académie Julian during his last year abroad. Eventually he became head of the art department at LDS University for the school year 1930–31. A painter of both portraits and landscapes (*Utah Hills, East of Springville,* 1937, SMA, **plate 52**), he continued a halting career in art education with the Mountain School of Art (1932–33) and then as director of the Art Barn School and teacher for the WPA (1939–1941).

While others left the territory for artistic studies in eastern centers, John Heber Stansfield (1878–1953) of Mt. Pleasant had stayed home to draw and paint in his spare time away from his family business, one of the biggest sheep-holding interests in central Utah. In 1905, he married and settled down as a local building contractor, decorator, and Presbyterian Church trustee. He also served as Sanpete County Welfare Department administrator and, for four years, as a Mount Pleasant town councilman.

Continuing to paint, Stansfield managed to visit the studios of H. L. A. Culmer and Harwood on occasion, and while on a summer painting trek early in this century was able to spend an afternoon with Thomas Moran in Santa Barbara, California. With no formal training, but possessing a uniquely powerful perception of light and especially the intense patterns created by a strong and direct light source, the artist could produce very personal, even mysterious, apprehensions of reality on canvas (*Mt. Nebo, Early Spring,* 1942, SMA, **plate 63**). In the early years he made images which Haseltine called "lean, dry, and taut." By middle age he was able to devote more of his time to the brush, and eventually, he discovered a saleable, though less-satisfying palette-knife formula.

Stansfield took summer painting trips to California,

the Southwest, and the Canadian Rockies. He taught thirteen seasons at Snow College and was also a volunteer art instructor for the inmates of the Utah State Prison. By the time of his death in Mt. Pleasant at the age of seventy-five, he had painted over 2,000 pictures, was a regular exhibitor in state fairs and exhibitions, and was a happy, well-loved, and home-loving man.

(Lafayette) Maynard Dixon (1875–1946) on the other hand, came originally from Fresno, California. Before he ever lived in Utah he had established a strong national reputation as a painter of western subjects in the spirit of Frederick Remington and Charles Russell—"Cowboy and Indian" pictures.

Dixon saw Zion Canyon in 1938, and in late autumn of the following year he purchased ten acres near Mt. Carmel, not far away. In April of 1940, he came from his winter home in Tucson to supervise the building of a new summer place in Utah, thus establishing a living pattern which persisted through his last years (*Road to the River, Mt. Carmel, Utah,* 1941, SMA, **plate 62**).

In Utah's Dixie, he painted both "Mormon houses" and cubist-influenced expressions of that region's natural grandeur. In 1944, he traveled with friends to Capitol Reef, where he created a series of powerful sketches. Unfortunately, Dixon's health was already on the decline, and though he painted once more at Mt. Carmel in the summer of 1945, he died in Tucson in November of the next year. His ashes are buried in a place overlooking his beloved Utah residence.

Francis Leroy Horspool (1871–1951), was self-proclaimed primitive painter unique in both method and intention. Born in Ogden, Horspool was the son of a Mormon emigrant from England. The father, William F. Horspool, drove for Ben Holliday's Overland Stage Company between 1864 and 1969, and his tales of the haunted Riverbed Station may have inspired his son to maintain that various of his works were "haunted by fairies."

The younger Horspool worked as a fireman and railroad man before moving to Salt Lake in 1907. He held various jobs, but in 1917 took a position as a draftsman where he developed a skill and love for precision drawing. Between 1924 and 1927 Horspool listed himself as a patent attorney, but soon afterward he returned to drafting as a main source of income. Then, probably after the age of sixty, Francis Horspool dedicated himself to the brush and photography (*Utah Pioneer Home,* 1939, SMA, **plate 58**).

"I paint from photographs, as I can get the complete picture as a camera shows it," Horspool said and then, in

Francis Horspool with his painting, *Pioneer Home*. "It's all two coat work." (Photo courtesy SMA.)

response to those who claimed that he simply painted over photographs, the old man exclaimed, "My price is reasonable. My work is all two-coat work, that is, the second coat is the same as the first in color."

Horspool was fond of augmenting his scenes with fantastic figures and faces done in great detail, though he condemned all art which failed to share his "primitivism." Before his death at the age of eighty in Salt Lake City, this artist had at least two Utah showings of his pictures, one in 1940 at the Utah Art Center and the other in 1947 at the Pioneer Craft House.

MODERNISM

George Smith Dibble (1904–) has been a coalescent power in the history of modern art in Utah since he was young man. As painter, teacher and critic he has influ-

enced artists, students, and the general public. With native talent and intellectual curiosity he has combined the best of both his Utah background and his metropolitan New York experiences in a long and rich career. Dibble's interest in art is a family legacy. His great-grandfather, Philo Dibble was preoccupied with building a museum in the valley of the Great Salt Lake, "a repository in which shall be collected from all parts of the earth, specimens of the works of nature and art." And his mother was George's first instructor.

Subsequent instruction came via the mail, as it did for quite a few other artists in Utah. Dibble signed up for a correspondence course with a Cleveland cartoonist and caricaturist named William L. Evans. Describing the style of his first outside influence, Dibble recalls that Evans had "a robust, intense style and was always looking back to

Thomas Nast. . . he used that kind of pen technique, crosshatching, etc. . . ."

Other sources of inspiration came through the mail as well. "The mailbox was the most fascinating thing on [our] place in Layton," he says. He remembers having been inspired by drawings in newspapers and magazines, "*Scribners', Harper's, Review of Reviews, Literary Digest,* the old *Independent,* we just ate those. We just devoured those!"—particularly the drawings of Thomas Fogarty. "I admired his facile use of pen and ink, his romantic style. And I identified with his subjects: homes, villages, trees, fields and lanes—very rural." As Dibble studied these drawings and practiced, it became clear to him that he wanted to "get out of there and go do New York."

What Dibble learned in his correspondence "cartoon course" and from teachers as Brigham Young College in Logan led to his first sale of artwork the year he was a freshman at the University of Utah. "I took a drawing into Joel Priest, who was the city editor of the *Salt Lake Tribune.* He liked it."

While studying to be a teacher he continued to submit drawings, and was eventually hired to produce cartoons twice a week for the *Tribune.* He soon earned his own byline: "Dib the Penman."

After graduating with a teaching certificate in 1926, Dibble taught elementary school in Davis County for two years. He returned to the University of Utah in the spring of 1928 to resume art classes—and he continued drawing cartoons.

When Joel Priest found out that Dibble intended to continue his education, he told him, "George, you are a damned fool." But Dibble knew he still wanted to go to school in New York, and talked about it until his father "concluded that the only way to keep everybody happy was to get this guy out of town. So he let me have a patch of ground that was probably the best on the place in Layton." When enough money had been raised growing peas, Dibble finally went to New York.

He found the city enriching and informing, "a seedbed, a greenhouse, a nursery of ideas." Reminiscing on the experience, he continues, "I found my style at the Art Students League. School was a drudge until I got to New York and realized I had a point of view, that I could use it and get recognition for it."

At the Art Students League, he signed up for a class with George Bridgeman:

Do you know his Constructive Anatomy? He had a way of breaking down anatomy so that the bones and muscles are almost like flaps that you tack on. Big, very courageous, heroic type figures. One day we were drawing a blushing, sensitive girl who was a fellow student, and Bridgeman came by my board with that ever-ready chamois of his—off goes my drawing. And then he creates a two-ton dancing girl, right out of his mind with no relation to the model whatsoever! It was a cliché, and I just didn't want to be another "Bridgeman person."

So Dibble began studying with the Russian portrait painter Ivan Olinsky. When Olinsky was completing an out-of-town commission, his classes were taught by Howard Giles of the Grand Central Art School. Olinsky had a "very realistic, a hyper-naturalistic approach," while Giles "immediately tore everything down and said 'Now we'll start building up on the logics.' He had us read a lot of mathematical material." This was Dibble's introduction to cubism, and he recalls it with enthusiasm. "It was quite interesting to me because I found that it was strengthening to organize the canvas in spatial terms, in terms of concept. The multiple viewing for example, understanding what's inside the cup as well as outside, was fascinating."

"I was very taken up with it," Dibble remembers, "it was an enigma to me, I was nonplused—How do I handle this? I found that I could get to do some things by adhering to several of the routines which Giles prescribed." Continuing his discussion of cubism, Dibble says, "In this country at the end of the 1920s, the school in Philadelphia was already pushing color, full color! In contrast, the purely analytical cubists were sticking with a controlled palette. It was fun to consider the relationship of the impressionist palette to the cubist palette . . . to see how they would hit a triad, and yet still use black and white—using the points of the triad well within the circle. That gave a logical sense of order and sense of control—extremely delightful."

During that year at the Art Students League, Dibble was "strictly a student, no exhibitions." Though he'd been offered a job at the *New York American,* taking it would have meant going to school half-time, and he opted for full-time involvement in his classes. He returned to Utah in the summer of 1930 and was employed as art supervisor in Murray. For the next seven years, he taught in the Murray school system. He also met his wife there. Cleone Atwood was secretary to the board and to the superintendent of schools.

In 1935 the artist decided to continue his education at Columbia University. While there, his work took on "a

fairly cubistic direction . . . a little more Cézanne-influenced, using parallel perspective."

Through the late twenties and thirties, Dibble was still working almost exclusively in oils. One example, painted while he was at Columbia, won honors at the intercollegiate show. This painting was a reference to a seascape "in the most extreme sense," Dibble adds. The title of the piece is *Long Island Sound*. It's the sound as I visualized it, with a high sense of order. It's strictly cubist, absolutely non-objective. About the only recognizable thing is a triangular sail." This sort of painting is the kind of work Dibble's future boss at the U of U art department, Chairman LeConte Stewart would call "purely laboratory research." Dibble smiles as he explains, "Out here in Utah, the experimental urge . . . well, it wasn't very well received . . ." (*Marine #2,* 1938, **plate 56**, SMA). Though it is often suggested that he was influenced by John Marin, Dibble remarks, "I wasn't consciously aware of being influenced by his work until later, in the 1940s."

In 1938 Dibble got his bachelor's degree at Columbia, and took a new teaching post at the Washington School in Salt Lake. School officials were interested in his approaches to teaching art, and in the fact that his research had been published in eastern journals. But though in demand as an art teacher, Dibble was still not satisfied with the outcome of all the years of study and work. "Then in the winter of 1940, just about February 1, I got a telegram from the head of the Columbia Teacher's College art department, Sally Tannahill. She said 'we've talked of an M.A. degree. If you can be here by 2:00 on the 4th, you would be eligible for the Arthur Wesley Dow Scholarship.'" The Salt Lake School District gave him a leave of absence, and he, Cleone and their young son, George Jr., left immediately.

By working until two in the morning and then getting up for 8:00 A.M. classes, Dibble completed his work for the master's degree in just three semesters. Though they had considered moving, the couple returned to Utah because there were "a lot of good people working out this way."

But if there were kindred artists in Utah, there were others less friendly to abstract art. Dibble recalls the time when B. F. Larsen, then chairman of the art department of BYU told him "Now look, if you persist in following this modern trend, you will find yourself in the Communist camp. It'll do you no good!" Dibble adds, "This was the same general time when [Avard] Fairbanks was preaching to the whole and sundry here that art was 'going to the dogs.' "

Indeed, of the three art department chairmen at Utah universities—Larsen of BYU, LeConte Stewart of the University of Utah and Calvin Fletcher of Utah State—only Fletcher was really sympathetic to modern art. Dibble asserts that "Fletcher's personal 'fame' suffered because of it—in many cases because his energies were spent in helping to develop better students, a better department, a more open department." In 1940 Dibble went to work for Fletcher as visiting professor at Utah State Agricultural College in Logan.

But when it came time to decide on a long-term position, Dibble chose to work at the University of Utah, both because of its Salt Lake location and because he got a job there almost without his having known it was being offered. He recalls his meeting with then U of U President George Thomas with amusement. "It was like being swept in with a blast of air. He brought you in and sat you down. I had my little book that I had carried around Columbia; they wrote the grades in and you got to keep it. And it did have a lot of nice-looking letters (grades) in there.

"Well, Thomas asked to see the book. He took it, put it on his desk, and I never saw it again. Then he asked 'Would you accept a job here, at the (Stewart) Training School?' And I said 'Well yes I would, depending on . . .' And he said 'Good' and then the interview was over." Dibble thought he would be getting some more information on the position within the next few days, but what he got was the job. Evidently, Thomas "went into a meeting at 12:30 the same day I saw him, and put my name on the slate."

The art faculty of the William M. Stewart Training School was a center for some of the most dynamic educational ideas of the period, owing to its founder's belief in John Dewey's theory of "learning by doing." This teaching philosophy suited Dibble well. He feels he thrived as a student when given the freedom to follow his own ideas, and as a teacher he has always encouraged his students to develop their own style. During the next seven years he trained art teachers while he continued to develop as a painter. In the late thirties, he and Bill Parkinson had a show at the Utah State Art Center. That, Dibble recalls, was possibly the first show Salt Lake had of non-objective artwork.

In 1941 Don Goodall, director of the Utah State Art Center, called a group of people together to form what became the Modern Artists of Utah. Nine artists—Goodall, Dibble, Fletcher and his wife Irene, Harry Reynolds, Henry N. Rasmusen, Millard Malin, Alberta

3. *Uses emotional and intellectual freedom in organizing the subject into unified form.*

4. *The modern artist respects the validity of the picture field. This picture field is composed of front, back and side planes, determined by the artist.*

It is the hope and desire of the persons listing the above aims that the Utah artists trying to achieve similar ideals will join with them in an exhibition of their work. No other qualification than a similarity in purpose is required for entrance. The exhibition will be held January 6 to 27, 1942 at the Utah State Art Center, Salt Lake City. If you are attempting similar objectives, you are cordially invited to join. Since complete realization of all these aims has as yet been reached by no one artist, it is stressed by the committee that purpose is more important, currently, than effectiveness of achievement in this first bringing together of Modern Artists in Utah.

Dibble recalls that this document grew out of casual discussions and seminars. "It simply resulted from the need for the public to recognize that there weren't two kinds of art: good and modern."

Yet, as Dan Burke has written:

. . . though attendance figures to the . . . [Art Center's] exhibitions indicate the public's general support, some exhibits were not as well received as others. Alice Merrill Horne in the April 1940 edition of Art Strands *writes: I went to what they call The Art Center and there I saw "Woman in Labor," which I think should instead be called "The Lay of the Last Minstrel" though the arm and leg and abdomen appear somewhat like a pot-bellied man and though the scarlet drape (which somehow wasn't intended to drape) is a nice color near like chaunticleer's head. Also I beheld a dozen suggestive nudes with no drapes (when even the barbarians use a breech clout) and they are teaching art to our young while they smoke!!— the "Vandals!!"*

If showing nudes was a controversial issue during this period, an even more heated issue evolved around "modern" versus "traditional" art. This issue eventually elicited a statement prepared by nine Utah artists and arts administrators . . . This statement is both a justification for modern art and an attempt to give the public a definition of modern art. How successful this movement was in changing people's opinions in Utah is impossible to evaluate. However, the opportunity to view modern art along with traditional styles was a valuable educational experience for the public, as well as for other artists.

Kondratieff and Leone Eitel—got together and issued a statement as " 'representatives of a modern movement in the graphic and plastic arts in Utah.' We drew up a set of conclusions, in terms of 'How are we going to open this up? How are we going to get modern concepts generally accepted here in Utah?' "

When finished, the philosophy of this group of Utah modern artists read as follows:

The Modern Artist does not attempt to reproduce the photographic or surface appearance of things but,

1. *Uses individually conceived forms, the products of his experience, to express his aesthetic ideas and emotions, in terms of the particular medium employed.*

2. *Employs the design elements contained in plastic form, including relationships of line, tone, space, planes, texture, color and subject matter.*

In 1949 Dibble was promoted to associate professor at the U, and in 1950 he began a series of summer stints as visiting professor at the College of Southern Utah in Cedar City, an area he loves to paint. Having found in watercolor "a medium that allows for the expression of anything from a whimsical mood to feelings of danger," he became increasingly aware of a "poetic" aspect to his preferred medium and increasingly adept in handling its demand: to commit to an image, because there was "no chance for revision . . . over-management results in muddy, unclear passages" (*The Garfield Copper Smelter*, 1950s, SMA).

Though Dibble had become an artist and an educator in the 1920s, it was not until 1953 that he began to write a weekly art column for the *Salt Lake Tribune*. For almost thirty-eight years he has, in the most articulate way, managed to tell the absolute truth about hundreds of local artists without losing his job. For those who have extensive background in art, what Dibble has to say is pertinent and thought-provoking. For those whose artistic training is less sophisticated, enough is there to inform and challenge. As he explained his approach to a *Tribune* colleague in a 1978 interview, "In my criticism, I try to encourage things growing and developing."

Among other Utahns who shared George Dibble's early interest in modernism is Florence Bohn Drake (1885–1955), who was originally from Winona, Minnesota. Moving to Utah in 1917, she eventually studied elsewhere with Dong Kingman and Millard Sheets, thus preparing herself to teach art at Ogden's Central High School.

Though Henry Neil Rasmusen (1904–) worked on the Barrier Canyon project with Lynn Fausett—and on other strict representational pieces—much of his work is modernist (*Allegory of War*, 1943, SMA, **plate 66**). A native Utahn, Rasmusen went from early training in Chicago at the American Academy of Art (1930) and at the Art Institute (1931) to accumulate an impressive list of awards and exhibition credits across the country. He taught at Utah's Art Barn and the Utah Art Center (1935–1941), the University of Texas (1943–51), the Houston Museum Art School (1950), and the Patri School of Art Fundamentals in San Francisco (1953–58). He also wrote a number of books on technique and design, and eventually was appointed "guest professor of painting" at the University of Buffalo where he stayed through the late fifties and early sixties.

H. Reuben "Harry" Reynolds (1898–1974), a close associate of Calvin Fletcher, was also a dynamic force in Utah State's liberalized approach to the arts in the thirties and forties. Reynolds was born in Centerburg, Ohio. Graduating from the Art Institute of Chicago in 1923, he immediately joined the Logan staff and remained there on the regular faculty into the 1960s. Reynolds won awards in drawing, painting and jewelry-making early, and later studied with William Owens, Randolph, Sandzen, Oldfield, Stackpole, Nordfeldt, and Grant Wood. A Charles Sheeler-like investigator of spatial relationships and simplified form (*Load of Hay, Logan*, 1941, SMA, **plate 61**), Harry Reynolds discovered photography as a medium of visual expression in the late thirties, and finally gave up painting altogether in 1941. Active in the organization of the Utah State Fair and Utah Centennial exhibitions, Reynolds had one-man shows in Salt Lake City, Logan, Ogden, Provo and Cedar City, and became a significant pioneer in the development of color photography.

WORLD WAR II AND THE POST-WAR PERIOD: 1942–1950

On 1 January 1942, the nation was still in shock over Japan's attack on Pearl Harbor. New Year's Day saw the issue, in Washington, D.C., of a Declaration of the United Nations by twenty-six countries—an affirmation of their cooperation against the Axis. Utah was headed by another Democrat, the newly-elected Governor Herbert B. Maw.

Under Governor Maw, the state continued a pattern of expanding federal influence established in the earlier decades.

The second world war also brought reversal of Utah's thirty-year pattern of out-migration. During the war years, Utah's population began to grow at a rate faster than the national average, this as a result of new jobs and many new babies. The period of war and its aftermath marks the pivotal phase of two great movements centered in the state—the ongoing Americanization of Utah and the LDS Church's vigorous renewal of internationalism, with the Mormonization of the world as its goal.

Wartime construction and population increases came on the heels of the Depression-era construction and cultural advances made in the previous phase. All that federal money had been good for the arts, providing buildings, an administrative structure, and heightening cultural awareness in the state—not only for the visual arts, but music, literature, and speech as well.

CAREERS ONGOING: BOTH OLD AND NEW

Professor A. B. Wright, having gone to Europe after his forced departure from the University of Utah, was captured by the Germans just after the invasion of France. The elderly painter spent several years in a prison camp under deplorable conditions. Friends and family kept him supplied with food, clothing, and art supplies however, and he continued to paint in pathetic circumstances until he was released in 1945. He died on 5 December 1952 in Le Buge, Dordogne, France, at the age of seventy-seven.

Meanwhile, Lee Greene Richards continued to teach at the U for nine years after his friend A. B.'s departure (*Self-Portrait,* 1942, SMA). The fresh, dashing portrait style of Richards's earlier years became (in Haseltine's words) "rather woolly" in his old age, but Lee Greene lived on as a respected elder of Utah's artistic community until early 1950. His death saddened everyone who had known him at all. The *Salt Lake Tribune* obituary read in part:

> The man who did the likenesses of governors, mayors, church officials, and other dignitaries of this state has finally laid away his brushes and palette. He leaves behind

not only memories of a kindly and generous artist, but hundreds of portraits and landscapes that gained him an enviable place among western painters.

When George Thomas appointed landscapist LeConte Stewart to succeed A. B. Wright as chairman of the art department in 1938, he gave the school a long-lasting legacy of influence. Stewart stayed at the university for eighteen years and those who worked under his leadership include not only the older Mabel Frazer, Jack Sears, Harvey Gardner, Florence Ware, Bernice Magnie and Lee Richards, but such later appointees as George Dibble, Avard Fairbanks, Alvin Gittins, Ruth Muroff, Dorothy Bearnson, Elbert Porter, Carmen Brooks, Delbert Smedley, Arnold Friberg, Keith Eddington, Sherm Martin and Doug Snow.

Stewart himself remained a dedicated realist painter (*Private Car,* 1937, MCHA, **plate 53** and *Threshing Wheat in Porterville,* 1948, SMA, **plate 68**) throughout a very long career stretching into the 1980s. By the time he retired in 1956, the essential form had been established for what became the dominant college art program in later decades. Much of the credit also belongs to Avard Fairbanks.

In 1946 (inspired by postwar expansion), U of U president, A. Ray Olpin, recommended that the fields of music, drama, dance, art and architecture be brought together and administered in a new School of Fine Arts. As a result, the University Board of Regents authorized Olpin to negotiate with Professor Avard T. Fairbanks, widely renowned as a sculptor in the faculty of the University of Michigan, to accept employment as first dean of the school.

Quite obviously, President Olpin had already been in contact with Fairbanks by the time of all these public pronouncements. In 1947 he came as dean and professor of art. That same year Bearnson, Muroff, Porter, Brooks, Smedley and Gittins joined the art faculty as well. The next few years saw great growth in the fine arts at the University of Utah, including the 1951 establishment of the Utah Museum of Fine Arts on the fourth floor of the John R. Park Building.

Yet the department was not without conflict. Dean Fairbanks was a progressive teacher, but an arch-conservative as an artist.

Within the context of the Cold War era of the 1940s and 1950s, much of Fairbanks's philosophy could be interpreted as a strong suggestion that modern abstraction was part of an international communist conspiracy. The year before Fairbanks's deanship ended in 1955, he had founded a separate, and very conservative, Department of Sculpture. That department's sculpture, ceramics, and industrial design program lasted until 1962, and included a small faculty drawn from the art department (Fairbanks as chairman, plus Elbert Porter and Dorothy Bearnson), as well as such associated teachers as Justin Fairbanks (one of the master's sons) and a young Ed Fraughton (just beginning his highly successful sculptural career). Meanwhile, the very talented and interesting sculptor, Angelo Caravaglia, was designated a "three-dimensional designer" over in the Department of Art—hopelessly tainted as it was by modernism.

Earning his bachelor's degree (1948) and M.F.A. (1950) while he taught at the University of Utah (instructor of art 1947–1952), Elbert H. Porter (1917–) also served as assistant professor of art, 1952–54 and assistant professor of sculpture, 1954–62), before resigning (with tenure) in 1962 to pursue sculptural projects on a larger scale (*Dinosaurs* in Vernal, etc.) His painting of *Orderville,* (Daughters of Utah Pioneers) is also quite well known locally as a topographical study of that early settlement in southern Utah.

Among the local talents who studied with Avard T. Fairbanks during his long career, the gifted sculptress and poet, Alice Morrey Bailey (1903–) is certainly one of the most interesting. Bailey was born in a small town of Joseph, Utah. She was a student at the University of Utah, first under Harwood, then Wright and Mabel Frazer. Bailey was employed by Torlief Knaphus on that sculptor's *Handcart Company* project while she studied further with Millard Malin and again at the university under Fairbanks. Throughout this ongoing study, she maintained her independence, and her marble, *Sappho* of 1943 (SMA) is an excellent example of the supple shaping her work can exhibit.

RETROSPECTIVES AT SPRINGVILLE

In 1990, Retrospectives, Inc., a non-profit group dedicated to preserving the art history of Utah, presented two simultaneous retrospective shows at the Springville Museum of Art. One (*Looking Back: A Three-Score Career*) celebrated the work of Theodore Milton Wassmer (1910–), the other displayed the work of Francis Hubert Zimbeaux (1913–) and his father, Frank. The stories of Wassmer and Zimbeaux, with their commonalities and differences, can stand for the stories of myriad other artists of the postwar period.

Francis Zimbeaux was born on Bastille Day. As an infant he traveled to Europe with his mother and then rejoined his father in rural Missouri where they lived eleven years. Francis remembers his childhood as a time when he played in magical forests, and heard stories of his parents' years in Europe.

In 1931 at the age of eighteen, he entered the Civilian Conservation Corps in southern Utah. It was his first experience away from home and it gave him the chance to develop his lifelong love of wilderness. He held several jobs in the CCC, but his favorite was "official bird bander in Zion National Park."

During World War II, Zimbeaux was drafted into the Air Force. He served for two years in the Azores where he developed a theme which has persisted throughout his career: figures—usually three—at the water's edge (*Beach at Terceira, the Azores* 1948, p.c.). His formal education came after the service—study with Bert Pumphrey at the Art Barn School and with LeConte Stewart and Alvin Gittins at the university.

His powerful fauvist-inspired landscapes construct, as Haseltine says, "an utterly convincing unselfconscious *parallel reality,* one built on a gentle, but strongly focused personal vision" (*Mystical Night*, 1948, p.c.). Francis is

also known for his extraordinary, otherworldly nudes (*Nude Bather,* 1948, p.c.). Visitors to Zimbeaux's century-old farmhouse notice his sweet, ethereal quality.

But if Zimbeaux is the shy seeker of rural refuge, Ted Wassmer epitomizes the outgoing artist who craves urban stimulation. Born in Salt Lake City, Wassmer was the eldest of eight children. He worked as a printer's devil in his youth and his first color paintings were made with discarded printer's ink. Seeing Frank Zimbeaux selling paintings in front of the old Salt Lake Theatre inspired Wassmer to become a painter. He even bought one to take home and study the technique. In 1929, bored with the printing trade, he took a job with a wholesale hardware firm at a salary of $55 a month. When the Depression hit hard, he became the sole support of his large family.

Wassmer wanted to go to the Chicago World's Fair in 1934 and financed the trip by selling his paintings. He remembers seeing Duchamps's *Nude Descending a Staircase,* not understanding it, but liking the design and color. Upon his return to Salt Lake, Wassmer became a student of Florence Ellen Ware.

As Ware's assistant, he chauffeured her on painting trips (accompanied by her father, the architect Walter Ware) to New Mexico and the Tetons (see Wassmer, *Florence Ware Swinging Under a Willow Tree,* 1937, SMA). While assisting and modeling for Ware on her Kingsbury Hall FERA mural project, Wassmer met Judy Farnsworth Lund, who was state art director. She moved to New York while he stayed in Salt Lake City, where his bachelor apartment on the Avenues was a center of activity for artists and musicians. (Wassmer, *Red Canyon on the Green River,* 1938 and *Timpanogos Peak,* 1939—both SMA).

He visited Lund in New York in 1941 and they corresponded all during World War II. Forsaking an offer of a contract at Paramount Pictures after Pearl Harbor, the handsome Wassmer enlisted in the Army Air Force in January of 1942. During off-duty hours, while stationed at Sheppard Field in Texas, he painted murals depicting "the Air Force in Action," and entertained the troops with his piano playing. In Mexico on furlough, he underwent an emergency appendectomy, and when he awoke from the anesthesia, found his painting arm paralyzed. He was transferred to a Brigham City hospital for therapy, and somehow managed to obtain another furlough, fly to New York, and become engaged to Judy Lund. They were married in 1945, and eventually settled in New York City and then in Woodstock, N.Y.

Wassmer attended the Art Students League to study with Yasuo Kuniyoshi, John Carroll, Arnold Blanch, Jon Corbino, Robert Beverly Hale and Sigmund Menkes. He also worked two years with Raphael Soyer at the American Art School. (See Wassmer, *Springtime Ballet,* 1949 and *Easter Bonnet,* 1950, **plate 70**—both SMA.)

After his work at the League, Wassmer gave up landscapes and concentrated on figure painting, specializing in compositions inspired by theatre and the dance. He cites Soyer as his greatest influence, and Vern Swanson observed that there is a "whole slice of New York that would be lost to Utah if it weren't for Lund and Wassmer."

Since their return to their home state in 1985, Wassmer and Lund have given more than 600 works—to Springville, the Brigham City museum and Snow College in Ephraim—from their personal collection gathered in America and Europe over fifty years.

In many ways, the year 1950 is not a natural transition. Most of the artists active in the years just after the war continued to be active well into later decades. The end of the federal projects, and the advent of a peacetime economy brought challenges and changes to the Utah arts community—challenges which have been met with innovation, changes which have encouraged diversity.

PLATE 64

Carlos J. Anderson,
Snake River, Near
Bliss; *c. 1942, oil on board,
28 3/4" × 41"; SMA, gift
of the Grace Muir
Collection Trust.*

Cornelius Salisbury,
Curtain Time
Pioneer Theatre, Salt
Lake; *1947, oil on board,*
24 1/2" × 33 1/4"; SMA,
gift of the Springville
Junior High School
Seventh Grade, 1947.

PLATE 65

Henry Rasmusen,
Allegory of War;
1943, pastel, 19" × 26 1/4";
SMA, gift of Mary Louise
Kimball, in memory of
Ranch Kimball.

PLATE 66

PLATE 67

*B*ent F. Larsen,
County Fair; *1943,
oil on canvas, 32" × 40";
Utah State Fine Arts
Collection, courtesy of
the Utah Arts Council.*

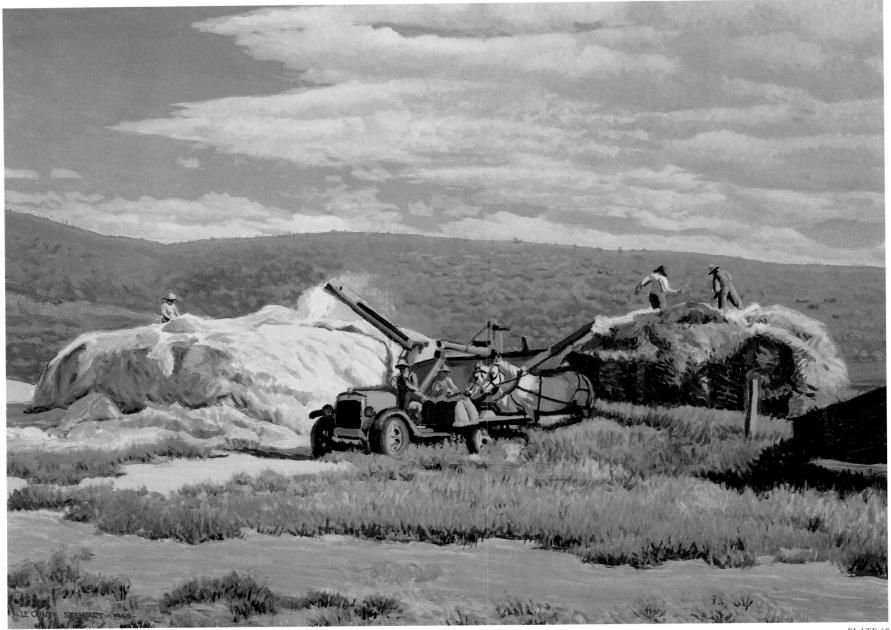

PLATE 68

*L*eConte Stewart, Threshing Wheat in Porterville; *1948, oil on board, 21 1/4" × 30"; SMA, gift of the Springville High School Junior Class, 1952.*

PLATE 69

*A*lvin Gittins, Card
Players; *1959, oil on
canvas, 20" × 44"; courtesy
of a private collector.*

PLATE 70

*T*heodore Milton Wassmer,
Easter Bonnet; *1950,
oil on canvas, 24" × 20";
SMA, gift of the
Lund-Wassmer Collection.*

PLATE 71

***P**aul Salisbury,*
Riders of the Range;
1953, oil on canvas,
30" × 36"; SMA, gift of
Max and Kolene Knight,
Springville.

Lynn Fausett, Angel's Arch; *1962, gouache on board, 36" × 48";* SMA, *gift in memory of Ruby J. Fawcett from her husband, Bill.*

PLATE 72

Denis R. Phillips, Near St. Charles, Idaho; *1974, oil on canvas, 22" × 28";* SMA, *gift of the Geneva Steel Corporation.*

PLATE 73

*E*verett Thorpe, Snow Banks; *1956, oil on canvas, 32" × 40"; courtesy of a private collector.*

PLATE 74

J. Roman Andrus, Cadmium Crest; *1964, oil on canvas, 30" × 38"; SMA, gift of the artist.*

PLATE 75

V. Douglas Snow,
Desert Landscape;
1959, oil on canvas,
68" × 44"; SMA, gift of
Nathan B. Winters,
Salt Lake City.

PLATE 76

PLATE 77

H. Lee Deffebach, Normandie Beach; *1956, oil on canvas mounted on board, 36" × 34"; SMA, gift of Mary Louise Kimball, in memory of Ranch Kimball.*

PLATE 78

H*. **Lee Deffebach**,*
Zelda: Los Truches;
1973, acrylic on canvas,
69 1/2" × 69 1/2"; SMA.

PLATE 79

*R**uth Wolf Smith,** Allegory of the 1960 Presidential Election; *1960, oil
and metalics on board, 38" × 28"; SMA, gift of the Geneva Steel
Corporation and Joseph Cannon.*

William J. Parkinson,
House Wife; *1961,*
oil on board, 16" × 20";
SMA, gift of the artist.

PLATE 80

Trevor J. T. Southey,
Eden Farm; *1976,*
oil on board, 48" × 72";
SMA, gift of Carole
Hoffman, Lido Gallery,
Park City.

PLATE 81

PLATE 82

Donald P. Olsen, Composition; *1963, oil on canvas, 70" × 68 1/2";*
SMA, gift of the A. Merlin and Alice Steed Collection Trust.

Donald P. Olsen,
Chelsea VI; *1980,
acrylic on canvas,
67 1/2" × 80"; SMA.*

PLATE 83

Maureen O' Hara Ure,
Mystery Theatre;
*1981, paint and fabric on
wood, 12 1/4" × 33 3/4";
Utah Museum of Fine Arts,
1985-15, Friends of the Art
Museum Collection.*

PLATE 84

*H*arrison T. Groutage, Along the Bear River; *1978, acrylic on canvas, 36 3/4" × 48 1/2"; SMA.*

PLATE 85

*E*arl Jones, Near Francis, Utah; *1978, oil on canvas, 20" × 24"; SMA, gift of the Lund-Wassmer Collection Trust.*

PLATE 86

PLATE 87

*V**aloy Eaton,* Sun,
Snow and Ice; *1981,
oil on board, 36"×48";
SMA, gift in memory of
W.W. Clyde, from his
daughters, friends, and
employees.*

PLATE 88

*B*onnie Sucec, Untitled;
1981, mixed media,
21 5/8" × 31 5/8"; Utah
Museum of Fine Arts,
1981-90, gift of the artist.

PLATE 89

Gary Ernest Smith, Youthful Games; *1984, oil on canvas, 48″ × 48″;
SMA, Lund-Wassmer Collection: Vern G. and Judy Swanson, Springville.*

*E**dith Roberson,* Channel Three; *1981, oil on board, 24" × 36"; SMA, gift of the A. Merlin and Alice Steed Collection Trust.*

PLATE 90

*N**eil Hadlock,* Effron; *1983, corten steel, 70" × 157" × 44"; SMA.*

PLATE 91

PLATE 92

R*obert L. Marshall,* Money Plant; *1982, oil on canvas, 60" × 48";*
SMA, gift of the George L. and Emma Smart Collection Trust.

PLATE 93

***D**avid Dornan,* Chair; *1983, oil on canvas, 61" × 72"; Utah State Fine Arts Collection, courtesy of the Utah Arts Council.*

PLATE 94

Randall B. Lake, The Studio Walls; *1984, oil on canvas, 39" × 32";*
Utah State Fine Arts Collection, courtesy of the Utah Arts Council.

*W*ulf E. Barsch,
 Toward Thebes;
1985, oil on canvas,
72" × 48"; SMA, gift in
memory of Ruth H. Nemelka
from David and Ingrid
Nemelka, Mapleton.

PLATE 95

James C. Christensen, Fantasies of the Sea; *1985, acrylic on board, 36" × 24"; SMA, gift of Blaine P. and Louise Clyde, Springville.*

PLATE 96

V. Douglas Snow, Cockscomb, Near Teasdel; *1985, oil on canvas, 68" × 84"; SMA, anonymous gift from Mapleton.*

PLATE 97

F. rank R. Huff Jr., Living Their Religion; *1987, oil on canvas, 48" × 54"; SMA, gift of the artist.*

PLATE 98

PLATE 99

***S**am Wilson,* Crow Crowded; *1985, acrylic on canvas, 36" × 42"; SMA, gift of the Dr. George L. and Emma Smart Collection Trust.*

PLATE 100

*J*eanne L. Lundberg Clarke,
The Earth is Full of the
Goodness of the Lord: Portrait
of Rebecca; *1985, oil on canvas,
44" × 60"; SMA, gift of Mark
and Nancy Peterson, Alpine.*

Gibbs M. Smith, Manhattan; *1988, oil on canvas, 49" × 50"; SMA, gift of the artist.*

PLATE 101

F. Anthony Smith, Cure; *1988, acrylic on canvas, 48 1/2" × 70"; SMA, gift of Louise C. Clyde, Springville.*

PLATE 102

PLATE 103

Paul H. Davis,
Enigmatic Figure;
1988, oil on canvas,
40 1/2" × 45 3/4"; SMA,
gift of the artist.

PLATE 104

Bruce H. Smith,
Jacob and Leah; *1990,*
oil on canvas, 48" × 60";
LDS Museum of Church
History and Art.

PLATE 105

Lee Udall Bennion, Full Bloom: Nicole and Daniel Ben Yehuda; *1989,oil on canvas, 40" × 30"; SMA, gift of Ray and Sue Johnson, Scottsdale, Arizona.*

PLATE 106

*D*ennis V. Smith, Keeper of the Gate; *1989, oil on canvas, 60" × 60";*
SMA, gift of David and Ingrid Nemelka, Mapleton.

Richard J. Van Wagoner, Donor Bank; *1990, oil on canvas mounted on board, 48" × 72 3/4"; SMA, gift of the Geneva Steel Corporation.*

PLATE 107

Allen Bishop, La Semilla Brota; *1990, oil on canvas and board, 56" × 88 1/2"; SMA, gift of the Geneva Steel Corporation.*

PLATE 108

Carol P. Harding,
Tinaja Voyage, West
Temple Zion; *1989, oil on
canvas, 42" × 50";
SMA, gift of the Geneva
Steel Corporation.*

PLATE 109

Gaell Lindstrom,
Remembering Butte;
*1991, watercolor, 11" × 17";
courtesy of the artist.*

PLATE 110

PLATE 111

***K**enneth B. Baxter,* Sheds in Herriman; *1991, oil on canvas, 28" × 22"; SMA.*

PLATE 112

*M*ichael Coleman,
Indian Camp; *1991,*
oil on canvas, 30" × 46";
courtesy of a private collector.

The Contemporary Scene

Vern G. Swanson

UTAH ART AT MIDCENTURY

With the demise of the New Deal Federal Art Project and the aftermath of World War II, Utah art was at an impasse during the late forties. The state's art at midcentury might be summed up in words that art historian Ellis Waterhouse used to combat criticism of British art during this same period, "Let us not decry our art for not being better, but rather let us search for what is good and useful."

Nevertheless, in 1950 Utah seemed to be, like the rest of the nation, poised on the edge of artistic maturity. Though no distinctive Utah style had emerged, growth had been both steady and satisfying. Without doubt, the state could boast a fine painting tradition which reflected most of the national and international developments of the latter half of this century.

Unlike the major metropolitan art centers of the country, Utah did not draw waves of foreign talent from the more advanced European schools of art. With two exceptions—the academic painter Alvin L. Gittins (1922–1981), and sculptor Torlief Knaphus (1881–1965)—most of the artists working in the state during this period were Utahns.

Despite the state's apparent geographic, economic and religious isolation, national trends influenced the work of Utah's student artists, who continued to travel to the prestigious art schools in the East. Even so, the radical innovations of twentieth-century American modernism were slow to gain support in Utah. A strong emphasis on traditional representationalism, on art that was "good" and "useful," persisted throughout these years. Still, Utah's first generation of modernists had, by midcentury, already established some major lines along which art would advance in the ensuing decades. Included were some of the midcentury modernists in Utah, like Calvin Fletcher (1882–1963), Everett Clark Thorpe (1904–1983), and J. Roman Andrus (1907–), who were more influenced by regionalism and the Art Students League teachings of Kenneth H. Miller, Barnard Karfiol and George Biddle, among others, than more radical exemplars. The work of other innovators, such as George Dibble (1904–), Henry Neil Rasmusen (1909–), and the transitional figure, Donald P. Olsen (1910–1983), form a more direct line with radical modernism.

One of Utah's most significant early modernists, Henry N. Rasmusen, left the state in 1950 to teach at the University of Texas. Before his departure he wrote an article for a January issue of the *Deseret News* entitled "Young Utah Artists." Rasmusen identified the finest young talent in Utah, working, as he was, in the more contemporary trends of the day—those that he said were "looking ahead, molding new forms and ideas that mirror the present and predict the future."

Rasmusen identified twelve nascent artists who were attempting to "express themselves in fresh new ways, to create, not in a language appropriate to a past generation, but according to their own new vision and times." Prophetically, he highlighted the work of V. Douglas Snow (1927–) and Gaylen C. Hansen (1921–)—both would become highly respected artists. The other ten, however, are either completely unheard-of or little known.

His article illustrates a major problem in chronicling the history of recent art, the discrepancy between contemporary opinion and the vision of the art historian looking back into the past. Growth in the number of artists, diversified styles and critical literature created another problem

in writing a definitive history of Utah art for the second half of this century. By 1950, a single Territorial Fair "Art Section," Spring Salon in Springville, or Arts Council Annual, was not enough to adequately represent Utah art.

Two 1947 centennial exhibitions can be used as a barometer of the vitality of Utah art at midcentury. The first, the Springville Art Association's show, exhibited painting that blended regionalism and impressionism. A pervasive conformity to a style that might be termed "Depression impressionism" held sway. It consisted largely of "old barn and quaking aspen" paintings and a disproportionate number of floral watercolors by female artists.

Representationalism likewise dominated the 1947 Salt Lake Fairgrounds Centennial exhibition, although a number of nationally known artists also exhibited. These infused Utah's local school with contemporary impulses, like the work of the New York expressionist Max Weber, a much-needed exposure to fresh new work. Not everyone reacted favorably to this confrontation with avant garde art at the state fair. Mayor Glade, of Salt Lake City, called Weber's work "a product of insanity," perhaps reflecting a common attitude at the time. At this, nineteen-year-old V. Douglas Snow wrote a letter to the mayor challenging his outright rejection of something that he clearly did not understand. Once confronted, the mayor apologized and noted that other points of view on modernism could be held honestly and by mentally well-balanced citizens. Clearly, public resistance to modernism would retard its acceptance in the state.

Despite a climate more conducive to the introduction of and experimentation with new styles, the 1940s and 1950s were a period of limited artistic production in Utah. Years of depression and war took their toll on the numbers of working artists and limited their output. The Springville Salon, Utah Art Institute Annuals, and state fairs were glutted with mediocre work, usually of the amateur class. By contrast, the more solid work of Bent F. Larsen (1882–1970), LeConte Stewart (1891–1990), J. Roman Andrus and Alvin Gittins stood out against that backdrop.

UTAH EXPATRIATES

After the First World War, New York and Chicago beckoned most of our artists for study and careers. With the rise of the American art museum and the increased sophistication of art academies in the United States, Paris's appeal for American artists declined. Some Utah artists, such as Cyrus Dallin, had already established residency in the East. Mahonri M. Young (1877–1957) first settled in New York in 1905, where his sculptural work, for sheer expressive force, gained national attention. He worked in a style similar to the British realist sculptor Albert Toft, which emphasized gestural modeling rather than excessive tooling of the surface. He mastered several media, including oil, watercolor, and especially etching; but by midcentury his health was failing and his best creative years were past.

In New York, Chicago, and Boston, Utah artists confronted the art world through the studios, schools and galleries that fed off the energy of these metropolitan areas. First, it was Robert Henri's studio in New York that attracted many of our best artists, including Minerva Teichert and Jack Sears. Then the Art Students League, at 57th Street, began to attract the next three generations of artists from Utah, including Lynn Fausett (1894–1977), Theodore Milton Wassmer (1910–), William Dean Fausett (1913–), Bruce H. Smith (1936–), and Earl Jones (1937–).

The eastern-bound Utah artist Waldo Park Midgley (1888–1986) first studied in New York in 1905. His work had a contemporary feel, and he continued to paint with strength through the decade of the fifties. Louis Heinzman (1905–1982) spent a considerable amount of his career between Utah and California. He was associated with the "desert painters" of the Palm Springs school of landscape painting. Gordon Cope (1906–), whose career was inextricably connected with the WPA program of the 1930s, had, like John Willard Clawson, moved from Utah to the West Coast. There his work found popularity and ready purchasers for its vigorous impressionistic realism. His *Sierra Snow Scene,* painted when he was seventy-two-years-old, (1978, SMA) has a scale, boldness, and subtlety usually lost by older artists.

During his student years, Cope criticized Theodore Milton Wassmer for not producing "art." But after moving to New York in 1947, Ted Wassmer and his wife, Judy Lund, a talented artist in her own right, began to create works of greater aesthetic viability. There he began to experiment with various styles, as his *Labyrinth* (1950, SMA) reveals in its abstract expressionistic ruminations. By 1954 he had developed a new technique called glapasto, which balanced glazes and thick impasto pigmentation.

Lynn Fausett was much influenced by Kenneth Hayes Miller and, after successes at the Art Students League in New York, returned to Utah in the forties for the balance of his career. He was the chief muralist in Utah during

the midcentury, but this activity was cut short in the early sixties due to injuries he received in an automobile accident. He did, however, continue to paint large-scale easel pictures such as *Angel's Arch* (1962, SMA, **plate 72**), which was exhibited in the national Supreme Court building in Washington, D.C. in 1962. It was credited, by Senator Frank Moss, with influencing Congress to create Arches National Park.

William Dean Fausett (1913–) became better known nationally than his older brother. Like Lynn, his professional career took him to New York, then to Vermont; but unlike Lynn, he never returned, except in response to a great number of portrait commissions from the LDS church, Brigham Young University, and wealthy private sitters.

THE BATTLE OF STYLES

The controversy that arose in Springville in 1950, regarding the purchase of an oil by the East coast artist Iver Rose, epitomized the ongoing conflict between traditional and more modern art. Rose's oil entitled *He Said,*

She Said, of several gossipers in a circle, was painted in an under-finished, flat, stylized manner unacceptable to the citizens of the city. The painting had been selected from the National Spring Salon by the art board. The unveiling created a wave of discontent among those who felt that the Springville Art Museum was becoming too modern. While the painting seems tame measured against other modern work, Utah County was even more conservative than Salt Lake.

In spite of this, the Utah State Institute of Fine Arts exhibit in 1951 at the State Capitol Building differentiated between the conservative and modernist styles in terms of exhibition space and award categories, an admission by the establishment that modernism must be officially dealt with. This seeming divergence over styles created an impossible situation, polarizing the arts in Utah throughout the decade.

That same year, 1951, representational art still dominated the exhibit. Alvin Gittins won the purchase prize for what was described as a "conservative portrait." But by the end of the 1950s, the traditionalists had lost out

to the more contemporary strains in the Utah annuals. The Utah Arts Council (Utah State Institute of Fine Art), for the preceding fifteen years, had strongly emphasized a more contemporary viewpoint with formidable hegemony.

For a brief time, the modernists had exhibit space, when, in March of 1952, the Contemporary Gallery of Art opened at 60 Post Office Place in Salt Lake City. An artist's cooperative, it burst upon the scene unapologetically as a modernist gallery. The star of its opening show was the Utah painter (then living in Mexico) Gordon Bailey. His huge and complex composition in green, red, yellow and orange, outlined in black, ". . . is the most spectacular work in the show," according to reviewer James Fitzpatrick in the *Salt Lake Tribune*.

The exhibition unveiled the work of the young Lee Deffebach (1928–) and other little-known artists of that day. More familiar were examples of contemporary art by Calvin Fletcher, Ev Thorpe, George Dibble, Gertrude Teustch, Myra Grout Powell (1895–1983), and Francis Zimbeaux (1913–). Most of the participants were young and those more mature artists either lived some distance from or were not available to administer the gallery, which soon closed. Despite modernist enthusiasm for the gallery, public support was not sufficient to support it. Similar to G. M. Ottinger's assessment of the 1862 Deseret Academy closing, we might say that the Contemporary Gallery of Art was "a little premature."

The decade when modern artists were struggling for recognition was also notable, both in Utah and in the nation, for its turbulence and violent extremes of style, bitter arguments, and incessant experimentation. The art of the New York school of Jackson Pollock, Willem de Kooning, Robert Motherwell, Ad Reinhardt, Clyfford Still, Franz Kline, Barnett Newman, and Mark Rothko dominated most of American art. Thanks to the articles of critics Harold Rosenberg and Clement Greenberg, Utah artists were exposed to the language of abstract expressionism. Radical changes in style, technique, and intent resulted in paintings on a new, larger scale that effaced the remaining differences between line and paint and affirmed two-dimensionality. The "friction in Zion" over the newly exalted torrential process of "action painting" paralleled the same "war of styles" being fought throughout the United States at the time.

The battles, which had been fought since the thirties, were mostly played out in Utah in the Art Barn (renamed Salt Lake Art Center in 1953) at Finch Lane, a gallery committed to the presentation of experimental art. The Utah State Art Center in 1942 had confronted the problem with a major exhibition and a manifesto articulating the goals of modern art, drafted and signed by George Dibble, William J. Parkinson, Henry Rasmusen and other exhibitors.

One of the most significant artists of the Utah modernist school to emerge from this period was Donald Penrod Olsen. Like Dale Fletcher and Lee Deffebach at this time, he was not closely associated with the state's major universities. He was, in fact, a high-school teacher in Jordan, Utah, and an instructor at the Art Barn. Olsen, Snow, and Deffebach became the most persuasive protagonists of nonobjective abstract art from the 1950s to 1980s. Unlike Snow, with his elegant amorphous landscapes, Olsen worked through many of the modernist languages of art more brutally, from "brushed-action-painting" abstract expressionism to "hard-edge" minimalism.

Olsen's "fill in between the framework of lines" Gothic abstract painting *Abstraction #4* (1953, SFAC) was exhibited at the State Fair and purchased for the state despite widespread controversy. His style became freer after he studied the summer of 1954 at Hans Hofmann's School of Art in Provincetown, Massachusetts. In 1955 he exhibited at the Salt Lake Art Center with a one-man show developed from his recent study with Hofmann. For a decade more, he would be known solely for his large, thickly painted-with-muscle brushwork. Olsen understood the intent of abstract expression better than any other Utahn.

H. Lee Deffebach, a native of Houston, Texas, was also preeminent among the abstractionists of the second generation. Abstract expressionism in the fifties, pop art in the sixties, and color field in the seventies were her major areas of concentration. Like Olsen, she has worked through several stylistic changes in her painting. She first studied at the University of Utah (B.A., 1949) and then on scholarship at the Art Students League. Deffebach received a Fulbright Fellowship in 1954–55 to study in Florence. She also studied with several New York modernists during the mid-1950s and early 1960s.

Deffebach's early works, such as *Normandie Beach* (1956, SMA, **plate 77**), convey a strong foundation in the principles of abstract expressionism. By the end of the fifties she had powerfully engaged her training and native sensibilities into canvases of scale and power. More than the other giants of Utah modernism, she was a colorist and concerned herself with nuance rather than with impasto or iconographic images.

Besides Deffebach, V. Douglas Snow and Dale Fletcher, who had returned in 1956 from Berkeley, were painting in an abstract expressionistic style.

COWBOY-WESTERN ART

Unlike other western states, Utah never had a strong cowboy-western school of art. Shepherding, rather than cattle ranching, dominated much of the state, a mythic tradition rarely pictorialized by artists. Peaceful farming was not the stuff of high adventure, and the early Mormon artists exulted more in the landscape than in the human struggle to subdue it.

Earlier Utah artists who did work in this western genre include Cyrus E. Dallin, Francis Horspool (1871–1951), Maynard Dixon (1875–1946), Mahonri M. Young, and Minerva K. Teichert (1888–1976). Dallin's work almost exclusively portrayed the noble Indian, usually on horseback in a somewhat classical style. He produced most of his work, as did M. M. Young, in the East. Young's work was different in that his few western pieces were snippets of low-life genre. His *Rolling Your Own* (bronze, MFA/BYU) depicts cowboy life in the plainest terms, which would have been anathema to Dallin.

Minerva K. Teichert (1888–1976) probably painted more square feet of canvas of pioneer and Indian subjects than any other Utahn. In 1950, after four years' effort, she completed fifty large-scale oils on the Book of Mormon. A monumental effort, these oils received little critical acclaim until after they were donated to BYU in 1969. By the 1980s, her work was finally recognized for its artistry, monumentality, and originality. Evaluating her oeuvre, one sees compelling evidence of her greatness.

Teichert's canvas entitled *Christ Is the God of This Land* (1950s, SMA) reveals the economy of detail and texture, strength of form, and power of image that characterize her tonal oils. She dealt with the epic subjects worthy of Friberg and Cecil B. De Mille. She painted the great themes of humanity which were central to our panoramic view of western and Mormon history. Her style of painting was largely unique and original to herself. Perhaps even more to her credit, she was able to be artistically prolific while raising a large family on her Wyoming ranch.

The growing trend during the fifties and sixties toward cowboy-western art manifested itself in the painting of Paul Salisbury and the sculpture of Hughes Curtis. Paul Salisbury (1903–1973), of Provo, was a significant "cowboy and Indian" artist. He was one of Utah's very few professional artists working full-time on his art and not affiliated with a university. It was apparent that Salisbury's conservative painting style was perfectly suited to traditional Utah tastes. His *Riders of the Range* (1953, SMA, **plate 71**) illustrates his ability in composition. Unlike most artists, Salisbury was able to paint his best work in the decade immediately preceding his death in 1973.

A barber by trade, Hughes William Curtis (1904–1972) was Utah's first real cowboy-western sculptor of note. Though self-trained, he was capable of convincing representations of cowboy life. He is credited, along with Glenn Turner, also of Springville, for building the first bronze fine-art foundry in Utah in the early 1950s at Springville. At this foundry, U. S. Grant Speed (1930–) and sculptor/foundryman Neil Hadlock gained their early experience. Curtis' *Rim Rock* (1961) and *Saddling Up* (both SMA) are notable for their authentic detail and forcefulness.

Along with Salisbury, Utah's most significant western artist is Arnold Friberg, who portrayed the Old West more authentically than it ever was in real life. Raised in Arizona and steeped in the art of the Old West, by the early fifties Friberg was producing high-adventure cowboy and Indian paintings. Through his dealer, Alan Husberg in Scottsdale, Arizona, his carefully crafted, heroic action pictures became national treasures. From the fifties to the eighties, he became increasingly known for his easel paintings of western genre. An excellent composer and draftsman, Friberg's authentic portrayals of the American Indian, the rough cavalry soldier, saloons, and locomotives have inspired a later generation of Utah western artists.

METAPHYSICAL AND METAPHORICAL ART

The metaphysical and metaphorical in art can be conveyed in a litany of styles: allegorical, mystical, mythological, Rosicrucian, science fiction, fantasy, shamanistic, spiritualistic, symbolistic, theosophical, dada, surrealistic, and visionary, to name a very few examples. There is no convenient umbrella term to describe this type of art—art which probes the metaphysical and metaphorical, and follows, to quote Novalis, "the mysterious road which leads to the interior." I have often called it "Art Extra-Ordinaire," but for the purposes of this discussion, I will use more familiar terms.

It is art that is aesthetically beyond conventional or objective human experience—it is inherently spiritual. It transcends the boundaries of dogma but probes the

artist's soul, the "Inner Landscape." In Utah, visionary and spiritualist artists often utilized the conventions of traditional art and the radicalism of the modernists to their advantage. Though there have been periods when metaphysical art coupled with modernist movements—with the Nabis, Belgian symbolists, secessionists, dadaists, surrealists, and so forth—generally speaking, it remained more private than public.

In Ruth Harwood (1896–1958), James T.'s daughter, Utah found its first full-blown metaphysical artist. It was probably through her mother, Harriett Richards, that she developed her interest in theosophy and spiritualism. Ruth Harwood's symbolist art was strongly influenced by the work of Aubrey Beardsley and the Belgian symbolist Jan Toorop. She devoted most of her career to creating symbolist and metaphysical posters, cards, graphics, and book covers for theosophical tracts and literary publications. It was generally conceived in a style related to the Art Nouveau and Deco treatments of the day. The quality was superlative, especially in such works as her *Wisdom* (nd., SMA).

One of the most idiosyncratic Utah artists of the mid-twentieth century was William J. Parkinson (1899–), of Salt Lake City. Starting about 1944, his heretofore typical WPA "Depression style" pictures began to take on more mystical overtones. Parkinson's work, such as *Crucifixion* (c. 1944, SMA), helped lay the cornerstone of a modernist symbolist-surrealist movement in Utah. His arcane oil, *Within the Ancient Underground Temple of Oude* (c. 1945, SMA) was one of Utah's very first mature metaphysical paintings. It is a surrealist contrivance with cubist influences. He was one of the first Utahns to accomplish this through his experimentation between 1944 and 1965. Not one to follow the New York school, as the situational aesthetics of Don Olsen were prone to do, Parkinson still struck a contemporary chord in his work. His self-portrait of about 1950 demonstrates psychological self-examination. By the late fifties and throughout the sixties, he began to place greater reliance upon oriental cultish and mystical motifs, especially Tibetan art. His *House Wife* (1961, SMA, **plate 80**) exemplifies Sino-symbolist influences upon his middle to late periods.

In the late fifties, Ruth Wolf Smith (1912–1980) of Salt Lake City began to produce works of an allegorical or fantastical nature. Her *Allegory of the 1960 Presidential Election* (1960, SMA, **plate 79**) is one of Utah's first fine-art political satires. It depicts Richard Nixon and Henry Cabot Lodge riding an elephant, while Lyndon Johnson leads the ass on which John Kennedy is riding. Behind them, as they follow the golden road to the White House, is a bandwagon, the sheep and goats, and the state delegates. All are painted in her typical American regionalist style, so different from her husband, Paul Smith's wispy landscape watercolors.

After the fifties, the state's university art departments provided the forum for the battle of the styles. It was George Dibble, Alvin Gittins, V. Douglas Snow, and Angelo Caravaglia, at the U of U about 1954–57, who opened the door to abstract art. Abstract modernism received official acceptance during the fifties, largely through the efforts of the USU, U of U, and BYU art departments.

UTAH STATE UNIVERSITY

Long-tenured Calvin Fletcher, nicknamed "Prauf" by his respectful students at Utah State University (USU), was at heart a man of fashion—not in his clothing, for which he cared little, but interested in the newest trends of art. Fletcher was an adapter to the current movements and latest innovations rather than an experimental developer of new styles. Nevertheless, he instilled an openness to contemporary art as department chair. Fletcher continued to associate with the art department for nearly a decade after he retired in 1947.

The addition of Everett Clark Thorpe assured USU its reputation for being artistically advanced. Like Fletcher, Thorpe was naturally open to experimentation, and also like Fletcher, his teaching career splintered his art. Thorpe joined the department in 1934 and continued to teach there for forty years.

Everett Thorpe's approach to teaching art was essentially to update his own art with the latest artistic developments so that he could impart these to his students. During the thirties and forties he worked in a regionalist style reminiscent of Thomas Hart Benton. Then, in the early fifties, he added a formalist abstract manner to his work. By 1955–56 he was studying, like Don Olsen, at the Hans Hofmann School of Art in Provincetown, Massachusetts. A fine painter, Ev Thorpe was a hybrid artist of effective, sometimes decorative, abstract paintings of which *Snow Banks,* (1956, p.c., **plate 74**) is a fine example.

Floyd V. Cornaby (1910–) replaced Fletcher in 1947 as department chair. Cornaby's orientation to art differed from Fletcher's because of his emphasis on the crafts. It was under his leadership that the move away from an

Gaell Lindstrom, *Across Market;* 1954, watercolor on paper, 19" × 27"; SFAC, courtesy of the Utah Arts Council.

emphasis in fine arts to the allied arts became apparent. In fact, the department tended not to hire many painters after 1955 but chose instead to strengthen its allied areas.

To fill the slot vacated by Ev Thorpe, who had left to study with Hans Hofmann, Harrison Thomas Groutage arrived in the summer of 1955 as a visiting professor and was appreciated so much that the department of art hired him that fall. A versatile and powerful man, he came to Logan as a painter, watercolorist, and printmaker. "Grout" was mostly known for his sensitive and moody tonalist acrylic paintings of the Cache County landscape. His work drew upon his recollected ideas added to segments of nature in such a way as to redesign the landscape in celebration of the forces of nature. His *Along the Bear River* (1978, SMA, **plate 85**), which was exhibited at the National Academy of Design in New York, is an ideal example of this method.

In 1957 the department hired Gaell W. Lindstrom (1919–) as a ceramicist and watercolorist. Dissatisfied with the "don't do" restrictions and the pretty delicacy of most of the J. A. F. Everett school, he began experimenting

with paint—how dark his pigments could get, how many layers could be laid down, and how off-color his hues could be and still comprise a workable watercolor. "I wanted," he explained, "to get the guts back into Utah watercolor painting again!" He has not been prolific, producing perhaps ten watercolors per year. But his veiled illusionist images—with the more designed ones of George Dibble, Conan Mathews, and Ed Maryon—offer an alternative to the didacticism of previous generations.

UNIVERSITY OF UTAH

Nineteen forty-seven was a watershed year at the U of U, seeing Fairbanks, Gittins, and the ceramicist Dorothy Bearnson (1921–) join the faculty. Conservatives at the U of U could boast Avard T. Fairbanks (1897–1987) as their leading exponent. Boisterous and doctrinaire, this son of John B. Fairbanks utilized every opportunity to "bash" modernism on moral and aesthetic grounds. His tenure at the university was tumultuous and finally ended in 1965.

Fairbanks dominated Utah sculpture, leaving others

Avard Fairbanks sculpting in clay his *Esther Hobart Morris* (c. 1957-58) for a group of students at the University of Utah. Fairbanks lectured widely and often modeled as he spoke. In a philosophical turn of phrase that was characteristic, he said, "The hope of the world lies in our faith and in our spiritual ideals. Such ideals we express in material form." (Photo courtesy of the College of Fine Arts, U of U.)

artists for study and personal purposes but not necessarily for sale or exhibition, and there was little public or institutional encouragement. Some galleries and museums continued to refuse to exhibit nudes at the time. By the time the Springville Museum purchased Fairbanks's *Mother and Child* (1928, marble, SMA, **plate 26**), twenty-three years after he had finished it, public opinion had softened enough to support its public display. Fairbanks's domestic, unthreatening subject matter and presentation helped accustom Utah audiences to nude sculpture.

During the 1950s, an Englishman, Alvin L. Gittins (1922–1981), upset established patterns of Utah art as well. Despite exposure to French academic art in the 1890s at Paris's art academies, Utah artists had gone from pioneer art directly to conservative French rural-impressionism, which developed into regionalism without ever really having an academic realist artist to claim, excepting perhaps J. T. Harwood, in the Royal Academy or French salon sense. Certainly none of Harwood's major students—A. B. Wright, L. G. Richards or M. M. Young—built their style upon this stylistic and technical approach. Possibly because of the state's isolation, class structure and lack of monied buyers, this "brand" of art was never able to get a foothold in Utah.

So academic realism, especially of the more polished sort, was not the mainstay of any Utah artist until Alvin Gittins. Gittins's unique aesthetic and vigorous regimen demanded acute observation of his surroundings, with less reliance upon intuition than any of his colleagues exhibited. His tightly conceived portraits, figures and still lifes are remarkable for their perceptive vigilance. For Gittins, academic realism was more than a tool; it was the foundation of his own art and, through his teaching, became the foundation for many of his students—such as Don Doxey and William Whitaker. Another Gittins contribution was the elevation of drawing to an art form. Only Harwood, A. B. Wright and LeConte Stewart had seen much value in it, but Gittins broke it loose from being merely a painter's aide to being an end in and of itself.

Alvin Gittins may have been a conservative in his academic approach to art, but he was intellectually progressive and cosmopolitan. He felt as much at home with Utah modernists like Doug Snow, as he did with old-guard conservatives like Fairbanks and LeConte Stewart. In an age when portraiture was little esteemed, his major contribution was not at his studio easel but in the classroom atelier.

As department chair from 1956 to 1962, Alvin

such as Torlief Knaphus, Millard Malin (1891–1974), Maurice Brooks (1908–1970) and Elbert Porter (1917–) behind when it came to the major sculptural commissions. Best known in Utah for his representations of LDS church history, Fairbanks's plaster entitled *Head of Abe Lincoln* (c. 1950, SMA) depicts the great emancipator in colossal size, with his typical raked surface texture, bold modeling and idealizing. Fairbanks's many successful students—Justin Fairbanks (his son), Alice Morrey Bailey, Ed Fraughton, Grant Speed, Clark Bronson, and others—attest to his ability to inspire.

One of Fairbanks's significant contributions in Utah art was in making the nude figure acceptable to the public. Nudes had been painted or sculpted by most Utah

Alvin Gittins teaching a life drawing class at the University of Utah in the early sixties. (Photo courtesy of the College of Fine Arts, U of U.)

Angelo Caravaglia, *Dance Number 1;* 1986, clay sculpture; p.c., courtesy SMA.

Gittins was instrumental in bringing Angelo Caravaglia (1925–) to the staff, thus breaking the stranglehold of conservatism in the sculpture department. Like Doug Snow, Angelo Caravaglia studied at Cranbrook Academy in Michigan. He joined the faculty in 1956 and assumed the position, perhaps unwittingly, of the counterweight to the ultraconservative sculptural wing of the U of U's art department. Though often perceived as a radical modernist at the time, he was in fact a talented figurative sculptor with strong academic credentials. Through him, Franz M. Johansen (1928–) at BYU, and Larry E. Elsner (1930–1990) at USU, sculpture in the state quickly began to reflect more contemporary national trends.

Another artist who joined the U of U's art department at this time through Avard Fairbanks's intervention was Arnold Friberg (1913–). Although his stint was short-lived (1949–56), it was very important. Friberg was a transitional figure who helped break the taboo in Utah of painting religious art. Utahns' native tastes reflected the iconoclastic sensibilities of their northern European Protestant ancestors, and very few artists have produced

Arnold Friberg, the famous Utah realist, shown in his studio surrounded by the props he used in the painting of *Washington at Valley Forge*. (Photo courtesy SMA.)

Mounties pictures, and Old West high-adventure paintings established him as an important artist-illustrator.

Working alongside Gittins, Fairbanks and Friberg, the ageless LeConte Stewart continued to dominate Utah landscape painting from his position at the University of Utah until he retired in 1956. Although he was unable to maintain the level of artistic achievement of the previous forty years, his oil *The Corral at Grass Valley, Near Richfield* (1978, SMA) is a fine example of the artist's late style, which was highly influenced by a summer of study at the Pennsylvania Academy of Art in Philadelphia in 1949. Though his middle period (1932–50) could be characterized as somewhat regionalist, his work displayed a brand of tonal impressionism and became more conservative during his latter years.

Leaving the art department, however, did not hinder Stewart's teaching career. From the 1950s to the end of the 1980s he continued to be one of the most significant teachers of landscape in the state's history. The list of his students is immense and includes Robert Day, Earl Jones, Denis R. Phillips (1938–), and George Handrahan (1949–) to name a very few. Throughout his extremely long and highly productive life, certain images came to be identified with the artist. Davis County and Kaysville farmhouses and barns, country roads, and brush-covered mountainsides in all seasons, but especially winter, were his hallmark.

The work of another University of Utah professor inspired by the Utah landscape could not have been more different from LeConte Stewart. V. Douglas Snow ranks among the most significant influencers of the Utah modernist school. He studied at Cranbrook and received a Fulbright grant to study in Rome. He came with credentials and backing to the U of U in 1954—but not without some opposition.

Not a typical avant-garde expressionist, Doug Snow's work might be better described as "academic abstract impressionism." The landscape of Utah has, in fact, been his chief inspiration over the past forty years. Snow's "indirect" approach to abstraction and obvious interest in creating paintings of Apollonian beauty place him outside the mainstream of most painterly abstraction. He, more than anyone, synthesized the two opposing camps of art in an intellectual and rational way. The surreal beauty of his *Desert Landscape* (1959, SMA, **plate 76**) can be appreciated by both lovers of modern art and its detractors.

An excellent teacher, Snow worked intellectually in tandem with Gittins to bring about this synthesis. In a series of radio programs and lectures, the two propounded

more than historical church and Book of Mormon paintings. Friberg's representations of Christ drew some criticism from the LDS church, but his persistence prevailed and he is, in the l990s, considered the most beloved religious painter in Mormonism. Friberg popularized the genre of religious art, subject matter rarely used by contemporary Utah artists.

Although Friberg's significance was frequently unappreciated, it seems to transcend the connoisseur's preconceived notions of "illustrator" and must ultimately be appreciated in terms of fine art. His Book of Mormon series for the LDS Church, work for Cecil B. De Mille's *Ten Commandments* film, Northwest Paper Company's

Members of the University of Utah Art Department, c. 1958 including Sherm Martin, George Dibble, Ed Maryon, Doug Snow, Angelo Caravaglia, Alvin Gittins, and Keith Eddington. (Photo courtesy of the College of Fine Arts, U of U.)

the virtues of stylistic pluralism to a tradition-bound Utah audience. Disheartened in 1957 by their seeming lack of success, Snow remembered a visit by B. F. Larsen who had been chairman of the BYU art department from 1936 to 1953 and was then a "grand old man" of Utah art. He came to Snow and gave him a bear hug, saying, "You are doing something really important; keep up the lonely battle!"

Ed Maryon (1931–) joined the U of U faculty in 1958 and became one of the most influential watercolorists in Utah since J. A. F. Everett. Maryon was highly acclaimed by the critics, who saw in his work a consummate blend of traditional and modern forces. His position, like that of Gittins and Snow, was one of reconciliation between the opposing forces. With his instruction and that of Gaell Lindstrom at USU and Osral Allred at Snow College, watercolor in Utah began to take on a more contemporary look.

BRIGHAM YOUNG UNIVERSITY

In Provo, BYU's art department was located on

Ed Maryon, *Big Sur Nursery;* 1975, watercolor, 17" × 22"; SMA.

191

or Thorpe, he had but one style at a time which he developed with progressive consistency.

After receiving his training at the Otis Art Institute in California, J. Roman Andrus entered the BYU art department in 1940 and in 1942 founded the university's printmaking department. By the fifties, lithography had become an essential element in his artistic vocabulary. Though he had many portrait commissions, he was best known for his sweeping, pantheistic, and abstracted mountainscapes, as revealed in his oil *Cadmium Crest* (1964, SMA, **plate 75**) and lithograph *Sunrise Peak* (1972, SMA). A fine teacher, Andrus's large frame, rough-hewn face, strong voice, and dominant personality captivated and inspired many students.

Glenn H. Turner came into the art faculty as a watercolorist in 1947 at the behest of his uncle, B. F. Larsen. He had been the art teacher of Springville High School and its museum director from 1940 to 1947. During the early fifties, Turner, with the encouragement of Larsen, went to New York to learn the "lost wax" method of bronze casting. He later worked with Hughes Curtis to develop a foundry in Springville and even built another foundry at Lower Campus. Warren B. Wilson (1920–) arrived at BYU from USU in 1954 as an assistant professor in art education and ceramics. The "art ed." department of J. Roman Andrus and Richard Gunn was also strengthened by hiring other art educators—Conan Mathews in 1956 and Frank M. Tippetts in 1958.

Hailing from Providence, Utah, Conan E. Mathews (1905–1972) replaced Larsen as department chair in 1956. His administrative leadership was further utilized at BYU when he was named dean of the College of Fine Arts and Communications from 1959 to 1967. Mathews was a fine watercolorist, an able and intellectual teacher, writer, and administrator. During his tenure the department grew in size, and the new Harris Fine Arts Center was built in 1964, largely due to his political savvy.

Franz M. Johansen (1928–) was a significant addition to the faculty at BYU during the fifties. Both a sculptor and a painter, he joined the faculty the same year that Angelo Caravaglia came to the U of U. Johansen came to the department with a decidedly modernist bent and, with Caravaglia, produced the first nonobjective sculpture in Utah. He was also known for producing works of a religious nature, in three dimensions as well as in Francis de Erdely-inspired drawings and oils. De Erdely was a California artist who had come to the U of U for a term in the early fifties as a visiting professor. Johansen might be considered a precursor and influencer of the Art and

"Lower Campus," which was the original site of the old Brigham Young Academy. Coming into the second half of the century, the BYU faculty was a small five-person operation, including Bent Franklin Larsen (1882–1970), J. Roman Andrus, Glenn H. Turner (1918–), Richard L. Gunn (1918–) and Maynard Dixon Stewart (1923–). By the end of the decade, even with turnover, the faculty doubled in size.

The venerable B. F. Larsen was to BYU what Calvin Fletcher had been to USU. From the 1930s until 1953, he headed the department with strength of character and artistic leadership. His painting *Susquehanna River* (1955, SMA) bridged the gap between his typical landscape style and his late modernist experimentation. Unlike Fletcher

Belief movement at BYU during the mid-1960s. As much as anyone, during his tenure at the university he helped to foster the attitude of the sanctity of the human form through his drawings, oil paintings, and sculpture.

Certainly the bellespirit of the art department was Alex B. Darais (1918–). Arriving in 1957 as a designer and painter, he became one of the most beloved and respected faculty members. Deeply influenced by cubist watercolorist John Marin and the abstract artist Marsden Hartley, as well as oriental philosophies of Zen, Darais's works became paragons of taste, perceptivity, and quality. His metaphorical work *Over Three Billion Served* (1974, SMA) demonstrates his awareness of his textural rustication, use of banal objects, and shibui color. Unfortunately, his productivity was low and he remained chiefly known for his teaching.

Francis R. Magleby (1928–) was the last major addition to the BYU art department during the fifties (1959). Trained at BYU and the U of U, he, as was typical for the period, taught art education classes, alongside another new arrival Dr. Wesley Burnside (1918–). Magleby was influenced by his uncles—the brothers Fausett—and had learned their "old master" technique in painting. He was one of the first faculty members to augment his salary by painting for the non-Utah art market.

The doubling of faculty members in the art department during the decade precipitated a renaissance in the quality of students the department would attract and train. This increase was built on the back of art education for primary and secondary teachers, but it nevertheless created a critical mass of professional artist-educators that established a viable art community on campus. The rapid growth continued in the 1960s until it rivaled the size, though not necessarily the quality, of the University of Utah art department.

WEBER STATE COLLEGE

Until 1959 Weber State College (now University) was known as Weber Junior College. Its first full-time artist-teacher, Farrell R. Collett (1907–), trained at BYU and the U of U, came in 1939. Collett had a long career at the college, retiring in 1976. He became Utah's most noted wildlife painter, while serving thirty years as chairman of the art department. Doyle M. Strong (1917–1985) came to teach painting in 1940. Strong became known as the department's modernist. His tenure lasted forty-two years, until 1982.

ART MUSEUMS AND CENTERS

The old G. M. Ottinger dream of a university gallery was finally fulfilled in 1951 with the establishment of the Utah Museum of Fine Arts at the U of U campus. The catalyst was the donation of Mrs. Richard A. Hudnut's collection that year. University president Ray Olpin organized the museum and had the fourth floor of the Park Building redesigned as a museum. Thus, Utah's second art museum was founded.

The first "director" of the museum was Dr. I. Owen Horsfall, a mathematics professor who was appointed "caretaker" of the collection and served until 1964. The base of the collection, the Hudnut "old master" group, remained the largest bequest during this period, though other gifts and purchases steadily enhanced and diversified the collection. By the end of the fifties the museum chronicled fifteenth-to-nineteenth-century European art, eighteenth-to-nineteenth-century American paintings, and Utah art.

The Ogden Arts Council founded the (Bertha) Eccles Community Art Center in Ogden on 16 October 1959. Located on property deeded by the LDS Church at 2580 Jefferson Avenue in the old 1884 Armstrong-Eccles mansion, the Eccles Community Art Center promoted both local and statewide artists through exhibitions, art classes, public tours, meetings, recitals, and the Autumnfest.

FIN DE LA FIFTIES

The decade of the 1950s ended even more stormily than it had begun, as demonstrated by the Fourth Annual Invitational Exhibition at the University of Utah department of art. Chairman Alvin Gittins, Angelo Caravaglia, George Dibble, E. Keith Eddington (1923–), Allan Sloan, and Doug Snow curated the Nine American Painters exhibition for the 1959 annual show. Art historian Robert Olpin states that the effect of the exhibition was the unfortunate mixture of artistic and political considerations which ". . . was to leave some fairly enduring rents in the local artistic and educational fabric." Artists in the exhibition included a broad swath of American artists: Stuart Davis, Rico Lebrun, Robert Motherwell, Andrew Wyeth, Abraham Rattner, Max Weber, and Hans Hofmann. In the wake of McCarthyism, socialist artists in the exhibition, such as Jack Levine and Ben Shahn, were still suspect in Utah, although BYU associate professor of art J. Roman Andrus bravely extended BYU's praise of

the exhibit at a time of mounting criticism. Again, philosophical lines of demarcation divided the artistic community of Utah.

In considering the close of the fifties, it is appropriate to remember those artists whose careers ended during this period. Gone was the unappreciated J. Henri Moser in 1951, the exiled A. B. Wright in 1952, and the Sanpete landscapist J. H. Stansfield in 1953. Mahonri M. Young died in 1957. With his death and that of John Held, Jr., who died the next year, Utah lost its two most nationally famous artists. Ruth Harwood, who was living on the West coast, also died in 1958.

DECADE OF THE SIXTIES

The 1950s and 1960s marked a period of national excitement in the visual fine arts. It was during these two decades that the art of the United States assumed world leadership. While the sixties did not elevate Utah to national preeminence in the arts, the decade was significant for its accelerated growth in most fine-art areas.

There were those like Deffebach and Olsen, who wanted to meld the Utah school with national directions of abstract expressionism, pop, op, and minimalist art. It was about this time that the modernist Alex Katz came to Utah and worked at Ogden High School before becoming famous nationally. Others, such as LeConte Stewart and Paul Salisbury, were content to foster a regional realism. Finally, there was a third group that felt that Utah and the Mormons had a special ethos and destiny in the arts. These three dialectics set up the major polemics of Utah art during the sixties and beyond.

Utah art at the beginning of the decade might be characterized as derivative rather than unique. There was little distinctively "Utah" about what was happening in terms of artistic innovation of style, content, technique, media, or even content. It is difficult to ascertain what Utah's contribution to the arts of the region or nation might be, except its production of quality works of art created in established modes, particularly the landscape. Except for the Art and Belief movement and the content of its landscape painting, Utah imported most of its artistic language from elsewhere—both coasts, Europe, etc.

By the beginning of the sixties, Utah was to a great extent following the more recent national trends of art, though leapfrogging several major innovations of art and accepting others a decade late. Generally, American art broke into two camps: those artists who were driven in a progressive attempt at new pictorial form or those who sought to synthesize formal abstraction with surrealist vision.

METAPHYSICAL AND METAPHORICAL ART

By the early 1960s, BYU faculty members J. Roman Andrus, Alex Darais, and Franz Johansen had established a climate at that university conducive to metaphysical and metaphorical art. During these years, Alvin Gittins made occasional forays, such as his *The Card Players* (1959, p.c., **plate 69**) into allegory and satire. His *Museum Piece* (1975, SFAC) is straight-faced and shocking fantasy. Influenced by the tenor of the times, Don Doxey was, by 1965, creating large-scale vanitas pictures. His memento-mori oil, *The Marriage* (1965, SMA), is typical of his work from this period, with its combinations of symbolism and academic still-life elements. His work in this mode lasted only five years when it was largely abandoned for southwestern subject painting.

But all this history may be considered prologue to the real flowering of metaphysical art in Utah. During this period of the Vietnam War, hallucinogenic drugs, psychedelic art, and student unrest, a movement began in Utah that focused on the examination of the interior self and expression of the spiritual in art. During the school year of 1965–66 at the BYU graduate painting lab, "The Cave," numerous informal discussions arose on the subject of what constitutes Mormon art. Here, a professor of art and art history, the enigmatic Dale Fletcher, held court. Around him clustered a number of art students, fired by the idea of creating a religious art for the present day—a great art, expressing the truths of the Mormon faith.

Graduate and undergraduate students were seized by the excitement of those heady days. With Fletcher, graduate-student artists such as Trevor Southey (1940–), Dennis Smith (1942–), Gary E. Smith (1942–), Larry B. Prestwich (1935–), and Michael C. Graves (1939–) formed the nucleus of the initial movement. Most concurred with Gary Smith's declaration, "I feel the need for combining religion and art." It was the mystical Fletcher who stressed the need for studying the ancient Egyptian and Greek canon. Understanding sacred geometry, divine symmetry, and those past epochs where religion played an integral part in the lives of artists were subjects for intense contemplation.

In the cynicism and turbulence of the 1960s, the Art

Gary Ernest Smith,
Steps of Conversion #1;
1968, oil on canvas,
17 3/4" × 48"; SMA.

and Belief movement was seen as an alternative. Fletcher conceded that Art and Belief was a new reactionary movement, "and we are brought at length to open surrender to the predicament, in the black square, the soup can, the raw portrayal of sexual confusion, and the twiddling of the optic nerve." For him, the antidote to such decadence was Old Testament Mormonism.

Like the Pre-Raphaelites, who revolted against the triviality and decadence of the art of their age, this new movement rallied all "wise-hearted" artists to the faith of the "seeing heart," the symbol for the group (see Exodus 28:3; 31:6; 35:31). Gary E. Smith's *Steps of Conversion* (1868, SMA) reveals the image of a "seeing heart" near its signature as a token of the painting's religious intention.

Some felt that a set of distinctively "Mormon" iconographs would soon emerge. Once invoked, these images would begin to dominate the individual styles of each artist to such a degree that the label "Mormon art" would be clear and discernible. Others, such as Dennis Smith, maintained that "each artist must find his own way to produce what is most meaningful to him, rather than to expect the emergence of a common style."

The First Annual BYU Festival of Mormon Art opened in February of 1969 and grew the next year to include music, drama, creative writing, dance, and cinema. The beginning was auspicious. To many, millennial art seemed just a few years away. However, by the mid-1970s, after nearly a decade of searching for an archetypal

Mormon idiom, some of the artists began to find other content, subjects, and philosophical directions. Fletcher left the university in 1979 and joined an Adam Rutherford Pyramid cult in Oregon. But, like the short-lived Pre-Raphaelite movement of the mid-nineteenth century, the Art and Belief movement has continued to inspire, in ripplelike fashion, the visual arts of Utah to the present day.

SECOND- AND THIRD-GENERATION MODERNISTS

The attention of most of Utah's first generation of modernists lay in their need to come to grips with fauvism, cubism and the abstraction of content. This was seen in progressive steps from, Moser's *Logan Canyon, Near Beaver Dam* (1926, SMA, **plate 39**), to Dibble's *Marine #2* (1938, SMA, **plate 56**), to Henry Rasmusen's *Fish and Sails* (1947, SMA), and finally to Thorpe's *Design in Polymer, Tempera, Sand, Clay, Oil, Metallics & Wax* (1954, SMA). This belatedly followed national trends, as did our second-generation artists in their concerns.

The second generation developed, from about 1955–56 in such gestural works as Dale Fletcher's *Lifting by Leverage* (1956, SMA) and Thorpe's *Snow Banks* (1956, p.c., **plate 74**), an action or abstract expressionist mode. After nearly a decade came such post-painterly abstractions as minimalism and color field. The second

group, or generation, of modernists led by Olsen, Snow and Deffebach were joined by others of their age who made contributions. The third generation were less aligned with any specific trends. They dispersed into a cavalcade of modernist approaches.

Ev Thorpe and Donald Olsen were the artists who bridged the early and later Utah generations of modernism most effectively. Until 1965–66, Donald P. Olsen's art was mostly painterly abstract expressionist in style. It reflected critic Harold Rosenberg's phrase "brushed action painting," which he used to describe the work of Hans Hofmann, Franz Kline, Jack Tworkov and Willem de Kooning. In his intense oil *Composition* (1963, SMA, **plate 82**) Olsen reached an immediacy, involvement, and energy level seldom attained by his Utah peers. It is an explosively vital work which attacks the viewer's sensitivities with visceral expressiveness. His work protests the niceties of his colleagues and exudes the art of alienation at its most ferocious.

According to James Haseltine, "Following his marriage to Betty in 1962, Don did some of his more ebullient work, a series of canvases dominated by white—as positive shape, negative passage or ground, dripped line or textural splatter. His colors are most often used unmixed, directly from the tube, alla prima, with reds still prominent and blues, greens and yellow playing a secondary role." In Olsen's words:

> *Painting is not an illusion. A painting can only be itself; it does not simulate, borrow from, or pretend to be anything outside itself. It is a real thing and its reality lies in being itself. A painting reveals the internal expression of the artist and has nothing to do with observation of visual facts.*

In October of 1966, after a dozen years of "push and pull," of force and counterforce, hazard, and tension of abstract expression, Olsen, the "great introducer," surprised Utah with a new direction in his art when he exhibited fifteen hard-edge works at the Phillips Gallery in Salt Lake City. He replaced his method of action painting with the architectural precision of masking tape, spray paint, and flat acrylic. If his work in the early sixties projected raw power, then cool intellectualism might describe his later work.

By 1960, H. Lee Deffebach (1928–) was also producing mature work which was both abstract and scintillating in its exuberant energy. She was the only working female nonobjective artist in Utah during the early sixties. Besides her paintings, she produced in Salt Lake and in her summer home in Tuscarora, Nevada, pop-art assemblages, the first by any Utah artist. It was a period of experimentation and play with pop-art-constructed toy sculptures from commonplace and discarded banal or commercial materials. The results were almost three-dimensional, concoctions with advertisement colors and ironic elements like soda cans and coffee cups. Her exhibition at the Phillips Gallery in November 1966 revealed the extent of her involvement. This exhibition was held the month after Olsen's solo at Phillips and proclaimed the strength of Utah modernism.

By 1965, the second generation of modernists were fully mature, while the third-generation artists were just developing. Denis R. Phillips was painting in an abstract expressionist form, while Earl Jones was formalizing LeConte Stewart's landscapes into a contemporary Utah idiom.

Denis Phillips (1938–), who began as an expressive figurative painter and then gravitated in the mid-sixties toward abstract expressionist painting, was one of the brightest of these new modernists. Like Earl Jones, by the seventies Phillips began to work a formal tonalism, realistically portraying the Utah landscape, as in *Near St. Charles, Idaho* (1974, SMA, **plate 73**). He kept a nonobjective side to his art however. During the seventies and eighties he also became known for colorful abstracted landscapes. With the natural forum of the Phillips Gallery, he was able to produce an outstanding body of work and develop a professional career.

The sixties saw the development of larger and more sophisticated institutions for art study. While study outside Utah was almost mandatory for the serious student, Utah's art departments at the high school, college and university levels were providing more-than-adequate training. The number of students wishing to study art in the state greatly increased. The G.I. Bill had provided a means for a liberal arts college education between 1940 and 1970. General prosperity since 1945 also fostered an interest in the liberal arts amongst the general student population. Many of these students majored in art education, art history and studio art, thus precipitating an expansion of art department facilities, faculties and curricula.

Utah's universities did not suffer from the hegemony of modernism in their art departments, as was true in some areas of the country. The presence of artists like Alvin Gittins insured Utah of a balance in approaches to contemporary art. Utah's third generation of modernists—

Earl Jones, one of the state's most respected private teachers, in his studio. (Photo by Gibbs M. Smith, courtesy SMA.)

those who matured during the later sixties and seventies—in many ways equaled the second generation.

UTAH STATE UNIVERSITY

In Logan, by 1960, the USU art department under Twain Tippetts had become part of a fine arts department which included music, theater, and art. New faculty members included Ralph T. Clark (1926–) in photography, Jon I. Anderson (1934–) in commercial art, and Larry E. Elsner (1930–1990) in sculpture and ceramics. The first phase of the Chase Fine Arts Center was planned and constructed. Harrison Groutage became the department head in 1965 and soon upgraded and accelerated the graduate programs, awarding the first M.F.A. degree in 1966.

The printmaking and drawing area advanced in 1965 when Adrian C. Van Suchtelen (1941–) came to the faculty. Talented in several media, including drawing, etching, and watercolor, Van Suchtelen exuded both mystery and finesse of handling in his work. An artist intrigued by the metaphysical and metaphorical, his style might be considered allegorical rather than academic. Marion R. Hyde, (1938–) of Brigham City, followed in 1968 as a painter, sculptor, and woodcut and wood-engraving printmaker. In the woodcut media he joined Blanche P. Wilson (1922–) and Royden Card (1952–) as Utah's best. Like Card, Hyde added a hint of otherworldliness to his work.

UNIVERSITY OF UTAH

Meanwhile, at the U of U, the department solidified its preeminent position among Utah art departments. Including only the studio faculty, about seven professors of art began the sixties. Over the decade, this section increased by three full-time and several more part-time faculty members. The quality of the U's studio artists reflected its commitment to professionalism.

A most interesting artist, who became the torchbearer of the native landscapist school of LeConte Stewart, was

Earl Jones. (1937–) A fifth-generation Utahn, he studied at the Art Students League in New York, then at the U of U for an M.F.A. From 1964 to 1970, Jones passed from art student to faculty member there. He had been an activist involved in the peace movement during the Vietnam War and against the university's research in chemical warfare. He was denied tenure in 1969, a decision he fought but which was upheld by out-of-state critics. In l970, Jones left the university to teach privately in his own studio.

During the late 1960s, Jones's style evolved away from expressionist figurative painting toward a bold and highly composed realism depicting the Utah landscape. His consuming interest since that time has been the rural and wilderness areas of Utah. See for example, his *Near Francis, Utah* (1978, SMA, **plate 86**). Absorbed by the formalist beauty and broad vistas of the western scene, he has become a premier painter and natural heir to the legacy of LeConte Stewart and Maynard Dixon.

A contemporary and friend of Jones, Frank Anthony Smith (1939–) was, during the sixties, an abstract expressionist. A Salt Lake City native, he received his M.F.A. from the U of U in 1964 and by 1967 was a faculty member at the university. Almost immediately he began producing canvases that propelled him into a more national arena. By 1970 Tony Smith had embarked on a career which was rich in diversity yet constant in aesthetic direction.

Robert W. Kleinschmidt (1927–) came to the faculty in 1969 in the printmaking and graphics area of the art department. This area served more of an ancillary role in a program which emphasized painting and drawing. Adept in lithography, silkscreen, etching, monoprint, and drawing, Kleinschmidt was noted for combining media. His content had a strong autobiographical concentration, and he tended to focus on animals such as sheep and opossums—or skulls—for some time, as a springboard for his work's imagery.

BRIGHAM YOUNG UNIVERSITY

At BYU, plans were underway for a new fine arts facility. Dedicated in 1964, the Harris Fine Arts Center provided a prestigious headquarters for both the performing and the visual fine arts on campus. Though criticized on practical and aesthetic grounds, the new facility gave a major boost to the fine arts department.

In 1961, Floyd E. Breinholt (1915–) joined the art department, having taught for more than twenty years in the public schools. One of the most beloved professors on campus, he taught landscape painting using the indirect method promulgated by Lynn Fausett and Frank Magleby.

Paul P. Forster (1925–) came from New York in 1964 and taught painting for five years, until 1969. His intensely artistic personality and knowledge of the craft of painting proved very beneficial to the department in both landscape and figure painting. The major influences on his art were the linear dynamics of Michelangelo and Rubens and the space-color concepts of Japanese shibui. Shibui was an art form which emphasized the restraint of autumn and winter as found in the colors black, grey, and brown. Forster's paintings began with bright, stainy colors creating the forms of his subject, then many glazes were added, restraining the underpaint.

The addition of the painter Dale T. Fletcher (1929–1990) in 1965 noticeably changed the department in several ways. Fletcher, the son of Calvin Fletcher, had been trained in Berkeley as an abstract expressionist but had undergone a major spiritual metamorphosis and was now a John Ruskin naturalist-realist. What bird nests had been to the Pre-Raphaelites, tree houses were to Fletcher. A man of cosmic causes, his dry intellectualism and ever-more-radical beliefs could not be sustained in the classroom, and he exchanged positions with Peter Myer in the mid-seventies as director of the student-faculty exhibition gallery in the HFAC.

Dallas Anderson (1931–), a convert to Mormonism, had studied sculpture at the Danish Royal Academy of Fine Arts (M.A., 1967) before joining the department. In a sense, his conservatism became a complement to Franz Johansen's contemporaneous three-dimensional work. More formulaic than inspired, Anderson's work, heavily influenced by Dale T. Fletcher's metaphysics, was often a confused tangle of nudes. He left the university in 1983 to devote himself to the televangelist Robert Schuller's "Tower of Power" center in Los Angeles.

By the end of the decade, the BYU art department had expanded to about fourteen professors and instructors. This was a net gain of two positions from the previous decade. Utah County had but one independent full-time artist, Paul Salisbury, during the sixties, so the growth of the BYU faculty bolstered the professional artists' community in Utah Valley.

WEBER STATE COLLEGE

The sixties saw a profound change in the art department of WSC in Ogden. Up to that period the college had had a very small department and was mostly known for illustration and art education. The Collett Art

Building, built in 1964 and dedicated two years later, lent impetus to an emerging art department. In the autumn of 1959 Richard Van Wagoner (1932–) came to the faculty, making a five-man department. At first he taught in all areas, but eventually he settled into teaching watercolor, foundation drawing, and painting. During the sixties and early seventies he was basically a "figure in landscape" artist, but his work has increasingly depicted the western urban landscape of freeways and automobiles against a backdrop of inner-city and suburban vistas. See, for example his *Donor Bank* (1990, SMA, **plate 107**).

By 1969, when David Chaplin came to the department in art education, there was already friction between the old and new faculty. The influx of younger artists set the department on edge, and strident differences in stylistic approaches and teaching methods between Farrell Collett and the younger faculty threatened the department. In 1970, Charles Groberg replaced Collett, who had held the department chair for thirty years.

Chaplin's logical mind and winning spirit helped unify the two factions by implementing written policies and procedures. These became more than contracts, amounting to professional codes to live by. The shift from squabbling and factionalism to the cooperative informal department of today was the legacy of the short-termed Chaplin, who left in 1972.

ART MUSEUMS AND CENTERS

The Springville Museum of Art's by-laws had been amended in 1962 in response to the general discontent and negativity surrounding the closed leadership of the museum's board of trustees. Now city and citizen representation began to influence the board. This farsighted action allowed the museum to better sustain the loss of the high school's presence when it moved to its new campus in l967. The museum's continued growth was sustained by the construction of a new wing for the Springville Museum of Art in July of 1964. A gift from the Clyde family, the addition reflected the original character of the building and added 5,300 square feet.

Five miles north, at BYU, a vision for a new art museum was beginning to form. Although the first recorded work of art in the BYU collection was listed in 1908, the collection itself was not formally organized until 1965. Dr. Wesley Burnside was the collection's first curator, and throughout the sixties and seventies he worked to increase the size of the permanent collection with the view of building a major art museum on campus.

Also founded in 1965 was the Atrium Gallery in the new Salt Lake City public library at 209 East 500 South. Although its exhibition space is small, the Atrium Gallery has steadily become one of the state's most active and experimental galleries for contemporary Utah art.

The Utah Museum of Fine Art (UMFA) named its first professional museum director in January of 1967. E. Frank Sanguinetti, who had been the director of the Tucson Museum of Art in Arizona, has become the "dean of Utah museum directors" during his tenure at the UMFA. He established the museum as Utah's premier fine arts resource, chronicling the broad expanse of world art history.

In September of 1968 the UMFA, still in the Park Building's fourth floor, exhibited a solo show for M. Wayne Thiebaud (1920–) of California, one of America's most noted artists. Although born in Mesa, Thiebaud had lived in Hurricane, Utah, near Zion National Park, during his junior-high-school years (1931–32). He then lived in St. George and subsequently on a ranch located between St. George and Cedar City (1932–33), before his family moved to Long Beach, California. Later, his childhood recollections of Utah red rock, clouds, and sunsets became the source for the imagery and titles of some of his works.

ART DEALERS AND COLLECTORS

In October and November of 1965, the Salt Lake Art Center and *Salt Lake Tribune* sponsored an exhibition, "100 Years of Utah Painting," which chronicled Utah art up to 1950. Except for the 1947 centennial catalogue, the catalogue accompanying this exhibition was the first major publication on Utah art since Alice Merrill Horne's 1914 book *Devotees and Their Shrines: Hand Book on Utah Art*. In it, James L. Haseltine, then director of the Salt Lake Art Center, perceptively surveyed the development of art and artists in this state.

The importance of this book/catalogue was immeasurable. It became the bible for art historians, collectors, and dealers of Utah art. Its biographical section became a checklist for local art collectors and dealers to rely upon.

By 1962, Dan Olsen, then a student at BYU, had begun to buy and sell art, especially the Utah masters. In 1965, he had a limited partnership with Graydon Foulger, and in 1968 he and five other people formed a corporation and opened the Tivoli Gallery on Third South in Salt Lake City. Later it moved to 250 South Main. Eventually, with his wife and son, Olsen built the gallery into one of Utah's grandest fine-art venues.

This was about the same time (1965) that Denis and

Bonnie Phillips opened their gallery at 200 South and 350 East, selling art supplies, framing materials, and modern and contemporary art. More than anyone else, the Phillipses challenged the bounds of Utah taste through their intelligent promotion of less traditional art. While all other galleries were attempting to land the most saleable artists for their stable, the Phillips Gallery was the first viable modernist and avant-garde concern in the Utah art market.

THE SIXTIES CONCLUDE

The list of those who died in this decade includes several important artists. The most famous of these was the much-loved Calvin Fletcher of Logan, who died in 1963 at the age of eighty-two. The sculptor of the Mormon handcart monument on Temple Square, Torlief S. Knaphus, passed away in 1965 at the age of eighty-four Mary L. Bastow (1897–1967), a Logan native but Cedar City resident, who painted bold landscapes in oil, died at seventy. Philip H. Barkdull, who had taught at Logan High School, lived eighty years and died in obscurity in 1968. At ninety-four years of age, the fauvist landscape painter Louise Richards Farnsworth died in 1969 with little notoriety.

DECADE OF THE SEVENTIES

The last half of the sixties had seen the rise in America and Utah of the hippie movement, the drug culture, and the antiwar movement. By 1970, the strains of war, economic inflation, and racial violence were tearing the country apart. This would be the last full decade during which the mythos of modernism was fully believed. By the next decade, the avalanche of radical manifestos would moderate until a greater plurality of styles became acceptable.

A militant Robert Smithson proclaimed "the dislocation of craft and the fall of the studio." Founder of the earthworks movement (earth art), his transcendent icon, the *Spiral Jetty* (1970), made of rock and debris, swirled into the Great Salt Lake. Nevertheless, it was still diversity and fragmentation that best characterized Utah's contemporary art scene.

Though more conservative and provincial than either coast, Utah partook of the national ethos for contemporary art. The Utah Arts Council, which had for some years been committed to contemporary approaches to art, continued more steadfastly in this direction. The universities,

though much more moderate than many throughout the United States, became intellectually, if not artistically, "middle-modern."

Enrollment, faculty, and facilities continued to expand in Utah colleges during the seventies, as it had for the previous two decades. The growth of significant art departments at Snow College (Ephraim), College of Eastern Utah (Price), Dixie College (St. George) and Southern Utah State College (Cedar City) is a hallmark of the decade. In the meantime, all the major art schools boasted art history programs.

USU

USU added Ray W. Hellberg (1929–) to the faculty in 1972. He immediately became department head for eight years, succeeding Groutage. He oversaw the construction of the art wing of the Chase Fine Arts Center and hired Craig Law in photography, Tetsuo Kusama in 1975 in textiles and Moishe Smith (1929–) in 1977 for printmaking. Primarily a watercolorist, Hellberg's own later work was heavily influenced by Chinese painting.

Moishe Smith (1929–) ranks among the best artists in the country working in intaglio. His *Jewish Cemetery, Prague* (1980, SMA) is admirably drawn and sensitive to the mood of his subject, as is the atmosphere of the landscapes he often captures. The terrain of Utah enthralled Smith and propelled him to seek firsthand experience with the mountains of Logan Canyon and the southern deserts. In 1980 he was commissioned by USU to make a suite of etchings of the mountains surrounding Cache Valley. The resultant prints reveal an intimate and keen interest in his subject, which he explored relentlessly.

BYU

The Provo school saw rapid growth during the 1970s. Robert L. Marshall (1944–) joined the faculty in 1969 as a realist watercolor painter of the western landscape. First influenced by Andrew Wyeth, he later found the watercolor medium self-limiting. Sensing the dichotomy between his art and his professional judgment, he sought after a more intensely personal and sensual mode of expression.

Trevor J. T. Southey was also hired by BYU in 1969 and stayed until 1977 as a teacher of drawing and printmaking. Better known as a painter of the male nude, etching seems his more natural medium. His predilection for Mormon art during his graduate study at BYU took on more general interest in metaphor rather than overt symbol.

Moishe Smith, *Jewish Cemetery, Prague;* 1980, intaglio/etching, 17 1/2" x 17 3/4"; SMA.

Trevor J. T. Southey, one of the founders of the Art and Belief movement, came to BYU from South Africa and stayed eight years. (Photo courtesy SMA.)

A series of challenging four-by-eight-foot allegorical paintings depicting male and female nudes, like *Eden Farm* (1976, SMA, **plate 81**), painted during the mid-seventies, aroused some controversy that strained the relationship between artist and administration to the breaking point. Southey left the university to work at his studio in Alpine, Utah, on civic and private commissions. Later, he moved to San Francisco.

William F. Whitaker (1943–) was also given an appointment at BYU in 1969. He was highly influenced by seventeenth-century Dutch high-life painters and also enthralled by European nineteenth-century academic artists such as Jean E. L. Meissonier, Horace Vernet, and L. Alma-Tadema and his work took on the polished luster of their cabinet paintings. Perhaps Utah's only pure classical realist of the time, he has sought to portray ideal feminine beauty by posing seminude figures in quiet interiors.

An LDS convert from Germany, Wulf E. Barsch (1943–) joined the faculty in 1972 and received the Prix de Rome from the American Academy in Rome in 1975. He breathed new life into the sagging Mormon art movement and basically propelled it into the 1980s.

Barsch's exploration of spiritual-mystical themes through his own very private interpretations has established him as one of America's premier religious artists. Unlike Southey, whose work is based on late Renaissance models, Barsch's meditations have propelled him into metaphorical painting.

Utah's premier fantasy painter is James C. Christensen (1942–) of Orem. In the fall of 1976 he became a faculty member of the art and design department at BYU. Christensen brought to the department an irrepressible personality, at once witty and profound. By 1980 he had moved away from incessant illustration commissions to more personal "noodling" of his own fantastical vision. This vision the artist calls "a credible illusion of an incredible reality." Shortly thereafter he migrated from the design to the fine art area of the department and has greatly influenced the student artists in fantasy and surrealistic art.

A painter living in Springville, Bruce Hixson Smith came to BYU as an instructor in the fall of 1978. The next year he became an assistant professor and has been an integral part of the faculty since. An intense man with redoubtable knowledge of the craft of oil painting, he has become a beloved professor to the serious art student. His own art is underscored by an interest in his materials: he grinds his own pigment, concocts his own oil-resin vehicles—on which he is one of America's recognized experts—and builds his own stretches and frames.

Also in 1978, Hagen Haltern was hired as a faculty member. Haltern's style and content also places him in the Mormon art movement. His drawings/paintings are often broad marble powder washes, interspersed with subtle and intricately drawn architectural elements, landscapes, or figurative forms. He has sought to merge abstract and realistic form.

U OF U

In Salt Lake City, the U of U's art department was at its zenith during the seventies.

The figurative painter Paul H. Davis (1946–) received his B.F.A. and M.F.A. at Boston University before coming to the U of U in 1976. He was hired as a painter to teach figure drawing and painting with Alvin Gittins and was to some degree more "liberated" from narrative realism than Gittins.

Davis's first work at the university were urban landscapes conceived in a colorful and painterly style. He felt at that time that a painting should have thick paint and flat planes; display irony, detachment, or anger; and be painted alla prima. By 1980, however, he discovered that he had his own sense for more refinement. A beautiful and indirect technique marks his *Enigmatic Figure* (1988, SMA, **plate 104**). "I discovered picture window space," he exclaims. "To hell with flatness; it's just one idea of many. I break with the inherited concepts of modernism."

Dorothy Bearnson, who had ably handled the ceramics area of the department, got help in 1977 with the addition to the faculty of David Roy Pendell (1944–). Unlike the more classic Bearnson, Pendell's work is experimental in form rather than surface and glaze. He has worked in both functional and nonfunctional ceramic sculpture and blown glass, as well as in a number of other media such as leather, fiber, wood, and small-scale metals.

WSC

One of Utah's most successful ceramic-sculptor/potters, David Newton Cox (1939–) was hired at WSC in 1971 and has been there since. His contribution to Utah art is in the strong impact his own work has enjoyed among Utah ceramicists and the exposure to outside influences he has brought through traveling exhibitions. The hand-colored photography, printmaking, and drawing side of the department was enhanced in 1977 when Susan Makov (1952–) joined the faculty. She brought a shamanistic interest in mystic fantasy.

LANDSCAPE AND STILL-LIFE GENRES

Landscape and still-life genre continued to exert considerable influence on Utah art during the seventies. Landscape painting had always been the mainstay of art in the state from pioneer times. Although landscape continued to be basically conservative, it had its modernist proponents, as attested by Fred Hunger's abstract landscapes and Milford Zornes's (1908–) structural watercolors. Zornes was from California and moved to Mt. Carmel, where he lived in Maynard Dixon's old home from the early seventies. Zornes, the "abstract realist," came as a noted regional artist and painted bold, almost architectonic, watercolors of the landscape.

But the most significant landscape painters of the decade were V. Douglas Snow and A. Valoy Eaton (1938–). They found the path that united the Utah school with national contemporary painting issues. Valoy Eaton was able to fuse landscape painting with the subtle neo-regionalist genre. He opted to imbue the smaller subjects of life and nature with grander qualities. Born in Vernal and schooled at BYU under Dale Fletcher (M.F.A., 1971), he became a teacher at Cyprus High School in Magna, Utah. He decided that when he made as much money from his art as he did from teaching, he would quit and become a full-time painter, which happened in the mid-seventies.

Shunning technical rigidity, Eaton felt that the artist's work should "be a spontaneous by-product of your enthusiasm . . . a series of corrected mistakes." He attacked his work with power surges, laying on thick impastos, splattering flecks of wet paint, loading his brush, dragging his dry brush, and pushing and shoving the pigment around. In spite of its coarseness of texture and masculine manipulation, most of his work revealed, at a distance, an almost dainty brilliance and purity.

By the end of the sixties, Ken B. Baxter (1944–) had asserted himself as a leading young traditional-realist painter in Utah. Gifted with a deft touch, Baxter rose in fame and fortune during the decade of the seventies. Through historical reconstructions of downtown Salt Lake City, which were quite faithful and charming, he gained a wide following among collectors and patrons. Trained by Alvin Gittins, as was his talented though less disciplined artist brother Dan, Ken Baxter was a consummate realist with an almost journalistic eye.

Baxter was able to paint canvases of almost any subject with flair and appealing candor. Paintings such as *Mecham's Boots* (1973, SMA) show his first hermetic attempts at realism, while his later works opened up to plein-air treatments of nature. Through it all, he had a marvelous sense and flair for composition, color, and gritty brushwork. He and Earl Jones remained the most influential teacher-painters on the Utah scene. Founder of the plein-air school in the state, Baxter helped direct the aesthetic lives of many art students.

FIGURATIVE, WESTERN, AND WILDLIFE GENRE

During the seventies, several Utah artists became prominent nationally for western genre and wildlife. Among sculptors of western genre, Edward J. Fraughton (1939–) was unique because of the depth of his classical academic training. Fraughton's work was remarkable in its technical and conceptual adroitness. A Park City native, Fraughton trained with Avard Fairbanks at the U of U's department of sculpture. From Fairbanks he developed an idealist-realist approach to sculpture, which, given his formidable ability to compose and meticulous care for surface, has won him many prestigious commissions.

Besides his richly worked monumental and heroic-sized bronzes, Fraughton was also a creator of medals and medallions. His smaller bronzes have the same close attention to detail as his larger pieces. Occasionally, the sheer magnitude of his technical virtuosity overwhelms his diminutive work, but seldom his bronzes of larger scale. The power of *One Nation* (1988, SMA) absorbs the surface gesticulation and minutiae into a satisfying whole.

U. S. Grant Speed of Texas and now of Lindon, Utah, has with Fraughton, become the state's most significant western sculptor. Formerly a professional rodeo star, Speed turned to cowboy art as that career dimmed. Unlike the academic Fraughton, his style is more impressionistic in surface and gesture. A founding member of the Cowboy Artists of America, he has earned a reputation for authenticity and spirit in his bronzes. His *Ropin' Out the Best Ones* (1984, SMA) is an action-packed western which not only informs us about cowboy life, but interests us in it.

Toward the end of the seventies, Gary L. Kapp (1942–), of Provo, left commercial illustration to become a fine artist in the western genre. Unlike most illustrators-turned-artists, his brushwork and pigmentation are rich and broad. More a painter of cowboys than of Indians, he retained a strong landscape element in most of his work.

The young Provo artist Michael Coleman (1946–) was at first, a painter unabashedly in the Hudson River style. Gallery owner Dewey Moore quickly perceived Coleman's marketability and began to persuade the doyens of Salt Lake City that a great artist was in their midst. Coleman was productive and soon began painting compelling scenes like *Dusk on Utah Lake,* with luminous sky and muted colors.

These nostalgic scenes of Native American life instantly found a demand, and Michael Coleman, like Ken Baxter, became the artist "for the people" of Utah. Coleman's dark work of the late sixties and early seventies gradually gave way to a lighter palette and more figures and animals as evident in his *Indian Camp* (1991, p.c., **plate 112**). The artist then began to find an outlet for his paintings, first in Los Angeles, then in New York City at Kennedy Galleries, and eventually with Michael Frost at Bartfield. To this day, he is one of Utah's most financially secure artists.

The nationally noted illustrative wildlife painter Farrell R. Collett bridged the gap between western and native Utah rustic landscape painters. Noted for his portrayals of cougars from the fifties to the present, he reflected national trends in realistic and illustrative styles of representation. His tenure at WSC in Ogden, Utah, established a platform for wide acceptance of wildlife art

Michael Coleman, one of Utah's most successful contemporary painters, shown in his studio surrounded by the artifacts of the American West which inspire him. (Photo courtesy SMA.)

Clark V. Bronson, *Big Boys;* 1984, small bronze, 22" × 28 1/2" × 14"; SMA.

in Utah. Because of this a number of talented artists have worked in this genre.

The most important of these is Clark Bronson (1939–), of Kamas, Utah, and more recently of Bozeman, Montana. He started his career by making watercolor and pencil-drawing illustrations for the Utah Fish and Game Department. This was followed by ten years as a freelance artist, but by 1970 he concluded that sculpture best expressed his gifts as an artist. This decision proved correct, as demonstrated by sales, award recognition, and membership in such organizations as the National American Wildlife Association, National Sculpture Society, Society of Animal Artists, and Wildlife Artists International. The strength of his craft lay in firsthand experience with the animals he portrayed. With an academic naturalistic style he depicts the deer, elk, eagle, or bear in its environment without further interpretation.

Perhaps the most significant of the younger wildlife painters is Nancy Glazier-Koehler (1947–), of Salt Lake and Lindon, but later of Montana. With an acute eye for observation and supple effect, she was noted for her portrayals of North American big game, especially buffalo and cougars. Her *Peaceable Kingdom* (1984, MCHA) painting of the lamb and the lion is a masterpiece of Pre-Raphaelite-influenced composition and color. Also noted for her landscapes, still lifes, and portraits, she focused on wildlife and was a member of the Society of Animal Artists.

METAPHYSICAL AND METAPHORICAL ART

By the 1970s, an increasing number of metaphysical and metaphorical artists began to assert themselves and receive critical acclaim. Although a mature artist by this time, Francis Zimbeaux was just becoming understood and appreciated. His work was unlike any in Utah except that of his father, Frank I. Zimbeaux, who also painted nymphs and mystical landscapes, though on a smaller scale. Francis's style diverged from his father's in several significant ways, including the younger artist's use of the tonal palette rather than colorist approach. The father painted small figures in the Elysian landscape, but the son would boldly paint full-sized nymphet nudes in oil, watercolor, or pen.

In Salt Lake City, Frank Anthony Smith blended the finely applied acrylic painting style with trompe-l'oeil content and unsettling existential juxtapositions. His work in the seventies and eighties, "simultaneously created and repudiated illusionism," straddling the real world and the world of dreams. It seemed to be influenced by the special effects of cinema, but with more intelligence than that medium usually offers. He was caught between time and space on a very jolted continuum. As Frank Sanguinetti noted, "He is absorbed by the ambiguities of visual and spatial perception."

His *Coleus* (1974, SMA) is metaphorical painting at its best. Without protracted explanation, the cosmic explosion of the coleus nucleus forms a mandala for meditation. Another idiosyncratic approach can be seen in his masterful *Cure* (1988, SMA, **plate 102**). It depicts, with eschatological overtones, a lone oriental vase sitting on a skyscraper, centered in the midst of a swirling cosmos, gripped by oblivion. As in most of his work, a contrived trompe-l'oeil deliciousness is denied full reign by a flat, dry, airbrushed acrylic surface. A dense, mysterious, hallucinatory imagery pervades his canvases, which often have classical and Zen elements. He remains Utah's virtuoso abstract illusionist.

In Edith Taylor Roberson (1929–), Utah inherited one of its most significant metaphysical artists. Born in Delaware, she studied with Hobson Pittman, whose own dreamlike visions of the antebellum South influenced, as Robert Olpin notes, "[her] rather romantic interest in the lives surrounding and shaping and touching the surfaces of inanimate objects." She settled in Salt Lake City in 1963, where she became an active participant in exhibitions, including two solo shows at the Salt Lake Art Center.

Her statements on the passage of time are revealed in her painting of found objects: old rusty tricycles, dolls, miniatures, toys, old prints, antique clothing, and so on. Roberson has as wide a range of subjects, techniques, and styles as any Utah artist. From virtuosity for the sake of trompe l'oeil to direct landscape painting to abstract fundamentalism for the purpose of imagery, her work always catches poignant melancholia. Her paintings, such as *Channel Three* (1981, SMA, **plate 90**) of a kitchen's corkboard, fool the eye and boggle the brain.

MODERNISM AND THE AVANT GARDE

Abstract, brutalist, and conceptual art were still considered modernistic in the seventies. A much larger audience was becoming sophisticated enough to appreciate these "outrages" of vanguard painting and sculpture. Although, in Springville, an Ed Dollenger exhibition in late 1979 still aroused criticism.

Regardless, Utah's modernists continued to produce important new work. By 1974, Lee Deffebach was

Francis Zimbeaux, in his studio in 1990. Zimbeaux shares mystical themes in common with his father, Frank, though their styles are very different. (Photo courtesy SMA.)

prepared to embark upon a series of mural-sized stained canvases a la color-field painters Helen Frankenthaler or Paul Jenkins. Aided by a grant of $5,000 from the Western States Art Foundation 1975–76, she was able to travel, study, and paint. From this came a number of vividly colored, translucent, acrylic-washed canvases. Like a veil of color, the exploratory, unmanipulated interaction of viscous paint spread translucently and transparently down a white canvas had an exhilarating effect. At the same time that Don Olsen's work was becoming increasingly geometric, minimalist, and hard-edged, Deffebach was painting wet into wet, with sensuous biomorphic wisps of color and light.

Deffebach's spilled-paint canvas *Zelda: Los Truches* (1973, p.c., **plate 78**) is an early example of thalassic waves of color poured across the canvas. As much suggestive watercolor as opaque painting, this is work in which she was willing to risk everything for veiled sensations of color.

Very few other artists attempted color-field painting in Utah. By the mid-seventies, it was somewhat passé

in New York. Claudia Sisemore (1937–), of Centerville, was another of the first artists during the seventies to paint large acrylic chromatic abstractions. To her, they represented the topography of the Utah Canyonlands, though to the viewer they were decidedly nonobjective.

Leaving the radical abstract expressionism of the sixties, Denis R. Phillips developed a more decorative chromatic abstraction style tied to the landscape of Utah. Cathy Pardike (1939–) worked subconsciously in the realm of inner feelings, her abstractions being controlled as dream therapy to interpret that private world. John Hess (1939–), a member of the Atwater Weaver's Guild, was a noted fiber artist of simple abstract design in muted colors. Marah B. Rohovit (1942–), of Salt Lake, painted throughout the seventies in a hard-edge manner. In 1981, she began painting in a gestural textural manner that was equal parts expressionism and impressionism.

By this period, the list of Utah modernists began to fall off substantially. Margaret Carde's (1944–) etching and silkscreen pieces are often large, with layered-ink drawings on gessoed Masonite or canvas. As she builds

her layers of interweaving and overlapping lines into a pattern, a crucial surface tension is created. John W. Wood (1945–) has also concerned himself with light and color in his mixed-media-on-paper work. His works are personal responses to experience and light. While he often works from the figure and nature, his pieces are more abstract impressionist than objective.

One of the strongest abstract modernists in Utah is Ronald V. Clayton (1946–), of Salt Lake. In contradistinction to the strident modernist ideologues who preached against craft and beautiful painting, Clayton's bravura in paint applications and interest in color and light place him in the optical-abstract-impressionist mode. A totally different approach is represented in the works of Richard W. Shepherd (1947–), of Ogden, who attempts to visually assault the viewer. Shepherd's insistence on working in various media, techniques, and styles was a personal decision. An exploratory artist, he often uses one style in painting a series or suite and then alters it for his next work. Painting social commentary, then abstract expressionism, then realism, then kinetic light, and so forth, has hurt his rating as an artist in Utah because the diversity of his work does not draw a consistent following.

North Mountain Artists Cooperative

Utah had its Templeton Building and later its Guthrie Building and Pierpont/ArtSpace Studios in Salt Lake, but not until a number of artists moved to Highland, Utah, at Bull River, did it have an artists' community. The core group of the coalition, which had been deeply involved in the Mormon Art and Belief movement of the late sixties and early seventies at BYU, included Michael C. Graves, Neil Hadlock, John Marshall, Ray Morales, musician Marvin Payne, Dennis Smith, Gary E. Smith, Frank Riggs, and Trevor Southey.

This group formally organized under the title of North Mountain Artists Cooperative about 1970, at Alpine, in Utah County. All were interested in Mormon art and viewed their cooperative in utopian terms. As Frank Riggs put it, "If Mormon art ever develops anywhere, there's as good a chance as any it will develop here." Their original goal was to build an artists' association, art center, and art school. This was a lofty ambition in a culture in which artists seldom worked closely together.

Eventually the communal aspect became a reality when, in 1976, they began purchasing land at Bull River, mostly on Gamble Oak Circle and Tamarack. As the cooperative grew, it included twelve acres along Dry Creek for a sculpture park, a proposed site for an art center to serve Utah County and the state. Each home along Gamble Oak Circle was "artist-designed" to suit the aesthetic temperament of the professional artist, in a manner very similar to the Victorian St. John's Wood Clique in London, where artists' homes sided against each other. Here, some of Utah's premier artists lived and worked together in a support system that helped make it possible for them to become the first generation of Utah artists who could make their livelihood totally from their art. Somewhat like the Pilgrims, who came to America in order to do good but instead did well, these younger idealists soon became successful both artistically and financially. (Since that time, some of these artists have moved out-of-state to continue their work.)

Art Museums, Societies, and Centers

The decade of the seventies was a very good one for the growth of visual arts institutions in Utah. The state was inexorably developing support facilities and institutions to foster education in the visual fine arts. Not only did art museums and centers improve and multiply in the more urban areas of Utah, but they also dispersed to Cedar City, Park City, and Brigham City as well.

The Brigham City Museum-Gallery was founded in 1970 and housed in the basement of the new city hall. Directed by Fred M. Huchel in the seventies, then by Larry Douglas in the eighties, this museum mixed fine art with historical artifacts in an active exhibition schedule.

In September of 1970, the Utah Museum of Fine Arts opened at the University of Utah campus, with Frank Sanguinetti at its head. This structure was constructed as a part of the new art and architecture complex and stepped forward as the capital's first major art museum. A later addition, funded by Perry Thomas and Mrs. Hubert Michael in 1972, brought the building to 35,000 square feet for the museum's permanent collection, adjunct spaces, and exhibition galleries.

Also in 1972, the museum organized the Friends of the Art Museum to acquire and exhibit works of art that would otherwise be impossible for the museum to purchase. Under Sanguinetti's guidance, the Utah Museum

of Fine Art's collection development was impressive. Its diverse holdings included European, American, Native American, primitive African and Oceanic, and oriental (particularly southeast Asian) art, along with ancient objets d'art.

A new art organization began in Bountiful in conjunction with the U of U department of art and Division of Continuing Education. The Bountiful/Davis Art Center began in October of 1974, with Anton J. Rasmussen as director. Then in June of 1979, a newly remodeled building at 2175 South Main greatly improved the facilities for art courses and exhibitions, such as the annual LeConte Stewart show.

The building housing the Springville Museum of Art, owned by Nebo School District since 1937, was turned over to the City of Springville in 1975. The museum had, to a great extent, lost its former prestige and certainly its momentum. In contrast, in Park City, the Kimball Art Center opened in the fall of 1976, accentuating the meteoric rise of that city in the fine arts. Bill Kimball, of Ogden, founded the 17,000-square-feet center, with Allan Crooks as its first director, followed by David Fernandez in 1977. It provided both art classes and exhibition space and has had a great impact on the exhibiting patterns of Utah artists.

Allan Dodworth (1938–) directed the Salt Lake Art Center from December 1976 to 1981, first in its facilities at the old Art Barn on Finch Lane, then, beginning in 1978, at new accommodations near Symphony Hall and the Salt Palace at 20 South West Temple. (The modern complex was constructed as part of the Bicentennial Celebration of 1976 but was not completed until 1978.) Dodworth ably guided the art center for three more years before leaving. The Salt Lake Arts Center, which had been founded on the values of contemporary art, now began to face financial difficulties, undoubtedly due to the strains of maintaining the new and larger facility.

Once the Salt Lake Art Center left the facilities at 54 Finch Lane in 1979, that address was taken over by the Salt Lake Council for the Arts. During the intervening years the council has developed into another art center of sorts for artists of Salt Lake County. Unlike the Utah Arts Council, the "other" Salt Lake Arts Center is primarily a visual arts institution.

The Braithwaite Fine Arts Gallery at SUSC was begun in 1976 under the hand of Thomas Leek. He stayed on as professor and gallery director until 1982. Like Gallery 303 at BYU and Gallery East at the College of Eastern Utah, it was a traveling and student/faculty exhibition space. It also displayed SUSC's permanent collection of works by nineteenth- and twentieth-century European, American and Utah artists.

The early 1970s saw the rise of Park City as the most impressive market for art in the state. With the development of the city as a ski resort, the town began to grow in size and wealth. Though it was a seasonal area, the Meyer Gallery (founded in 1969 by Darrell and Gerri Meyer) and the Kimball Art Center, and eventually many others, were able to do well. Then, with David Chaplin, the Art Center founded the Park City Annual Art Festival in 1977. As an art community, Park City remains Utah's version of Jackson Hole, Wyoming; Carmel, California; Santa Fe, New Mexico; and Scottsdale, Arizona.

Founded in November of 1974, the Utah Watercolor Society has been a major force in the arts community, helping to make watercolor a medium in which many Utahns excel. Charter members included George Dibble, Homer Clark, Ed Maryon, Thomas Leek, Harrison Groutage, and Richard Van Wagoner. Though basically centered in Salt Lake City, the society's annual juried show moves about the state from year to year.

THE SEVENTIES CONCLUDE

The roll call of those significant artists who died during this decade is larger than any before. Among the losses of art teachers and faculty artists were BYU professor B. F. Larsen, who died in 1970, having passed the apex of his art by the late fifties. Cornelius Salisbury died in 1970 and his cousin, Paul Salisbury, three years later. The retired Conan Mathews died in 1975. Retired U of U instructor Florence Ware passed away in 1971, a decade after her best work was completed. The sculptors Millard Malin and Hughes Curtis both died in 1972. In most cases, these artists, with the exception of Paul Salisbury, were generally forgotten until the 1980s. H. Reuben Reynolds, of Utah State University, lived until 1974, and the Art Barn teacher Lynn Fausett until 1977. Minerva K. Teichert passed on in 1976.

The seventies would have to be characterized as the decade when Utah art came of age. In relative terms, Utah measured up to national art centers if one factors out the obvious advantages of being in a major metropolitan area replete with art market, established studios and long tradition. By the end of the decade, Utah was becoming an art-exporting state, a trend that would greatly increase during the eighties.

Lee Deffebach shown in her studio in Salt Lake City, c. 1984. Deffebach is one of Utah's premiere innovators. (Photo courtesy SMA.)

DECADE OF THE EIGHTIES

As Utah art entered the new decade, there were a number of uncertain voices predicting where art would proceed nationally. Novelist and critic Tom Wolfe felt that by the early 1980s modernism had died from exhaustion and was fit to take its place among museums. Not everybody agreed with this assessment; in fact, *Time* magazine art critic Robert Hughes, at a Salt Lake City lecture, called Wolfe "a horse's ass in a white suit!" Yet the art world seemed to have entered into the postmodern era, in which the incessant rollover of successive stylistic developments came to an end. Writer Susie Gabblick noted that the avant-garde was enervated, would no longer be able to sustain itself in the future and must, of necessity, fall back upon rehearsing its innovations over the past century. Thus, the "art of appropriation" became a fixture of the late-twentieth century. Upon hearing this, critic Arthur Danto recently quipped,

"There are to be no next things. The time for next things is past."

Neoexpressionism, neojungenstil, neogeo, and other such movements have cast an inconstant specter over contemporary art nationally and to a lesser extent in Utah. One of modernism's basic credos, "There is no past— only the future," pushed originality too fast and too far beyond itself. Now, instead of originality we offer mere novelty. Without being over-critical of new trends, many of which are exciting, some new aggression on the cutting edge of the avant-garde seems compromised by overmuch borrowing.

MODERNISM AND NEOMODERNISM

The pendulum in the 1980s seemed to swing sideways, as opposed to back and forth, forming a contemporary synthesis between the concerns of midcentury abstract expressionism and representationalism. Nonobjective abstract painters were vanishing both in Utah and nationally. They seemed more conventional or

"middle-modern" in the sense that we became accustomed to their experimental and expressive devices. Given the difficulties of producing cutting-edge art in a regional environment, the provincialism and usual parochialism of the intermountain area perhaps worked against this kind of creativity.

By the end of the seventies, H. Lee Deffebach had moved away from her bold and extemporaneous color-wash paintings and worked more classically in an abstract expressionist mode. In the eighties, she continued to work in large format with atmospheric, luminous and saturated color abstractions applied in thin layers. Scraping back, then repainting, with patches of pure paint intermixed, created in her acrylics subtlety, muted tonalities, and hued articulations.

One of Utah's leading radical modern art activists is David A. Sucec (1937–), of Salt Lake City. He taught at the Salt Lake Art Center and elsewhere, promoting conceptually experimental and anti-market-oriented art. His goal was to develop funding strategies for modernist artists who could not support themselves from their art and had no teaching positions, yet whose contributions were needed as "a seed for the future." As an advocate for vanguard, innovative, and radical conceptions in art, Sucec believed that the present health of stylistic pluralism is vouchsafed by our predecessors. "The avant-garde," he contends, "unblocks passages for all to pass. For the broad expanse of today's artists are indebted to the vanguard, those who are breaking new ground."

A significant fiber artist in this decade was Sharon Davis Alderman (1941–). Her work single-handedly ended the debate over whether fiber is only a craft and not an art. Concerned with color and light nuance, she chose to use cotton sewing thread to weave her color studies because the fineness of the thread allows the color blendings to be smooth, creating a subtle movement of color and light across the woven surface. Usually the surface plane is covered with squares that vary slightly in terms of value and hue, and within the squares, metamorphoses also occur.

One of Utah's few op artists, Bonnie G. Phillips (1942–), of Salt Lake City, is best known for her watercolors on satin fabric, which are unique in the technique combining stencil, tape, and resist process to give a luminous optical effect. A devotee of contemporaneous strains of art, she developed her own style, a complex and reticular montage which might be termed "geometric impressionism."

Another talented artist is Allen Bishop (1953–),

Bonnie Phillips, *Whole Wheat On Tuna;* 1981, watercolor on satin, 42" × 36". (Photo courtesy SMA.)

from Moab and Salt Lake City. Originally, Bishop was reluctant to study with Don Olsen at Jordan High School, but within a week he was converted to the joys of "formal relationships." In this respect, his work runs counter to that favored at Utah's universities, which stress skillful academic modernism, or well-painted abstractions. Perhaps more than anybody, Bishop has addressed painting issues of his day. He might be termed a "prismatic abstractionist" because his work utilizes the full range of color. Rather than establishing certain palette limitations that would lend cohesive results, his colors often clash in ways that disturb interior designers. See, for example, *La Semilla Brota* (1990, SMA, **plate 108**). Color coordination is sacrificed, along with skillful brushwork and

regularly shaped canvases, in order to challenge preconceptions of what art should be.

Some of Utah's most significant nonobjective two-dimensional artists actively working in the eighties were Anna Campbell Bliss (1925–), who is especially known for her use of computer-generated images and purist color in silkscreen; Carolyn Ann Coalson (1939–) and Nel Ivancich (1941–), who developed, during the later eighties, painterly abstract impressions of significance; and Randi L. Wagner, (1952–) of Salt Lake, who paints more decorative abstractions, often in large scale.

Highly regarded by insiders of contemporary Utah art, the sculptor Raymond V. Jonas (1942–), of Provo, is little known elsewhere. Outwardly shy and self-effacing, he lets his work, especially in butchered wood, act as a spokesman for his inner personality. In three-dimensional work he is eloquent, powerful, and even aggressive.

Another sculptor who came into his own during the eighties is W. Neil Hadlock (1944–). Descended from two generations of blacksmiths, he became a founding member of the North Mountain Artists Cooperative. Since then, his attention has been divided between his art and his foundry, Wasatch Bronzeworks in Lehi. A devotee

of noted sculptors Anthony Caro, Ellsworth Kelly, and Eduardo Chillida, Hadlock combines elements of their work with his own sense of form, materials, and surface to form a formidable gestalt. His *Effron* (1983, SMA, **plate 91**) is an outsized corten steel hard-edge minimalist piece that commands the grove of trees in its setting at the Springville Museum of Art, like an altar.

Kraig Varner (1949–), also a sculptor in bronze, melds the influences of Giacomo Manzu and the academic figurative style of BYU professor Dallas Anderson. Varner's personal style exhibits a powerful sense of expression and sensitivity to surface. David Adams (1950–), of Lehi, creates sculptured, wrapped, and painted metal-and-wood wall pieces, often of large scale.

Minimal abstractionist sculptor, Ron Zollinger (1951–), of Logan, studied at USU with Larry Elsner and did graduate work at Arizona State University. Using metal and wood that were often painted but sometimes buffed, he creates works of a refined eloquence.

In quality of modernist statement, Michael C. Hullet (1953–) is both profoundly and riotously extravagant. Like the works of David Adams and James Jacobs, Hullet's constructions work both as paintings and wall

sculptures. His early work dealt with precarious balance and playful effect. The use of elements taken from signage—colorful strips, markers, and shapes painted on aluminum—enliven his work.

Among the most significant nonobjective sculptors is Frank Riggs (1922–), of Highland, who is noted for his painted and highly designed aluminum minimalist constructions; Karl K. Momen (1934–), who made his contribution to the state's art annals (though not fully a Utahn by birth or long-term residency) through his *Tree of Utah* sculpture in the salt flats west of Salt Lake City; Frank Nakos (1939–), who is noted for work in a classical minimalist vein; ceramic sculptor Diana I. Toth (1941–); and Nathan A. Johansen (1958–) who works more psychologically.

NEOREALISM

Randall Lake (1947–) came to Utah in the autumn of 1973 to study with Gittins. "Alvin never encouraged students to work from memory, but only from models," reminisces Lake. "With him, getting nature right was an absolute, a moral imperative, which allowed no distortion or arbitrariness. The primacy of craft and technical excellence guided his work and teaching methods."

During the seventies, Lake moved toward classical academic tradition by learning the forgotten lessons of the French ateliers. Lake's image as Utah's realist master was properly cultivated through his "velveteen painting-jacket" manner. In a sense, he is a torchbearer of sorts for both Gittins in the figure genre and LeConte Stewart in landscape.

Along with portraiture he has, more recently, chosen contemporaneous subjects such as city streets and social genre. His preferred motifs are figurative work (which sometimes borders on the surreal) landscape, and, above all, still life (which proffers his best statements). *The Studio Walls* (1984, SFAC, **plate 94**) shows the strong modeling, succulent color, and juicy pigment of his beloved Manet. Though Lake paints from life, and is also a plein-air painter, he is primarily a studio artist in the academic sense.

Among the decade's genre artists, Gittins's student Sam Collett (1942–) is a figure drawer and fine painter of realist inclinations. Another most interesting talent is Kate Clark Spencer (1946–), of Orem. Her work is drawn from contemporary life without preconception, though it is strong in interpretation and untrammeled spontaneity. Her works are almost painted line drawings, filled in with patches of color against white backgrounds.

One of the leading genre and figurative painters of the seventies and early eighties was Danny Baxter (1948–1986), who died before he reached the pinnacle of his career. He was an important teacher, like his brother, Ken Baxter, and had some influence on the figurative direction of Utah art.

Annette LeSueur (1949–) is a graduate of BYU and of the Richard Lack Atelier in Minnetonka, Minnesota. There she developed her art along classical realist lines that could trace their heritage back to R. H. Ives Gammell, Jean Léon Gérôme, and Jacques Louis David. The resurrection of the classical nude and religious ideals in art has been her cause. LeSueur feels that the preservation of the perfected principles of art is absolutely vital to the well-being of art today. This view is held in much the same way that David Sucec believes that avant-garde innovations are essential for the well-being of art tomorrow.

One of the lights in contemporary figurative painting is Margaret W. Morrison (1960–), of Salt Lake City. Her art consists most often of figures arranged in quiet interiors reminiscent of the work of John Koch of New York. The masterful manipulation of enclosed space gives her work its peculiar authority. Her figures communicate mentally, much like Edward Hopper's, in their elusive and illusive quality.

Gibbs M. Smith (1940–) is a strong colorist, both in highly stylized urban-inspired imagery and in individualistic landscapes. His emotionally charged images are inspired by his first impression of a motif. Often, the image is quickly sketched, then developed or synthesized through reflection and from memory, in the studio. His landscape motifs are often gleaned from the area around his home in West Kaysville where, as a younger person, Smith often visited with LeConte Stewart, painting en plein air.

His urban imagery sometimes contains a figure reflecting on the city through a window (see *Manhattan*, 1988, SMA, **plate 101**). The paintings depart from reality in ways that give Smith's work its surreal quality. The use of color is inspired by the French Nabis, particularly Pierre Bonnard.

Shauna Clinger (1954–), a student of Gittins, is a leading Utah portrait painter. Her recent work develops significant imagery that captures the feminist sensibility.

Will South (1958–) is producing paintings of strong value contrast created by brilliant highlights against dark backgrounds. His work has a structural quality that creates strong forms and encompasses still life, figure, and

the landscape. In addition to his painting, South is an art historian who has done work on J. T. Harwood, an arts administrator, and a dealer.

LANDSCAPE

Landscape is Utah's most significant genre, the one to which many of our most talented artists apply themselves. What sets Utah apart from the eastern schools of landscape painting, more than anything, is the landscape itself. Utah's overpowering mountains, cliffs, arches, canyons, gorges, panoramas, and towering stone monuments are hyperbolic landforms.

It could be argued that Valoy Eaton and V. Douglas Snow were still the most significant landscapists in Utah in the l980s. From the 1950s through the 1980s, Snow exalted the Utah desert in poetic abstractions. As a *Life Magazine* article in 1957 perceptively noted:

> *The primeval shapes and rich colors that enliven the landscape of Utah were a constant stimulus to 28-year-old Douglas Snow, who lived in Salt Lake City. While an art student in Michigan he painted scenes of everyday life in a realistic manner. But back in Utah the soaring mountains and bizarre formations of the region compelled him to develop an abstract style to convey the variety and rugged drama of the land.*

With scintillating surface effect, his improvisations of nature reflect the mammoth power of the Utah landscape. From the late seventies he owned a residence at Teasdel, Utah, near Capitol Reef. While his abstract landscapes through the seventies were more enigmatic equivalents of the Utah desert, during the eighties his conceptions became more naturalistic. Snow's technique in *Cockscomb, Near Teasdel* (1985, SMA, **plate 97**) is as abstract as the limestone formation he painted, and his stylistic approach is as impetuous as the stunning combinations of color found in nature.

The 1980s saw a number of artists working in and dealing with the landscape of Southern Utah. Thomas A. Leek (1932–) became nationally known for his mystical watercolors of that region's landscape. Another watercolorist, Donal C. Jolley (1933–), a member of the National Watercolor Society, has a preference for the towering forms of the Canyonlands. In fact, he was actually born in Zion National Park, where his father had been a ranger.

Though traditional in approach, the meticulous finish of Carol Pettit Harding's (1935–) landscapes have a profound, magic opulence. The Pleasant Grove resident's *Tinaja Voyage* (1989, SMA, **plate 109**) is a large oil of the immutable rock faces of Zion National Park. This work and her oeuvre in general show a contemplative solitude very much in keeping with the paradisiacal content of her work. Along with Harding, Lou Jene Carter (1933–), of Springville, and Marilee B. Campbell (1938–), of Provo, have spearheaded the use of pastels in Utah.

James F. Jones (1933–), of Cedar City, has also painted the vast range of southern Utah landscape without embellishment. More intellectual in approach, his vision universalizes his subject into pure design and profound introspection. Jones's canvases are succinctly painted in a skillful union of form and color anticipated by Maynard Dixon. Unframed and painted around the edge of the canvases, his slightly textured paintings effectively unite conception and construction. Jones would have to be considered the premier landscapist of southern Utah.

J. Tom Mulder (1939–) is noted for his simplified desert themes, ripe with cogent definitions of light on form. Anton J. Rasmussen (1942–) is chiefly known for his amazing performance in huge canvas murals of the red-rock country on display at the Salt Lake International Airport. Both he and Carl L. Purcell (1944–) approach the Utah landscape more abstractly. Purcell's watercolors have an energetic impetuosity in their cubist closeups of cliffs and geologic formations.

Certainly the most interesting movement in Utah landscape painting for the past decade and a half would be the Plein-air Painters of Utah. A national school of painters with nearly the same title and including such Utah luminaries as Kent Wallis (1945–) and Gregory Hull (1950–) inspired a local movement. Since 1987, this group of Utah artists, mostly centered around their president, Ken Baxter, have attempted to paint on location, out-of-doors. See, for example, Ken Baxter's rural landscape, *Sheds in Herriman* (1991, SMA, **plate 111**).

An interesting sidelight is the amazing number of women artists who have achieved professional status in their mature years. One of these, Elva E. Malin (1933–), paints rural scenes depicting people in settings as well as mountain landscapes. Bonnie Posselli (1942–) is the daughter of May Blair, who was a landscape painter herself. A student of Frank Ericson and the Baxter brothers, Posselli is a landscape and figurative painter of buttery pigmentation, saturated color, and rustic genre.

Another plein-air painter is Kathryn Stats (1944–), of Salt Lake City. Her rural Utah scenes deal to a great extent with veils of light, atmospheric and aerial perspective, and the evocative nature of color. Subtle nuances of violet, turquoise, and shades of grey and green set her

apart from most Utah landscapists, who saw only the highlights and never into the shadows. Stats has a confident control of her medium, and her later paintings propelled her to the forefront of landscape painting.

In the 1980s, Robert L. Marshall (1944–) grappled with larger canvases, employing oil rather than watercolor. A master at color and effect, he did not abandon the strength of his bravura but merely applied it to larger abstract realist ceramic images, like *Money Plant* (1982, SMA, **plate 92**) and viscous landscapes. The large pots and tribal carpets which populate some of his work filled a need to describe reality and were a bridge to his present-day impressionist "ecosystem" wetland landscapes. "My work," Marshall declared, "is the result of fifteen years' experience dealing with aqueous materials. My oils are extensions, not a repudiation of my watercolors; a continuity still exists." In this decade, his paintings grew more sensuous and certainly more formalist. Unlike his work of the seventies, his oils of the eighties are an original contribution of the artist, who produced these large canvases in prodigious rhythm. Robert L. Marshall and Douglas Snow provided local modernist landscape examples to serve as catalysts for younger Utah artists.

The term "lyricist in paint" describes Richard A. Murray (1948–), of Salt Lake City, when represented by his best works. His wet-into-wet oils are among the most engaging of any by Utah artists. At once romantic and nostalgic, his wooded interiors, farm scenes, and vistas abound in emotion and memories.

In 1979, watercolorist Ian M. Ramsay (1948–) left an architectural practice to devote his talents full-time to painting. Born in England, he combines the gentle rustic beauty of the Kent countryside with contemporary rural Utah back roads. Kirk H. Randle (1952–), of Bountiful, is also an architectural draftsman who gained recognition during the eighties for his mixed-media landscapes and townscapes. At the same time, the LeConte Stewart school of landscape painting continued unabated. George W. Handrahan (1949–), of Layton, maintained the tradition of Stewart while finding his own personal strength of expression. D. Lynn Cozzens (1955–), from Stewart's hometown of Kaysville, concerned himself with pointillist brushwork and fauvist color.

Certainly one of the best young landscape painters of the eighties is Frank Huff, Jr. (1957–), of Salt Lake City. Trained at the University of Utah with F. Anthony Smith and Alvin Gittins, Huff is able, through his watercolors and oils on paper, to capture the stark essence of the Utah landscape with great power. A devotee of Edgar Degas, Richard Diebenkorn, and Edward Hopper, Huff successfully combines strong abstract design with the subtleties of contemporaneous representation. The spontaneity and immediacy of Huff's vision is captured without arduous labor. The singular quality of isolation so notable in the desert country of southern Utah, in the tract houses of new subdivisions, emptied drive-in theaters, and storefronts was captured by his brush as in *Living Their Religion* (SMA, 1987, **plate 98**). Huff's work is contemplative in its solitude and uncanny in its compositional invention.

WESTERN AND WILDLIFE ART

The numbers of artists painting in the western genre during the 1980s was proof of its continuing draw. A cowboy from Moab, Pete Plastow (1930–) came into his own as an artist during this decade. Plastow is a painter of both cowboys and landscapes, the latter being among the most spectacular representations of the rock formations of southeastern Utah. Though his technique is dryly academic and sometimes archaic, the pictorial effect of such oils as *Monitor and Merrimack* (1989, SMA) is stunning.

An important western artist throughout the eighties was John B. Jarvis (1946–). Born in American Fork but living in Pleasant Grove, he was a fully mature landscape and western genre painter when the eighties began. Like Lyn Briggs and Bruce Cheever, he works mostly in gouache. Like Michael Coleman, he was initially influenced by the nineteenth-century Cincinnati artist Henry Farney. Jarvis integrates landscape and the figure, revealing them in dramatic ways and with stunning effect. His *Jacob Hamblin Among the Hopis* (1982, MCHA) is a fine example. Like Coleman, his pictures are usually multifigured, with Indian encampments being a specialty. His *Southern Utah Landscape* (1989, SMA) reveal tightly controlled detailing unified by tonality and color.

Another artist who, like Jarvis, is able to combine western genre and landscape effectively is E. Kimball Warren (1952–), also of Pleasant Grove. Warren's brushwork reflects the fresh pigmentation of Clyde Aspevig, while his depictions of the high Uinta Mountains are quite original. His subjects vary widely within the genre and include rural farming landscapes, pack-horsing in the high country, and sometimes the distinct southern desert. Warren works from field studies painted on location. Some of these become the final painting, while others are translated into larger studio versions.

Another of Utah's most painterly western artists is James C. Norton (1953–), of Santaquin. Like Warren, he

John Jarvis, *Jacob Hamblin Among the Hopis;* 1982, oil on canvas, 30" × 38"; MCHA.

relies on field studies to guide his work; but unlike him, Norton is likely to make the figure more prominent. Simple subjects such as backpacking, riders on the range, cowboys roping steers, or other ranching chores are often depicted in Norton's paintings. While his works are realistic, they seem as effortless as his brushwork, which is fluid and loaded.

The Salt Lake City watercolorist Al Rounds (1954–) defined quite a different approach to landscape painting. He won fame regionally through his convincing and authentic depictions of historic and pioneer Utah architecture. With archaeological exactitude, Rounds has recreated the Utah scene as it was a century ago.

Another architectural renderer who proved his talent in western art is Bruce Cheever (1958–), of Orem. A

painter in gouache, somewhat similar to Jarvis, he also tends to emphasize the landscape over the figure. The integrity and beauty of the landscape, dwarfing mounted explorers, bespeaks a poetry and fragility not often found in the work of Utah artists.

Provo sculptor Blair Buswell (1956–) is influenced by the technique and academic realism of Ed Fraughton. His bronzes of mountain men and busts of Hall of Fame football players reflect an artist of consummate ability. An athlete himself, his work reflects great insight into sports movements and ethos. His bronze of BYU basketball player *Danny Ainge* (1981, SMA) depicts that moment of glory in which Ainge drove to score the winning basket against Notre Dame.

In sculpture, Peter M. Fillerup's (1953–) work is

reminiscent of Avard Fairbanks, not only in surface finish but in interest toward monumental commissions. His *Kit Carson—Frontiersman* (1981, SMA) was produced in three sizes, the largest being in heroic scale for the Whitney Museum at Cody, Wyoming. Not only is Fillerup involved in cowboy-western subjects but in wildlife as well. Academic realists such as Collett and Bronson had inspired Utah toward the wildlife genre, but as long as wildlife sculpture was merely illustrative, its appeal within the fine art community was limited, though intense. When more innovative approaches began to be explored, appreciation increased. The work of Jeannine Young Newman (1952–) conveys the archetypical image she wished to portray rather than a portrait of any individual animal. David W. Jackson (1951–), of Clinton,

studied with Farrell Collett and is known for his watercolors and oils, as well as bronzes, from 1984. Jonathan Bronson (1952–) is another wildlife sculptor of note whose work rejects manipulated realism for a more impressionistic approach.

As much as anyone, Gary Lee Price (1955–), attempts to balance realism, impressionism, and abstraction in his sculpture. He worked three-dimensionally after 1979, when he apprenticed at Stan Johnson's foundry in Mapleton. Ed Fraughton also critiqued his art, which was, during the early eighties, basically southwestern in orientation. As his work matured, by the end of the decade, he moved away from western subjects toward more figurative and wildlife genre works, especially choosing birds as a recurring subject. His *Interlude*

Al Rounds, *Mt. Olympus at 45th South;* 1988, watercolor, 35" × 49 1/8"; SMA.

(1990, SMA) depicts two great blue herons.

Another practitioner of wildlife and figurative bronze sculpture is Korry R. Bird (1961–) of Springville and Mapleton. Though academically trained, he is more involved with expression than execution. His six-foot bronze of two eagles fighting in midair, *Stolen Meal* (1990, p.c.), consummately portrays the major dialectics of his art: accuracy in representation, strong action and emotional value, and strength of design and composition.

LeRoy D. Jennings (1946–), of Ogden, through scintillating light and color, reminiscent of the artistry of Joseph Raphael, beautifully depicts fish in water or on the riverbank. Bri D. Matheson (1952–), of Salt Lake City, is a contemporaneous sculptor of painted papier-mâché, mostly of fish. His highly colored fish, often suspended like mobiles, are respected because they attempt no "high art" pretensions. The painter Joseph Ostraff (1957–), of Alpine, also uses the fish motif in modernist portrayals of salmon.

NEOREGIONALISM:

One of the most interesting developments that took hold in Utah art during the late seventies and eighties was that of figurative neoregionalism. Like other great revivalist styles, regionalism raises its standard several times per century. The verities of America's heartland were painted in many cases by artists who were the sons and daughters of farmers and small-town laborers. From farm and factory and from the roots of rural Utah came an emerging neoregionalist movement, in which urbanism gave way to ruralism.

Whereas in most "Wild West" paintings, accessories and illustrative technique create an illusion of reality, in neoregionalism one senses, or feels, reality. Its essence is in heartfelt sentiment, not in mere nostalgia, and in expressive form, light, and color rather than in mere didactic detail. Though some neoregionalists observe reality more closely than others, it is not the standard means of expression.

One of America's most significant neoregionalists is Gary Ernest Smith, who was raised on a farm near Bake, Oregon. He came to Utah as a student at BYU and studied with Joseph Hirsch in 1972. An integral part of the Mormon Art and Belief movement at this time, he developed through the seventies into a painter of history, depicting wheat harvesting from early in this century as he envisioned it from recollections of the old machinery rusting at his father's farm. He also portrayed mining from his memories of tunnels and creeks in eastern Oregon and, of course, LDS church history.

By 1980, Smith was directing his art to more elemental and metaphysical concerns. His palette-knife paintings became symbolic forms laden with feeling. His subjects were farmers and laborers, the nameless sod busters which no self-respecting cowboy artist would dare paint. Gary E. Smith's art resounds with metaphors, formal abstractions, and truthful depictions of real life. His country figures are the emblems of all that is true, simple, and beloved in the American culture. *Youthful Games* (1984, SMA, **plate 89**) is tenderly evocative. Theodore F. Wolff, art critic for the *Christian Science Monitor,* wrote of him:

Finally, Smith is a rural artist, not an urban one. His interests lie with individuals and families interacting patiently and philosophically with the land. The people in his paintings are at peace with themselves and with their world—and when they're not, they accept their fate with quiet dignity. Even his children at play remain, at all times, part of the landscape; they and the rhythms and patterns made by their activities are not more and not less a part of the total picture than the fields in which they play, the ponds on which they skate, or the wooded farmland in which it all takes place.

Valoy Eaton is equally a landscape and neoregionalist painter. When he paints a landscape, the ranch, farm, or farmhouse is usually seen in the distance. Cattle, horses, ranchers, and their families often populate his Masonite panels. Being a country person, he never forgot his origins. He and his large family lived in Midway, Wasatch County, before moving back to Vernal in the 1980s. "When you live with your subject matter," he stated, "you see beyond the superficial." Instead of searching for the exotic, Eaton paints what he knows and loves, as he did in *Sun, Snow, and Ice* (1981, SMA, **plate 87**).

Arch D. Shaw (1933–) came to Utah from Kansas to live on a farm and herd sheep in eastern Utah. By 1980, he began to gain confidence in his ability as an artist while studying with Ken and Dan Baxter and Earl Jones. Shaw was associated with the Plein-air Painters of Utah. While he paints a large number of field studies, unlike the purist plein-air painters, he usually paints the larger pictures in his studio and is essentially a figurative genre painter. Formal relationships and construction of a solid abstract basis are of foremost importance to his painting. He portrays rural life with a little nostalgia.

A painter of women and children is Robert K. Duncan (1952–), of Midway. His work is more sentimental than that of most neoregionalists, but he seeks to

portray the same simple joys of family life. He studied at the University of Utah for two years before going to Europe for personal study. After relocating to Midway in 1976, he moved away from historical painting and began painting the life of his day but with the values of the past. He attempts to glorify the positive side of life and, by concentrating on it, make it a reality. Duncan's posters and prints illustrate his talent, usually depicting mothers with babies, children with animals, and fathers with their families.

METAPHYSICAL AND METAPHORICAL ART

The past decade has welded the metaphysical and the modern into imagerist, new-age, and new-wave art. With their cartoonlike apparitions of hallucinogenic essence, their use of obsessive color, bizarre teratological animals, and a Polynesian tapa sense of design, these new-wave "imagerists" place Utah art in an international mainstream.

The vehemency of the work of Donald Judd (1940–), formerly of Salt Lake City, and Boyd Reese (1932–1990), of Ogden, bludgeons the viewer by its sheer primitive force, unsettling, raucous and brutal content. A man of little formal art training, Reese described himself as an "artist who has loved art, literature, and alcohol in equal amounts. . . . As he has battled with his own personal demons," Reese explains, "he has channeled his creative resources to advocate awareness of the . . . street people, unemployed people, welfare people, disinherited, disenfranchised, unemployable and emotionally ill."

Bruce H. Smith's experimental approach to the realities of nature metaphorically expresses the perplexities of life. His painted melons, pears, grapes, bottled peppers, brilliant shrouds and ribbons suffused with color, and figures of young adults in architectural abstractions are idioms for the metamorphoses of objects through the process of life. His oils have succulent pigmentation, dazzling colors and brilliant whites, striking observation, and always an enigmatic character. "If there's anything controlling art today it's a lack of the spirit," Smith explained. "Most art has a fatalistic, nihilistic attitude. . . . If I could set objective reality in a spiritual context, I would be very happy." The "spirit" in Bruce Smith's work is characterized by luminosity: things resound according to their brilliance. See for example, his reinterpretation of the biblical story in *Jacob and Leah* (MCHA, 1990, **plate 104**).

During the 1970s, Dennis V. Smith was noted for his impressionistic sculptural portrayals of children and

Dennis V. Smith, one of Utah's best-known sculptors, constructing one of his fanciful assemblage pieces in the 1970s. (Photo courtesy SMA.)

women, often in monumental size. While representing his figures naturalistically, he is less concerned about detail or form than about gesture and light upon the bronzes. His work is thoughtfully reminiscent of childhood. As much as any other artist, Dennis Smith probes his own origins in his work; it is ultimately autobiographical. Smith also sculpts assemblage pieces, is an etcher of note, an inveterate sketcher, and a poet. Since 1983, when he began to oil paint in earnest, he has painted over four hundred canvases. Most of these have been destroyed, except for those dating from about 1987—the time at which they began to reflect the artist's expressive requirements. In these even more than in his sculpture, Smith is able to plumb his past, or the origins of his past, to form the basis of his art. "You find in the end," Smith's journal records, "not answers for who you are, but a visual sense of what it is that has come together to be you. I'm not making pictures but creating metaphors."

Smith's *Keeper of the Gate* (1989, SMA, **plate 106**), like most of his paintings, offers a naive bird's-eye view,

looking down over his world as if it were laid out on a desk—a life in review. The landscape becomes a web to which all things, events, and recollections are attached. It has new religious and spiritual intent drawn from his childhood and adult dilemmas. Its impulsive brushwork explodes with complementary colors: oranges against blues, pinks against greens, and such. In a pantheistic sense, everything is spiritually invested and every organic object has a symbolic equivalent: power lines mean consciousness of power overhead; trees are trinity images; and fire is both a cleansing and a searing element. His paintings are, in effect, ancestral mythic self-portraits.

James C. Christensen's fantasy pieces are nationally known, while his more realistic religious pieces are not. Christensen's whimsical chimeras, fish, and other zoomorphs, enlivened by punnish titles, have won critical and popular acceptance nationally. His fantasies seem as alien to the dryness of Utah's conventional art as did Trevor Southey's mannerist nudes during the same period. Nevertheless, Christensen's work, as much as Southey's eclectic work, delighted viewers, and both soon attracted disciples. Beyond the faddish medieval "dungeons-and-dragons" look, Christensen's work is deeply spiritual. "My own work is symbolic," he explained, "a parable there for interpretation."

Christensen's chef d'oeuvre is *Fantasies of the Sea* (1985, SMA, **plate 96**), a large acrylic of the beautiful sea queen examining her realm. She is accompanied by a host of mermaids, buffoonish councilors riding shellfish, soldiers, and scouts. In the lower reaches of the picture lurks the evil moray. In one picture, Christensen encapsulated his style, technique, and content.

There are also a number of erotica-spiritual artists in Utah whose art is both disquieting and subliminal. Perhaps the best of these provocative artists in the eighties were Trevor Southey, Carleen Jimenez (1941–), J. S. Wixom (1941–), Alex W. Bigney (1952–), C. Kent Wing (1954–), and M. Jean Lambert (1960–).

Carleen Jimenez's use of magical perspectives and gemlike exotic palaces are very much like a medieval manuscript illumination. Her work has a precious quality to it. The garden and fountain motifs resonate sensual overtones. J. S. Wixom's paintings reveal his broad talent as a figure, portrait, and landscape painter. His most powerful statements emanate from paintings of handsome young men in various degrees of nudity. With overt classical and Renaissance references, these oils, often of large size, maintain a veneer of public acceptability.

Alexander William Bigney works in a vaguely androgynous style quite different from Wixom's more classical academic approach. His erotic figures often are large in scale and set in profile, evoking primal associations too deep and profound to be vulgar. His *God Descending into the Garden* (1983, SMA), though not sexually oriented, examines his depth of vision of the Adamic myth.

Wulf Erich Barsch's idiosyncratic reflections on the Book of Abraham (1984, SMA) and his *Amduat* (1982, SMA) express ancient landscapes of the soul, maps and charts for the "stranger in a strange land." Content, motifs, and metaphors are seen in magical palm and cypress trees that look like Utah poplars, ubiquitous pyramids, sacred numbers, geometry, and eternal schemas. Key words, signs, and tokens fill his ideograms like notations from da Vinci's sketchbook. Egyptian mysteries as revealed in facsimiles, scrolls, secret transcriptions, divine symmetry, and sacred geometry seemingly chaotic or random were the critical language of Barsch's art, but they are visions "seen through a glass darkly." Barsch's canvas entitled *Toward Thebes* (1985, SMA, **plate 95**) deals with the theme of bringing order out of chaos. A magic square, hastily drawn and seemingly random, reveals itself after careful examination to be highly ordered and meaningful. Barsch's intense intellectuality and deep spiritual underpinnings have been frequently misunderstood.

H. Douglas Himes (1956–), of Provo, unlike the imagerist or new-wave/age artists following fashions set in the Midwest or the East, is a third-generation Mormon Art and Belief movement painter and lithographer. His formal taxonomy and inconography are as enigmatic as his mentor, Barsch. His stained grounds, applied numbers and letters, pyramids, checkerboards, cryptic scrawls, and so forth are reminiscent of the family of Barsch's work. They were, however, perceptively different and individual. His large oil, *Tabernacle* (1989, SMA) translates the typography of the atoning blood into visual idioms which suggestively evoke primal ceremonial associations of some ancient Hebraic ritual.

Lee Udall Bennion (1956–) came to Utah in September of 1974 to attend BYU, and then, with her husband, ceramicist Joe Bennion, moved to Spring City. Her canvases are mostly figurative and often autobiographical. Her typically elongated women and children are usually set in commonplace interiors and invested with a spiritual countenance seldom found in Utah art. Her *Full Bloom* (1989, SMA, **plate 105**) is not elegant but has a sincerity and naturalness far outstripping more sophisticated approaches.

Steven James Fawson (1952–), a decided counter-cultural, metaphorical expressionist artist, was U-of-U-trained. And, like many artists who were the beneficiaries of instruction from Gittins, he struggled to shuffle off his overreliance on the practiced eye in favor of more subjective revelations. Fawson's work does not have so much the exuberance of spirit as the pallor of the ominous. His large figurative canvases seem populated by an enervated race, while his semioriental still lifes are elegant haiku.

Bonnie Sucec (1942–), of Salt Lake City, was a student of Don Olsen at Jordan High School and attributed her initial interest in art to him. She is one of Utah's more important imagerist artists. Her *Untitled* (1981, UMFA, **plate 88**) attests to the spiritual shamanism she shares with other metaphysical artists like Frank McEntire and Susanah J. Kirby. Sucec's hauntingly magic artworks of this decade, painted mostly in gouache, acrylic, and oil pastel, contain many of the standard iconographic images of the school within which she works, especially her ubiquitous dog forms. Also discernible are disjunctive dream images, Mexican folk in color and content, and raucous energy levels which are seldom equaled in this region of the country.

Another new-wave metaphysical artist is Maureen O'Hara Ure (1949–), of the Guthrie. She is, like Louise Fischman, half painter and half sculptor. Ure's autobiographical works became more three-dimensional during the eighties, making use of an odd assortment of found objects to suggest stories told in a kind of code. These cryptic messages are supposedly undecipherable, except by those with the gnosis—the initiated. Her *Mystery Theatre* (1981, UMFA, **plate 84**) is a fine example of such magical visual metaphor.

The work of the sculptor Silvia Lis Davis (1957–), of Salt Lake City is difficult to place within a single category. She was influenced by the work of Angelo Caravaglia and interested in realistic observations made from life. Davis focuses a geometric clarity on her subjects, which are a combination of natural forms in a manmade environment. Her work is a blend of pop art and new realism.

The eighties saw the relative decline in the influence of the state's universities and colleges upon the state of the arts. Whereas academia had dominated the arts during the previous three decades, now the nascent art museums and art centers began to assert themselves. Most high schools and colleges leveled off in size of art faculty, and some experienced crisis in the perpetual "changing of the guard" from older to younger faculty.

The late seventies and eighties marked a period in which many more artists were able to make their livelihood as professionals; their ranks increased to well over a hundred by 1990. This, along with the greying of the professors of the Utah avant-garde and the rise of "decor" modernism led to a shift in focus away from the universities as bastions of art.

BRIGHAM YOUNG UNIVERSITY

During the early eighties, under the leadership of Robert L. Marshall, BYU began to match, in size and quality, the U of U's art department. During Marshall's chairmanship the department metamorphosed from a bread-and-butter department based on art education and graphic design, to a department balanced in favor of professional studio artists.

This had been the difficulty encountered during the mid-1950s at the U of U between the teacher-training emphasis of Delbert Smedley and the professional-artist emphasis of Friberg and Gittins. But with Robert Marshall's political adroitness, the needs of all concerned were balanced and a department based on mutual trust was built. Marshall was able to break the cycle of art educators teaching studio classes. Traditionally, almost all of the backbone staff of the BYU art department had art education backgrounds—Andrus, Breinholt, Burnside, Gunn, Mathews, Raty, Takasaki, Tippetts, Turner, Wilson, and others; these people acted as the leading studio faculty as well. By moving the two areas apart to some degree, each was able to function more effectively.

The full-time studio faculty grew to eleven professors during the 1980s. In the fall of 1980, Jeanne L. Lundberg Clarke (1925–) became an instructor of painting, after receiving her M.F.A. from BYU in the previous year. Her colorful style of widely dispersing, crystallographic centers of interest throughout the painting is both decorative and laden with symbolism. See, for example, the fine *Portrait of Rebecca* (1985, SMA, **plate 100**).

Warren Wilson retired in 1983 and was replaced by Von Allen (1950–) as head of the ceramics area. Her own work may be termed organically abstract ceramic sculpture. With unearthly shapes and colors in contrast, it challenges decor yet entreats the onlooker.

Brent Gehring (1942–), a BYU graduate, is an abstract metaphorical sculptor of interest who joined the BYU faculty in 1981. He brought with him a nonfigurative approach to sculpture, stressing the "events and myths surrounding our lives as the adequate subject of reality, as a mystery worth questioning." He headed the

sculpture area after Franz Johansen retired in 1989. This section was further strengthened with the addition of W. Neil Hadlock in 1990. Hadlock brought a thoroughgoing knowledge of both the figurative and nonobjective approaches.

The BYU sculpture department lost Dallas J. Anderson in 1984 and, with him, the academic approach to sculpture. His slot was filled that autumn by W. Wayne Kimball, Jr. (1943–), a printmaker. Kimball received his M.F.A. from the University of Arizona and his master printer certificate from Tamarind Institute at the University of New Mexico in 1971, then taught at various colleges thirteen years before coming to BYU in 1984. His lithographs are interesting arrangements and juxtapositions of objects, usually taken from classical or medieval iconography. They beg to be interpreted or unraveled by the spectator in much the same way that the disguised symbolism of Netherlandish painting does. His use of unrelated objects strewn across architectural settings is presented in an ethos of magic or heightened realism.

At BYU during the late eighties and early nineties the planning and construction of a major campus art museum north of the Harris Fine Arts Center was begun. Dr. James Mason, the dean of the College of Art and Communications, almost singlehandedly raised the millions of dollars to construct the museum, which will be completed by 1992. A musician by profession, Mason's vision foresaw the need of an art museum on many levels: professional, political, and educational. Envisioned as the largest museum of art in Utah, it will focus on an international art collection with an American emphasis. Virgie Day, the associate director, was instrumental in planning and organizing the museum after she came to the university as collections manager in 1983.

UNIVERSITY OF UTAH

With two exceptions, the U of U's department remained fairly constant during the eighties. Adjunct instructors took an increasing amount of the workload as older, tenured professors tended to lessen their teaching load in order to concentrate on production of art. The loss of Alvin Gittins in 1981 was a devastating blow to the art department. He had been one of the critical players, and his death left a void on the whole realist side of the equation. The university called upon the noted art historian and past art department chairman Robert S. Olpin to act as dean of the College of Fine Arts in 1987.

Sam Wilson (1943–), had been a visiting professor from California since 1978. In 1983, he was hired as a tenure-track professor. His addition to the faculty greatly strengthened the department's diversity and saved it from being painfully "high art" in orientation.

Wilson's subjects supersede the natural world and are spatially fractured, and his content's juxtaposition is abrupt. This makes interpretation of his works all the more difficult, and his curious titles only compound the difficulty. A suspended fish, a stuffed pheasant held together by cardboard and masking tape, and the inevitable cigarette burn are placed next to a totally abstract passage. An example of such scintillating egocentricity is *Crow Crowded* (1985, SMA, **plate 99**). The artist called his later works "altarpieces for an as-yet-to-be-defined religion."

One of the finest young talents of recent years to teach at the University of Utah is E. David Dornan (1954–). Born in Aurora, Colorado, his career interests lay in science, particularly marine biology and math. After moving to Utah with his family and starting school at the U of U, he became fascinated with art. He taught as an instructor at the university from 1982 until 1988, when he was made an adjunct associate professor of painting in the art department, teaching more than half-time. Renaissance and modernist space and form coexist confrontationally in his paintings and monotypes. Simple geometric still-life motifs, as in *Chair* (1983, SFAC **plate 93**) become shapes of color and spots of paint, rather than portraits of things. The dynamic activity of his art is balanced with complex tension, creating classical constructions and abstract expressionism. Unlike the avant-garde, he works as much for the layman as for the initiated.

UTAH STATE UNIVERSITY

The eighties saw the continued building of USU's reputation in commercial art with Anderson and Edwards. The department appointed the photographer R. T. Clark as department head in 1980, where he served until July of 1984. Marion Hyde followed and is the present chairman. Watercolorist Gaell Lindstrom and Twain Tippetts both retired in 1984. Lindstrom's *Remembering Butte* (1991, p.c., **plate 110**) testifies to his continuing presence in the contemporary scene. The textile and fiber program was also terminated, as it had been at WSC.

In 1984, the department hired John Neely (1953–)

to direct the ceramics program. He received his M.F.A. at Ohio University before studying ceramics in Japan for two years. Neely was known for his teapots and other functional pottery with sensitive, high-keyed colors. After 1986, Alice Brown-Wagner (1953–) taught part-time in painting and drawing. She explains that her oils and drawings are characterized by a labyrinthine space between a cube and infinity. Her interest in the man-made world—the industrial and urban landscape—is revealed in a process best described as "palimpsest," the excavated surface. Christopher T. Terry (1956–) came in the fall of 1988. His work is classical realistic in style, with simple still-life interiors as content.

THE OTHER COLLEGES

Several major additions to the faculty of WSC helped the art department to renew itself during the decade of the eighties. Mark A. Biddle (1952–) came to Ogden from Indiana State University in 1981 as a pioneer in the computer graphics area and as a painter of abstract-impressionist canvases. He is chiefly known for his action paintings, which he called "goal-less at the beginning, the product of a quiet mind ordering variables—a therapeutic and psychological process with surprising results." James Clayton Jacobs (1955–), a blend of painter and sculptor came to WSC in 1985. Nineteen eighty-eight brought Drex Brooks (1952–) to the photography section.

At Dixie College, Gerald P. Olsen retired in 1987, and his position was taken by Delwin Parson (1948–) in 1988. Parson, from Rexburg, came both as a figure and landscape painter. The son of Oliver Parson, past director of the Springville Museum of Art and professor of art at Rexburg, Del Parson found a powerful, broad, realistic style to match the LDS religious and landscape subjects he paints. His work for the LDS church catapulted him into prominence. Max E. Bunnell (1927–) also came about this time as well, painting in a style similar to Olsen's.

ART MUSEUMS AND CENTERS

Like the seventies, the eighties showed spectacular growth in the number and quality of fine arts institutions. Timothy Rose left the Springville Museum of Art in August of 1980 and was replaced by Vern G. Swanson. Over the decade of the eighties, the educational program, staff, and art collection had doubled in size and focused on Utah art. Remarkably, the city of Springville contributed about $15.28 a year for every man, woman, and child among its residents for the arts, with most of this money going to the museum. When Sherrill D. Sandberg, the museum's assistant director, left to become the visual arts coordinator of the Utah Arts Council in 1987, the museum hired U of U graduate Lila D. Larsen.

After the Bountiful/Davis Art Center was cut off from the U in 1983-84, Marilyn Coleman, the new director, saw it through its most difficult but productive years. Allison and Will South also contributed to the center's program throughout the eighties. At this time, the Eccles Community Art Center, under Sandy Havas, built a new exhibition addition beside their main gallery.

In Park City, the Kimball Art Center hired Diane Balaban in the fall of 1983, who helped to refurbish the main floor galleries and bring financial stability to the Center.

After many years of effort by Twain Tippetts and others, USU, through funds from Nora Eccles Harrison, built a major museum of art which opened in 1982. The gleaming structure of about 20,000 square feet was a highly important addition to the art institutions of the state. Directed by Peter Briggs until 1989 and by Steve Rosen since, it has emphasized twentieth-century American art and traditional Native American and twentieth-century ceramics.

In 1983, the LDS Church Museum of History and Art, west of Temple Square, was dedicated with an inaugural exhibition reviewing the history of LDS art from the time of Joseph Smith until today. A masterworks gallery on the second floor, with the LDS church's best pieces, was installed and a catalogue published. With Glen Leonard as director and Richard Oman, Robert Davis, and Linda Gibbs as curators, the museum quickly became one of the most vital in the state. Since that time, major exhibitions on C. C. A. Christensen, LeConte Stewart, Minerva Teichert and the French Mission artists have proved successful.

Meanwhile, just half a block south on West Temple, the Salt Lake Art Center began to slide into difficulties and a succession of directors followed, including Allan Dodworth, Richard Johnston, and Dan Burke. Finally, Allison South was hired by the board in 1989, after one year as acting director. Benefited by generous endowment gifts from major donors and special grants from the Utah Arts Council, the financial woes were mitigated. Through it all the Salt Lake Art Center maintained an impressive exhibition schedule.

Randall Lake's studio in the Guthrie Building is a modern reinterpretation of the nineteenth-century atelier. Lake's painting, *The Studio Walls* (plate 94) offers another view. (Photo by Gibbs M. Smith, c. 1986.)

THE PAINTERS OF THE GUTHRIE

The studio environment of the Guthrie Building was the epicenter of metaphorical and metaphysical art during the late seventies and eighties. Located in the top two floors of the old Guthrie bicycle shop at 156 East 200 South in Salt Lake City, it made a haven for a changing crowd of roughly ten artists. The Soho-style ambiance of the upper floors exudes more the atmosphere of an Ashram than that of a city-center gang hideout.

Richard Murray, the landscapist, was the first to establish himself in this bohemia. About 1970, he persuaded the management to let a room for an art studio. In the early seventies came Randall Lake, Steven James Fawson. Other denizens include Susan J. Beck (1943–), Sam Collett (1942–), Pat Eddington (1953–), John O. Erickson (1953–), Lucy Fairchild (1953–), Frank Huff, Jr., Linda Adams Kesler (1944–), Dianne Pierce (1952–), Bonnie Sucec, and Maureen O'Hara Ure.

John Owen Erickson, of Salt Lake City, arrived at the Guthrie in 1982 and quickly established himself as a major Utah independent expressionist. Unlike many painters in this area, he came with a point of view, a program, almost a manifesto. His harmonic key of blue and white adds unity and structure to his canvases, which are, according to the artist, "overlaid with wild assertions. Tangential points where assumption meets assertion, the objective and the subjective collide and do battle—that is where my catharsis resides." Thick, juicy pigmentation, electric blue, snowy white, frantic motion, and troubled emotion epitomize his style.

John Owen Erickson, *Gethsemane: Self Portrait;* 1985, acrylic on canvas, 34" × 29"; collection of the artist.

ARTSPACE, INC., AND THE PIERPONT DISTRICT

In a sense, Artspace, Inc., and the Guthrie were for Salt Lake City what North Mountain was for Utah County—-an artists' community founded upon the premise that the quality of Utah art could be vastly improved if its artists had working conditions more conducive to production. By creating a communal series of studios, artists could energize one another through their proximity. Artspace was a nonprofit corporation attempting to assist artists with their studio needs.

Founded in 1979, it was not until 1983, when a grant was awarded to Stephen A. Goldsmith, that real progress was made. Starting at 325 West Pierpont Avenue, Artspace converted a 1910 produce warehouse, then fronting the entire 300–400 West Pierpont block. A warehouse district formed a new cultural area. Boutiques, art galleries, and antique shops lined the street.

One of the most significant Artspace artists is the German-born sculptor Ursula Brodauf-Craig (1926–). She brought with her Bauhaus training and interest in the work of the sculptor William Zorach. The power of her figurative works defies their modest size. Their monumental strength and empathy for the human condition are metaphysical in their universality. Her *Duality* (1989, SMA), of an embracing anonymous couple, is at once depressing in its forlorn condition and inspiring in its endurance. Brodauf-Craig also sculpted highly polished minimalist painted aluminum pieces and rusticated metal pieces.

A painter of nonobjective canvases, Chad Merrill Smith (1940–), of Murray, was at Artspace after 1983.

Ursula Brodauf-Craig,
Duality; **1989, small
bronze; SMA.**

He developed his art at the "process level" of indirect painting. By using stencils, resists, masking tape, and stains to create marks, he makes the process of painting a primary concern.

An abstract landscape painter and screen printer, Marilyn R. Miller (1942–) has worked at Artspace since 1985. From her first opening, she became known for her handmade paper, silkscreens, and oil paintings of highly stylized and colorful abstracts and landscapes.

A few Utahns have found contemporary ontological expression in three dimensions. Among them is Stephen A. Goldsmith (1954–), whose disjunctive but highly crafted mixed-media pieces both surprise and excite. He is the founder and executive director of Artspace, Inc. The impact of Goldsmith's Artspace project on the Utah art

scene is difficult to assess. Although it provided studios and atmospherics, it has not produced quite the sense of community that the Guthrie exuded. However its future has greater potential in terms of expansion, development, and influence on Utah art.

ART DEALERS

The eighties saw the number of sales galleries in Salt Lake City expand to over forty from less than half that in 1970. When Dan Olsen's Tivoli Gallery moved to its present location at about 250 South State in Salt Lake City during the late seventies, it strengthened a longtime association with Jack Irvine's Era Antiques, next door. This association became a symbiotic relationship as the proprietors traded early Utah art back and forth. Usually Irvine's walls were hung four high with pieces of little-known Utah artists for sale at moderate prices. Tony Christensen's strategy at his store, Anthony's Antiques, at 300 South and 300 East in Salt Lake City was different. Opening in 1985, this antique gallery soon became one of Utah's important sources for high-end antiques and art.

By the early eighties, David Ericson's Gallery 56 on 400 South in Salt Lake City was becoming the most significant sales gallery for early Utah art. From pioneer painters to contemporary realists, his gallery is noted for its consistent high quality. Ericson carried works of such artists as Randall Lake, Lee Bennion, Ken Baxter, Frank Huff, Earl Jones, Al Rounds, and Kimball Warren. Werner Weixler, of F. Weixler Galleries on E Street in Salt Lake City sells art and furnishings of fine quality, including art by such masters as Valoy Eaton, Hagen Haltern, Robert Shepherd, and the regionalist Utah painters of the twenties through the forties.

Perhaps the most exciting developments of the last decade were the phenomenal growth and development of the Phillips Gallery into two locations (200 South and at Pierpont), the Gayle Weyher Gallery on Main Street, and Dolores Chase Fine Art on 260 South 200 West. All have dealt with the more contemporary strains of Utah art. In a sense, they marked the maturation of the state's art scene from the sale of merely decorative art to more sophisticated work. Chase Fine Art, one of the most elegant galleries in Utah, deals with artists such as Edith Roberson, L. Meacham, and William Carman. Interestingly, it seems that the state's modernist sales galleries in this decade were all owned by women.

Nyal Anderson's Beehive Collector's Gallery (368 East 300 South) has long been a major source for Utah paintings with particular strength in the period 1900

Denis and Bonnie Phillips, artists and owners of Phillips Gallery. (Photo courtesy SMA.)

moved to Park City in 1982 because of the greater market. With a decidedly western art flavor, the Lido's forte is selling high-end recognized western artists.

DEATHS IN THE EIGHTIES

Utah lost several of its most important artists during the eighties. The lyrical, surrealistic figurative painter Ruth Wolf Smith died in 1980. Mabel Pearl Frazer died in 1981 at the age of ninety-four. Alvin Gittins's death in late 1981 was doubly sad because at fifty-nine he was still at his best work. His insistence upon the artist's obligation to nature placed him squarely against the steamroller modernist movement of the second half of the century. He was able to balance the demands of contemporary and traditional aesthetics in a way

through 1950s. Apple Frame Galleries at 40 South Main in Bountiful sells contemporary and vintage Utah paintings. Brushworks Gallery in Salt Lake City at 175 East 200 South offers framing services and a good collection of Utah paintings.

Williams Fine Art at 175 West 200 South in Salt Lake City was founded in 1988 by retired-businessman-turned-painter, Clayton Williams. It specializes in the work of early Utah artists, including J. T. Harwood and LeConte Stewart.

Sharon Swindle opened the Frameworks Gallery in Orem in 1979, then established branches in Salt Lake City in 1988, and in Park City two years later. Beyond selling prints, she handles the work of James Christensen, Gary Kapp, and others. Utah county also has the framers and art dealers, Arthur Pheysey and Allman-Ricks.

By the mid-1980s, Park City alone would claim nearly half of the Utah art market. Darrell and Gerri Meyer continued to have the premier Park City sales gallery of Utah and regional art. The Meyer Gallery's art is traditional but not entirely western in orientation. Carol Schmidt, of the Lido, had her beginnings in Provo but

that strengthened both schools.

Utah's great modernist, Donald Olsen, died in 1983 at the age of seventy-three. He did as much for the avant-garde as his friend Gittins did for the traditionalists. In spite of painting in opposing styles, they were not bitterly opposed, as smaller souls might have been. Like Gittins, Olsen was painting his best work at the time of his death, as can be seen in the late *Chelsea VI* (1980, SMA, **plate 83**.)

Everett Thorpe, of Logan, died in 1983 at seventy-nine years. Like Olsen, Thorpe was interested in bringing into this area the shape and content of all the modernist styles. Waldo Park Midgley died in Salt Lake City in 1986 at the age of ninety-eight. Interest in his work by Robert S. Olpin and George Wanlass, of Logan, resulted in a major retrospective exhibition and catalogue of Midgley's work in 1982, through the Utah Museum of Fine Art.

In 1987, Avard Tennyson Fairbanks died at the age of ninety, after a career that spanned most of the century. He had begun as a boy prodigy at age fourteen and sculpted almost until the day he died. An ideologue, he inspired Utah sculpture toward conservative traditionalism while

LeConte Stewart, the godfather of Utah landscape, on a painting trip with students in the Davis County hills. (Photo courtesy of the College of Fine Arts, U of U.)

many artists were being lured away to the modernist camp from the 1950s through the 1980s.

Finally, to bring this necrology to date, LeConte Stewart died in 1990 at the age of ninety-nine, having been an active painter and teacher until the last year of his life. In a sense, he was contemporary Utah's John F. Carlson in that he continued to exert an influence on landscape painting decade after decade. Although his own work had slowly weakened with his advancing age, he continued to be prolific with the brush and taught a multitude of ready students. It was almost requisite for every landscape artist to visit and study with this legend.

CONCLUSION

Utah has adopted, to some degree, most of the modernist stylistic innovations of the twentieth century. The state has its abstractionists, expressionists, conceptualists, surrealists, and so on, but fewer figurative contemporary genre artists—image makers for today. The importance of

contemporary content is explained by Barbara Rose:

In the eighties, the role of content has proven once again paramount, as it was initially among the founders of the New York School, who began by rejecting purist abstraction and non-objective art as meaningless decor, inadequate to express the existential facts of a troubled moment.

Contemporary Utah has perhaps never really understood that artists make better journalists than historians. Our artists must increase their efforts in self-reflection, investigation, and articulation. Recognition of the artist as a leading agent of change, capable of transforming the way we feel, view, and understand our present world, is the raison d'être for future Utah art. Only the insightful eye can see clearly through the bewildering maze of the here and now, and only the insightful hand can arouse, inspire, and provoke new dimensions of reflection and experience.

Will South, *Francis's Studio;* 1991, oil on paper; p. c. The young painter and art historian depicts the studio of one of his mentors, Francis Zimbeaux.

Royden Card, *Jenni's Bookshelf;* 1984, woodcut / blockprint, 11" × 8 3/4"; SMA. A contemporary subject depicted in an ancient medium.

U.S. Grant Speed, *Ropin' Out the Best Ones;* 1984, bronze, 19 1/2" × 34 1/4" × 17; SMA. Speed is among the best of the contemporary practitioners of the cowboy genre.

Shauna Clinger, *That They That See Not Might See;* 1987, oil on canvas, 76" × 72"; photo courtesy MCHA, by permission of the artist. The Salt Lake City portraitist explores contemporary spiritual and feminist themes.

The conclusion of this essay brings us into a situation analogous to that of Henry Rasmusen, writing for the *Deseret News* in January of 1950. He tried to forecast the future leaders of Utah art and the form which art would take but failed miserably. Can we predict, with greater accuracy the next forty years' major artists and the course of Utah art? In terms of numbers and depth of quality artists, Utah art has never been better than it is right now. There is no need to bemoan the state of the arts in Utah either qualitatively or quantitatively.

NATIVE, IMMIGRANT, AND ITINERANT ARTISTS OF UTAH

Though we realize that worthy artists might have been inadvertently omitted, and that these abbreviated descriptions of style, subject matter, and media will often be oversimplified, we nevertheless present the following list gleaned from histories, exhibition catalogues, reviews, and collections.

Abbott, Gregory L. (1945–), Salt Lake City/St. George: fantasy; mixed media

Abbruzzese, Richard J. (1948–), Heber City: landscape; oil

Adams, Corinne Damon (1870–1951), Corinne/Ogden: floral; oil

Adams, David H. (1950–), Lehi: abstract sculpture

Adams, Richard R. (1949–), Cedar City: abstract sculpture

Adams, Steven L. (1962–), Springville: figurative; oil

Adams, Willis A. (1854–1932), Park City: landscape; oil, drawing

Adelmann, Arthur R. (1940–), Ogden: landscape; watercolor, drawing

Ahrnsbrak, David R. (1948–), Vernal: landscape, figurative; oil

Alderman, Sharon Davis (1941–), Salt Lake City: fiber art

Allen, Donald F. (1927–), Mapleton: still life, landscape; oil

Allen, George W. (1948–), Salt Lake City: figurative, portrait; oil, drawing

Allen, J. Clyff (1941–1987), Provo: modernist, wildlife; sculpture

Allen, Roma Poole (1923–), Logan: floral, landscape; watercolor

Allen, Verlaine (1926–), American Fork: landscape; oil

Allen, Von (1950–), Provo: ceramics

Allred, Osral B. (1936–), Spring City: trains, landscape; watercolor

Andelin, Brigham Youth (1894–1986), Ogden: landscape; oil

Anderson, Bethanne P. (1954–), Provo: expressionist; oil

Anderson, Carlos J. (1904–1978), Salt Lake City: historical, landscape; painting, drawing

Anderson, Dallas Jasper (1931–), Provo: academic sculpture

Anderson, David Ralph (1957–), Provo: metaphysical/metaphorical; oil

Anderson, F. Euray (1902–1988), Salt Lake City: cowboy/western; oil

Anderson, George Edward (1860–1928), Springville: photography

Anderson, Glen Dale (1931–), Logan/Cedar City: landscape; oil

Anderson, Jerry (1935–), Leeds: western sculpture

Anderson, Jon I. (1934–), Logan: commercial art

Anderson, Peggy (1939–), West Jordan: landscape; watercolor

Anderson, Robin C. (1956–), Utah/Montana: classical realist; oil

Andrus, J. Roman (1907–), Provo: landscape, portrait; oil, lithography

Angell, Susan Eliza Savage (1825–1893), Salt Lake City:

Angell, Sr., Truman O. (1810–1887), Salt Lake City: architectural; landscape

Argyle, David G. (1945–), Spanish Fork: Indian; oil, wood sculpture

Armitage, William Joseph (1817–1890), Salt Lake City: history; drawing, painting

Avati, James R. (1950–), Salt Lake City: bronze sculpture

Baddeley, David (1961–), Salt Lake City: photography

Bagley, Elfie Huntington (1868–1949), Springville: photography

Bagley, Patrick F. (1956–), Salt Lake City: cartoon; drawing

Bailey, Alice Morrey (1903–), Salt Lake City: realist sculpture

Bailey, Carol (1957–), Logan: landscape; oil

Bailey, Roger (1897–1985), Salt Lake City: architectural, landscape; watercolor

Bales, Marcia M. (1953–), Provo: mystical, landscape; oil

Ballif, Arta Romney (1904–), Provo: miniature, landscape; oil

Bancroft, Bessie Alice (1887–1945), Salt Lake City: floral, landscape; watercolor

Bangerter, John Mark (1951–), Bountiful/Cedar City: landscape, genre; oil, watercolor

Barkdull, Philip Henry (1888–1968), Fillmore/Logan: fauvist landscape; oil, watercolor, drawing

Barnard, Lanny A. (1938–), Salt Lake City: floral; oil, watercolor

Barnes, Linda Kohler (1949–), Park City: landscape, floral; watercolor

Barrett, Elsie Elizabeth T. (1866–?), Provo: floral, landscape; watercolor

Barrett, Robert T. (1949–), Provo: illustration, painting; oil

Barsch, Wulf Erich (1943–), Germany/Utah: symbolist; oil, printmaking

Bartholomew, E. Byrd (1928–), Orem: landscape; oil

Bartholomew, Steven Mark (1958–), Orem: landscape; oil

Barton, Dawna (1932–), Salt Lake City: landscape, genre; watercolor

Barton, Nadine E. (1921–), Orem: southwestern; silkscreen

Bastow, Mary (1871–1918), Salt Lake City:

Bastow, Mary Lovina (1897–1967), Logan/Cedar City: landscape; oil

Baughman, Milo R. (1923–), Salt Lake City: furniture design

Baxter, Dan (1948–1986), Salt Lake City: figurative, landscape; oil

Baxter, Ken B. (1944–), Salt Lake City: landscape; oil

Beard, George (1855–1944), Coalville: landscape; oil

Bearnson, Dorothy (1921–), Salt Lake City: ceramics

Beattie, Donna Kay (1941–), Photo illusionist; acrylic, oil

Beauregard, Donald (1884–1914), Fillmore: landscape, figurative; oil, watercolor

Beck, James (1812–1866), Salt Lake City

Beck, Stephen Reid (1937–), Salt Lake City: abstract

Beck, Susan J. (1943–), Salt Lake City: expressionist

Benner, Cherie (1964–), Provo: abstract; figurative

Bennett, Lowell B. (1948–), Sandy: landscape, genre; oil

Bennett, Lynn H. (1945–), Sandy: landscape, genre; oil

Bennion, Joseph W. (1952–), Spring City: ceramics

Bennion, Lee Udall (1956–), Spring City: figurative

Berryhill, Lynn O. (1948–), Springdale: designed landscapes

Best, LaVonne Vincent (1904–1988), Salt Lake City: landscape, portrait; oil, watercolor

Bettin, Edward Tom (1948–), Salt Lake City: ceramics

Biddle, Mark A. (1952–), Ogden: abstract; computer graphic

Bierstadt, Albert (1830–1902), itinerant: Rocky Mountain School; landscape; oil

Bigney, Alex William (1952–), Payson: metaphysical/metaphorical

Bilboa, Janette G. (1937–), Tooele: landscape

Billedaux, Susette (1949–), Murray: figurative

Bills, Zelda (1936–), Salt Lake City: abstract landscape

Bird, Elzy J. "Bill" (1911–), Salt Lake City: landscape, figurative; watercolor

Bird, Korry R. (1961–), Springville: figurative, wildlife; sculpture

Birrell, Verla L. (1903–), Salt Lake City: landscape; watercolor

Bishop, Allen C. (1953–), Moab/Sandy: abstract

Blain, Max H. (1906–), Spring City: landscape; watercolor, oil

Blain, Max (1906–), Spring City: landscape; watercolor, oil

Blair, May A. (1921–), Salt Lake City: landscape

Bliss, Anna Campbell (1925–), Salt Lake City: abstract printmaking

Boorman, Birdie B. (1921–), Provo: landscape; oil

Borglum, Gutzon (1867–1941), Bear Lake: sculpture

Borglum, Solon H. (1868–1922), Ogden: sculpture

Borup, Connie M. (1945–), Salt Lake City: landscape; oil, pastels

Bowcutt, Jon James (1953–), St. George: figurative; drawing

Bowring, C. K. (19th century), Salt Lake City: figurative; oil

Bradford, Colleen H. (1934–), Brigham City: metaphysical/metaphorical

Braithwaite, Arlene Van Dyck (1949–), Cedar City: landscape, still life; pastel

Brazzeal, Wallace (1942–), St. George: western, landscape; watercolor

Breeze, Lois S. (1912–), Ogden: landscape, floral; watercolor

Breinholt, Floyd Elmer (1915–), Provo: landscape; oil

Brest van Kempen, Mark (1962–), Salt Lake City: abstract

Brewster, La Rue M. (1920–), Salt Lake City: landscape; watercolor, oil

Briggs, Lyn E. (1946–), Annabella: western genre; oil

Brodauf-Craig, Ursula (1926–), Salt Lake City: modernist sculpture

Bronson, Clark Vern (1939–), Kamas/Montana: wildlife sculpture

Bronson, Jonathan (1952–), Pleasant Grove: wildlife sculpture

Brooks, Drex (1952–), Ogden: photography

Brooks, Maurice E. (1908–1970), Salt Lake City: plaster sculpture

Brotherhood, Amelia A. (19th century), Salt Lake City: watercolor

Brown, Charles (early 20th century), landscape; watercolor

Brown, Elizabeth Low (1944–), Logan: symbolist; oil

Brown, Harry (?–1887), Logan: sculptor

Browning, George Wesley (1868–1951), Salt Lake City: landscape; pastel, oil

Brown-Wagner, Alice (1953–), Logan: urban landscape; oil, drawing

Bryner, Dale W. (1935–), Ogden: symbolist-realist; acrylic, pencil

Bullough, R. Vern (1926–), Salt Lake City: landscape; oil

Bunnell, Max E. (1927–), St. George: landscape; oil

Burningham, Stanley (1922–): Springville: painting; teacher\conservator

Burningham, Zan P. (1956–), Monticello: still life; watercolor

Burnside, Wesley M. (1918–), Provo: art history; landscape; watercolor

Burrows, Harold "Hal" (1890–1965), Salt Lake City: illustration, landscape; watercolor

Burt, Melody A. (1956–), Salt Lake City: expressionist

Buswell, Blair (1956–), Provo: sports, western; bronze sculpture

Butcher, Roy H. (1909–?), Ogden: landscape, genre; oil

Cahoon, Carol (1916–), Bountiful: landscape; oil

Call, Margie Morris (1933–), Ogden: western; pastel, oil, watercolor

Call, Robert A. (1932–), Bountiful: landscape; oil

Campbell, Betsy (1931–), Salt Lake City: surrealist, landscape; watercolor

Campbell, Marilee B. (1938–), Provo: landscape; pastel

Campbell, Orson D. (1876–1933), Provo: landscape; oil

Cannon, Lucille B. (1916–), Murray: landscape; watercolor

Cannon, Marsena (1812–1900), Salt Lake City: photography

Cannon, Michael Ritter (1913–?), Salt Lake City: still life; oil

Caravaglia, Angelo (1925–), Salt Lake City: contemporary sculpture

Carawan, Robert G. (1952–), Spring City: landscape; printmaking

Card, Royden (1952–), Orem: landscape, interiors; oil, woodcut

Carde, Margaret (1944–), Salt Lake City: abstract; drawing

Carman, William H. (1957–), Provo: fantasy, surrealist; oil, acrylic

Carroll, Susan S. (1943–), Salt Lake City: abstract metaphorical; mixed media

Carter, Lou Jene (1933–), Springville: landscape, still life; oil, pastel

Carvalho, Solomon Nunes (1815–1897), itinerant: portrait; oil

Case, Stephen Reid (1948–), Salt Lake City: mixed media

Cauffman, Lara Rawlins (c. 1860–c. 1940), Salt Lake City/California: portrait, landscape; watercolor

Chader, Inez C. (1904–), Springville: landscape; oil

Chaplin, David (1937–), Park City: figurative; oil

Cheever, Bruce (1958–), Orem: western, landscape; gouache

Christensen, Carl C. Anton (1831–1912), Ephraim: primitive genre, LDS subjects; oil

Christensen, Day (1950–), Pleasant Grove: conceptualist; printmaking, sculpture

Christensen, James Calvin (1942–), Orem: fantasy; acrylic, etching

Christensen, Jenni J.(1949–), Pleasant Grove: floral; intaglio

Christensen, Karen A. (1951–), Kaysville: landscape; watercolor

Christensen, Larry R. (1936–), Salt Lake City: landscape; watercolor

Christensen, Larry W. (1945–), Provo: neoregionalist; figurative; oil

Christensen, LuDeen (c. 1860–c. 1940), Gunnison/California: figurative and landscape; oil and watercolor

Christensen, Marrian G. (1924–), Springville: landscape; oil

Clark, Homer H. (1922–), Salt Lake City: landscape, figurative; watercolor, oil

Clark, Ralph T. (1926–), Logan: photography

Clarke, Arthur B. (1955–), Provo: realist; landscape; oil, drawing

Clarke, Jean L. Lundberg (1925–), Provo: decorative-symbolist, figurative; oil

Clawson, Grant Romney (1927–), Salt Lake City: illustrative realist, genre; oil

Clawson, John Willard (1858–1936), Salt Lake City: portrait, landscape, figurative; oil, watercolor

Clayton, Ronald V. (1946–), Salt Lake City: abstract; oil

Clements, Barbara L. (1952–), Holladay: expressionist, figurative

Clinger, Shauna Cook (1954–), Salt Lake City: portrait; oil

Coalson, Carolyn Ann (1939–), Salt Lake City: abstract; oil

Coleman, Garth J. (1945–), Sandy: realist; oil

Coleman, Michael (1946–), Provo: western, wildlife; etching, gouache

Coles, Arlo L. (1925–), Rexberg: landscape; oil

Collett, Farrell R. (1907–), Ogden: wildlife; oil

Collett, Sam (1942–), Salt Lake City: figurative; oil

Collins, Gary M. (1936–), Salt Lake City: abstract; landscape

Colton, Sid J. (1955–), Salt Lake City: academic orientalist; oil

Colvin, Rob A. (1960–), Farmington: oil

Comish, Florence S. (1948–), Provo: portrait; oil

Cope, Gordon N. (1906–), Salt Lake City/San Francisco: landscape; oil

Coray, Sharon (1942–), Salt Lake City: Indian still life; oil

Corbett, Kenneth A. (1963–), Salt Lake City: wildlife; oil

Corliss, D. Wayne (1948–), Provo: abstract; silkscreen

Cornaby, Floyd V. (1910–), Spanish Fork/Logan: landscape; oil, watercolor; crafts

Cornia, Ivan E. (1929–), Hooper: painting; art education

Covington, I. Loren (1885–1970): landscape; oil

Cox, David Newton (1939–), Ogden: ceramics

Cozzens, D. Lynn (1955–), Kaysville: expressionist; landscape; oil

Crawford, William "Galbraith" (1894–1978), Salt Lake City: cartoon, illustration; pen/ink

Crookston, Nancy S. (1948–), Logan: impressionist, figurative; oil

Culley, Hugh (1947–), Salt Lake City: metaphysical/metaphorical; sculpture

Culmer, Henry Lavender Adolphus (1854–1914), Salt Lake City: Rocky Mountain School landscape; oil and watercolor

Culmer, H. Wells (1883–1959), Salt Lake City: landscape; watercolor

Curtis, Hughes William (1904–1972), Springville: cowboy-western; bronze sculpture

Cutler, Grayce S. (1906–), Salt Lake City: landscape; oil, watercolor

Dabb, Blaine Jay (1943–), Heber: wildlife; oil

Dallin, Cyrus Edwin (1861–1944), Springville/Massachusetts: epic sculpture; bronze and marble

Darais, Alex Basil (1918–), Provo: metaphysical/metaphorical; painting

Darais-Oberbeck, Christina (1955–), Provo/Salt Lake City: painting, sculpture

Davis, Paul H. (1946–), Salt Lake City: figurative; oil

Davis, Silvia Lis (1957–), Salt Lake City: pop sculpture; wood

Dawson, Richard R. (1927–), Layton: wood sculpture

Day, Robert B. (1920–), Kaysville: landscape; oil

Dayton, Steven (1955–), West Jordan: sculpture; mixed media

DeDecker, Thomas A. (1951–), Highland: landscape, Indian; oil

Deffebach, H. Lee (1928–), Salt Lake City: abstract; oil, assemblage

Della Piana, Leandro (1932–), Salt Lake City: metaphysical/metaphorical

Denys, Frederick (1946–), Provo: academic, landscape; oil

DeWitt, Robert (1945–), Orem: fantasy; acrylic

Dibble, George S. (1904–), Salt Lake City: landscape; oil, watercolor

Dibble, Philo (1806–1895), Springville: religious;

Dillon, Lee A. (1950–), Sandy: ceramics

Dixon, L. Maynard (1875–1946), California/Mt. Carmel: formal, landscape, figurative; oil

Dodworth, Alan (1938–), Salt Lake City: arts administration

Dolinger, Ed (1948–), Salt Lake City: abstract; paper

Dornan, E. David (1954–), Salt Lake City: expressive; still life

Doty, Sheri Lynn B. (1949–), Salt Lake City: portrait; colored pencil

Douglas, Larry G. (1950–), Brigham City: landscape; art direction

Dowd, Andrew W. (1869–1942), Salt Lake City: landscape; oil

Doxey, C. Don (1928–), Salt Lake City: academic; figurative, landscape; oil

Drake, Florence Bohn (1885–1955), Ogden: abstract; watercolor

Duncan, Robert K. (1952–), Midway: figurative, genre; oil

Dunford-Jackman, Carol (1933–), Provo: academic; bronze sculpture

Dunn, Dennis A. (1952–), Payson: landscape; oil

Dunn, Marian C. (1930–), Salt Lake City: landscape, buildings; watercolor

Dunston, Clifford F. (1945–), Orem: academic; figurative; drawing

Durrant, Jerry D. (1942–), Sandy: symbolist; oil

Eager, Cecilia V. (1957–), Salt Lake City: fiber art

Earl, LaVieve (1896–1958), Provo: floral; watercolor

Eastmond, Elbert Hindley (1876–1936): landscape; oil

Eaton, A. Valoy (1938–), Vernal: landscape; oil, watercolor

Eddington, E. Keith (1923–), Salt Lake City: graphic design

Eddington, Patrick J. (1953–), Salt Lake City: fantasy, mystical

Edwards, Barbara S. (1952–), Smithfield: genre; oil

Edwards, Glen L. (1935–), Smithfield: illustrative genre; oil, acrylic

Eisele, Christian (1854–1919), itinerant: landscape; oil, drawing

Ellingson, Paul L. (1938–), Salt Lake City: architectural; watercolor

Elliott, Henry Wood (1846–1930), itinerant: landscape, figurative; watercolor, drawing

Elsner, Larry E. (1930–1990), Logan: abstract sculpture

Empy, Glenna (1929–), Tooele: landscape; oil

Enk, Patricia G. (1955–), Utah/California: floral; watercolor

Erdmann, Darryl B. (1951–), Salt Lake City: abstract; paint

Erickson, Connie J. (1958–), Salt Lake City: ceramics

Erickson, Frank (1922–1989), Salt Lake City: landscape

Erickson, John Owen (1953–), Salt Lake City: independent expressionist; oil

Esmay, Larry R. (1955–), Orem: fantasy; acrylic

Eva, Kerry (1952–), Santaquin: western sculpture, drafting

Evans, Carole Howe (1933–), Salt Lake City: watercolor

Evans, Edwin (1860–1946), Lehi/Salt Lake City: landscape; oil, watercolor

Evans, Elaine S. Michelsen (1905–), Salt Lake City: painting

Everett, Joseph A. F. (1883–1945), Salt Lake City: landscape, floral; watercolor

Fairbanks, Avard T. (1897–1987), Provo/Salt Lake City: idealist sculpture; bronze, marble

Fairbanks, Daniel J. (1956–), Provo: bronze sculpture

Fairbanks, John B. (1855–1940), Payson: landscape, oil

Fairbanks, Justin (1926–), Salt Lake City: bronze sculpture

Fairbanks, J. Leo (1878–1946), Payson and Oregon: landscape, sculpture; oil, bronze, stone

Fairbanks, Ortho (1925–), Salt Lake City: realist sculpture

Fairchild, Lucy (1952–), Salt Lake City: metaphysical/metaphorical

Fairclough, Gerald D. (1938–), Salt Lake City: figurative; oil

Farnsworth, Louise Richards (1878–1969), Salt Lake City: fauvist, landscape; oil, pastel

Farrar, Laura Lynn W. (1950–), Mapleton: figurative; oil

Fausett, Lynn (1894–1977), Price/New York City/Salt Lake City: landscape; tempera/gouache

Fausett, William Dean (1913–), Price/Vermont: landscape, portrait; oil, watercolor

Fawson, Steven James (1952–), Salt Lake City: metaphorical expressionist; oil

Fehr, Cynthia M. (1928–), Salt Lake City: landscape, urban; watercolor

Fehr, Kindra M. (1963–), Salt Lake City: still life; watercolor

Fery, John (1859–1934), itinerant: landscape, wildlife; oil

Fillerup, Peter M. (1953–), Heber: western sculpture; bronze

Fillin, Jeff (1954–), Kaysville: landscape; oil

Finlayson, Kathryn (1953–), Salt Lake City: surrealist; oil, drawing

Fischman, Louise (1958–), Salt Lake City: modernist; assemblage

Fisher, Flora D. (1891–1984), Provo: floral; watercolor, oil

Fjellboe, Paulmar T. (1873–1948), Salt Lake City: landscape; oil

Flannery, Kit (1933–), Salt Lake City: fiber art

Fleming, Susan F. (1942–), Salt Lake City: traditional, still life

Fletcher, Calvin (1882–1963), Logan: landscape; oil, watercolor

Fletcher, Dale T. (1929–1990), Logan/Provo: landscape; oil

Fletcher, Irene Thompson (1900–1969), Logan: figurative; oil, watercolor

Fletcher, Leone Wooley (1932–), Provo: landscape; oil

Fliegel, Vivian (1953–), Salt Lake City: imagerist; mixed media

Folland, Jr., Lorin G. (1922–), Salt Lake City: landscape; oil

Forsberg, Norma S. (1920–), Bountiful: landscape; oil

Forsberg, Patricia (1944–), Salt Lake City/New Mexico: allegorical

Forster, Paul Peter (1925–), Salt Lake City: figurative, landscape; oil

Foulger, Graydon K. (1942–), Murray: landscape; oil

Fox, Larnie R. (1955–), Salt Lake City: contemporary

Frandsen (Neslen), Florence (1908–), Springville/Salt Lake City: oil, watercolor

Fraughton, Edward J. (1939–), Jordan: western sculpture; bronze

Frazer, Mabel Pearl (1887–1981), Salt Lake City: landscape; oil, watercolor

Friberg, Arnold (1913–), Salt Lake City: western, religious, patriotic; oil

Frye, Todd J. (1947–), Springville: lithography, printing

Fuhriman, Jerry W. (1942–), Logan: landscape; watercolor

Gagon, Ira D. (1942–), Provo: allegorical; oil

Gardner, Henry LeRoy (1884–1979), Payson: landscape; oil, drawing

Gatherum, G. Merrell (1903–1956), Provo: landscape; oil

Gehring, Brent (1942–), Provo: abstract sculpture

Gittins, Alvin (1922–1981), Salt Lake City: portrait, figurative; oil, drawing

Glazier, Beverly B. (1951–), Orem: abstract; silkscreen

Glazier, Gregory A. (1962–), Salt Lake City: abstract symbolist

Glazier-Koehler, Nancy (1947–), Salt Lake City/Montana: wildlife; oil

Glidden, Craig (1960–), Salt Lake City: symbolist, abstract; oil

Glidden, Roberta B. (1944–), Ogden: floral; watercolor

Goldsmith, Stephen A. (1954–), Salt Lake City: abstract sculpture

Goodliffe, Kent P. (1946–), Orem: academic realist; prismacolor

Goodman, Jack (1913–), Salt Lake City: architectural; watercolor, drawing

Gordon, Joyce Thyberg (1938–), Utah: large floral; watercolor

Gordon, Patricia H. (1943–), Logan: designed subjects, still life

Gourley, Elizabeth "Bessie" Eastmond (1886–1961), Provo: floral, still life; watercolor

Graves, Daniel (19th century), Salt Lake City: religious; drawing

Graves, Michael Clane (1939–), Provo: graphic design

Gray, Sharon R. (1947–), Orem: mixed media

Greenhalgh, Kaye E. (1943–), West Valley City: wildlife; oil

Griffin, Lynn S. (1940–), Escalante: landscape; oil

Groberg, Charles A. (1913–), Ogden: semiabstract, landscape; oil

Grondahl, Calvin (1950–), Ogden: cartoons

Groutage, Harrison Thomas (1925–), Logan: landscape; acrylic

Grover, Roscoe A. (1901–1984), Salt Lake City: landscape, portrait; oil

Gunn, Richard L. (1918–), Provo: landscape, figurative; watercolor, drawing

Haag, Herman H. (1871–1895), Salt Lake City: figurative; oil

Haddock, Brent R. (1949–), Provo: landscape; watercolor

Hadlock, W. Neil (1944–), Highland: modernist sculpture

Hafen, John (1856–1910), Springville: landscape, portrait; oil, drawing, pastel, watercolor

Hafen, Virgil Otto (1887–1949), Utah\Oregon: landscape, figurative; oil

Hafen, Louise (1929–), Utah/Seattle: landscape; watercolor

Hague, Donald V. (1926–), Salt Lake City: landscape; oil

Haley, Martha Klein (1944–), Salt Lake City: fiber art

Haltern, Hagen G. (1947–), Orem: metaphysical, abstract, realist

Halverson, Michael (1952–), Spanish Fork: landscape; oil

Handrahan, George W. (1949–), Layton: landscape; oil

Hansen, Florence P. (1920–), Salt Lake City: realist sculpture

Hansen, Gaylen C. (1921–), Logan: metaphysical/metaphorical

Hansen, Louise B. (1927–), Utah/Indiana: landscape; watercolor

Hansen, Omar M. (1922–), Springville: landscape; oil

Hanson, Kevin D. (1952–), Salt Lake City: film

Harding, Carol P. (1935–), Pleasant Grove: landscape, figurative; oil, pastel

Harding, C. Lance (1951–), American Fork: divine symmetry; sculpture

Harding, Elaine S. (1951–), Salt Lake City: paper, mixed media

Hardman, Maud (?–1981), Salt Lake City: printmaking; woodcut

Harris, Melinda (1953–), Spring Lake: Indian genre, portrait; oil

Harrison, Magie Greever (1948–), Salt Lake City: fiber art

Hartvigsen, Rebecca (1947–), Centerville: nostalgic landscape; watercolor

Hartwell, Rose (1861–1914), Salt Lake City: figurative; oil, watercolor

Harvey, Alpheus (1900–1976); Kaysville: landscape; oil; ceramics

Harvey, Madeline (1938–), Salt Lake City: drawing

Harwood, Harriett Richards (1870–1922), Salt Lake City: still life; oil

Harwood, James Taylor (1860–1940), Lehi/Salt Lake City: landscape, figurative; oil, watercolor

Harwood, Ruth (1896–1958), Salt Lake City: symbolist; drawing, printmaking

Hase, Melvin F. (1929–), Murray: machinery, landscape; watercolor

Haseltine, James (1924–), Salt Lake City: landscape contemporary

Haws, Marion (1947–), Newton: western sculpture

Hedgepeth, Stephen (1949–), Ogden: landscape; oil

Heinzman, Louis (1905–1982), Salt Lake City/California: landscape; oil, drawing

Held, Jr., John (1889–1958), Salt Lake City/New York City: illustration

Hellberg, Ray W. (1929–), Logan: oriental, landscape; watercolor

Hess, John W. (1939–), Salt Lake City: fiber art

Heywood, Margaret T. (1911–), Salt Lake City: figurative, landscape; watercolor

Hill, Bill L. (1922–), Mendon: cowboy-western; oil

Hill, Sherron D. (1936–), Provo: abstract, landscape

Himes, Hal Douglas (1956–), Provo: symbolist; oil

Hirsch, Joseph (1910–), New York City: figurative

Hogle, Mary Ellen (1946–), Salt Lake City: ceramics

Holman, Kay A. (1952–), Providence: wildlife; oil

Holstein, Horst (1952–), Salt Lake City: surrealist; collage

Holt, Marjorie J. (1919–), Salt Lake City: painting

Holz, David (1945–), Salt Lake City: sculpture

Hone, Richard L. (1954–), Provo: religious, figurative

Hopkinson, Harold (1918–), Provo/Wyoming: western; oil

Horne, Alice Merrill (1868–1948), Salt Lake City: painting; art dealer

Horne, Phyllis F. (1937–), Salt Lake City: figurative, landscape; oil

Horspool, Francis (1871–1951), Salt Lake City: primitive landscape, historical; oil

Hoskins, Marilyn W. (1945–), Salt Lake City: landscape; oil

Hubbard, Louis G. (1934–), Logan: floral; watercolor, oil

Hudgens, Cynthia Faye (1956–), Provo: symbolist; intaglio

Huelskamp, Willamarie (1959–), Salt Lake City: realist, abstract; oil

Huff, Jr., Frank (1957–), Salt Lake City: landscape; watercolor, oil

Hughes, Marie Gorlinski (1861–1938), Salt Lake City: still life; oil, watercolor

Huish, Orson Pratt (1851–1932), Payson: landscape; watercolor, oil

Hull, Gregory (1950–), Utah/Texas: landscape, still life; oil

Hull, Richard D. (1945–), Logan/Bountiful: commerical, fantasy

Hullet, Michael C. (1953–), Salt Lake City: abstract sculpture

Hulsman, Michael (1952–), Utah/New Mexico: expressionist; printmaking

Humphreys, Edward E. (1937–), Provo: abstract; acrylic

Hunger, Fred J. (1936–), Ogden: monumental landscape sculpture

Hunt, David J. (1938–), Provo/Colorado: modernist; ceramics

Huntington, Bonnie S. (1924–), Provo: landscape, figurative; oil

Huntsman, S. Ralph (1896–?), St. George: landscape; oil

Hyde, Marion R. (1938–), Brigham City/Logan: printmaking, woodcut

Inshaw, George Edward (1861–1938), Springville: landscape; oil, watercolor

Irvine, Ida C. (1910–), Salt Lake City: modernist; serigraph

Ivancich, Nel O. (1941–), Salt Lake City: abstract

Jack, Gavin Hamilton (1859–1938), Manti: landscape; oil

Jackson, David W. (1951–), Clinton: wildlife; watercolor, oil, sculpture

Jackson, William Henry (1843–1942), itinerant: genre; drawing, watercolor

Jacobs, James C. (1955–), Ogden: abstract sculpture, painting

Jarvis, John B. (1946–), Pleasant Grove: western genre; gouache

Jenkins, Miriam Brooks (1885–1944), Salt Lake City: landscape; watercolor, oil

Jennings, LeRoy D. (1946–), Ogden: wildlife, landscape; oil

Jensen, Mildred (1922–), Salina: traditional genre; oil

Jensen, Olive Belnap (1888–1979), Ogden: floral, landscape; oil

Jensen, Rex F. (1938–), Mapleton: landscape; oil

Jenson, Edgar M. (1888–1958), Ephraim/Provo: landscape; oil

Jepperson, Samuel Hans (1855–1931), Provo: landscape, florals; oil

Jesus, Ricardo (1947–), Springville: figurative

Ji, Hongyu (1954–), Cedar City: landscape, figurative; oil

Jiang, Lin Xia (1962–), Salt Lake City: metaphorical; oil

Jimenez, Carleen (1941–), Salt Lake City: allegorical, symbolist

Jimison, Carla S. (1960–), Mt. Pleasant: figurative, landscape; oil

Johansen, Franz Mark (1928–), Provo: figurative; oil, sculpture

Johansen, Nathan A. (1958–), Springville: abstract sculpture

Johnson, Mary C. Kimball (1906–), Salt Lake City: landscape, floral; watercolor

Johnson, Sandra (1937–), Mt. Pleasant: landscape, figurative; oil, pastel

Johnson, Stanley (1939–), Mapleton: Indian, western; bronze sculpture

Johnson, Victoria Hixon (1951–), Salt Lake City: ceramics, watercolor

Johnson, Wayne (1872–1950), Springville: landscape; oil

Johnston, Richard M. (1942–), Salt Lake City: abstract sculpture

Jolley, Donal C. (1933–), Cedar City/California: landscape; watercolor

Jolley, Richard K. (1954–), Logan: wildlife, landscape

Jonas, Raymond V. (1942–), Provo: abstract sculpture

Jones, Earl M. (1937–), Salt Lake City: figurative, landscape

Jones, James F. (1933–), Cedar City: landscape; oil

Judd, Tom (1952–), Salt Lake City: expressionist, genre; assemblage, mixed media

Juhlin, Eugene V. (1917–), Salt Lake City: landscape; oil

Kapp, Gary L. (1942–), Provo: western, religious, landscape; oil

Kearns, Howard (1907–1947), Springville: landscape; oil, watercolor

Kelly, Geri (1928–), Ogden: pastel, watercolor

Kempster, Frances Saunders (early 20th century), Salt Lake City: painting

Kent, Cloy P. (1917–), Bountiful: portrait; oil

Kent, Frank Ward (1912–?), Salt Lake City: figurative, landscape; oil, drawing

Keogh, Dennis C. (1953–), Logan: fantasy; printmaking

Keogh, Michael J. (1951–), Ogden: printmaking

Keough, David B. (1952–), Sandy: realist, landscape; watercolor

Kerby, Joseph (1852–1911), Provo: landscape, stage scenery; oil

Kern, David E. (1953–), Orem: fantasy

Kerr, Grace Y. (1894–1959), Provo: landscape, floral; watercolor

Kershisnick, Brian T. (1962–), Provo: allegorical, figurative; oil

Kesler, Linda Adams (1944–), Salt Lake City: landscape; watercolor

Kilbourn, Dale (1929–), Salt Lake City: illustration; oil

Kimball, Jr., W. Wayne (1943–), Pleasant Grove: symbolist; lithography

Kimball, Ranch S. (1894–1980), Salt Lake City: landscape; drawing, oil

Kinateder, Richard L. (1945–), Provo: landscape, architectural; watercolor

Kirby, Susannah J. (1953–), Salt Lake City: modernist, metaphysical/metaphorical

Kirkham, Reuben (1845–1886), Logan/Salt Lake City: landscape; oil

Kirkpatrick, W. William (1944–), Alpine: portrait; oil

Kleinschmidt, Robert Walter (1927–), Salt Lake City: printmaking

Klinge, Nellie Kilgore (contemp of Minerva Teichert), Salt Lake City: floral, landscape; oil

Knaphus, Torlief S. (1881–1965), Salt Lake City: sculpture; plaster, bronze

Kotok, Peg (1914–), Ogden: watercolor

Krasnow, Andrew H. (1959–), Salt Lake City: assemblage sculpture

Kuhni, Paul (1895–1986), Salt Lake City: landscape; oil

Kuzminski, Catherine M. (1944–), Salt Lake City: ceramics

Lafon, Dee J. "Pete" (1929–), Ogden: various media

Lake, Randall B. (1947–), Salt Lake City/Spring City: figurative, still-life, landscape; oil

Lambert, M. Jean (1960–), Salem: figurative, expressionist; oil

Lambourne, Alfred W. (1850–1926), Salt Lake City: romantic, landscape; oil

Larsen, Bent Franklin (1882–1970), Provo: landscape; oil, watercolor

Larsen, Jacqui Biggs (1962–), Provo: abstract painting

Larsen, Jessie C. (1912–), Logan: landscape; oil; crafts

Lattin, Virginia H. (1925–), Salt Lake City: floral; watercolor

Lauritzen, Gay Nickle (1956–), Mt. Pleasant: soft sculpture

Law, Craig (1946–), Logan: photography

Laycock, Brent (1947–), Provo/Canada: landscape; watercolor

Lee, Douglas (1942–), Heber: landscape; watercolor

Lee, Roland L. (1949–), Dammeron Valley: western landscape; watercolor

Leek, Thomas A. (1932–), Cedar City: landscape, abstract, watercolor

Lemon, David (1945–), Salt Lake City: western, wildlife; sculpture

Lemon, Liz M. (1953–), Orem: western; oil

Lenzi, Martin (1815–1898), Salt Lake City: academic; still life; oil

LeSueur, Annette (1949–), Provo/Minnesota: classical realist; oil

Lifferth, Wesley H. (1947–), Payson: figurative genre; oil

Lindstrom, Gaell W. (1919–), Logan: watercolor, ceramics

Lippe, Laurie (1952–), Salt Lake City: abstract expressionist

Liston, Betty M. (1927–), Pleasant Grove: landscape; oil

Littlefield, Nancy C. (1954–), West Jordan: birds; watercolor

Long, Sarah Ann Burbage, (1817–1878), Salt Lake City: portrait; oil

Lomahaftewa, Dan V. (1951–), Ft. Duchesne: metaphysical/metaphorical

Lund, Judy F. (1911–), Salt Lake City: landscape, figurative; oil

Lund, Nancy A. (1931–), Bountiful: floral, landscape; watercolor

Lyman, Fred (1939–), Payson: abstract

MacDonald, Mary M. (1920–), Cedar City: ceramics

MacFarlane, Donald (1940–), Provo: figurative; drawing, oil

Macpherson, Charles H., (19th century), itinerant: portrait; drawing, oil

Madden, Susan (1955–), Magna: printmaking

Madsen, Barbara (1958–), Mapleton: printmaking

Magleby, Francis R. (1928–), Provo: landscape; oil

Magleby, McRae (?–), Salt Lake City/Provo: commercial art, graphics, design

Maiben, Henry J. (1855–1907), Provo: stage scenery, portrait

Major, William Warner (1804–1854), Salt Lake City: portrait; oil, watercolor

Makov, Susan (1952–), Ogden: hand-painted photographs, printmaking

Malin, Elva E. (1933–), Salt Lake City: landscape; oil

Malin, Millard F. (1891–1974), Salt Lake City: sculpture; marble, bronze

Malloy, R. Eddi (1943–), Ogden: designed; landscape; watercolor

Mann, Paul H. (1955–), Bountiful: western, figurative; oil, watercolor

Mann, Rebecca G. (1938–), Farmington: painting

Manning, Nellie May (1879–1950), Salt Lake City: landscape; watercolor

Marotta, Joseph (1949–), Salt Lake City: photography

Marsh, Sharon L. (1940–), Salt Lake City: landscape; oil

Marshall, Robert L. (1944–), Springville: landscape; oil, watercolor

Martin, John W. (1954–), Provo: portrait; oil

Maryon, Edward D. (1931–), Salt Lake City: landscape; watercolor

Mason, Fred R. (1935–), Salt Lake City/Connecticut: portrait, genre

Mastrim, Beverly Ann (1923–), landscape, figurative; oil

Matheson, Bri D. (1952–), Salt Lake City: papier mâché, sculpture

Mathews, Conan E. (1905–1972), Provo: abstract, landscape; oil, watercolor

Mathews, Craig (1948–), abstract; oil

Mayer, Evelyn S. (early 20th century): painting

McBeth, James R. (1933–), Ogden: sculpture

McBride, Stanley T. (1933–), Salt Lake City: abstract; watercolor

McClure, Marjorie Ann (1946–), Holladay: figurative, genre

McConkie, Judith (1946–), Salt Lake City: printmaking

McDonald, Amy (?–), Salt Lake City: ceramics

McDonald, Deana C. (1901–?), Salt Lake City: watercolor

McEntire, Frank (1946–), symbolist, shamanist; sculpture

McGinty, Steven E. (1956–), Murray: landscape; oil

McKay, Fawn Brimhall (1889–1960), Salt Lake City: landscape; watercolor

McKay, Shirley (1936–), Salt Lake City: landscape; watercolor

McLaughlin, Howard B. (1930–), Salt Lake City: landscape; oil

Meacham, Layne R. (1948–), Murray: abstract; oil, mixed media

Mehr, Judith (1951–), Salt Lake City: figurative genre; oil

Merrill, David M. (1912–), Farmington: landscape; oil

Midgley, Waldo Park (1888–1986), Salt Lake City/New York City: landscape, cityscape; oil, watercolor, drawing

Miles, Dorothy "Dottie" (1931–), Salt Lake City: colored pencil

Miles, Richard A. (1938–), Fruit Heights: academic, landscape; oil

Miller, Marie Clark (1891–1962), Springville: landscape; oil, watercolor

Miller, Marilyn R. (1942–), Salt Lake City: silkscreen, oil, handmade paper

Miller, Sandria J. (1937–), Ogden: hand-painted photographs

Millman, David (1955–), Provo: realist; watercolor, oil

Millman, Dean (1948–1977), Provo: realist; landscape, still life; watercolor

Millman-Weidinger, Lynne (1953–), Provo: western realist; oil

Mitchell, Arthur Frederick (1837–1901), Farmington/Salt Lake City: landscape, still life, figurative

Moench, Louis Frederick (1846–1916), Salt Lake City: drawing

Moench, Meredith Lee (1945–), Salt Lake City: expressionist, imagerist

Moffitt, Valaine J. (1928–), Salt Lake City: landscape, buildings; watercolor

Moller, Oscar Olaf (1903–1985), Utah/Idaho: landscape; oil

Momen, Karl K. (1934–), Sweden/Salt Lake City: abstract; painting, sculpture

Montgomery, Gloria (1944–), Heber City: magical realist

Morales, Raymond C. (1946–), Highland: design, graphics, commercial art

Moran, Thomas (1837–1926), itinerant: Rocky Mountain School; landscape; oil, watercolor and drawing

Morris William C. (?–1889), Salt Lake City: landscape; oil

Morris, William V. (1821–1878), Salt Lake City: decorative

Morrison, Margaret W. (1960–), Salt Lake City: figurative, interior; oil

Moser, John Henri (1876–1951), Logan: fauvist; landscape; oil

Moss, LaVelle R. (1941–), Orem: landscape, figurative

Mulder, J. Thomas (1939–), Salt Lake City: buildings, landscape

Munger, Gilbert Davis (1836–1903), itinerant: landscape; oil

Murdock, Kathleen Torgesen (1945–), Utah/Idaho: landscape; watercolor

Murray, Linda Anderson (1952–), figurative, allegorical

Murray, Richard A. (1948–), Salt Lake City: landscape; oil

Myer, Peter L. (1934–), Provo: kinetic light sculpture, pastels

Myrup, John L. (1945–), Lewiston: magical realist, landscape

Nakos, Frank J. (1939–), Springville: abstract sculpture

Nebeker III, Royal Gay (1946–), Utah/Oregon: figurative; oil

Neely, John (1953–), Logan: ceramics

Nelson, Joan N. (1927–), Salt Lake City: designed contemporary scenes

Nelson, Kathleen Cassity (1937–), Salt Lake City: ceramics

Neslin, H. Edward (1917–), Salt Lake City: surrealist; oil

Newhouse, Patricia M. (1943–), West Jordan: still life

Newman, Jeannine Young (1952–), abstract, wildlife; sculpture

Nielson, Rebecca Ann (1948–), Sandy: realist; watercolor

Norton, James C. (1953–), Santaquin: western, landscape

Novak, Barbara (1926–), Provo: urban; watercolor, oil

Nyman, Ivan T. (1939–), Salt Lake City: landscape; oil

Oberbeck, Edwin Charles (1951–), Salt Lake City: fantasy; oil, watercolor

Oborn, Anne Marie (1949–), Bountiful: landscape; oil

Oldham, Rebecca A. (1954–), Spanish Fork: landscape

Olpin, Lucille Harman (1909–1990), American Fork, Salt Lake City: figurative, portrait; oil

Olsen, Donald Penrod (1910–1983), West Jordan: abstract expressionist; oil, acrylic

Olsen, Gerald P. (1926–), St. George: landscape; oil, watercolor

Olsen, Gregory K. (1958–), Provo: academic realist, figurative; oil

Olsen, Harold DeMont (1928–), Salt Lake City: landscape; oil, watercolor

Omans, David L. (1933–), Fairview: landscape; oil

Omans, Sherry L. (1937–), Fairview: landscape; oil

Ong, Wilson J. (1958–), Provo: academic figurative; oil

Orton, Brent C. (1958–), Provo: surrealist, landscape; oil

Ostergaard, Clark (1937–), Taylorsville: realist, birds, wildlife

Ostraff, Joseph E. (1957–), Alpine: modernist, wildlife

Ottinger, George Martin (1833–1917), Salt Lake City: genre, landscape; oil, watercolor, drawing

Ottinger, George Neslen (1875–?), Salt Lake City: landscape; oil, photography

Oviatt, Susan E. (1950–), Salt Lake City: metaphysical/metaphorical

Oyler, Lynn W. (1934–), Sandy: figurative, still life

O'Higgins, Paul "Pablo" (1904–1983), Salt Lake City: muralist in Mexico

Packard, F. Calvin (1927–), Springville: landscape; oil

Palmer, Herman (1894– ?), Farmington: illustrations, animals; drawing, watercolor

Papworth, Dennis F. (1923–), Fairview: realist; pastel

Pardike, Cathy (1939–), Salt Lake City: abstract

Parker, Colleen Lewis (1927–), Bountiful: landscape

Parker, Virgil J. (1925–), Orem: landscape, wildlife; oil

Parkin, Leonard (1941–), Salt Lake City: science fiction

Parkinson, Lee K. (1913–), Ogden: landscape; oil

Parkinson, William Jensen (1899–), Salt Lake City: symbolist; painting

Parry, Caroline K. (1885–1967), Salt Lake City: sculpture, painting

Parson, Delwin O. (1948–), St. George: figurative, landscape; oil

Parson, Oliver (1916–), Springville/Rexburg, Idaho: landscape; oil

Parson, Thelma B. (1927–), Murray: landscape; watercolor

Parsons, Steven M. (1950–), Santaquin: landscape; oil

Paul, Ethel Strauser (1900–), Clearfield: landscape; oil

Paulsen, Esther Erika (1895–1978), Logan: landscape; oil

Paulson, Curt (1945–), Parowan: genre; oil

Pavola, Gayle D. (1941–), Salt Lake City: orientalist, figurative; oil

Paxton, Marjorie W. (1921–), Salt Lake City: still life; oil

Payne, Hilma Mole (1901–1973), Logan: landscape; oil

Peacock, Ella G. (1905–), Spring City: landscape; oil

Pendell, David Roy (1944–), Salt Lake City: ceramics

Perkins, Stanley M. (1915–1974), Salt Lake City: portrait; oil

Perova, Galina (1958–), Russia/Salt Lake City: abstract, realist; oil

Perry, April L. (1948–), Provo: expressionist, figurative; oil

Perry, Jr., Enoch Wood (1831–1915), itinerant: portrait; oil

Peters, William (1901–1963), Provo: portrait, landscape; oil, drawing

Petersen, Mark B. (1953–), Salt Lake City: landscape; oil

Peterson, Harold D. (1930–), Salt Lake City: photo-realist, symbolist; watercolor

Peterson, Karen N. (1946–), Salt Lake City: watercolor, oil

Peterson, Kathleen B. (1951–), Ephraim: landscape; watercolor

Petterson, Cliff J. (1952–1986), Salt Lake City: academic surrealist; oil

Pheysey, Arthur A. (1945–), Provo: drawing; framing

Phillips, Bonnie G. (1942–), Salt Lake City: geometric abstract; watercolor

Phillips, Denis Ray (1938–), Salt Lake City: abstract, landscape; oil

Pierce, Diane (1952–), Salt Lake City: figurative; oil

Piercy, Frederick (1830–1891), itinerant: scenic; drawing

Plant, Jody (1954–), Salt Lake City: metaphysical/metaphorical

Plastow, Pete (1930–), Moab: academic, landscape, cowboy

Porter, Elbert H. (1917–), Salt Lake City: sculpture

Posselli, Bonnie (1942–), Salt Lake City: landscape; oil

Powell, Myra Grout (1895–1983), Ogden: abstract; oil, watercolor

Pratt, Irvin T. (1891–1955), Salt Lake City: landscape; watercolor

Pratt, Lorus Bishop (1855–1923), Salt Lake City: landscape; oil

Pratt, Lorus Orson (1884–1964), Salt Lake City: landscape; oil, watercolor

Prestwich, Larry B. (1935–), Colorado: figurative; drawing

Price, Clark Kelly (1945–), Provo: cowboy, religious genre; oil

Price, Gary Lee (1955–), Springville: wildlife, figurative; sculpture

Psarras, Dan G. (1956–), Salt Lake City: landscape; pastel

Purcell, Carl Lee (1944–), Ephraim: landscape; watercolor, etching

Pursley, David (1957–), Salt Lake City: modernist; mixed media, sculpture

Quilter, Karl (1929–), Salt Lake City: western sculpture

Ralphs, Donna P. (1931–), Springville: landscape; oil

Ramsey, Ian M. (1948–), Salt Lake City: rustic, landscape; watercolor

Ramsey, Lewis A. (1875–1941), Salt Lake City: landscape; oil

Ramsey, Ralph (1852–1905), Salt Lake City: painting

Ramsey, William (19th century), Salt Lake City: pioneer; wood sculpture

Randle, Kirk H. (1952–), Bountiful: rustic, landscape; watercolor

Randolph, Lee F. (1880–1956), California: modernist

Rasmusen, Henry Neil (1909–?), Salt Lake City: formal, landscape, still life, genre; oil, pastel, mixed media

Rasmussen, Anton Jessie (1942–), Salt Lake City: landscape; oil

Raty, T. Laine (1927–), Provo: portrait; oil

Rawson, Joyce G. (1943–), West Valley City: watercolor

Read, Marilyn L. (1946–), Salt Lake City: landscape; oil

Reber, Mick (1942–), Provo/Colorado: pop art; sculpture

Redd, Lura (1891–), Salt Lake City: landscape; watercolor

Reese, Boyd (1932–1990), Salt Lake City: expressionist, genre; oil

Reinholt, Allen K. (1936–), American Fork: landscape; watercolor

Rencher, Ron D. (1952–), Utah/New Mexico: landscape; oil, watercolor

Renzetti, Woodie (1925–), Salt Lake City: painting, drawing

Reyes, Jaime C. (1957–), Woodland Hills: still life; drawing

Reynolds, H. Reuben (1898–1974), Logan: landscape; oil, photography

Reynolds, Olinda H. (1947–), Bountiful: figurative; watercolor

Reynolds, Ralph H. (1916–1984), Salt Lake City: illustration, nudes; oil

Reynolds, Suzanne Garff (1941–), Salt Lake City: still life, genre

Reynolds-Cowles, Joan (1953–), Salt Lake City: abstract; mixed media

Richards, Glen M. (1958–), Sandy: modernist

Richards, Lee Greene (1878–1950), Salt Lake City: landscape, portrait; oil

Ricks, Don F. (1929–), Utah/Idaho: floral, landscape; oil

Ricks, Kent J. (1949–), Salt Lake City: abstract; mixed media

Ridges, Joseph H. (1827–?), Salt Lake City: decorative, crafts

Rigby, Cleston H. (1905–1981), Provo: landscape; oil

Riggs, Carl Eugene (1944–), St. George: ceramics

Riggs, Frank P. (1922–), Highland: minimalist sculpture

Rindlisbacher, David L. 1947–), Provo: figurative, landscape

Robbins, Clayton (1919–), Salt Lake City: bronze sculpture

Roberson, Edith Taylor (1929–), Salt Lake City: fantasy, trompe l'oeil; oil, assemblage

Roberts, C. Larry (1946–1988), Salt Lake City: film

Robertson, Bruce D. (1959–), Riverton: abstract; mixed media

Robinson, Mark W. (1957–), Orem: fantasy; acrylic

Rohovit, Marah B. (1942–), Salt Lake City: abstract; oil

Romney, Mary Lou (1929–), Salt Lake City: floral; watercolor, mixed media

Rose, ViviAnn (1954–), Salt Lake City, Moab: photography, hand painted photographs

Rosenbaum, David Howell (1908–1982), Brigham City: landscape; oil, watercolor

Rosiers, Roger des (1935–), Salt Lake City: abstract

Rounds, Al (1954–), Salt Lake City: historical, architectural; watercolor

Rowe, Victoria (1957–), Logan: printmaking, drawing

Russell, Andrew Joseph (1830–1902), itinerant: landscape; oil, photography

Russon, Joseph Franklin (1874–1958), Salt Lake City: landscape; oil, watercolor

Salisbury, Cornelius (1882–1970), Salt Lake City: landscape, genre; oil

Salisbury, Paul (1903–1973), Provo: western landscape, cowboy; oil

Salisbury, Rosine Howard (1887–1975), Salt Lake City: figurative, landscape, floral; oil, watercolor

Salisbury, Stanley (1910–), Salt Lake City: landscape; watercolor

Sandzen, Sven Birger (1871–1954), Kansas/Utah: landscape; oil

Savage, Charles Roscoe (1832–1909), Salt Lake City: photography

Sawyer, Myra L. (1866–1956), Salt Lake City: figurative; oil, watercolor

Saxod, Elsa (1892–?), Salt Lake City: landscape; oil

Schaefer, John (?–), Salt Lake City: photography

Schafer, Frederick F. (1839–1927), itinerant: landscape; oil

Schnirel, Ben J. (1961–), Moab: fantasy; landscape

Schnirel, James R. (1931–), Summit Park: landscape; watercolor

Schofield, Ralph H. (1921–), Salt Lake City: figurative; oil

Schumann, Nina N. (1927–), Lehi: landscape; oil

Sears, John S. "Jack" (1875–1969), Salt Lake City: drawing, illustration

Seegmiller, Donald G. (1955–), Orem: classical realist; oil

Seely, Naoma Roundy (1924–), Roy: landscape; oil

Sellers, H. Francis (1937–), Salt Lake City: cityscape, landscape; watercolor

Senior, Lillian W. (1904–), Ogden: landscape; watercolor

Serbousek, Rodney A. (1959–), Holladay: landscape; oil

Shaw, Arch D. (1933–), West Valley City: neo-regionalist, landscape, figurative; oil

Shaw, Diane O. (1946–), North Salt Lake: ceramics

Shaw, Doyle D. (1947–), Springville: landscape, figurative; oil

Shaw, John D.(1945–), North Salt Lake: ceramics

Shepherd, Donald B. (1940–), Salt Lake City: modernist, abstract

Shepherd, Richard W. (1947–), Ogden: abstract; oil, mixed media

Shepherd, Robert L. (1909–), Santa Clara: mural, landscape; watercolor, oil

Shepherd, Sharon (1943–), Salt Lake City/California: abstract impressionist; watercolor, paper

Shimmin, Linda L. (1940–), Vernal: landscape, figurative; oil

Shorton, Richard H. (1929–), Salt Lake City: sculpture

Silver, William J. (1832–?), Salt lake City: drawing

Sievers, Gregory B. (1951–), Utah/Idaho: western genre; oil

Sisemore, Claudia (1937–), Centerville: abstract, film

Slack, Ethel H. (1893–1965), Provo: landscape; oil

Smart, Emma S. (1862–1924), Springville: landscape

Smedley, Delbert W. (1908–1978), Logan/Salt Lake City: oil, watercolor; art education

Smith, Afton B. (1924–), Logan: landscape; oil, pastel

Smith, Bathsheba W. (1822–1910), Salt Lake City: drawing

Smith, Bruce H. (1936–), Springville: metaphorical, figurative; oil

Smith, Cecil A. (1910–1984), Salt Lake City/Idaho: cowboy/western; oil

Smith, Chad M. (1940–), Salt Lake City: abstract

Smith, Clara K. (1894–1965), Ogden: landscape, floral; watercolor

Smith, Dennis V. (1942–), Highland: children, metaphorical; sculpture, painting

Smith, Frank Anthony (1939–), Salt Lake City: abstract illusionist; airbrush, acrylic

Smith, Gary Ernest (1942–), Highland: neo-regionalist; figurative, landscape; oil

Smith, Gibbs M. (1940–), Kaysville: contemporary, urban landscape; oil

Smith, LaWanna (1942–), Bountiful: landscape, figurative

Smith, Leah Tippetts (1947–), Salt Lake City: metaphorical

Smith, Mary Ann F. (1946–), Alpine: landscape; watercolor

Smith, Moishe (1929–), Logan: landscape; intaglio, printmaking

Smith, Pilar P. (1929–), Salt Lake City: contemporary; painting, sculpture

Smith, Ruth Wolf (1912–1980), Salt Lake City: lyrical, surrealist; figurative

Smith, S. Paul (1904–), Salt Lake City: landscape; watercolor

Smith, William Rowe (1918–), St. George: landscape, still life; oil

Smithson, Robert (1938–), visiting artist: modernist

Snow, V. Douglas (1927–), Salt Lake City: abstract, landscape; oil

Sohm, Sheri Lyn (1950–), Salt Lake City: still life

Songer, Steve F. (1947–), Ogden: landscape; watercolor

South, Will R. (1958–), Bountiful: landscape, figurative; oil

Southey, Trevor J. T. (1940–), Rhodesia/Alpine: symbolist; figurative; oil, drawing, etching, sculpture

Speed, U. S. Grant (1930–), Lindon: cowboy/western sculpture

Spencer, Kate Clark (1946–), Orem: figurative; oils, pencil

Spens, Nathaniel (1838–1916), Mt. Pleasant: landscape, genre; oil

Spiess, Anna R. (1909–1986), Bountiful: landscape; oil, watercolor

Squires, C. Clyde (1883–?), Salt Lake City: drawing, illustration

Squires, Harry (1850–1928), Salt Lake City: primitive, landscape; oil

Squires, Lawrence (1887–1928), Salt Lake City: portrait, landscape; oil, watercolor

Stansfield, Earl (1920–), Salt Lake City: landscape; oil

Stansfield, John Heber (1878–1953), Mount Pleasant: landscape; oil

Staplin, Jane C. (1953–), Salt Lake City: still life, figurative

Stats, Kathryn (1944–), Salt Lake City: landscape; oil

Stay, Laura Lee (1958–), Provo: sculpture

Steadman, Kent (1942–), Salt Lake City: landscape; oil

Stephen, Virginia Snow (?–), Salt Lake City: watercolor, art education

Stetzko-Taff, Julie (1952–), Salt Lake City: fiber art, oil, printmaking

Stevens, June Lloyd (1919–), Salt Lake City: landscape; oil

Stevenson, David Mac (1942–), Ogden: art education

Stewart, LeConte (1891–1990), Kaysville: landscape; oil, drawing, printmaking

Stewart, Maynard Dixon (1923–), California/Utah: portrait; oil

Stillman, Marilyn (1936–), Salt Lake City: abstract still life

Stilson, R. Todd (1961–), Provo: metaphysical/metaphorical

Stokes, Marjorie M. (1924–), Mapleton: landscape; oil

Stone, Helen S. (1907–1987), Ogden: watercolor

Stoops, Herbert Morton (1888–1948), Idaho/Logan: cowboy/western, illustration; oil, drawing

Streadbeck, Steve (1946–), Lehi: western; bronze sculpture

Streble, Steven J. (1947–), Salt Lake City: landscape; pastel

Strong, Doyle M. (1917–1985), Ogden: modernist, still life, landscape; oil

Stubbs, Charles B. (1930–), Salt Lake City: art education

Stubbs, Marjean (1934–), Bountiful: landscape; oil

Sucec, Bonnie P. (1942–), Salt Lake City: metaphysical/metaphorical

Sucec, David A. (1937–), Salt Lake City: avant-garde

Sullivan, K. Sean (1957–), Taylorsville: academic, figurative

Sullivan, Nola de Jong (1924–), Provo: watercolor

Sutulov, Alexander (1962–), Salt Lake City: figurative; drawing

Swinyard, Fae E. (1943–), Provo: ceramics

Taggart, George Henry (1865–1924), itinerant: portrait, genre; oil

Taggert, Edward L. (1945–), Logan: abstract; landscape

Takasaki, Fred Yasuo (1924–), Provo: painting

Talbert, Mark A. (1955–), Cedar City: ceramics

Taylor, Clint (1955–), Mapleton: wildlife; oil

Taylor, James Harvey (1946–), Orem: landscape; watercolor

Taylor, Rachel Grant (1878–1969), Salt Lake City: landscape, floral; watercolor

Teare, Bradley L. (1956–), Salt Lake City: woodcut

Teasdel, Mary H. (1863–1937), Salt Lake City: figurative, landscape; oil, watercolor

Teichert, Minerva K. (1888–1976), Utah/Wyoming: history, religious; oil, drawing, watercolor

Telford, John W. (1944–), Sandy: photography

Terry, Christopher T. (1956–), Logan: classical realist; oil

Terry, Kaye T. (1944–), Salt Lake City: abstract

Thayne, Brian J. (1956–), Orem: landscape; watercolor

Teutsch, Gertrude (1874–1964), Salt Lake City: watercolor, oil

Thiebaud, M. Wayne (1920–), Hurricane/Cedar City: modernist; oil

Thomas, Karl (1948–), Orem: landscape; oil

Thorpe, Everett Clark (1904–1983), Logan: landscape, figurative; oil, watercolor

Thurman, Matilda E. (1904–1972), Salt Lake City: landscape; watercolor

Tikker, Nancy R. (1929–), Salt Lake City: watercolor, landscape;

Tippetts, Twain C. (1917–), Logan: photography; arts administration

Topham, Joyce M. (1936–), Salt Lake City: landscape; watercolor

Toth, Diana I. (1941–), Logan: ceramics

Treseder, Francis M. (1853–1923), Salt Lake City: primitive, pioneer genre; oil

Trueblood, L'Deane (1928–), St. George: children, portraits; sculpture, watercolor

Truelson, Florence M. (1901–1959), Salt Lake City: fantasy, figurative; oil, watercolor

Tullidge, John (1836–1899), Salt Lake City: ornamental, still life, landscape, seascape

Turner, Diane E. (1932–),Bountiful: landscape; oil

Turner, Glenn H. (1918–), Springville: landscape; oil, watercolor

Unseld, George P. (?–1962), Salt Lake City: landscape; oil

Untermann, G. Ernest (1864–1956), Vernal: primitive, dinosaur, landscape; oil

Ure, Maureen O'Hara (1949–), Salt Lake City: metaphysical/metaphorical

Van Evera, Caroline (act. 1920s–30s), Salt Lake City: landscape; oil

Van Frank, Edna Merrill (1899–1985), Salt Lake City: mural, figurative; oil

Van Suchtelen, Adrian C. (1941–), Logan: watercolor, printmaking

Van Wagoner, Richard J. (1932–), Ogden: urban landscape; oil, watercolor, drawing

Varner, N. Kraig (1949–), Provo: figurative sculpture

Venus, Joseph S. (1936–), Sandy: illustrative western; oil

Vernon, Sandra (1943–), Tooele: landscape, figurative; oil

Vigos, Harold "Jack" (1914–1983), Salt Lake City: figurative, landscape; oil

Vincent, Marcus A. (1956–), Provo: figurative, symbolist; oil

Wade, David C. (1952–), Salt Lake City: wildlife, landscape; oil

Wagner, Randi L. (1952–), Salt Lake City: abstract; oil

Wagstaff, Clay (1964–), American Fork: metaphorical, landscape; oil

Wallingford, Lucy K. (1956–), Moab: landscape

Wallis, Kent R. (1945–), Logan: impressionist, landscape; oil

Wangsgard, Erica (1953–), Salt Lake City: abstract, landscape

Wanlass, Stan (1941–), Lehi/Salt Lake City: automotive, figurative; sculpture

Ward, William C. (19th century), Salt Lake City: sculpture

Ware, Florence Ellen (1891–1971), Salt Lake City: landscape, figurative; oil, watercolor

Warnock, Mary R. (1906–), Bountiful: illustration, painting

Warren, E. Kimball (1952–), Pleasant Grove: western, landscape; oil

Wassmer, Theodore Milton (1910–), Salt Lake City: landscape, figurative; oil, glapasto, drawing, watercolor

Watkins, Dorothy (1911–), Orem: landscape; oil, watercolor

Weaver, Max D. (1917–), Provo: landscape; oil

Webster, Maryann Sorensen (1947–), Salt Lake City: metaphorical sculpture

Weggeland, Danquart Anthon (1827–1918), Salt Lake City: pioneer; genre, landscape; oil

West, Evelyn R. (1929–), Provo: expressionist, figurative; sculpture

West, Lorraine M. (1938–), Layton: abstract sculpture

Weyher, Gayle (1953–), Salt Lake City: abstract; fiber art, other media

Wheadon, Linda (1943–), Utah/Texas: formal; still life; drawings

Whitaker, William F. (1943–), Provo: academic realism; figurative

Whitesides, Kim (?–), Salt Lake City: graphic art

Wiberg, Maurice C. (1947–), Hyrum: landscape; oil

Wilcox, James F. (1941–), Utah/Wyoming: western, landscape; oil

Wilde, Stephanie (1952–), Utah/Idaho: allegorical; pen and ink

Williams, Clayton R. (1926–), Salt Lake City: landscape; oil

Williams, Karen I. (1945–), Kaysville: landscape; oil

Williams, N. Lyn Diehl (1936–), Brigham City: mixed media

Willis, Helen W. (1914–), Utah/Nevada: pastels

Wilson, Blanche P. (1922–), Ogden: landscape, urban scenes; woodcuts

Wilson, James H. (1942–), Sandy: figurative, landscape; oil

Wilson, H. W. (19th century), Salt Lake City: portrait; ink, pencil

Wilson, Kathy C. (1943–), Salt Lake City: landscape; watercolor

Wilson, Roger D. "Sam" (1943–), Salt Lake City: fantasy, symbolist; acrylic, mixed media

Wilson, Warren B. (1920–), Provo: ceramics

Winborg, Larry C. (1942–), Farmington: genre; oil

Wing, C. Kent (1954–), Spanish Fork: expressionism; figurative; oil

Winters, Nathan B. (1937–), Salt Lake City: illustration; pen/ink, watercolor; art education

Wixom, J. S. (1941–), Ogden: allegorical, figurative; oil

Wood, John W. (1945–), Salt Lake City: abstract impressionist

Woodbury, Michael G. (1962–), Provo: symbolist; landscape

Woolley, Sheila W. (1926–), Escalante: western, landscape; watercolor

Woolstenhulme, Kate (1950–), Salt Lake City: fiber art

Woolston, Faye White (1912–), American Fork: landscape; oil, watercolor

Woolston, Harold (1906–), American Fork: landscape; oil, watercolor

Workman, Michael (1959–), Pleasant Grove: rural realist; oil

Wright, Alma B. (1875–1952), Salt Lake City: landscape, portrait; oil, drawing

Yasami, Masoud (1949–), Salt Lake City/Arizona: modernist; oil

Yazzie, Kelvin E. (1954–), Cedar City: sculpture, crafts; mixed media

Young, Aretta (1864–1923), Provo: painting, art education

Young, Christopher W. (1963–), Provo: photo-realist, still life

Young, David B. (1932–), Provo/Wyoming: expressionist, landscape

Young, Erla Palmer (1917–), Midway: naturalist, landscape; acrylic

Young, James L. (1937–), Price: sculpture

Young, Mahonri M. (1877–1957), Salt Lake City: realist, figurative, landscape; sculpture, etching, painting

Young, Ned L. (1954–), Brigham City: western, rural genre; oil

Young, Phineas Howe (1847–1868), Salt Lake City: portrait, genre, copies; oil

Zimbeaux, Francis H. (1913–), Salt Lake City: allegorical, figurative; oil

Zimbeaux, Frank Ignatius S. (1860–1935), Salt Lake City: souvenir urban scenes; oil

Zollinger, Ron (1951–), Ogden: abstract, minimalist; sculpture

Zornes, J. Milford (1908–), Mt. Carmel: landscape; watercolor

Zupan, Dennis (1943–), Provo: ceramics

History of the Art Movement in Springville, Utah

by Yvonne Baker Johnson and Dianne Clyde Carr

Within the galleries of the Springville Museum of Art is an impressive collection of works by Utah, American, and European-born or -trained artists acquired a few at a time over the past ninety years. This art movement was instituted by the offerings of two gifted artists, one a Springville-born sculptor, Cyrus E. Dallin (1861-1944), who left his home town for the East in his nineteenth year to develop his talents. The second was a Swiss-born convert to the Mormon church, John Hafen (1854-1910), who came to Utah as a child to make his home in Springville. He had received training as one of the five Mormon "art missionaries" who were sent to Paris in 1890 to refine their skills in order to paint murals in the church's temples then under construction.

Even in the beginning days of the settlement of Springville in the 1850s, the arts of all kinds were nourished, a hallmark of the Mormon pioneer influence. Philo Dibble, an early Springville settler, as he was coming west, "called for the creation of a fine arts museum or gallery to be established for the benefit of the Mormon people." The foundation for the art movement, however, was not laid until 1901, when Springville organized a very active library and art committee.

Under the direction of L. E. Eggertsen, who was superintendent of Springville schools, twelve prints of old masters were acquired to teach art appreciation to the students. A library and art evening was held on February 1, 1902, where these prints were featured on the program and later distributed among the various classrooms, forming the basis for lessons in art awareness.

It was in about 1903 that three men—L. E. Eggertsen, John Hafen, and Dr. George Smart, a patron of the arts and physician in the community—traveled to the Brigham Young Academy to attend a lecture titled "The Value of the Fine Arts in Making a More Abundant Life." The three returned home determined to pass on the inspiration of that evening to the students of Springville. The next day these three men met again in Mr. Hafen's studio, where he took from the wall one of his finest canvases, *The Mountain Stream,* and presented it to Mr. Eggertsen for the Springville schools. He expressed the hope that this picture would be the nucleus around which an art collection would grow that would be a credit not only to the City of Springville, but to the entire state.

At about the same time, Cyrus E. Dallin, who was visiting his home town from the East, accepted an invitation to speak to the students. In the course of his talk, Mr. Dallin offered to give his plaster model of *Paul Revere* to the students to start an art collection. In due time, this statue would be created in heroic size to stand near Boston's Old North Church.

Hafen, George and Emma Smart, and J. B. Fairbanks talked to artist friends about the interest in art at Springville and suggested that they might also donate paintings to add to the beginning collection. Nine additional paintings and seven pencil sketches were donated by Utah artists. In April 1907, the annual Utah Art Institute was held in Springville. This same year, the school board pledged to contribute $50 to be used toward the purchase of works for the growing collection. Not to be outdone, the students and teachers volunteered to contribute an equal amount. This became known as the Springville High School Prize, which was used for obtaining the best painting in the Utah Art Institute show. The practice continued until 1915.

At this time, under the school consolidation law, Springville became part of Nebo School District. This precluded Springville schools receiving preferential funding for local art purchases. For a few years it was considered too big a responsibility for the students to raise the entire purchase prize, and interest in the art movement waned.

In 1919, when Ray L. Done became principal, he, along with teachers J. F. Wingate and Wayne Johnson, sought to revive interest in the arts. In 1920, students were invited by Mr. Done to join a faculty-student art committee. In 1921, Dr. George Smart spoke to the high school students and promised them if they would keep alive the art spirit by maintaining and adding to the collection, his private collection would be given to Springville High School at a future date. In 1925, Dr. George Smart gave his collection of sixty-four paintings to the students.

John Hafen died in 1910, but his son, Virgil O. Hafen, after returning from Paris where he had been studying in 1920, introduced the idea of a spring salon such as the ones which were held annually in Paris. In April 1921, the first spring exhibit was instituted. The works entered were from Utah artists. By 1922 the permanent collection consisted of forty paintings and three statues, all by Utah artists. By 1923, works of art from out of state began to be exhibited.

Many supporters of art in Springville dreamed of constructing a building to house the growing collection of the high school. Dr. George A. Anderson, who was then mayor of Springville, and Wallace Brockbank, principal of the high school and president of the Art Board, began efforts in about 1935 to secure funds for a museum through the Works Progress Administration (WPA). The museum in Springville was to become the only art museum in the nation built completely by the WPA program.

The total cost of the project was approximately $100,000, with $54,000 coming from WPA funds, $25,000 from residents, and the balance from donated equipment and materials, with participation by the LDS church. Nebo School District donated the site. One source lists approximately $29,000 in equipment and materials donated by Springville City.

The building was designed by Claude Ashworth in Spanish colonial revival style, and the preliminary work began November 23, 1935. In April 1937, the sixteenth annual national exhibit was held in the new gallery. The building was not totally complete at this time and the grounds were not landscaped, but the building was sufficiently completed to hang an exhibit.

David O. McKay, of the first presidency of the Church of Jesus Christ of Latter-day Saints, offered the dedicatory prayer, during which he characterized the building as "a sanctuary of beauty, a temple of contemplation." Wayne Johnson, art instructor at Springville High School, became the gallery's first director. It should be noted that the museum was called the Art Gallery until 1964.

In 1921, the high school initiated a program of selecting art queens, although a young girl named Aileen Dunn had been chosen on a one-time basis several years prior. The purpose of this program was not only to arouse interest among high school students, but also to help raise funds for the purchase of works of art.

Another custom begun in the early thirties under the direction of Mae Huntington was the writing of art themes. Students in the English classes were asked to select and write about a work of art from the April show. The themes were judged and prizes given for the most outstanding ones.

Civic groups and clubs became involved in the art movement and contributed scholarships and awards. The Federated

Women's Clubs sponsored an annual Art Tea in April, which became an important social event in the state. In 1935, the Hafen-Dallin Club was organized to promote the arts and perpetuate the names of the two artists who inspired the beginning of the art movement. In 1986, this club merged with the volunteer guild at the museum and became known as the Hafen-Dallin Guild. In 1981, an active docent program began under the curator of education, Sherrill D. Sandberg, with periodic training for all docents.

The April exhibit, going by various names, including National April Exhibit, April Salon, or just art exhibit, has been held every year since 1921, with the exception of the war years from 1942-1946. During this time, however, the first catalogue was prepared under the direction of Mae Huntington, long-time English teacher, and publicity director and secretary of the Art Board. She brought Springville's art project to the attention of some of America's artists by sending clippings and comments and essays.

In 1949, A. Merlin and Alice W. Steed of Glendale, California, made a gift of their extensive collection to the Art Gallery. This collection consisted of 133 American and European works of art. The Steeds were both natives of Utah, and after visiting in the area a number of times, they selected Springville as the spot for their collection because they felt it was the most likely spot in their home state for their art works to be appreciated and enjoyed.

In 1964, the Clyde Foundation donated $85,000 in the memory of Hyrum S. and Eleanora Jane Johnson Clyde to erect a new wing on the west side of the original building. This wing, built in the style of the original building, provided two large, well-lighted galleries, a basement preparator's room, a vault, additional storage and a freight elevator. The new wing increased the exhibition wall space to some 15,000 square feet, making it the largest in the state at that time. The dedicatory prayer was given by Governor George D. Clyde, and the presentation was made by W. W. Clyde, president of the Clyde Foundation.

The year 1967 signaled a time of crisis for the museum because Springville High School was moved to a new campus some distance from the museum. Until this time, the administration of the museum rested with the members of the high school faculty, with the high school principal serving as president of the Art Board and the art teacher serving as curator of the collection. Students helped to type letters to artists, uncrate paintings, hang them in the exhibit, prepare them for shipping after the exhibit was over; they had also acted as guides and hosts.

Over the years, some apathy had crept into the community. Many of the older paintings in the collection needed conservation, the building needed cleaning and renovating and the grounds were somewhat neglected.

Responding to these needs, in March of 1964 a mass meeting of the public was held at the high school to consider some proposed amendments to the Articles of Incorporation of the Art Association. Among those proposed was one to provide a perpetual period of duration for the corporation, a provision for memberships in several categories, and an increase in the number of trustees on the governing board of the corporation. These amendments followed some of the recommendations written in a masters thesis in 1963 by Rell Francis, a former museum curator. The changes paved the way for more community participation and involvement in the art movement in Springville. In April 1964, W. W. Clyde was elected president of the Art Board, the first citizen not connected with the high school to assume this position.

This broke ground for many new community action programs, one of which was the membership drive. In an effort to relate to the artists in the state, the museum, under the high school art teacher-director Stanley Burningham, established an All-State Utah Art Exhibition in January/February of 1965. This highly important exhibition continued until 1974, after which it was replaced by the quilt exhibition.

In 1967, the Board of Trustees hired the first full-time director, Bruce Braithwaite. He was replaced in 1969 by Peggy Forster, who, during her forceful tenure and along with Julie Berkheimer, completed an updated catalogue of the museum's permanent collection.

Also in 1967 the modern Art Ball was initiated. There were various social events at the museum previously, but at this time the ball was instituted as a way to generate added enthusiasm and attendance at the April Salon. Yvonne and LaRell Johnson were the first chairpersons of the ball, a gala event with music, dancing and a program.

In 1969 and 1970, the Federated Women's Clubs of Springville, under joint chairwomen Louise Clyde and Marie Johnson, undertook an ambitious community project entitled "Art Is In." During this time, among other projects, hostesses were recruited to serve at definite times so that the museum could be open more hours. During 1969, over 2,000 hours were donated. Other civic clubs, including the men's service clubs, also responded to this program. In the spring of 1975, the Chamber of Commerce published a set of note cards which illustrated ten favorite museum paintings.

On July 15, 1975, in an agreement between the Board of Education of Nebo School District and the City of Springville, it was decided that a continuation of an art program which could have desirable educational and cultural benefits both for students and the general public could best be served by a cooperative effort between the City of Springville and the Springville High School Art Association. The Nebo School District was relieved of obligation for operation and maintenance of the building. Furthermore, the legal title to the land upon which the art building is located was transferred from the Nebo School District to the City of Springville.

In the early years, the main focus of the museum, outside of the use by Springville High School, was the annual April exhibit. Gradually, with the hiring of a full-time director, it became possible to offer more shows, including solo and traveling exhibitions. In 1982, and in connection with the Utah National Parks Council of the Boy Scouts of America, the museum was the only one in the Rocky Mountain area to sponsor and exhibit thirty-seven scouting paintings by Norman Rockwell. This show alone brought almost 50,000 visitors.

In 1985, Director Vern Swanson initiated a second major annual show, the Autumn Exhibit. Geneva Steel Corporation became the exhibition's corporate sponsor in 1988. Whereas the spring exhibit was a general juried show, the annual Autumn Exhibit had a specific theme and was curated rather than juried. Such exhibitions as "Image of the Artist," "Utah Art Extra-ordinaire," and "Utah Grandeur" surveyed significant areas of Utah art from pioneer to contemporary times. Major catalogues were produced for these shows.

Another popular exhibit at the museum is the quilt show held during Art City Days in June. This show was initiated in 1973 by Director Peggy Forster. In recent years, this has been co-sponsored by the Utah Valley Quilt Guild, with prizes and a reception. Also during Art City Days a popular Children's Arts Festival is held.

During February/March the annual All State High Schools of Utah Show is held, featuring outstanding junior

and senior student artists in the state. Not only are a number of awards offered, but many universities and colleges participate and students are invited to bring their portfolios and compete for art scholarships.

In 1972, the Board of Directors made a decision to begin focusing on art indigenous to the western United States, and in 1982 a decision was made by the Board of Trustees to make the museum a center to document the history of Utah Art. An extensive historical library was developed and in 1983 was named the Mae Huntington Research Library.

During the bicentennial year of 1976, the Community Progress Committee, chaired by LaRell and Yvonne Johnson, spearheaded an effort to acquire a piano for the museum. Money was raised, under the direction of Karl and Rayma Allred, to acquire a beautiful grand piano and also a smaller upright piano, making possible concerts and programs.

The City of Springville and its volunteers have been generous in restoration and remodeling projects to maintain the museum as the centerpiece of Springville. As of 1991, the City of Springville contributes $15.28 per capita to the fine and performing arts. This is the greatest contribution to the arts of any city in the United States. It is hoped that by Utah's centennial year of 1996, a new wing will be built as the museum's collection and programs continue to grow.

Past directors and curators of the museum and the years they served include: B. F. Larsen, 1907-1908; Wayne Johnson, 1912-1939; Glenn Turner, 1940-1947; Richard Gunn, 1947-1948; Oliver Parson, 1948-1954; Stanley Burningham, 1954-1967; (Mae Huntington and Melva Harrison kept the museum open during the summer of 1967, but they were not directors); Bruce Braithwaite, 1967-1969; Peggy Forster 1969-1975; Rell Francis, 1975-1976; Ross Johnson, 1976-1977; Tim Rose, 1977-1980; and Vern G. Swanson, 1980-present.

Vern G. Swanson came to the museum with professional experience. During his tenure and because of a strong Board of Trustees, staff, and new bylaws, the number of employees increased fourfold, the art collection doubled, and the budget tripled during the eighties. Also in the 1980s the museum remodeled its facilities to increase exhibition and supporting spaces.

The enriching influence of the Springville Museum of Art will continue to be felt beyond the confines of the city of Springville as long as there are people who believe in its enduring value and who will lend their time and means to its continuing efforts.

SELECTED BIBLIOGRAPHY

The following bibliography is not exhaustive, as students of the field will recognize. We tried to give complete references for most of the sources we used in the preparation of the essays, including a number of unpublished materials which exist in the files of the Springville Museum of Art or in Robert Olpin's files at the College of Fine Arts, University of Utah. In additon, both Olpin and Swanson have conducted many interviews with artists and others, only some of which have been fully transcribed. We have chosen, for reasons of space, not to include in this listing full bibliographic information for each original period newspaper article; but we have cited in text the date, title of the article, and title of the publication whenever we were able to obtain them.

Abersold, Lila. *Avard T. Fairbanks: Eight Decades—A Retrospective Exhibition.* Salt Lake City: Retrospectives, Inc., 1987.

Arrington, Harriet Horne. "Alice Merrill Horne, Art Promoter and Early Utah Legislator," *Utah Historical Quarterly* 58 (Summer 1990) no. 3: 261–276.

"Art Is In" project for Utah Federated Women's Clubs. Document in possession of Dianne Clyde Carr, Springville, Utah.

Bradley, Martha Elizabeth, and Lowell M. Durham, Jr. "John Hafen and the Art Missionaries," *Journal of Mormon History* 12 (1985): 91–105.

Bradley, Martha S. "Mary Teasdel, Yet Another American in Paris," *Utah Historical Quarterly* 58 (Summer 1990) no. 3: 244–260.

Browning, Robert Pack. "Seeing: The Paintings of Earl Jones" in *Earl Jones 1985.* Salt Lake City: Salt Lake Art Center, 1985.

Burke, Dan E. *Utah Art of the Depression: An Exhibition Curated from the Utah State Fine Arts Collection.* Salt Lake City: Utah Arts Council, 1986.

Burnside, Wesley M. *Maynard Dixon: Artist of the West.* Provo, Utah: Brigham Young University Press, 1974.

Carmer, Carl. "A Panorama of Mormon Life," *Art in America* 58, no. 3 (May-June 1970): 52–65.

Carter, Kate B. "Early Arts and Crafts of the West" in *Heart Throbs of the West*, 2: 463–475. Salt Lake City: Daughters of the Utah Pioneers, 1940.

Christensen, Richard, art critic for the *Deseret News* from 1977 to present (various articles).

Conant, William Lee Roy, Jr. "A Study of the Life of John Hafen, Artist, with an Analysis and Critical Review of His Work." Master's thesis, Brigham Young University, 1969.

Croft, Grace Hildy. *With a Song in Her Heart.* Morgan, Utah: The Jepperson Family, 1960.

Daughters of Utah Pioneers. *Utah Art Exhibition.* Salt Lake City: Daughters of Utah Pioneers, 1966.

Davies, J. Kenneth. *George Beard: Pioneer Artist with a Camera.* Provo, Utah: privately printed, 1975.

Davis, Robert O., and Hugh Nibley (introduction and essay). *Wulf Barsch: Looking Toward Home.* Salt Lake City: The Church of Jesus Christ of Latter-day Saints, 1985.

Davis, Robert O. *LeConte Stewart: The Spirit of Landscape.* Salt Lake City: The Church of Jesus Christ of Latter-day Saints, 1985.

Dawdy, Doris Ostrander. *Artists of the American West: Biographical Dictionary.* 4 vols. Chicago: Sage Books (The Swallow Press), 1975.

Dickson, Mamie Platt. "The Work of LeConte Stewart, Painter, Lithographer, Etcher, and Designer." Master's thesis,

University of Utah, 1955.

Dibble, George S., art critic for the *Salt Lake Tribune* from 1953 to 1991 (various articles).

Dodworth, Alan. "Appraisal Report on Edna Ensign Merrill Van Frank." Salt Lake City: unpublished, 26 March 1986.

Dulle, Dorothy T. *Paintings by Donald Beauregard.* Santa Fe: Museum of New Mexico, 1964.

Eastwood, Laurie Teichert, and Robert O. Davis. *Rich in Story, Great in Faith: The Art of Minerva Kohlhepp Teichert.* Salt Lake City: The Church of Jesus Christ of Latter-day Saints, 1988.

Fairbanks, Eugene *The Life and Work of Avard T. Fairbanks, Sculptor.* Salt Lake City: privately printed, undated.

Florice, H. Giles. "Harvesting the Light—1890 Paris Art Mission." *Ensign,* October, 1988.

Forster, Peggy, ed. *Springville Museum of Art Permanent Collection Catalogue.* Springville: SMA, 1971.

Francis, Rell G. "A Critical Analysis of the Management of the Springville High School Museum of Art." Master's thesis, Brigham Young University, 1963.

———. "G. E. Anderson, Springfield & Spanish Fork Utah." *Popular Photography* 77, no. 2 (August 1975): 86–97.

———. *Cyrus E. Dallin: Let Justice Be Done.* Springville: Springville Museum of Art, in cooperation with the Utah American Revolution Bicentennial Commission, 1976.

———. "Cyrus E. Dallin and His Paul Revere Statue." *Utah Historical Quarterly* 44, no. 1 (Winter 1976): 4–39.

———. *The Utah Photographs of George Edward Anderson.* Lincoln: University of Nebraska Press, 1979.

Frazer, Mabel P. *Edwin Evans Art Exhibition: Representative of His Life's Work.* Salt Lake City: University of Utah Press, 1941.

Gerdts, William. "Utah." In *Art Across America,* 3:128–145. New York: Abbeville Press, 1990.

Gibbs, Linda Jones. *Masterworks from the Collection of The Church of Jesus Christ of Latter-day Saints.* Salt Lake City: The Church of Jesus Christ of Latter-day Saints, 1984.

———. *Harvesting the Light: The Paris Art Mission and Beginnings of Utah Impressionism.* Salt Lake City: The Church of Jesus Christ of Latter-day Saints, 1987.

Graham Gallery. *The Watercolors of John Held, Jr. (1889–1958).* New York City: Graham Gallery, 1981.

Hafen, John. "Art Student in Paris," *Contributor* (Salt Lake City) 15 (1893–94):487.

Hafen, LeRoy R. *The Hafen Families of Utah.* Provo, Utah: Hafen Family Association, 1962.

Hague, Donald Victor. "The Life and Work of Lynn Fausett." Master's thesis, University of Utah, 1975.

Hamilton, C. Mark, and C. Nina Cutrubus. *The Salt Lake Temple: A Monument to a People.* Salt Lake City: University Services, Inc., 1983.

Hanniball, Ann N., comp. and ed. *Directory of Utah Museums and Galleries,* 2d ed. Salt Lake City: Utah Arts Council, in conjunction with Utah Museum Association, 1982.

Harmon, Dean. *One 8: A Proposal for a Visual Arts Facility at Utah State University.* Logan, Utah: Utah State University, 1972.

Haseltine, James L. *LeConte Stewart.* Salt Lake City: Salt Lake Art Center, 1962.

———. *100 Years of Utah Painting.* Salt Lake City: Salt Lake Art Center, 1965.

———. "100 Years of Utah Painting: Some Further Thoughts." *Utah Architect* 40 (Winter 1965–66): 15–18.

———. "Don Olsen: The Man and His Work."

Don Olsen: Retrospective/1940–1983. Salt Lake City: Salt Lake Art Center, 1984.

———. *Francis Zimbeaux: Gentle Visionary.* Salt Lake City: Retrospectives, Inc., 1990.

Hearn, Jane K., Judith Giles, Marie Jones, and Ruth K. Stone. "Catalogue of Art in Salt Lake City." Salt Lake City: American Association of University Women, Salt Lake City Chapter, unpublished, 1969.

Hedgpeth, Don. *From Broncs to Bronzes: The Life and Work of Grant Speed.* Flagstaff, Ariz.: Northland Press, 1979.

Hinton, Wayne K. "A Biographical History of Mahonri M. Young, a Western American Artist." Ph.D. dissertation, Brigham Young University, 1974.

Horne, Alice Merrill. *Devotees and Their Shrines: A Hand Book of Utah Art.* Salt Lake City: Deseret News Press, 1914.

———. "Art Strands" (brochure for the Tiffin Gallery). 1930s–40s. copies found at the Springville Museum of Art, and Marriott Library U of U campus.

———. "The Painter Lee Greene Richards: Retrospective Exhibition." Salt Lake City: Utah State Art Center, unpublished, 1941.

Huntington, Mae B. "An Investment in Culture." *The Improvement Era* 35 (April 1932): 336–339.

———, ed. *Permanent Gallery Catalogue: Springville Art Gallery.* Springville: Art City Publishing, 1947.

———. "Life Sketch of Mae B. Huntington." In possession of Mary Huntington Fillmore, Tooele, Utah.

———. "Springville High School Art Gallery: Its History and Contribution to the English Department." Master's thesis, Brigham Young University, 1950.

James, George Wharton. *Utah, Land of Blossoming Valleys.* Boston: Page Company, 1922.

Jensen, Richard L., and Richard G. Oman. *C. C. A. Christensen 1831–1912: Mormon Immigrant Artist.* Salt Lake City: The Church of Jesus Christ of Latter-day Saints, 1984.

Jesus, Ricardo T. "A Study of the Cultural Impact and the Extent of Social Uses: Springville Museum of Art." Master's thesis, Brigham Young University, 1977.

Jones, Carl Hugh. "The Archaeological Paintings of George M. Ottinger." *Papers of the Fourteenth Annual Symposium on the Archaeology of the Scriptures* (April 1963): 5–11.

Jones, Cary Stevens. *A Woman's View: The Photography of Elfie Huntington (1868–1949).* Salt Lake City: Utah Arts Council, 1988.

Kaysville Art Club. *Pioneers of Utah Art.* Logan, Utah: Educational Printing Service, 1968.

Kirk, Kathryn Fairbanks, ed. *The Fairbanks Family in the West: Four Generations.* Salt Lake City: Paragon Press, 1983.

Larsen, Bent F. "Random Thoughts on Utah Art." *Scratch* 3 (December 1930): 9–10, 28.

———. "Recent Trends in Art." *Utah Academy of Sciences, Arts, and Letters* 12 (November 1935): 89–91.

———. "A Brief from an Illustrated Paper on the Life of John Hafen." *Utah Academy of Sciences, Arts, and Letters* 12 (November 1935): 93–94.

———. "The Meaning of Religion in the Life of John Hafen." *The Improvement Era* 39 (January 1936): 155–160.

———, and Ethel Strauser. "Donald Beauregard." *Utah Academy of Sciences, Arts, and Letters* 15 (November 1937): 7–8.

———. "Preliminary Study of the Life of John Willard Clawson." *Utah Academy of Sciences, Arts, and Letters* 17 (December 1939): 57–58.

Larson, Lila Duncan. " H. L. A. Culmer, Utah Artist and Man of the West 1854–1914." Master's thesis, University of Utah, 1987.

Leek, Thomas A. "A Circumspection of Ten Formulators of Early Utah Art History." Master's thesis, Brigham Young University, 1961.

Lindstrom, Gaell. "Thomas Moran in Utah." Sixty-Eighth Faculty Honor Lecture, Utah State University. Logan, Utah: undated.

Long, E. Waldo. "Dallin, Sculptor of Indians." *The World's Work* 54 (September 1927): 563–568.

Martin, Gail, author of "At the Galleries" art columns in the *Deseret News,* 1930s (various articles).

Mendelowitz, Daniel Marcus. *A History of American Art.* New York: Holt, Rinehart, and Winston, 2d ed., 1970.

Myer, Peter, and Marie Myer. "New Directions in Mormon Art." *Sunstone* 2, no. 1 (Spring 1977): 32–64.

O'Connor, Francis. *Art for the Millions, Essays from the 1930s.* Greenwich, Conn.: New York Graphic Society.

O'Brien, Terry John. "A Study of the Effect of Color in the Utah Temple Murals." Master's thesis, Brigham Young University, 1968.

Olpin, Robert S. "Contemporary Utah Arts Exhibition." *Utah Holiday,* 30 September, 1974:

———. "Painting an Environment." *Southwest Art* (September 1975) 73–75.

———. *Celebration of the University of Utah Founding: American Painting Around 1950.* Salt Lake City: Utah Museum of Fine Art and Utah Bicentennial Committee, 1976.

———. *Dictionary of Utah Art.* Salt Lake City: Salt Lake Art Center, 1980.

———. *A Retrospective of Utah Art: Selections from the State's Fine Art Collection.* Salt Lake City: Utah Museum of Fine Art, 1981.

———, ed. *Portrait of a Portraitist.* Salt Lake City: College of Fine Art, University of Utah and University of Utah Press, 1981.

———, "The Visual Arts", *Utah: A Guide to the State,* 2d ed.(edited by Ward J. Roylance) Salt Lake City: 1982: 209–229.

———. *Waldo Midgley: Birds, Animals, People, Things.* Salt Lake City: Utah Museum of Fine Arts and University of Utah Press, 1983.

———. Introduction and notes for *A Basket of Chips: An Autobiography by James Taylor Harwood.* Salt Lake City: Tanner Trust Fund, University of Utah Library, 1985.

———. *Salt Lake County Fine Art Collection.* Salt Lake City: Salt Lake County, 1987.

———. "Signs and Symbols in Early (and Sometimes Much Later) Utah Art: A Slide Collage." Fiftieth Annual Frederick William Reynolds Lecture, University of Utah. Salt Lake City: 20 October 1988.

———. *Joseph A. F. Everett 1883–1945: A Retrospective Exhibition.* Salt Lake City: Retrospectives Inc., 1988.

———. *George Dibble: Painter-Teacher-Critic.* Salt Lake City: Utah Museum of Fine Art and University of Utah Press, 1989.

Oman, Richard. "Louise Richards Farnsworth (1878–1969)." Salt Lake City: unpublished, undated.

———. "An Oral History of Jack Sears," (from interviews with Jack Sears and George Dibble). Salt Lake City: unpublished, 4 December 1977.

Pioneer Craft House. *A Tribute to Edna Merrill Van Frank.* Salt Lake City: Pioneer Craft House, 1985.

Pyper, George D. "President Grant: Patron of Drama, Literature, Art and Music." *The Improvement Era* 39 (November 1936): 671–679.

Quinlan, O.D. "The Works of a Western Master," *Utah* 13 (winter 1954).

Reynolds, Alice Louise. "Art in Utah in Pioneer Days." In *Women of the West,* edited by Max Binheim, 170–171. Los Angeles: Publishers Press, 1928.

Richards, Heber C. "George M. Ottinger, Pioneer Artist of Utah." *Western Humanities Review* 3, no. 3 (July 1949): 209–218.

"Roster of Utah Artists." *Utah Educational Review* 18, no. 9 (May 1925): 387.

Samuels, Peggy and Harold. *Samuels' Encyclopedia of Artists of the American West.* Santa Fe, N.M.: Castle, 1985.

Sanguinetti, E. Frank, and Judith McConkie. *Wulf Barsch: In the Desert—A Stranger in a Strange Land.* Provo, Utah: College of Fine Arts and Communications, Brigham Young University Press, 1984.

Schwarz, Ted. *Arnold Friberg: The Passion of a Modern Master.* Flagstaff, Ariz.: Northland Press, 1985.

Seifrit, William C. "Letters from Paris." *Utah Historical Quarterly* 54, no.2 (Spring 1986): 179–202.

Smedley, Delbert Waddoups. "An Investigation of Influences on Representative Examples of Mormon Art." Master's thesis, University of Southern California at Los Angeles, 1939.

Smith, Mary Bennett, "Utah Artists." Salt Lake City: Utah State Historical Society, unpublished, undated.

South, William R. *The Life and Art of James Taylor Harwood, 1860–1940.* Master's thesis, University of Utah, 1986.

———. *James Taylor Harwood 1860–1940: A Retrospective Exhibition.* Salt Lake City: Utah Museum of Fine Arts, 1988.

———. *Paul H. Davis: Recent Work.* Salt Lake City: Salt Lake Art Center, 1989.

———. "The Federal Art Project in Utah: Out of Oblivion or more of the same?" *Utah Historical Quarterly.* 58 (Summer 1990) no. 3: 277–295.

Stewart, Zipporah L. *Door to Noisemakers Inn: Stewart.* Kaysville: privately printed, 1976.

Swanson, Vern G. *The Fantasy Art of James C. Christensen.* Provo: Springville Museum of Art and Lido Gallery, 1981.

———. "Philip Henry Barkdull: Forgotten Artist," *SMA Newsletter.* Springville: SMA, 1983.

———. *Sculptors of Utah.* Springville: SMA, 1983.

———. *Form, Color, and Symbol: The Art of Gary Ernest Smith.* Salt Lake City: SMA, 1983.

———. *Collectors of Early Utah Art.* Springville: SMA, 1983.

———. *Women Artists of Utah.* Springville: SMA, 1984.

———. *Contemporary Utah Genre: Vision of the Here and Now Among Utah Artists.* Springville: SMA, 1985.

———. *Image of the Artist: Self-Portraits and Portraits of Utah Artists.* Springville: SMA, 1986.

———. *Utah Art Extra-Ordinaire.* Springville: SMA, 1988.

———. *Utah Grandeur: Grand-Style Landscape Painting.* Springville: SMA, 1989.

———. *Theodore Milton Wassmer: Looking Back: A Three Score Career.* Springville: SMA, 1990.

Tullidge, Edward W. "Art and Artists in Utah." *Tullidge's Quarterly Magazine* 1 (January 1881): 213–220.

———. *History of Salt Lake City and its founders, incorporating a brief history of the pioneers of Utah.* Salt Lake City: Star Printing, 1886.

Thomason, Maxine and James K. Shoppe. "Maxine Kohlhepp Teichert: Woman of Art, Woman of Testimony."

Salt Lake City: (Essay submitted to the LDS Church Public Communications Department), unpublished, 26 March 1974.

Utah Arts Resources Directory: 1984 Edition. Salt Lake City: Utah Arts Council, 1984.

Van Stipriaan, Dorothy. "Biographical Dictionary of Utah Artists." Master's thesis, Case Western Reserve University, 1959.

Weaver, Max D. "The Development and Transition of the Art of Calvin Fletcher from Naturalism to Abstraction during the Period 1895–1953." Master's thesis, Utah State Agricultural College, 1955.

Wheelwright, Lorin F., and Lael J. Woodbury. *Mormon Arts.* Vol. 1 (no subsequent volumes). Provo, Utah: Brigham Young University Press, 1972.

Winters, Nathan. "Pioneer Art and Artists." In *An Enduring Legacy,* 7: 233–272. Salt Lake City: Daughters of the Utah Pioneers, 1984.

Writer's Program of the Works Projects Administration. *Utah: A Guide to the State*: 153–187. New York City: Hastings House, 1941.

Young, Mahonri Sharp. "Mormon Art and Architecture," *Art in America* 58 (May-June 1970): 66–69.

PERMANENT UTAH ART COLLECTION, SPRINGVILLE MUSEUM OF ART

GREGORY L. ABBOTT (1945-) Salt Lake City/St. George

Cows of Art History: At the End of Innocence 1986 mixed media, 23" x 39 1/4" (58.8 x 99.4 cm) Museum purchase from Spring Salon 1987.010

CORINNE DAMON ADAMS (1870-1951) Corinne/Ogden

Hollyhocks 1928 oil on canvas, 40" x 27 1/2" (101.8 x 70.0 cm) "Gift from the artist, Corrine D. Adams"1939.001

MARLIN ADAMS (1948-) Provo/Texas

Portrait of a Bowl 1977 oil on canvas, 30" x 24" (76.4 x 60.8 cm) Museum Purchase from Spring Salon 1977.001

WILLIS A. ADAMS (1854 -1932) Park City

Evening 1903 oil on canvas, 22" x 36" (56.0 x 91.4 cm) "Gift from Frederick C. and Sherry Ross, New Jersey" 1991.003

DONALD FERRIS ALLAN (1927 -) Mapleton/New York

Watermelon 1981 acrylic on board, 12" x 16" (30.5 x 40.5 cm) "Gift from the Artist, Donald Allan, Mapleton" 1981.039

OSRAL B. ALLRED (1936 -) Spring City/Ephraim

Front Hook-up 1984 watercolor, 21" x 29" (53.3 x 74.0 cm) Museum Purchase from Spring Salon 1984.016

BERTRAN YOUTH ANDELIN (1894 -1985) Ogden

High Sierras c. 1962 oil on board, 27 3/4" x 34" (70.9 x 86.5 cm) "Gift from the Artist, B. Y. Andelin" 1982.010

CARLOS J. ANDERSON (1904 -1978) Salt Lake City

Snake River, near Bliss c. 1941 oil on board, 28 3/4" x 41" (73.0 x 104.2 cm) "Gift from the Grace Muir Collection Trust" 1989.070

(JAMES) ROMAN ANDRUS (1907 -) Provo

Cadmium Crest 1964 oil on canvas, 30" x 38" (76.2 x 96.4 cm) "Gift from the Artist, J. Roman Andrus, Provo" 1981.043

Portrait of Thelma de Jong 1964 pencil, 12 1/4" x 9 1/2" (31.1 x 24.1 cm) "Gift from Thelma de Jong, Provo" 1984.014

Sunrise Peak 1972 lithograph, 12 1/4" x 19 1/2" (31.4 x 49.5 cm) "Gift from the Artist, J. Roman Andrus, Provo" 1972.001

ALICE MORREY BAILEY (1903 -) Salt Lake City

Sappho 1943 marble, 23 3/4" x 27" x 16 1/4" (60.5 x 68.6 x 41.3 cm) "Gift from Joseph Eli Rawlinson, Burbank" 1986.025

(JOHN) MARK BANGERTER (1951 -) Salt Lake City

Bulk Cars, West Cedar City, Lund Highway 1988 watercolor, 13 3/4" x 19" (35.0 x 48.2 cm) "Gift from the Artist, Mark Bangerter" 1989.019

PHILIP HENRY BARKDULL (1888 -1968) Fillmore/Logan

Near Paradise, Utah 1929 oil on canvas, 22" x 18" (55.9 x 45.8 cm) "Gift from Francis M. West, Provo" 1988.078

Red House in Cache Valley 1929 oil on canvas, 18 1/4" x 22" (46.0 x 56.0 cm) "Gift from Francis M. West, Provo" 1988.079

Seagulls on Utah Lake, The Gulls 1930 oil on canvas, 30" x 24" (76.5 x 61.0 cm) "Gift from Evelyn Barkdull Stoddard, Logan" 1982.021

Designed Landscape: Symphony in Color 1930 oil on canvas, 30" x 24" (76.2 x 61.0 cm) "Anonymous gift from Mapleton" 1989.018

The Great White Throne 1920s woodcut/blockprint, 12" x 9" (30.5 x 22.8 cm) "Gift from Vern G. and Judy N. Swanson, Springville" 1981.036

ELSIE ELIZA TURLEY BARRETT (1866 -) Provo

Still Life with Letter 1908 watercolor, 8 1/4" x 17 3/4" (21.4 x 45.0 cm) "Gift from Vern G. and Judy N. Swanson, Springville" 1987.039

WULF ERICH BARSCH (1943 -) Provo/Boulder

Book of Abraham 1984 seventeen pages, seven prints by Barsch lithograph, 15" x 9 1/4" (38.1 x 23.4 cm) "Gift from Steve and Kathyrn Allen, Springville" 1985.035

Amduat 1982 lithograph, 19" x 24 3/4" (48.0 x 63.1 cm) Museum Purchase 1983.004

Toward Thebes 1985 oil on canvas, 72" x 48" (183.0 x 122.4 cm) "Memory of Ruth H. Nemelka from David and Ingrid Nemelka" 1986.088

STEPHEN MARK BARTHOLOMEW (1958 -) Orem

Altarpiece to Maynard 1989 oil on canvas, 24" x 54" (61.0 x 56.5 cm) "Gift from Grace Muir collection trust" 1990.008

NADINE B. BARTON (1921 -) Orem

Desert Summer 1984 silkscreen/serigraph, 26 1/2" x 22 1/4" (67.0 x 56.5 cm) "Gift from the Artist, Nadine B. Barton" 1990.003

EARL WESLEY BASCOM (1906 -) Provo/Victorville

Homestead 1972 lithograph, 8" x 12" (20.2 x 30.0 cm) "Gift from the Artist, Earl W. Bascom" 1983.002

DAN BISCHOFF BAXTER (1948 -1986) Salt Lake City

East from Jordan River 1978 acrylic on board, 6 3/4" x 14 1/2" (17.1 x 37.0 cm) "Gift from the Artist, Dan Baxter" 1981.017

Garden Still-Life 1976 oil on board, 16" x 22" (40.7 x 55.5 cm) "Gift from Doug Muir, In memory of Grace Muir" 1989.044

Kennecott at 3 Degrees 1982 oil on canvas, 18" x 24" (45.8 x 61.0 cm) "Gift from F. Ed and Judy Bennett, Salt Lake City" 1982.031

My Side of Town 1980 oil on canvas, 15" x 30" (38.4 x 76.0 cm) "Gift from Doug Muir, In memory of Grace Muir" 1989.041

Self Portrait in Studio 1980 oil on canvas, 40" x 30" (101.5 x 76.2 cm) "Gift from Doug Muir, In Memory of Grace Muir" 1989.034

KEN BISCHOFF BAXTER (1944 -) Salt Lake City

Mecham's Boots 1973 oil on board, 30" x 30" (76.0 x 76.2 cm) Museum Purchase from Spring Salon 1974.001

Self-Portrait 1986 oil on board, 10" x 15" (25.5 x 38.0 cm) "Gift from the Artist, Ken B. Baxter" 1988.009

Truck Farm 1970s oil on board, 10 3/4" x 13 3/4" (27.4 x 35.2 cm) "Gift from Doug Muir, In memory of Grace Muir" 1989.045

DONALD BEAUREGARD (1884 -1914) Filmore

Artist's Father Clearing Sagebrush c. 1907 oil on canvas, 15" x 22" (38.1 x 55.9 cm) "Gift from A. Merlin and Alice Steed trust" 1984.005

Still-Life with Lemon c. 1900 oil on canvas, 13" x 18" (33.0 x 46.0 cm) "Gift from F. Ed and Judy Bennett, Salt Lake City" 1980.005

Working from Dawn till Dusk, near Filmore c. 1908 oil on canvas, 22" x 28" (56.0 x 71.1 cm) "Gift from David Dee, Salt Lake City" 1988.054

STEPHEN REID BECK (1937 -) Salt Lake City

Unequal Farce 1978 intaglio/etching, 26 1/2" x 22" (67.1 x 55.8 cm) Museum Purchase from Spring Salon 1978.001

LEE UDALL BENNION (1956 -) Spring City

Full Bloom: Nicole and Daniel Ben Yehuda 1989 oil on canvas, 40" x 30" (102.0 x 76.1 cm) "Gift from Ray and Sue Johnson, Scottsdale Az"

Self in Studio 1985 oil on canvas, 26" x 22" (65.8 x 55.5 cm) Museum Purchase 1987.033

ALEXANDER WILLIAM BIGNEY (1952 -) Payson

God Descended into the Garden 1983 lithograph, 30" x 22" (76.5 x 56.1 cm) Museum Purchase 1983.005

ZELDA BILLS (1936 -) Salt Lake City

Rock Surfaces 1970s oil on canvas, 30" x 28" (75.7 x 70.9 cm) "Gift from Doug Muir, In memory of Grace Muir" 1989.050

ELZY J. "BILL" BIRD (1911 -) Midvale

City Creek 1934 pastel, 9 3/4" x 7 3/4" (24.7 x 19.7 cm) "Gift from Will and Allison South, Bountiful" 1983.037

Mill Creek-Autumn Morning #1 1934 oil on mounted canvas, 30" x 24" (76.2 x 60.8 cm) "Gift from Sheldon and Beverly Hyde, SLC" 1984.024

Old Barn 1936 watercolor, 11" x 8 1/2" (28.1 x 20.7 cm) "Gift from Lund-Wassmer Collection" 1986.105

Pony Express 1933 intaglio/etching, 8 3/4" x 6" (22.2 x 14.8 cm) "Gift from Vern G. and Judy N. Swanson, Springville" 1985.020

ALLEN CRAIG BISHOP (1953 -) Salt Lake City

La Semilla Brota 1990 shaped pieces oil on canvas and board, 56" x 88 1/2" (142.4 x 224.7 cm) "Gift from the Geneva Steel, Orem" 1990.064

Zonic Talon 1990 oil on canvas and board, 73 1/4" x 189 3/4" (186.0 x 481.8 cm) "Gift from the Geneva Steel, Orem" 1990.068

ANNA CAMPBELL BLISS (1925 -) Salt Lake City

Spider-walk 1983 silkscreen/serigraph, 30 1/2" x 22 1/2" (77.5 x 57.0 cm) Museum Purchase 1983.006

JOHN GUTZON BORGLUM (1867 -1941) Bear River

Conception c. 1904 white marble, 18" x 9 3/4" x 12" (45.9 x 24.8 x 30.5 cm) "Gift from Dr. Kirke Van Nielsen, Kalispell Montana" 1986.089

CONNIE McCORMICK BORUP (1945 -) Salt Lake City

Burr Trail 1989 pastel, 18" x 26 1/4" (45.8 x 66.5 cm) "Gift from the Artist, Connie Borup" 1989.073

COLLEEN HANSEN BRADFORD (1934 -) Brigham City

One Red Bean 1988 mixed media, 16 1/4" x 21 1/4" (41.1 x 54.2 cm) "Gift from the Artist, Colleen Bradford" 1989.024

FLOYD ELMER BREINHOLT (1915 -) Provo

Tree in Landscape 1950s oil on board, 12" x 16" (30.3 x 40.0 cm) "Gift from David and Karen Ericson, Salt Lake City" 1990.055

URSULA BRODAUF-CRAIG (1926 -) Salt Lake City

Duality 1989 bronze, 20 1/2" x 16" x 9" (52.1 x 39.9 x 22.7 cm) Museum Purchase from the Spring Salon 1990.016

CLARK VERN BRONSON (1939 -) Kamas/Bozeman

Big Boys 1984 bronze, 22" x 28 1/2" x 14" (44.5 x 73.2 x 35.6 cm) "Gift from Geneva Steel, Orem" 1990.065

JONATHAN BRONSON (1952 -) Pleasant Grove

Autumn Flight 1983 bronze, 10" x 10" x 7" (25.5 x 25.5 x 17.7 cm) "Gift from Herbert Solo, Malibu California" 1991.009

MAURICE EDMUND BROOKS (1908 -1970) Salt Lake City

Bust of Henry N. Rasmussen 1934 plaster, 15" x 7" x 8" (38.7 x 18.0 x 20.0 cm) "Gift from Maureen Brooks Humiston, Cedar City" 1986.007

Madonna 1950s plaster, 26" x 9" x 7" (65.8 x 23.0 x 17.7 cm) "Gift from Faye Brooks Pewtress, Salt Lake City" 1988.057

Young Girl 1934 bronze, 9 3/4" x 7 3/4" x 5" (24.1 x 19.7 x 12.7 cm) "Gift from Lund-Wassmer Collection" 1986.111

GEORGE WESLEY BROWNING (1868 -1951) Salt Lake City

Farm House 1911 pastel, 12 1/2" x 19 1/2" (31.8 x 39.5 cm) "Gift from Dr. George L. and Emma Smart collection" 1925.002

Early Morning, Big Cottonwood Canyon 1923 watercolor, 17 1/2" x 13 1/2" (44.6 x 34.5 cm) "Gift from Dr. George L. and Emma Smart collection" 1925.003

Sunset in the Wilderness 1905 pastel, 18 3/4" x 12 3/4" (47.8 x 32.5 cm) "Gift from Dr. George L. and Emma Smart collection" 1925.004

The Storm White House by the Jordan River 1911 oil on canvas, 23 1/2" x 17 1/2" (59.7 x 44.3 cm) Museum Purchase 1922.001

Utah Landscape 1921 oil on canvas, 21 1/2" x 15 1/2" (54.5 x 39.0 cm) "Gift from A. Merlin and Alice Steed Trust" 1989.074

Wasatch Mountains in Early Spring c. 1921 pastel, 15 3/4" x 23 3/4" (40.0 x 60.0 cm) "Gift from the artist, G. Wesley Browning, SLC" 1921.001

A. DEWEY BULKLEY (1926 -) Orem

Alternatives 1981 mixed media, 22 1/2" x 22 1/2" (57.0 x 57.0 cm) "Gift from the Artist, Dewey Bulkley, Provo" 1981.048

WESLEY MILBURN BURNSIDE (1918 -) Provo

Farmer 1954 watercolor, 22" x 30" (56.0 x 76.1 cm) "Gift from David and Karen Ericson, Salt Lake City" 1990.056

Round Hills 1980 oil on canvas, 15" x 30" (38.1 x 76.2 cm) "Gift from the Artist, Wesley M. Burnside" 1981.001

HAROLD LONGMORE BURROWS (1889 -) Salt Lake City/New York

Fishing Village Montauk Point—Long Island c. 1921 watercolor, 11 1/4" x 16" (28.2 x 40.5 cm) "Gift from Robert N. and Peggy Sears, Salt Lake City" 1988.070

JOHN BLAIR BUSWELL (1956 -) Provo

Danny Ainge 1981 bronze, 20 1/4" x 13 1/2" x 16" (51.2 x 34.0 x 40.0 cm) Museum Purchase from Spring Salon 1982.012

KENT BUTLER (1944 -) Utah

Homestead, Spring City 1982 pencil, 29 1/2" x 39 1/2" (74.8 x 100.1 cm) "Gift in Honor of Hyrum Alexander Butler and his wife" 1982.016

ORSON DEWSNUP CAMPBELL (1876 -1933) Provo

Aspen Grove, North Fork Provo Canyon 1931 oil on board, 12" x 16" (30.5 x 40.6 cm) "Gift from Mrs. H. K. (Margaret) Richards, Santa Barbara" 1989.060

Mt. Timpanogos 1923 oil on board, 16" x 23 3/4" (40.5 x 60.4 cm) "Gift from Springville High School" 1923.001

MICHAEL RITTER CANNON (1913 -) Salt Lake City

Pink Roses c. 1955 acrylic on board, circular 30" (circular 76.0 cm) "Gift from F. Ed and Judy Bennett, Salt Lake City" 1981.002

ANGELO CARAVAGLIA (1925 -) Salt Lake City

Mountain Man 1982 bronze, 71 1/2" x 72" x 28" (181.6 x 182.9 x 71.1 cm) "Gift from American Savings of Utah" 1986.013

ROBERT G. CARAWAN (1952 -) Spring City

Jewels of Zion 1988 silkscreen/serigraph, 9 1/4" x 22 3/4" (23.5 x 57.7 cm) "Gift from the Artist: Robert Carawan" 1990.048

ROYDEN CARD (1952 -) Orem

Jenni's Bookshelf 1984 woodcut/blockprint, 11" x 8 3/4" (27.8 x 22.0 cm) Museum Purchase 1986.004

LOU JENE M. CARTER (1933 -) Springville

Navajo Girl 1982 pastel, 31 1/2" x 39 1/2" (79.7 x 100.3 cm) "Gift from the Artist, Lou Jene Carter, Springville" 1982.027

INEZ CHADER (1904 -) Springville

'Beef-Stake' Harrison Hotel in Springville 1938 oil on canvas, 22" x 30" (55.9 x 76.3 cm) "Gift from the Artist, Inez Chader, Springville" 1989.035

MONTAGUE CHARMAN (1894 -) New York/Utah

Going Home c. 1946 watercolor, 22" x 30 1/2" (56.1 x 77.0 cm) "Gift from Springville High School, Junior Class" 1946.001

CARL CHRISTIAN ANTON CHRISTENSEN (1831 - 1912) Ephraim

Handcart Pioneers' First View of the Salt Lake Valley 1890 oil on canvas, 16" x 12" (40.8 x 30.6 cm) "Gift from Neil and Jane Schaerrer, Salt Lake City" 1982.028

Winter Quarters 1891 oil on canvas, 14" x 22" (35.5 x 56.3 cm) "Gift from A. Merlin and Alice Steed trust" 1983.020

JAMES CALVIN CHRISTENSEN (1942 -) Orem

Fantasies of the Sea 1985 acrylic on board, 36" x 24" (91.0 x 60.7 cm) "Gift from Blaine P. and Louise Clyde, Springville" 1985.008

The Bread and the Stone 1975 -76 oil on board, 20" x 16" (50.6 x 40.5 cm) "Gift from David and Ingrid Nemelka, Mapleton" 1988.083

The Gift 1987 Winter intaglio/etching, 9 3/4" x 7" (24.7 x 17.8 cm) "Gift from James and Lyn Mason, Provo" 1988.075

The Rhinoceros 1981 acrylic on board, 14 3/4" x 11 3/4" (37.5 x 29.8 cm) "Gift from the Artist, James C. Christensen, Orem" 1985.011

JENNI JENKINS CHRISTENSEN (1945 -) Pleasant Grove

Morning Glory 1980s intaglio/etching, 15" x 11" (37.8 x 28.0 cm) "Gift from James and Lyn Mason, Provo" 1990.029

Sunflowers 1983 intaglio/etching, 23 1/2" x 16 1/4" (59.7 x 41.0 cm) Museum Purchase from Spring Salon 1984.017

LARRY WILLIAMS CHRISTENSEN (1945 -) Provo

Almost Dusk 1989 oil on board, 36" x 48" (91.5 x 121.0 cm) "Gift from the Artist, Larry Christensen" 1989.017

HOMER HONE CLARK (1921 -) Salt Lake City

25th Street, Ogden 1970 watercolor, 18" x 24" (45.7 x 61.0 cm) "Gift from A. Merlin and Alice Steed trust" 1981.008

JEANNE LEIGHTON LUNDBERG CLARKE (1925 -) Orem

The Earth is Full of Goodness of the Lord: Portrait of Rebecca 1985 oil on canvas, 44" x 60" (111.7 x 152.4 cm) "Gift from Mark and Nancy Peterson, Alpine" 1985.009

JOHN WILLARD CLAWSON (1858 -1936) Salt Lake City

Plein-air Landscape of Southern California 1925 oil on canvas, 24" x 30" (61.4 x 76.5 cm) "Gift from A. Merlin and Alice steed trust" 1987.011

Portrait of a Gentleman 1894 oil on canvas, 25" x 20" (63.4 x 50.9 cm) "Gift from David and Karen Ericson, Salt Lake City" 1988.049

Portrait of Mathew Henry Walker 1923 oil on canvas, 34 1/4" x 40 1/4" (87.1 x 102.3 cm) "Gift from Mr. and Mrs. Matthew Walker Wallace, SLC" 1989.077

Portrait of Mrs. Angelina Andrews Walker 1901 oil on canvas, 48 1/4" x 37 1/2" (123.0 x 95.1 cm) "Gift from Mr. and Mrs. Matthew Walker Wallace, SLC" 1989.071

Windy Day, California Shore 1928 oil on canvas, 22" x 27" (55.8 x 68.7 cm) "Gift from A. Merlin and Alice Steed trust" 1987.012

FARRELL R. COLLETT (1907 -) Ogden

Elk in Wooded Landscape late 1960s watercolor, 13" x 9 1/2" (33.2 x 24.4 cm) "Courtesy of Karl Shipman, Provo" 1990.041

Sudanese 1953 oil on board, 16" x 11" (40.6 x 27.8 cm) "Gift from Springville High School, Senior Class" 1953.001

GARY MAX COLLINS (1936 -) Salt Lake City

Lake Powell Reflections 1985 acrylic on board, 24" x 30" (61.0 x 76.1 cm) "Gift from the Artist, Gary M. Collins, SLC" 1987.004

HARRIETTE ANN H. CONOVER (1877 -1964) Springville/Provo

Pink Anemones date unknown watercolor, 11 1/2" x 8" (29.0 x 20.7 cm) "Gift from Margaret Conover, Springville" 1984.030

GORDON NICHOLSON COPE (1907 -) Salt Lake City/San Francisco

Sierra Snow Scene 1978 oil on canvas, 40" x 50" (101.8 x 127.4 cm) "Gift from the Artist, Gordon N. Cope, San Francisco" 1986.012

Utah Hills, East of Springville 1937 oil on board, 30" x 36" (76.0 x 91.3 cm) "Gift from Springville High School, Junior Class" 1937.004

KENNETH A. CORBETT (1963 -) Salt Lake City

Cows are Beautiful Too 1988 oil on canvas, 18" x 24" (45.7 x 61.0 cm) Museum Purchase from Spring Salon 1989.010

D. WAYNE CORLISS (1948 -) Provo

Early Spring Plowing 1987 (23/32) serigraph, 14" x 18 1/2" (35.0 x 47.2 cm) "Gift from the artist, Wayne Corliss" 1991.008

CLYDE CORNICK (1897 -1986) Salt Lake City

Salt Lake Valley c. 1920 oil on board, 12 1/2" x 18" (31.8 x 46.0 cm) "Gift from David and Karen Ericson, Salt Lake City" 1990.053

Self-Portrait 1920s oil on board, 18 1/2" x 14 1/2" (46.7 x 36.7 cm) "Gift from David and Karen Ericson, Salt Lake City" 1990.052

ISAAC LOREN COVINGTON (1885 -1970) Utah

Bryce Canyon 1930s oil on board, 15 3/4" x 23 3/4" (40.0 x 60.4 cm) "Gift from A. Merlin and Alice Steed trust" 1990.049

TRAVIS D. CROWTHER (1947 -) Ogden

Reflective Involvement 1975 bronze, 8 3/4" x 8" x 8 1/2" (22.3 x 20.4 x 21.5 cm) Museum Purchase from Spring Salon 1975.001

HENRY LAVENDER A. CULMER (1854 -1914) Salt Lake City

Approaching Salt Lake City from City Creek Canyon c. 1906 watercolor, 7 3/4" x 14" (19.5 x 35.4 cm) "Gift from A. Merlin and Alice Steed trust" 1982.020

Brush Creek Gorge, Ashley Utah 1886 oil on canvas, 30" x 18" (75.7 x 45.4 cm) "Gift from A. Merlin and Alice Steed trust" 1989.056

Grand Canyon of the Colorado c. 1904 watercolor, 9 3/4" x 15 3/4" (25 x 40.4 cm) "Gift from A. Merlin and Alice Steed trust" 1990.045

Mission San Carlos Borromeo de Carmelo c. 1893 oil on canvas, 18" x 26 1/4" (45.9 x 66.4 cm) "Gift from A. Merlin and Alice Steed trust" 1982.029

Sunshine and Shadow: Walker Lane Salt Lake 1903 oil on canvas, 40" x 30" (102.0 x 76.5 cm) Museum Acquisition through exchange 1985.010

Three Tetons 1911 -12 oil on canvas, 42 3/4" x 60 1/2" (108.2 x 153.5 cm) "Gift from Neal and Jane Schaerrer, Salt Lake City" 1984.001

HUGHES WILLIAM CURTIS (1904 -1972) Springville

Death and the Drunkard 1940 plaster, 27" x 12 1/2" x 10 1/2" (68.5 x 31.5 x 26.7 cm) Museum Purchase 1941.001

Rim Rock 1961 bronze, 15 1/2" x 21 1/2" x 6 1/4" (39.3 x 54.5 x 16.0 cm) Museum Purchase from Spring Salon 1968.001

Saddling Up 1942 bronze, 22" x 14" x 7" (56.0 x 35.5 x 17.2 cm) "Gift from Springville High School, Senior Class" 1950.001

GRAYCE ELIZABETH S. CUTLER (1906 -) Salt Lake City

Early Spring in the Rockies 1985 watercolor, 14" x 21" (35.6 x 53.5 cm) "Gift from the Artist, Grayce E. S. Cutler" 1988.032

CYRUS EDWIN DALLIN (1861 -1944) Springville

Appeal to the Great Spirit 1912 bronze, 39" x 37 3/4" x 24" (99.0 x 95.8 x 61.0 cm) "Anonymous Donor" 1974.003

Appeal to the Great Spirit 1912 plaster, 40 1/2" x 39 1/2" x 24 1/2" (102.8 x 100.4 x 62.2 cm) "Gift from the artist, Cyrus E. Dallin, Springville" 1924.002

Beverly Hospital Medallion 1930 bronze medal, 2 3/16" diameter (5.6 cm.) "Gift from Gorham Silver Corporation, Providence RI" 1967.001

Captured, but not Conquered 1918 bronze, 32 3/4" x 10" x 7 1/2" (83.2 x 25.4 x 18.9 cm) "Gift from Gorham Silver Corporation, Providence RI" 1968.002

Chief Washakie 1914 bronze, 43" x 39" x 17 1/2" (109.5 x 99.0 x 44.3 cm) "Gift from Mr. & Mrs. Jack S. Allen, Springville" 1975.002

High Country: Wasatch Range 1934 oil on canvas, 15 1/4" x 24" (38.9 x 61.1 cm) "Gift from Frederick C. and Sherry Ross, New Jersey" 1982.014

Homage from Massachusetts to the Victorious Commander Foch 1921 bronze medal, 2 3/4" diameter (6.9 cm) "Gift from Gorham Silver Corporation, Providence RI" 1967.002

Jane Dallin-The Artist's Mother 1904 marble, 22 1/2" x 18 1/2" x 10 3/4" (57.5 x 47.2 x 27.6 cm) "Gift from A. Merlin and Alice Steed trust" 1976.020

Lane off Marsh Street, Belmont Mass. 1920s oil on canvas, 17" x 23" (43.5 x 58.5 cm) "Gift from David and Karen Ericson, SLC" 1981.018

Massasoit a reproduction 1921 metal, 11" x 3" (27.9 x 7.5 cm) "Gift from Miss Edith Richardson, SLC" 1971.002

MEDAL OF HONOR: *Massachusetts Normal Art School* 1924 bronze medal, 2 1/2" diameter (6.0 cm) "Gift from Mrs. Bertam Dallin" 1973.002

Medicine Man 1899 bronze, 30 3/4" x 29 1/2" x 7" (77.9 x 75.0 x 18.0 cm) "Gift from Lee A. Carson, Provo" 1974.004

Merion Cricket Club, National Archery Association 1914 bronze medal, 2 3/4" diameter (6.9 cm) "Gift from Mrs. C. C. (Verne) Trittin, Sandy, Utah" 1971.001

Olympic Bowman League, Nat. Archery Association 1941 bronze medal, 2 3/4" x 1 3/4" (6.9 x 4.5 cm) "Gift from Mrs. C. C. (Verne) Trittin, Sandy, Utah" 1971.003

On the War Path, Sioux Tribe 1914 bronze, 21 1/4" x 22" x 7" (54.0 x 56.0 x 17.5) "Gift from A. Merlin and Alice Steed trust" 1978.002

Paul Revere 1899 plaster, 36 1/2" x 33 1/4" x 36" (92.6 x 48.6 x 37.0 cm) "Gift from the artist, Cyrus E. Dallin" 1903.001

Paul Revere 1899 bronze, 37 1/2" x 36" (95.9 x ? cm) "Gift from Utah American Revolution Bicentennial Com." 1976.002

Philip Son of Kicking Bear c. 1890 bronze, 4" x 3" x 3 1/4" (10.3 x 7.6 x 8.2 cm) "Gift from Arnold and Sue Mills, Mass." 1988.053

Pilgrim Half Dollar 1920 -21 silver coin, 1 1/4" diameter (3.2 cm) "Gift from Rell Francis, Springville" 1982.017

Pinnacles: Cathedral of the Pines 1920 oil on canvas, 18" x 24 1/4" (46.0 x 61.2 cm) "Gift from Lawrence Dallin, son of the artist" 1979.001

Portrait Bust of Emmeline B. Wells 1928 plaster, 26" x 20 1/2" x 12" (66.0 x 52.0 x 30.5 cm) "Gift from Kolob Stake Relief Society, Springville" 1928.001

Portrait bust of Oliver Wendell Holmes 1883 plaster, 24" x 9" x 9" (61.0 x 22.9 x 23 cm) "Gift from Hugh D. Gardner, Springville" 1977.002

Portrait of John Hancock 1896 bronze, 32 3/4" x 12 1/2" x 9 1/4" (83.4 x 31.3 x 23.3 cm) "Gift from Utah American Revolution Bicentennial Com." 1976.003

Pretty Eagle #51 1926 bronze, 28" x 17 1/2" x 22 1/2" (70.8 x 44.3 x 57.4 cm) "Gift from Gerald Peters Gallery, Santa Fe, New Mexico" 1984.022

Protest 1904 bronze, 20" x 16 1/2" x 5 1/4" (50.8 x 41.9 x 13.4 cm) "Gift from Hal & Aileen Clyde" 1972.002

Scout 1910 bronze, 33" x 39 1/4" x 10" (84.0 x 99.8 x 25.4 cm) "Gift from Lee A. Carson, Provo" 1978.003

Self-Portrait Bust 1927 bronze, 16 3/4" x 9 1/2" x 7 3/4" (42.4 x 23.3 x 19.7 cm) "Gift from Mother's Study Club, Springville" 1977.001

Signal of Peace 1890 bronze, 12" x 9 1/2" x 2 1/2" (30.5 x 24.0 x 6.5 cm) "Gift from A. Merlin and Alice Steed trust" 1973.003

Sketch Book Diary 1927 pencil, 9" x 11" (22.9 x 27.7 cm) "Gift from Martin K. Bovey, Chelmsford, Massachusetts" 1973.004

Standard Bred Stallion c. 1934 bronze, 17" x 19 1/4" x 4" (43.2 x 49.0 x 10.0 cm) "Gift from Ed Ace Powell Bronze, Kalispell, Montana" 1976.004

Theodore William Richards, Medal 1930 bronze metal, 2" diameter (6.0 cm) "Gift from Glenn Doherty, the artist's grandson" 1990.023

The Vision or A Boy or Bust of Charles A. Lindberg 1927 plaster, 17 3/4" x 9 1/4" x 7" (45.2 x 23.5 x 17.5 cm) "Gift from Mrs. L. J. Whitney for 1929 graduating class" 1929.001

War or Peace 1905 bronze, 33 1/2" x 16" x 10" (85.0 x 41.0 x 25.5 cm) "Gift from A. Merlin and Alice Steed trust" 1977.002

Winter at Arlington Heights 1935 oil on canvas, 16" x 24" (41.0 x 61.1 cm) Museum Purchase 1981.015

ALEX BASIL DARRAIS (1918 -) Provo

Over Three Billion Served 1974 mixed media, 36" x 36" (91.5 x 91.5 cm) "Gift from the Artist, Alex Darrais" 1989.025

KENNETH DAVIDSON (1910 -) Ogden

Gardenia Still Life 1947 oil on board, 22" x 28" (55.4 x 70.5 cm) "Gift from Lund-Wassmer Collection: Kenneth Davidson" 1990.021

Portrait of a Young Boxer 1950 oil on board, 20" x 16" (50.5 x 40.5 cm) "Gift from Lund-Wassmer Collection: Kenneth Davidson" 1990.020

ROBERT W. DAVIDSON (1904 -) Mapleton

September, Utah 1978 oil on canvas, 24" x 36" (61.8 x 91.7 cm) "Gift from the Artist, Robert Davidson" 1989.047

PAUL HOWARD DAVIS (1946 -) Salt Lake City

Enigmatic Figure 1988 oil on canvas, 40 1/2" x 45 3/4" (103.0 x 116.3 cm) Museum Purchase, 1991.019

Self-Portrait at 31 1977 oil on canvas, 30" x 28" (76.0 x 71.1 cm) "Gift from the Artist, Paul Davis" 1991.018

State Street 1979 1979 oil on canvas, 19 3/4" x 16" (50.2 x 40.4 cm) "Gift from the Artist, Paul Davis" 1986.064

DENIS JOSEPH DEEGAN (1947 -) Orem

Green Copper Chip Digger 1988 mixed media, 6 1/2" x 8" x 8 1/4" (16.5 x 20.3 x 21.0 cm) "Gift from the Artist, Denis Deegan" 1989.007

(HELEN H.) LEE DEFFEBACH (1928 -) Salt Lake City

Enjoy: Self Portrait 1979 crayon/conte, 18 3/4" x 22 3/4" (47.6 x 57.8 cm) "Gift from the Artist, Lee Deffebach, SLC" 1987.001

Zelda: Los Truches 1973 acrylic on canvas, 69 1/2" x 69 1/2" (176.5 x 176.5 cm)

Normandie Beach 1956 oil on canvas mounted, 36" x 34" (91.4 x 86.3 cm) "Gift from Mary Louise Kimball, In Memory of Ranch" 1988.001

GEORGE SMITH DIBBLE (1904 -) Salt Lake City

Marine #2 1938 oil on board, 16 1/2" x 19" (42.0 x 48.1 cm) "Gift from the Artist, George S. Dibble, SLC" 1988.063

The Garfield Copper Smelter 1952 watercolor, 20 3/4" x 27 3/4" (53.0 x 70.9 cm) Museum Purchase 1988.071

(LAFAYETTE) MAYNARD DIXON (1875 -1946) California/Mt.Carmel Utah

Road to the River, Mt. Carmel Utah October 1941 oil on board, 16" x l9 3/4" (40.8 x 50.0 cm) "Gift from Springville High School, Class of 1935 trust" 1988.007

ANDREW W. DOWD (1869 -1942) Salt Lake City

The Great White Throne, Zions c. 1925 oil on board, 12" x 9" (30.2 x 22.6 cm) "Gift from A. Merlin and Alice Steed trust" 1990.050

DON CLIFFORD DOXEY (1928 -) Salt Lake City

The Wedding Dress 1967 oil on canvas, 30" x 48" (76.2 x 122.0 cm) "Gift from the Artist, Don C. Doxey" 1984.007

FLORENCE BOHN DRAKE (1885 -1958) Ogden

Abstract Still-Life c. 1935 watercolor, 12 1/2" x 10 3/4" (31.5 x 27.4 cm) "Gift from Robert Stone, Salt Lake City" 1987.030

Fisherman date unknown mixed media, 20 1/2" x 13 3/4" (51.7 x 35.0 cm) "Gift from Robert Stone, Salt Lake City" 1987.029

MARION CLARK DUNN (1930 -) Salt Lake City

Onion Dome 1984 watercolor, 21 1/4" x 13 3/4" (54.1 x 35.0 cm) "Gift from Mrs. Beatrice Ellison Dunn" 1984.037

GEORGE R. DUNPHY (? -?) Salt Lake City

Study in Green and Rose 1960 oil on canvas, 24" x 20" (61.0 x 50.7 cm) "Gift from Lund-Wassmer Collection: Ursel Allred, SLC" 1986.070

LaVIEVE HUISH EARL (1896 -1958) Provo

Spring Glory 1950s watercolor, 24 1/2" x 17" (62.0 x 42.8 cm) "Gift from the Artist's husband, Frank Earl" 1978.005

ELBERT HINDLEY EASTMOND (1876 -1936) Provo

Scotch Broom in Bloom 1910s woodcut/blockprint, 11" x 7 1/4" (28.2 x 18.2 cm) "Gift of Helen Anderson & Ariane Rasmussen, Provo" 1982.023

Pageant of Clouds 1930 oil on board, 18" x 20" (46.0 x 50.7 cm) "Gift from the artist, Elbert H. Eastmond, Provo" 1931.001

Tramp Boat 1931 woodcut/blockprint, 8 3/4" x 6 3/4" (21.8 x 17.0 cm) "Gift from Mrs. H. K. (Margaret) Richards, Santa Barbara" 1989.061

Winter in Provo Canyon 1912 watercolor, 7 1/4" x 11 1/4" (18.9 x 28.5 cm) "Gift from the artist, Elbert H. Eastmond, Provo" 1907.002

(ARMON) VALOY EATON (1938 -) Midway/Vernal

Burning Leaves 1984 watercolor, 11 1/2" x 15 1/2" (29.0 x 39.4 cm) "Gift from the Artist, Valoy Eaton" 1984.009

Sun, Snow and Ice 1981 oil on board, 36" x 48" (91.0 x 122.0 cm) "Gift In Memory of W. W. Clyde, from daughter, friends, and employees" 1981.029

SOREN PETER BRILLE EDSBERG (1945 -) Orem

The Course of Life (set of six) 1988 lithograph, 27 3/4" x 19 3/4" (70.1 x 50.0 cm) "Gift from the Artist, Soren Edsberg" 1988.067

BARBARA SUMMERS EDWARDS (1952 -) Smithfield

Self-Portrait with Charlie 1984 oil on canvas, 24" x 20" (60.7 x 50.6 cm) "Gift from the Artist, Barbara Edwards" 1991.020

GLEN LYMAN EDWARDS (1935 -) Smithfield

Self-Portrait 1986 watercolor, 13" x 15 1/4" (32.6 x 38.8 cm) "Gift from the Artist, Glen Edwards" 1989.055

CHRISTIAN EISELE (1854 -1919) Utah/Itinerant

Landscape in the Rockies 1896 oil on canvas, 40 1/4" x 60" (101.9 x 152.3 cm) "Gift from Jane Gibson, SLC" 1986.086

FRANK ERICKSON (1922 -1990) Salt Lake City

Farm Shed 1949 oil on canvas mounted, 16" x 20" (40.4 x 51.0 cm) "Gift from Doug Muir, In memory of Grace Muir" 1989.049

EDWIN EVANS (1860 -1946) Lehi/Salt Lake City

American Fork Canyon c. 1900 oil on canvas, 21" x 28" (53.3 x 71.4 cm) "Gift from the artist, Edwin Evans, Salt Lake City" 1938.001

Ancient village in Les Baux France 1924 watercolor, 11 3/4" x 12" (29.6 x 30.2 cm) "Gift from Lund-Wassmer Collection" 1986.131

Harbor—France 1924 watercolor, 8 1/2" x 11 1/2" (21.1 x 28.8 cm) "Gift from Lund-Wassmer Collection" 1986.130

Over the Garden Wall, France 1920s watercolor, 7 3/4" x 12 1/2" (19.6 x 31.6 cm) "Gift from Phyllis Smart Olsen, Provo" 1987.021

JOSEPH ALMA F. EVERETT (1883 -1945) Salt Lake City

City Creek Canyon 1943 watercolor, 21" x 14" (53.4 x 35.5 cm) "Gift from the Joseph Everett Art Society, SLC" 1946.003

Old Salt Lake Theatre 1935 intaglio\etching, 6 1/4" x 8 3/4" (16.0 x 22.2 cm) "Gift from Lund-Wassmer Collection" 1986.132

Winter Landscape with Stream 1929 watercolor, 18 1/2" x 12 1/2" (47.0 x 31.6 cm) "Gift from Mrs. H. K. (Margaret) Richards, Santa Barbara" 1989.062

EUGENIA EVERETT-SMITH (1908 -) Utah

Head of a Young Girl 1930 marble, 8 1/2" x 6 3/4" x 6" (21.6 x 16.5 x 15.2 cm) "Gift from Milton J. and Louisa S. Thurber, Seattle WA" 1979.006

AVARD TENNYSON FAIRBANKS (1897 -1987) Payson/Salt Lake City

Buffalo 1912 bronze, 28" x 46" x 19 1/2" (71.1 x 1116.8 x 49.5. cm) "Gift from George S. & Delores Dore' Eccles Foundation" 1988.052

Flower Girl 1933 bronze, 62" x 22" x 15 1/2" (157.0 x 56.0 x 39.5 cm) "Gift from Sylvia W. Fairbanks, Bethesda Maryland" 1986.092

Head of Abe Lincoln c. 1950 plaster, 38 1/2" x 27 3/4" x 18 1/2" (97.2 x 69.9 x 47.0 cm) "Gift from the Artist, Avard Fairbanks" 1986.063

J. L. Fairbanks Sculpting Portrait of John Hafen 1982 plaster, 33 1/2" x 16 1/2" (85.2 x 88.7 x 42.1 cm) "Gift from the Artist, Avard Fairbanks, SLC" 1982.006

Mother and Child 1928 marble, 37" x 23" x 18" (94.0 x 58.4 x 45.6 cm) "Gift from the Artist, Avard Fairbanks" 1952.001

Pioneer Family Group 1941 plaster, 20 1/2" x 12" x 11 1/2" (52.1 x 30.5 x 29.2 cm) "Gift from Dr. and Mrs. David F. Fairbanks, Bethesda MD" 1973.005

Portrait bust of Mae Huntington 1967 plaster, 24 1/2" x 16 1/2" x 10" (62.2 x 41.9 x 25.4 cm) "Gift from the Mae Huntington Family, Springville" 1967.003

Rain 1932 bronze, 42" x 24" x 17 1/2" (106.7 x 61.0 x 44.5 cm) "Gift from Dr. and Mrs. David F. Fairbanks, Bethesda MD" 1981.052

JOHN B. FAIRBANKS (1855 -1940) Payson

Evening: A Dead Calm of Sunset 1906 oil on canvas, 12" x 18" (29.8 x 45.8 cm) "Gift from Dr. George L. and Emma Smart collection" 1925.006

Grain Stacks in France 1906 oil on board, 9" x 13" (22.7 x 32.5 cm) "Gift from Dr. George L. and Emma Smart collection" 1925.007

Harvest in Utah Valley 1913 oil on canvas, 20" x 30" (51.0 x 76.3 cm) "Gift from Blaine P. and Louise Clyde, Springville" 1983.033

Moonlight on the Marshes in Springville 1906 oil on panel, 12" x 18" (30.5 x 45.6 cm) "Gift from the artist, John B. Fairbanks, Payson" 1907.003

The Prairie (copy after Edwin Gay) c. 1902 oil on canvas, 22 1/4" x 34 1/4" (56.3 x 87.0 cm) "Gift from the artist, John B. Fairbanks, Payson" 1912.002

Sunset on Utah Lake, Springville 1909 oil on canvas, 22" x 36" (55.8 x 91.6 cm) "Gift from the artist, John B. Fairbanks, Payson" 1909.001

Sunset Wheat Fields c. 1905 oil on board, 6" x 8" (15.2 x 20.4 cm) "Gift from Dr. George L. and Emma Smart collection" 1925.010

JOHN LEO FAIRBANKS (1878 -1946) Payson/Eugene

Hulls c. 1903 oil on board, 10 1/2" x 8 1/2" (26.9 x 21.5 cm) "Gift from the artist, J. Leo Fairbanks" 1910.003

Jephthah's Daughter 1915 bronze, 6 1/2" x 8 3/4" x 6 3/4" (16.7 x 22.2 x 17.3 cm) "Gift from J. Austin and Florence Fairbanks Cope Family" 1982.005

Portrait Bust of John Boyleston Fairbanks 1906 bronze, l0 1/4" x 7 1/2" x 5" (26.0 x 19.0 x 12.7 cm) "Gift from Merwin Fairbanks, Orem" 1987.007

Portrait bust of John Hafen 1907 bronze, 13" x 10" x 6 1/4" (33.1 x 25.5 x 15.4 cm) "In Honor of Bill & Nell Allman from the Family" 1982.007

Quaking or Quaking Aspens, Brighton Big Cottonwood 1912 oil on board, 13 1/2" x 9 1/4" (34.5 x 23.4 cm) Museum Purchase 1981.009

Silver Lake, Brighton, Big Cottonwood Canyon 1935 oil on board, 18" x 24" (46.0 x 60.9 cm) "Gift from G. Theodore and Carol Nightwine" 1989.004

The First Snow (winter) 1910 oil on canvas, 18" x 32" (45.9 x 81.5 cm) Museum Purchase 1910.002

Utah Harvest 1905 oil on canvas, 16" x 25" (41.0 x 63.5 cm) Museum Purchase 1910.005

JUSTIN FOX FAIRBANKS (1926 -) Salt Lake City

Portrait Bust of Avard Fairbanks 1983 plaster, 29" x 24 3/4" x 19" (73.7 x 62.7 x 48.3 cm) "Gift from Avard Fairbanks, SLC" 1984.043

LOUISE RICHARDS FARNSWORTH (1878 -1969) Salt Lake City

Capitol from North Salt Lake 1935 oil on canvas, 15" x 22" (38.3 x 56.1 cm) "Gift from Lund-Wassmer Collection" 1986.134

Hay Stacks 1935 oil on board, 18" x 24" (45.5 x 60.3 cm) "Gift from Lund-Wassmer Collection" 1986.135

Springtime 1935 pastel, 11 1/2" x 15 1/4" (28.7 x 38.5 cm) "Gift from Lund-Wassmer Collection" 1986.137

Storm clouds in the Tetons 1950 pastel, 9 1/2" x 11 1/2" (23.7 x 29.4 cm) "Gift from Lund-Wassmer Collection" 1986.136

(WILLIAM) DEAN FAUSETT (1913 -) Price/Dorset

Double Nudes or *Two Female Torsos* date unknown charcoal, 23 1/2" x 17 3/4" (59.6 x 45.1 cm) "Gift from Jim Huish, Provo" 1982.002

Portrait of Lars E. Eggertsen 1950 oil on panel, 24" x 20" (61.0 x 50.8 cm) "Gift from Mrs. (Annie) Lars E. Eggertsen & Family" 1950.002

The Artist as a Young Man 1938 pencil, 23 1/2" x 17 1/2" (59.7 x 44.6 cm) "Gift from the artist, Dean Fausett, Dorset Vermont" 1989.028

Three Female Nudes date unknown mixed media, 15 1/2" x 11 1/2" (39.7 x 29.6 cm) "Gift from Vern G. and Judy N. Swanson, Springville" 1990.004

LYNN FAUSETT (1894 -1977) Price/Salt Lake City

Angel's Arch 1962 gouache/tempera on board, 36 x 48 inches (91.4 x 121.8 cm) "In Memory of Ruby J. Fawcett from her husband Bill" 1987.032

Flaming Gorge Dam under Construction 1961 gouache/tempera on board, 24" x 40" (60.5 x 101.4 cm) "Gift from Mrs. (Fiametta) Lynn Fausett, SLC" 1981.042

Rainbow Bridge, Utah 1960 gouache/tempera on board, 14" x 12" (35.4 x 30.5 cm) "Gift from Federated Aureole Club of Springville" 1982.003

St Louis Post Office, Overland Stage #5 c. 1935 gouache/tempra, 5 1/2" x 15 1/2" (13.7 x 39.3 cm) "Gift from Vern G. and Judy N. Swanson, Springville" 1986.093

St. Louis Post Office, Pony Express #4 c. 1935 gouache/tempra, 5 1/2" x 15 1/2" (13.7 x 39.3 cm) "Gift from Frederick C. and Sherry Ross trust, NJ" 1988.046

St. Louis Post Office, Riverboats #3 c. 1935 gouache/tempra, 5 1/2" x 15 1/2" (13.7 x 39.3 cm) "Gift from Frederick C. and Sherry Ross trust, NJ" 1988.045

St. Louis Post Office, Watson's Pony #2 c. 1935 gouache/tempra, 5 1/2" x 15 1/2" (13.7 x 39.3 cm) "Gift from Frederick C. and Sherry Ross trust, NJ" 1988.044

St. Louis, First Post Office l807 #1 c. 1935 gouache/tempra, 5 1/2" x 15 1/2" (13.7 x 39.3 cm) "Gift from Frederick C. and Sherry Ross trust, NJ" 1988.043

CYNTHIA MOORE FEHR (1928 -) Salt Lake City

Zion's Clock 1977 watercolor, 6 1/2" x 5 1/4" (17.0 x 13.2 cm) "Gift from Doug Muir, In memory of Grace Muir" 1989.046

PETER M. FILLERUP (1953 -) Heber

Kit Carson—Frontiersman 1981 bronze, 14 1/2" x 15 1/2" x 5 3/4" (36.8 x 39.5 x 14.5 cm) "Gift from A. Merlin and Alice Steed trust" 1990.051

FLORA DAVIS FISHER (1891 -1984) Utah

Roses 1950s watercolor, 19 1/4" x 11 1/4" (49.0 x 28.8 cm) "Gift from Ramona Whitney, Springville" 1984.011

PAULMAR TORSTEN J. FJELLBOE (1873 -1948) Salt Lake City

Black Rock 1910s oil on board, 12" x 18" (30.5 x 45.4 cm) "Gift from Richard Hilligas, Salt Lake City" 1988.059

Logan Canyon 1920s oil on canvas, 16" x 24" (4.7 x 61.3 cm) "Gift from A. Merlin and Alice Steed trust" 1983.030

CALVIN FLETCHER (1882 -1963) Logan

Cache Valley Populars 1932 oil on canvas, 24" x 35 3/4" (61.3 x 91.0 cm) "Gift from Leone Fletcher, Provo" 1981.010

Irene Sketching in Cache Valley 1927 watercolor, 14" x 21" (35.6 x 53.2 cm) "Gift from Frederick C. and Sherry Ross trust, NJ" 1987.035

Logan Baseball 1936 watercolor, 20 1/2" x 13 1/2" (52.0 x 34.3 cm) "Gift from Vern G. and Judy N. Swanson, Springville" 1983.024

Man with a Rake 1940s watercolor, 9 1/2" x 13 1/2" (24.0 x 34.1 cm) "Gift from Lynn Cozzens, Orem" 1987.008

Pioneer Homesteading c. 1935 charcoal, 13" x 21 1/2" (33.0 x 54.3 cm) "Gift from Leone Woolley Fletcher, Provo" 1985.001

Speed and Steel 1946 oil on canvas mounted, 24" x 29" (61.0 x 73.7 cm) "Gift from Mark and Nancy Peterson, Alpine" 1988.004

Wash Day Brigham City 1929 acrylic on board, 24 1/2" x 27" (61.3 x 68.0 cm) "Gift from F. Ed and Judy Bennett, Salt Lake City" 1982.034

DALE THOMPSON FLETCHER (1929 -) Logan/Provo

Lifting by Leverage 1956 oil on canvas, 39 3/4" x 49 3/4" (101.0 x 126.3 cm) "Gift from Leone Woolley Fletcher, Provo" 1982.024

IRENE THOMPSON FLETCHER (1900 -1969) Logan

Laid Off 1938 oil on board, 24" x 18" (60.7 x 45.4 cm) "Gift from F. Ed and Judy Bennett, Salt Lake City" 1982.035

NORMA SHURTLIFF FORSBERG (1920 -) Bountiful

Landscape: Hay Bales or Rocks? 1976 oil on canvas, 10" x 14" (25.4 x 35.5 cm) "Gift from Doug Muir, In memory of Grace Muir" 1989.043

PAUL PETER FORSTER (1925 -) New York/Draper

Church of San Cristo Rey 1980 oil on board, 24" x 30" (60.8 x 76.3 cm) "Gift from Paul and Peggy Forster, Salt Lake City" 1980.006

Portrait of Ray L. Done 1971 oil on canvas, 18" x 16" (45.7 x 41.1 cm) "Gift from Mrs. Ray L. Done" 1971.004

FLORENCE (NESLEN) FRANDSEN (1908 -) Springville/Salt Lake City

Guardian of The Gate 1942 oil on board, 24" x 30" (60.7 x 76.2 cm) Museum Acquisition through exchange 1984.031

EDWARD J. FRAUGHTON (1939 -) Park City/South Jordan

One Nation 1987 bronze, 23 1/4" x 20" x 14" (59.0 x 51.0 x 35.7 cm) "Louise C. Clyde, In Memory of Blaine P. Clyde" 1988.012

MABEL PEARL FRAZER (1887 -1981) Fillmore/Salt Lake City

Christ Among the Nephites 1930s oil on canvas, 77" x 161" (183.0 x 408.8 cm) "Gift from the Pioneer Craft House, SLC" 1989.011

The Harpist 1930s oil on board, 13 3/4" x 10 1/2" (35.0 x 27.0 cm) "Gift from A. Merlin and Alice Steed trust" 1984.003

Jungle Birds 1930s watercolor, 10 1/2" x 17" (27.0 x 43.3 cm) "Gift from Richard Waldis, In Memory of Nettie Waldis" 1988.066

Snow on the Wasatch 1930s watercolor, 21 1/4" x 29 1/4" (53.5 x 74.0 cm) "Gift from Richard Waldis, In Memory of Nettie Waldis" 1988.065

Squash Blossom c. 1920 oil on canvas, 15 1/2" x 13 1/4" (39.2 x 33.0 cm) "Gift from Mark and Nancy Peterson, Alpine" 1985.025

Stillman Bridge Parley's Canyon c. 1935 watercolor, 21" x 28 1/2" (53.3 x 72.2 cm) "Gift from Dr. George L. and Emma Smart trust" 1982.036

Sunrise, North Rim Grand Canyon 1928 oil on canvas, 33" x 57 3/4" (83.6 x 147.0 cm) "Gift from Waldis Family (Madeleine, Dick & Nettie) SLC" 1981.026

Venice Canal 1930 oil on canvas mounted, 19" x 16" (48.3 x 40.7 cm) "Gift from A. Merlin and Alice Steed trust" 1987.022

CLARK FAIRBANKS GARDNER (1940 -) Salt Lake City

Templescape 1985 ceramic tile, 31 1/2" x 27 1/2" (80.0 x 70.0 cm) "Gift from David and Ingrid Nemelka, Mapleton" 1988.085

HENRY LEROY GARDNER (1884 -1979) Payson

Depo Street, Payson 1910 pencil drawing, 5 3/4" x 8 3/4" (14.4 x 22.0 cm) "Gift from Bette Wycalis, Richfield, Utah" 1991.007

Buildings in Provo 1910 pencil drawing, 8 1/2" x 11 1/2" (22.0 x 30.0 cm) "Gift from Bette Wycalis, Richfield, Utah" 1991.010

Song of the Morning 1931 oil on canvas, 30" x 22" (76.4 x 56.0 cm) "Gift from Bette Wycalis, Richfield, Utah" 1991.006

ALVIN L. GITTINS (1922 -1981) Salt Lake City

Grounds Keeper 1976 oil on canvas, 21 1/4" x 31 1/4" (61.2 x 79.2 cm) "Gift from Vern G. and Judy N. Swanson, Springville" 1981.050

Portrait of Mrs. Thelma Bonham de Jong 1965 oil on canvas, 34" x 24" (86.5 x 61.2 cm) "Gift from Thelma Bonham (Mrs. Gerrit) de Jong, Provo" 1983.003

BEVERLY BARTON GLAZIER (1951 -) Orem

Patchwork 1980 silkscreen/serigraph, 20" x 20" (50.7 x 50.7 cm) "Gift from Peter and Donna Crawley, Provo" 1984.023

KENT PERRY GOODLIFFE (1946 -) Provo

Sitting on a Thornet Bentwood 1979 pencil, 22 1/2" x 13 3/4" (56.6 x 35.1 cm) Museum Purchase from Spring Salon 1979.002

JACK GOODMAN (1913 -) Salt Lake City

Seattle date unknown watercolor, 11 1/2" x 15 1/2" (29.2 x 39.3 cm) "Gift from Doug Muir, In memory of Grace Muir" 1989.076

BESS EASTMAN GOURLEY (1886 -1951) Provo

Petunias date unknown watercolor, 11" x 15 1/2" (28.0 x 39.4 cm) "Gift from David and Karen Ericson, Salt Lake City" 1981.019

Sego Lilies 1947 watercolor, 14 3/4" x 18 3/4" (37.5 x 47.5 cm) Museum Purchase 1947.005

GRANIZO (? -) Utah

Birds in Paradise 1983 ceramic tile, 35 1/2" x 23 1/2" (90.0 x 59.4 cm) "Gift from the Artist, Granizo" 1984.044

MICHAEL CLANE GRAVES (1939 -) Provo/Tempe

A Matter of Choice 1979 silkscreen/serigraph, 28 1/2" x 21 1/4" (72.7 x 53.7 cm) "Gift from Dr. George L. and Emma Smart trust" 1983.008

Night Passage 1979 silkscreen/serigraph, 38 3/4" x 24 3/4" (98.7 x 63.0 cm) "Gift from Dr. George L. and Emma Smart trust" 1983.009

The Attrition of the Soul 1979 silkscreen/serigraph, 28" x 20" (71.0 x 51.0 cm) "Gift from Dr. George L. and Emma Smart trust" 1983.007

CALVIN RAYMOND GRONDAHL (1950 -) Layton

Oh, Oh, I Think We've Done It Now! 1979 pencil, 10" x 12" (25.4 x 30.5 cm) Museum Purchase 1986.061

HARRISON THOMAS GROUTAGE (1925 -) Logan

Along the Bear River 1978 acrylic on canvas, 36 1/4" x 48" (92.0 x 122.1 cm) Museum Purchase from Spring Salon 1978.006

Back Road 1977 acrylic on canvas, 26" x 34" (66.1 x 91.5 cm) "Gift from Ardelle H. Ashworth Family and Friends" 1977.003

Integration 1959 watercolor, 24 1/4" x 36 1/4" (61.6 x 93.4 cm) "Gift from Springville Junior High School" 1959.001

ROSCOE ABNER GROVER (1901 -1986) Salt Lake City

Brigham Young Pioneer of 1847 1978 oil on board, 24" x 20" (60.9 x 50.6 cm) "Gift from the Artist, Roscoe Grover" 1982.032

Portrait of Prof. James T. Harwood c. 1937 oil on board, 14" x 11" (35.2 x 27.7 cm) "Gift from Lund-Wassmer Collection: Mrs. Roscoe A. Grover" 1986.075

NEIL WESLEY HADLOCK (1944 -) Highland

Effron 1983 metal corten steel, 79" x 157" x 44" (200.0 x 398.2 x 111.7 cm) Museum Purchase 1983.043

JOHN HAFEN (1856 -1910) Springville

Corral 1879 gouache/tempra, 4" x 6 3/4" (10.0 x 16.5 cm) "Gift from Mrs. Tess Hines Garrison, Hermosa Beach, CA" 1973.006

Dandelions date unknown watercolor, 8 1/4" x 10 1/2" (21.0 x 27.0 cm) "Gift from Dr. George L. and Emma Smart collection" 1925.012

Dutch Girl (copy after Rembrandt) 1908 oil on canvas, 40" x 34" (101.6 x 86.4 cm) "Gift from the artist, John Hafen, Springville" 1908.001

Fishing Boats, Bulrushes West of Springville 1899 intaglio/etching, 8 1/2" x 11" (21.6 x 28.0 cm) "Gift from Dr. George L. and Emma Smart collection" 1925.013

Fishing Scene at Springville: Hobble Creek 1886 on canvas, 19 1/4" x 15" (48.8 x 38.4 cm) "Gift from A. Merlin and Alice Steed trust" 1983.034

Garden Path 1893 oil on canvas, 22" x 15" (55.7 x 37.9 cm) "Gift from Taylor Family, honoring Albert W. Harmer" 1964.002

Geneva Dance Hall and Resort, Utah Lake 1896 oil on canvas, 20" x 38" (51.0 x 97.0 cm) "Gift from Capt. John Dallin estate, Springville" 1925.024

The Hermit's Home 1901 oil on canvas, 27" x 23" (67.8 x 58.5 cm) "Gift from Dr. George L. and Emma Smart collection" 1925.016

Hollyhocks 1907 oil on canvas, 36" x 42" (91.3 x 107.0 cm) Museum Purchase 1924.004

Home Stretch or *The Hut* date unknown pencil, 7" x 10" (17.8 x 25.4 cm) "Gift from Dr. George L. and Emma Smart collection" 1925.017

Indian Summer c. 1900 oil on canvas, 12" x 18" (30.3 x 45.6 cm) "Gift from Dr. George L. and Emma Smart collection" 1925.018

Lake Blanche, Cottonwood Canyon date unknown intaglio/etching, 11" x 8 1/2" (28.0 x 21.5 cm) "Gift from Dr. George L. and Emma Smart collection" 1925.019

Lake Mary, Brighton Cottonwood 1901 oil on canvas, 24" x 30" (61.0 x 76.2 cm) "Gift from Mary Melita Smith Coombs, Las Vegas Nevada" 1984.020

Landing at Geneva, Utah Lake 1905 oil on canvas, 12" x 18" (30.5 x 45.7 cm) "Gift from Dr. George L. and Emma Smart collection" 1925.020

Landscape study in Utah Valley date unknown oil on board, 9 1/2" x 13 1/2" (24.2 x 34.3 cm) "In Memory of Patrick O. Ward from his Family" 1986.014

Maple Trees 1909 pencil, 13 3/4" x 10 3/4" (35.6 x 27.4 cm) "Gift from Dr. George L. and Emma Smart collection" 1925.022

Milk House date unknown watercolor, 6" x 8 3/4" (15.2 x 21.8 cm) "Gift from Dr. George L. and Emma Smart collection" 1925.023

Mill Falls, Filmore 1887 oil on board, 18" x 12 1/4" (45.7 x 30.9 cm) "Gift from Charles and Josephine Burton, Salt Lake City" 1939.003

Mill Pond 1906 oil on canvas, 9 1/2" x 13 1/2" (24.0 x 33.7 cm) "Gift from Dr. George L. and Emma Smart collection" 1925.024

Minnesota Springs 1909 oil on canvas, 16" x 24" (40.8 x 60.2 cm) Museum Purchase 1922.002

Mountain Brook date unknown watercolor, 10 1/2" x 15 1/2" (26.2 x 39.1 cm) "Gift from Mr. and Mrs. T. Melvin Haymond" 1975.005

The Mountain Stream 1903 oil on canvas, 26" x 23" (66.0 x 58.6 cm) "Gift from the artist, John Hafen, Springville" 1903.002

Old Lodge Lake Tahoe or *In the Northwest* 1896 oil on canvas, 18" x 12" (45.6 x 30.5 cm) "Gift In Memory of Leslie B. Hales from her Family" 1983.035

Old Molasses Mill Race 1899 intaglio/etching, 8 1/2" x 11" (21.4 x 28.1 cm) "Gift from Dr. George L. and Emma Smart collection" 1925.027

Orchard in Bloom 1905 oil on canvas, 16" x 20" (40.1 x 50.8 cm) "Gift from Dr. Nephi H. Packard" 1971.005

Pasture or *Alfalfa Field in November in Springville* date unknown oil on board, 10" x 13 1/4" (25.2 x 35.1 cm) "Gift from Dr. George L. and Emma Smart collection" 1925.029

Pine Trees near Paris 1890 charcoal, 15 1/2" x 9 1/2" (39.2 x 24.1 cm) "Gift from Dr. George L. and Emma Smart collection" 1925.030

Portrait of Elizabeth Winsor Smart 1906 oil on canvas, 54 1/2" x 42 1/4" (138.5 x 107.2 cm) "Gift from Dr. George L. and Emma Smart collection" 1925.031

Portrait of Hezekiah Bayliss Smart 1906 oil on canvas, 54 1/4" x 42 1/4" (137.7 x 106.9 cm) "Gift from Dr. George L. and Emma Smart collection" 1925.032

Portrait of Mr. William H. Hooper 1880s charcoal, 24 1/4" x 20" (61.6 x 50.6 cm) "Gift from J. W. Hatch, Ogden" 1982.011

Portrait of Nephi Straw 1905 oil on canvas, 24" x 20" (61.1 x 50.8 cm) "Gift from the Family of Mrs. O. Earl Thomas" 1964.003

Provo River Bed 1880s pastel, 5 1/2" x 8" (13.5 x 20.0 cm) "Gift from Dr. George L. and Emma Smart collection" 1925.033

Quaking Aspens, Brighton 1907 oil on canvas, 62 3/4" x 33 3/4" (159.5 x 86.0 cm) Museum Purchase 1923.002

Red Mountain 1903 oil on canvas, 16" x 20" (40.5 x 50.7 cm) "Gift in memory of Heber D. Johnson." 1925.035

San Fernando Mission or *The Mission* 1901 oil on board, 13 1/2" x 9 1/2" (34.1 x 24.0 cm) "Gift from Dr. George L. and Emma Smart Collection" 1925.036

Sawmill up American Fork Canyon 1898 pastel, 17" x 20 1/2" (43.6 x 52.2 cm) "Gift from Dr. George L. and Emma Smart trust" 1987.023

Shaded Path date unknown pastel, 11 3/4" x 8 1/4" (30.0 x 20.7 cm) "Gift from Mrs. A. W. McCune, SLC" 1924.005

Sketch of the Valley 1909 pencil, 8 1/4" x 11 1/4" (21.0 x 28.4 cm) "In Honor of the John Hafen from His Family" 1910.006

Springville, My Mountain Home 1907 oil on canvas, 24" x 36" (61.0 x 91.3 cm) "Gift from A. Merlin and Alice Steed trust" 1989.002

Sunny Picture 1900 oil on canvas, 18" x 22" (45.9 x 56.0 cm) "Gift from Dr. George L. and Emma Smart collection" 1925.038

Tepees 1907 oil on canvas, 22" x 31" (56.1 x 79.0 cm) Museum Purchase 1913.001

The Wasatch Valley 1905 oil on canvas, 16 1/4" x 24" (41.0 x 60.2 cm) "Gift from the artist, John Hafen, Springville" 1907.004

Winter 1902 oil on board, 9 1/2" x 13 1/2" (24.4 x 34.2 cm) "Gift from Dr. George L. and Emma Smart collection" 1925.039

Yacht Race 1904 pencil, 5 1/4" x 8 3/4" (13.6 x 22.3 cm) "Gift from Dr. George L. and Emma Smart collection" 1925.041

Yachts on Utah Lake 1904 pencil, 7" x 10 3/4" (17.5 x 27.0 cm) "Gift from Dr. George L. and Emma Smart collection" 1925.042

VIRGIL OTTO HAFEN (1887 -1949) Springville

Indians c. 1933 oil on canvas, 20" x 26 1/4" (51.0 x 66.4 cm) "Gift from Hugh Dougall Gardner, Springville" 1975.006

La Cote d'Azure c. 1915 oil on canvas, 15" x 24" (38.1 x 60.6 cm) "Gift from Springville High School, Senior Class" 1915.001

Maple Tree Pass 1934 oil on canvas, 20 1/2" x 26" (51.9 x 66.1 cm) "Gift from an Anonymous Donor" 1988.003

GEORGE WILLARD HANDRAHAN (1949 -) Layton

Farmington in Fall 1985 oil on canvas, 36" x 48" (91.4 x 122.0 cm) "Gift from Walter Ulrich, Jr." 1989.031

LOUISE BRIMHALL HANSEN (1927 -) Utah

Canyonland Storm 1987 watercolor, 19 3/4" x 28" (50.4 x 70.7 cm) "Gift from the Artist, Louise B. Hansen" 1989.085

C. LANCE HARDING (1951 -) American Fork

The Glory of the Man (second of a pair) 1982 bronze, circular 37" diameter (94.6 cm dia.) "Gift from David and Ingrid Nemelka, Mapleton" 1989.081

Man in a Squared Circle (first of a pair) 1982 bronze, circular 37" dia. (94 cm dia.) "Gift from David and Ingrid Nemelka, Mapleton" 1988.084

Rugroll 1978 -79 alabaster stone, 19 1/4" x 17 1/2" x 20" (48.9 x 44.5 x 50.8 cm) "Gift from the Artist, Lance Harding, American Fork" 1981.035

CAROL PETTIT HARDING (1935 -) Pleasant Grove

Tinaja Voyage, West Temple Zions 1989 oil on canvas, 42" x 50" (121.8 x 131.8 cm) "Gift from the Geneva Steel, Orem" 1989.068

MAUD R. HARDMAN (? -1981) Utah

Bryce Canyon 1934 woodcut/blockprint, 6 1/4" x 4 1/2" (16.0 x 11.2 cm) "Gift from Lund-Wassmer Collection" 1986.147

JAMES TAYLOR HARWOOD (1860 -1940) Lehi/Salt Lake City

An Interesting Story 1904 oil on canvas, 15 1/4" x 18" (38.5 x 36.0 cm) "Gift from the artist, James T. Harwood, Salt Lake City" 1913.002

Apricots c. 1885 oil on canvas, 14" x 8" (36.0 x 20.3 cm) "Gift from A. Merlin and Alice Steed trust" 1983.012

Autumn-Millcreek Canyon 1933 oil on canvas, 22 1/4" x 14" (56.4 x 35.5 cm) "Gift from Lund-Wassmer Collection" 1986.150

Boy with a Bun 1910 oil on canvas, 40" x 32 1/4" (101.9 x 82.0 cm) Museum Purchase 1910.007

Cagnes France 1930, March 8 mixed media, 12" x 9 1/4" (30.6 x 23.0 cm) "Gift from James and Sandy Harrison, Bountiful" 1990.032

Exhausted Model 1924 oil on canvas, 24 1/2" x 16 1/2" (62.4 x 42.2 cm) "Gift from Dr. George L. and Emma Smart trust" 1985.012

Footsteps in Spring Liberty Park 1930 oil on canvas, 26" x 40" (66.5 x 102.0 cm) "Gift from Blaine P. and Louise Clyde, Springville" 1984.039

Harvest Scene in France 1890 watercolor, 11" x 18 1/2" (28.2 x 46.7 cm) "Gift from A. Merlin and Alice Steed trust" 1990.044

Harvest Time in France 1890 oil on canvas, 17 1/2" x 31" (44.0 x 78.5 cm) "Gift from Blaine P. and Louise Clyde, Springville" 1983.041

Pont Neuf at Dawn 1930 intaglio/etching, 12" x 15 3/4" (30.4 x 39.5 cm) "Gift from Mrs. H. K. (Margaret) Richards, Santa Barbara" 1989.063

Portrait of Harriet with baby Lawrence James 1900 oil on canvas, 46 1/2" x 27 3/4" (118.1 x 70.5 cm) "Gift from Lund-Wassmer Collection" 1986.073

Sand Market at Cannes France 1927 intaglio/etching, 8 3/4" x 10 1/4" (22.0 x 26.5 cm) Museum Purchase 1988.069

JOHN HELD, JR. (1889 -1958) Salt Lake City/New York City

Ma Lives c. 1924 gouache/tempera on board, 7" x 6 1/4" (17.4 x 16.0 cm) "Gift from Dr. George L. and Emma Smart trust" 1985.013

MARGARET TAYLOR HEYWOOD (1911 -) Salt Lake City

The Sketch: Self-Portrait 1986 watercolor, 21 3/4" x 27 3/4" (55.0 x 70.6 cm) "Gift from the Artist, Margaret Heywood" 1989.015

HAL DOUGLAS HIMES (1956 -) Provo

Tabernacle 1989 oil on canvas, 48" x 72" (122.0 x 182.5 cm) "Gift from Dolores Chase Gallery, Salt Lake City" 1990.054

HORST HOLSTEIN (1952 -) Salt Lake City

Mollusk 1985 mixed media, 33" x 25 3/4" (84.0 x 65.4 cm) "Gift from the Artist" 1991.014

FRANCIS LEROY HORSPOOL (1871 -1951) Salt Lake City

Horspool Pioneer Home 1939 oil on canvas, 31 3/4" x 37 3/4" (80.0 x 96.2 cm) "Gift from F. Ed and Judy Bennett, Salt Lake City" 1981.012

FRANK R. HUFF, JR. (1958 -) Salt Lake City

Jordan River Temple 1985 watercolor, 29 1/2" x 39 1/2" (74.7 x 100.0 cm) "Gift from Lund-Wassmer Collection" 1985.005

Living Their Religion 1987 oil on canvas, 48" x 54" (121.8 x 137.4 cm) "Gift from the Artist, Frank R. Huff, Jr." 1988.034

Mountain Peak, Little Cottonwood Canyon 1982 watercolor, 12 1/4" x 14 1/4" (31.0 x 36.3 cm) "Gift from David and Karen Ericson, Salt Lake City" 1983.015

Still Life with Cloth and Cup 1989 oil on paper, 10 1/2" x 14 1/2" (26.5 x 36.6 cm) "Gift from Peter and Donna Crawley, Provo" 1989.086

FRED J. HUNGER (1936 -) Utah

Morning-White, Shadows and Monoliths 1974 acrylic on canvas, 48" x 63 1/4" (122.0 x 160.7 cm) Museum Purchase from Spring Salon 1974.006

MARION ROUNDY HYDE (1938 -) Logan

Night Music 1988 woodcut/blockprint, 29" x 23 3/4" (73.8 x 59.4 cm) "Gift from Louise C. Clyde, Springville" 1990.018

GEORGE EDWARD INSHAW (1861 -1938) Springville

Evening 1904 watercolor, 9 1/2" x 13 3/4" (24.0 x 34.6 cm) "Gift from Wheeler Mortuary, Springville" 1984.045

Old Augustus Sell Boyer Home, Springville 1917 oil on board, 14" x 20" (35.6 x 51.0 cm) "In Memory of Mae Jenson Thomson from Elna T. Kuhlmann" 1988.041

JOHN BRENT JARVIS (1946 -) Pleasant Grove

Southern Utah Landscape 1989 gouache/tempra, 16 3/4" x 28 1/2" (42.5 x 71.7 cm) "Gift from Hans Burger Trust" SLC 1989.038

MIRIAM BROOKS JENKINS (1885 -1944) Salt Lake City

Late Afternoon from North Rim 28 May, 1928 watercolor, 9 3/4" x 13" (24.6 x 34.0 cm) "Gift from the Artist's family" 1989.012

Still-Life with Turnips and Clock 1940 watercolor, 8 1/4" x 10" (21.4 x 26.0 cm) "Gift from the Artist's family" 1989.013

246

OLIVE BELNAP JENSEN (1888 -1979) Utah

Vase with Flowers 1930s oil on board, 20" x 24" (50.8 x 61.0 cm) "Gift from Mrs. H. K. (Margaret) Richards, Santa Barbara" 1989.064

EDGAR M. JENSON (1888 -1958) Provo

Mother Tree 1940 oil on board, 22" x 18" (56.4 x 45.1 cm) "In Memory of Her Husband, from Maurine Fillmore Bryner" 1988.047

SAMUEL HANS JEPPERSON (1855 -1931) Provo

Goodbye Sweet Day 1919 oil on board, 15" x 20" (37.8 x 50.4 cm) "Gift from Vern G. and Judy N. Swanson, Springville" 1988.033

Indian Paradise 1920s oil on canvas mounted, 25 1/2" x 34 1/2" (64.5 x 87.6 cm) "Gift from the Eldred Center Foundation, Provo" 1988.031

Provo City in 1865 1928 oil on canvas mounted, 28 1/2" x 40" (72.5 x 101.5 cm) "Gift from the Eldred Center Foundation, Provo" 1988.030

Provo Haystack 1920s oil on canvas, 21 3/4" x 33" (55.5 x 84.2 cm) "Gift from Virginia Keeler, Provo" 1983.022

Provo River Settlement 1920s oil on canvas, 20" x 24" (50.8 x 61.0 cm) "Gift from Mrs. Ruth Brac of Salt Lake City" 1978.008

Utah Lake Bayou 1920s oil on canvas, 20" x 30" (50.8 x 76.4 cm) "Gift from Virginia Keeler, Provo" 1983.023

FRANZ MARK JOHANSEN (1928 -) Provo

Portrait bust of Gerrit de Jong 1962 bronze, 23 1/4" x 11" x 11" (59.0 x 28.4 x 28.0 cm) "Gift from Thelma Bonham (Mrs. Gerrit) de Jong, Provo" 1982.025

Veil Series 1986 oil on board, 47" x 39 1/2" (122.0 x 100.8 cm) "Memory of Ruth H. Nemelka from David & Ingrid Nemelka" 1987.036

NATHAN ALDOUS JOHANSEN (1958 -) Provo/Springville

Faith of a Mustard Seed 1987 stone, 17 3/4" x 21 1/2" x 3 1/2" (45.1 x 54.5 x 8.6 cm) "Memory of Ruth H. Nemelka from David and Ingrid Nemelka" 1987.037

MARY CLARK KIMBALL JOHNSON (1906 -) Salt Lake City

Survival, Tropic Canyon Utah 1945 watercolor, 22 3/4" x 17 3/4" (57.9 x 44.8 cm) "Gift from the Artist, Mary Kimball Johnson" 1988.068

STANLEY QUENTIN JOHNSON (1939 -) Mapleton/Benjamin

Eagle Boy 1982 bronze, 45 1/2" x 33" x 17 1/2" (115.8 x 83.9 x 44.4 cm) "Gift from Frederick C. and Sherry Ross, New Jersey" 1983.045

WAYNE JOHNSON (1871 -1950) Springville

Heading to Mouth of Hobble Creek Canyon 1931 oil on board, 12" x 15 3/4" (30.0 x 40.0 cm) "Gift from estate of Lucille C. Bird by her stepsons" 1973.007

Hobble Creek Canyon 1947 oil on board, 22" x 28" (56.2 x 71.4 cm) "Gift from the artist, Wayne Johnson, Springville" 1947.007

Provo Canyon c. 1935 oil on board, 15 3/4" x 19 3/4" (41.2 x 51.0 cm) Unknown source 1970.001

Winter Silence date unknown oil on board, 22 1/4" x 28" (50.5 x 65.8 cm) "Gift from Anonymous Donor" 1986.024

RICHARD MERVYL JOHNSTON (1942 -) Salt Lake City

Red Aluminum 1990 metal, 29 3/4" x 24 1/2" x 12" (75.5 x 61.5 x 30.4 cm) Museum purchase from Spring Salon 1990.015

RAYMOND VINCENT JONAS (1942 -) Provo

Abstract Configuration 1982 wood, 46" x 74" x 56 1/2" (117.0 x 188.0 x 143.5 cm) Museum Purchase 1985.019

Non-Objective Sycamore Sculpture 1976 wood, 35 1/2" x 15 3/4" x 14 1/2" (136.0 x 40.0 x 37.0 cm) "Gift from Peter and Donna Crawley, Provo" 1981.027

EARL M. JONES (1937 -) Salt Lake City

Near Francis, Utah 1978 oil on canvas, 20" x 24" (51.0 x 61.1 cm) "Gift from Lund-Wassmer trust Collection" 1990.006

HOWARD KEARNS (1907 -) Springville

Desert Barber Shop 1946 watercolor, 19" x 25" (48.7 x 63.6 cm) "Gift from Glen E. Robertson, Visalia California" 1980.004

Hills Near Scipio 1947 oil on board, 23 3/4" x 29 3/4" (60.1 x 75.8 cm) Museum Purchase 1947.008

Hitch-hiker date unknown watercolor, 13 3/4" x 10" (34.0 x 25.2 cm) "Gift from Mrs. Loretta Kearns, the artist's mother" 1951.002

Passing Shadows 1930s watercolor, 20 3/4" x 28 3/4" (52.8 x 73.2 cm) "Gift from Mrs. Loretta Kearns, the artist's mother" 1951.003

FRANK WARD KENT (1912 -) Salt Lake City

On the Waterfront, New York 1930 mixed media, 9 1/2" x 8" (24.1 x 20.0 cm) Museum Purchase 1989.037

JOSEPH KERBY (1857 -1911) Park City

Painted Stage set for Egyptian Theatre, Park City 1890s oil on canvas, 36" x 48" (91.5 x 122.3 cm) "Gift from Carolyn Ostler, Provo" 1990.070

Straw Hat with Apples c. 1900 oil on canvas mounted, 20" x 30" (51.1 x 76.1 cm) "Gift from a Friend of the Museum" 1991.002

BRIAN T. KERSHISNIK (1962 -) Provo

Fallen Icarus in the Park 1988 oil on canvas, 18" x 24" (45.8 x 61.0 cm) "Courtesy of the artist, Brian T. Kershisnik" 1990.038

RANCH SHIPLEY KIMBALL (1894 -1980) Salt Lake City

Entrance to Zion's 1934 oil on canvas mounted, 29" x 35" (73.6 x 89.0 cm) "In Memory of Thomas Rolo Kelly from Louise Kelly" 1988.027

Man Manicures Mountain 1934 pastel, 10" x 13 1/2" (25.8 x 34.3 cm) "Gift from Mary Louise Kimball, In Memory of Ranch" 1988.028

(WILFORD) WAYNE KIMBALL, JR. (1943 -) Pleasant Grove

2nd Elddir Without the (Ernst) Nightingale 1987 lithograph, 14" x 11" (35.5 x 28.0 cm) "Gift from Frederick C. and Sherry Ross trust, NJ" 1988.015

REUBEN KIRKHAM (1845 -1886) Utah

Castaway 1882 oil on canvas, 22" x 18" (55.6 x 45.3 cm) "Gift from Josephine S. (Mrs. Charles) Burton, SLC" 1968.005

Sunset in Blacksmith Fork Canyon, Logan 1879 oil on canvas, 29" x 45 1/2" (73.7 x 115.6 cm) "Gift from Lund-Wassmer Collection" 1989.032

TORLIEF SEVERIN KNAPHUS (1881 -1865) Utah

Sleep c. 1936 plaster, 7 1/2" x 35" x 16 1/4" (19.0 x 88.9 x 41.4 cm) "Gift from the Artist, Torlief Knaphus" 1952.002

Southern Utah Landscape 1925 oil on canvas mounted, 17 1/2" x 25 1/4" (44.1 x 64.6 cm) "Gift from Sherrill Sandberg, SLC" 1983.001

JEAN KRILLÉ (1923 -) Utah/France

International Landscape 1986 acrylic on board, 39" x 39" (99.0 x 98.9 cm) "Gift from Marcia Paulsen Price, SLC" 1987.020

PAUL S. KUHNI (1895 -1986) Salt Lake City

View of Timpanogas from Heber Valley 1938 oil on board, 14" x 18" (35.5 x 45.8 cm) "Gift from Dr. William Seifrit, SLC" 1990.009

RANDALL BRUCE LAKE (1947 -) Salt Lake City

Earl Jones Painting in His Studio 1981 oil on canvas mounted, 12" x 9" (30.5 x 22.6 cm) "Gift from David and Karen Ericson, Salt Lake City" 1988.022

Two Painters of the Guthrie 1979 oil on canvas, 51 1/4" x 38 1/4" (130.5 x 97.4 cm) "Gift from A. Merlin and Alice Steed trust" 1982.013

ALFRED EDWARD LAMBOURNE (1850 -1926) Salt Lake City

Black Rock, Great Salt Lake 1890 gouache/tempra, 6 3/4" x 23 1/2" (17.1 x 59.6 cm) "Anonymous Gift" 1941.002

Gunnison Island on the Inland Sea, Great Salt Lake 1903 gouache/tempra, 28 1/4" x 42 1/4" (72.0 x 107.6 cm) "Gift from Lela Nielson of Springville" 1982.019

Gunnison Island, West Shore, Autumn Sunset 1924 gouache/tempra, 7" x 24" (17.6 x 60.7 cm) "Gift from Marie Fowler Bozievich, Bethesda, MD" 1990.027

Moonlight—-Silver Lake, Cottonwood Canyon 1880 oil on canvas mounted, 17 1/2" x 29 3/4" (44.7 x 75.6 cm) "Honor of Harold L. Shanks from Rosalie Shanks Bregante" 1990.028

Summer noon, South side of the Great Salt Lake 1921 gouache/tempra, 7" x 24" (17.6 x 60.8 cm) "Gift from Marie Fowler Bozievich, Bethesda MD" 1990.026

Temples of the Rio Virgin, Utah 1886 oil on canvas, 22 1/4" x 35 1/4" (56.4 x 89.4 cm) "Gift from A. Merlin and Alice Steed trust" 1983.027

Twilight near the mouth of the Jordan, Utah 1872 oil on canvas, 12" x 24 1/4" (30.8 x 61.4 cm) "Gift from A. Merlin and Alice Steed trust" 1984.042

BENT FRANKLIN LARSEN (1882 -1970) Provo

Andre L'Hote Nude 1929 pencil, 12 1/2" x 9 1/4" (32.0 x 23.5 cm) "Gift from Milton J. and Louisa S. Thurber, Seattle, WA" 1989.021

Belgian Fields 1924 oil on canvas, 20" x 28" (51.0 x 73.0 cm) "Gift from the artist, Bent F. Larsen, Provo" 1926.006

Cordes, France, August 1929 1929 August mixed media, 11" x 14 1/2" (28.7 x 36.5 cm) "Gift from Milton J. and Louisa S. Thurber, Seattle, WA" 1987.017

Departing Summer near Provo 1936 oil on canvas, 32" x 40" (81.3 x 101.8 cm) "Gift from Earl Bonham, Salt Lake City" 1990.069

Eureka, Utah 1937 pencil, 8" x 9 3/4" (20.3 x 24.5 cm) "Gift from Milton J. and Louisa S. Thurber, Seattle, WA" 1976.007

Kolob Canyon, near Springville 1936 oil on canvas, 32 1/4" x 40 1/4" (82.0 x 102.0 cm) Museum Purchase 1968.006

Landscape at Cordes, France #226 1929 oil on canvas, 32" x 39 1/2" (81.0 x 100.9 cm) "Gift from Dr. George L. and Emma Smart trust" 1987.016

Mine at Mammoth, Utah 1932 oil on canvas, 24" x 20" (60.8 x 51.0 cm) "Gift from Milton J. and Louisa S. Thurber, Seattle, WA" 1989.020

Old Well at Taos 1937 pencil, 8 1/2" x 11" (21.5 x 27.7 cm) "Gift from Milton J. and Louisa S. Thurber, Seattle, WA" 1976.010

Scrubwoman 1937 pencil, 8" x 9" (20.4 x 22.8 cm) "Gift from Milton J. and Louisa S. Thurber, Seattle, WA" 1976.008

St. Cere, France, July 1929 1929 July watercolor, 13 3/4" x 10 3/4" (34.8 x 27.3 cm) "Gift from Milton J. and Louisa S. Thurber, Seattle, WA" 1976.009

Studies of two Nude Women 1929 pencil, 13 1/2" x 10 1/4" (34.4 x 26.4 cm) "Gift from Vern G. and Judy N. Swanson, Springville" 1989.022

Susquehanna River 1955 oil on canvas, 32 1/4" x 40" (81.8 x 101.5 cm) "Gift from Springville Junior and Senior High School" 1955.002

Taos, New Mexico 1937 pencil, 11 3/4" x 8 1/2" (29.9 x 22.0 cm) "Gift from Royden Card, Provo" 1980.001

The Mother Tree or *Autumn* 1926 oil on canvas, 25 1/4" x 31 3/4" (64.0 x 81.0 cm) "Gift from Springville High School" 1926.007

Uzerche Tannery, France 1929 oil on canvas, 32" x 40" (81.0 x 101.0 cm) "Gift from A. Merlin and Alice Steed trust" 1988.007

THOMAS A. LEEK (1932 -) Cedar City/Salt Lake City

Eternal Forces 1990 watercolor, 21" x 29" (53.3 x 74.0 cm) "Gift from David and Ingrid Nemelka, Mapleton" 1990.063

MARTIN LENZI (1815 -1898) Salt Lake City

Still-Life with Grapes October 1891 oil on board, 17 1/2" x 10 1/2" (44.2 x 26.2 cm) "Gift from Chris and Claudia Cannon, Mapleton" 1989.016

GAELL WILLIAM LINDSTROM (1919 -) Logan

Park City 1959 watercolor, 18 3/4" x 28" (47.3 x 71.0 cm) Museum Purchase from Spring Salon 1959.003

RONALD LITTLE (1933 -) Utah/Sacramento

Holy Family January 1987 wood, 9 3/4" x 5 1/2" x 2 1/2" (24.7 x 14.2 x 6.0 cm) "Gift from Vern G. and Judy N. Swanson, Springville" 1988.086

JUDY FARNSWORTH LUND (1911 -) Salt Lake City

In Fruita, Near Zions 1950 oil on canvas, 24" x 30" (60.7 x 76.3 cm) "Gift from Lund-Wassmer Collection" 1986.191

Provincetown Roof Tops 1946 oil on board, 23 1/4" x 19" (59.0 x 48.0 cm) "Gift from Lund-Wassmer Collection" 1986.189

September 1949 oil on canvas, 24" x 20" (61.0 x 51.1 cm) "Gift from Lund-Wassmer Collection" 1986.188

Theodore Milton Wassmer 1975 charcoal, 13 3/4" x 9 3/4" (35.0 x 25.0 cm) "Gift from Lund-Wassmer Collection" 1986.192

Yellow Moon 1948 oil on board, 22" x 28" (55.7 x 70.7 cm) "Gift from Lund-Wassmer Collection" 1986.190

NANCY A. LUND (1933 -) Bountiful

Just off Second Avenue 1979 watercolor, 17" x 18 1/4" (43.4 x 46.3 cm) "Gift from the Artist, Nancy Lund, SLC" 1981.044

THELMA JOHNSON LUND (1909 -1978) Utah

Still-Life 1940 oil on board, 24" x 18" (61.0 x 45.5 cm) "Gift from Lund-Wassmer Collection: Alton F. Lund, SLC" 1986.067

FRANK MAGLEBY (1928 -) Provo

Timpanogos from South Fork 1978 oil on board, 24" x 40" (61.0 x 101.6 cm) Museum Purchase from Spring Salon 1979.003

WILLIAM WARNER MAJOR (1804 -1854) Salt Lake City

. . . Rocky Mountains . . . Parishort, or Leap of Elk, Chief of Corn Creek. Near Fillmore . . . Pauvan May 1852 watercolor drawing, 8 1/2" x 6" (21.4 x 15.4 cm) "Gift from Blake & Nancy Roney, and Steve & Kalleen Lund, Provo" 1991.021

Wash'echick, Chief of the Shoshomas Tribe c. 1852 watercolor drawing, 7 1/2" x 5 1/4" (19.3 x 13.5 cm) "Gift from an Anonymous Friend of the Museum" 1991.022

ELVA E. MALIN (1933 -) Salt Lake City

Roundup in Peoa 1970s oil on canvas, 18" x 28" (45.7 x 71.0 cm) "Gift from Doug Muir, In memory of Grace Muir" 1989.048

MILLARD FILLMORE MALIN (1891 -1974) Utah

Chief John Duncan, Ute 1935 bronze, 19 1/2" x 9 3/4" x 8 1/2" (49.5 x 24.8 x 21.5 cm) "Gift from A. Merlin and Alice Steed trust" 1983.013

ROBERT LEROY MARSHALL (1944 -) Springville

Money Plant 1982 oil on canvas, 60" x 48" (152.4 x 122.3 cm) "Gift from Dr. George L. and Emma Smart trust" 1983.026

Snow Canyon 1984 watercolor, 23" x 33 1/2" (58.1 x 85.2 cm) Museum Purchase from Spring Salon 1984.018

EDWARD D. MARYON (1931 -) Salt Lake City

Big Sur Nursery 1975 watercolor, 16 1/2" x 21 1/2" (42.1 x 54.5 cm) Museum Purchase from Spring Salon 1977.004

BEVERLY WHEELER MASTRIM (1923 -) Salt Lake City

Self-Portrait 21 April, 1958 oil on canvas, 19 1/2" x 13 1/2" (49.8 x 34.5 cm) "Gift from the Artist, Beverly Mastrim, SLC" 1987.006

CONAN E. MATHEWS (1905 -1972) Providence/Provo

Capitol Reef II 1971 watercolor, 21" x 28 3/4" (53.7 x 73 cm) "Gift from the Artist's widow, Provo" 1981.038

FRANK McENTIRE (1946 -) Salt Lake City

Beginnings 1986 charcoal, 11 1/2" x 8 1/4" (29.2 x 21.5 cm) "Gift from Vern G. and Judy N. Swanson, Springville" 1989.001

Whisper to the Listening Stone 1991 mixed media sculpture, 56" (142.5cm) Museum purchase 1991.029

WALDO PARK MIDGLEY (1888 -1985) Salt Lake City/New York

At the Zoo 1935 pen & ink, 5 1/2" x 4 1/4" (13.3 x 11.0 cm) "Gift from Lund-Wassmer Collection" 1986.204

Atlantic Shores in Maine c. 1921 oil on board, 16" x 20" (40.5 x 50.4 cm) Museum Purchase 1923.200

Gardo House 1921 pen & ink, 8" x 11 1/2" (20.3 x 29.0 cm) "Gift from Mr. and Mrs. Frank J. Earl, Provo, trust" 1982.033

View of Park City 1924 oil on canvas, 20" x 24" (50.0 x 61.0 cm) "Gift from F. Ed and Judy Bennett, Salt Lake City" 1981.003

MARIE CLARK MILLER (1891 -1961) Springville/California

Study of Green Grapes 1908 watercolor, 10 3/4" x 9 1/2" (27.5 x 24.0 cm) "Gift Dorothy C. Minor in honor of Helen Clark" 1982.026

OSCAR OLAF MOLLER (1903 -1985) Utah/Idaho

Tiffany Poole 1927 oil on canvas, 30" x 36" (76.5 x 91.5 cm) "Gift of Springville High School, Junior Class" 1933.003

BART J. MORSE (1938 -) Utah

Rincon Watercourse, Arroyo 1978 watercolor, 20 1/2" x 27 3/4" (52.0 x 70.5 cm) Museum Purchase from Spring Salon 1979.004

JOHN HENRI MOSER (1876 -1951) Malad/Logan

Golden October—Quaking Aspens 1932 oil on board, 16" x 12" (40.5 x 30.1 cm) "Gift from Lund-Wassmer Collection" 1986.209

Logan Canyon, New Beaver Dam 1926 oil on canvas, 25 1/4" x 32 1/4" (64.0 x 81.7 cm) "Gift from Lund-Wassmer Collection" 1991.001

PETER LIVINGSTON MYER (1934 -) Provo

Self Portrait 1986 pastel, 17 3/4" x 14" (44.8 x 35.4 cm) "Gift from the Artist, Peter Myer" 1989.072

FRANK J. NACKOS (1939 -) Springville

Perigee 1/6 1971 metal, 41 1/2" x 24 1/2" x 24 3/4" (105.4 x 61.2 x 63.0 cm) "Gift from Walker Bank" 1987.018

ANN MARIE OBORN (1947 -) Bountiful

Snow Balls in the Sun 1990 oil on board, 20" x 16" (50.5 x 39.9 cm) Museum Purchase, 1991.017

DONALD PENROD OLSEN (1910 -1984) Salt Lake City

Chelsea VI 1980 acrylic on canvas, 67 1/2" x 80" (170.7 x 197.1 cm) Museum Purchase 1981.056

Composition 1963 oil on canvas, 70" x 68 1/2" (177.5 x 174.0 cm) "Gift from A. Merlin and Alice Steed trust" 1989.005

JOSEPH E. OSTRAFF (1957 -) Alpine

Albino Trout 1989 Acrylic on board, 48" x 24" (122.0 x 61.3 cm) "Gift from Vern G. and Judy N. Swanson" 1991.016

GEORGE MARTIN OTTINGER (1833 -1917) Salt Lake City

Aztec Maiden 1881 oil on canvas, 30" x 42" (76.5 x 107.0 cm) "Gift from the Ardelle H. Ashworth Family, Provo" 1977.005

Flowers of Cola Layona 1884 oil on canvas, 18" x 24" (46.0 x 61.1 cm) "Gift from Cyrus E. Dallin and Alfred Lambourne" 1924.006

Immigrant Train 1897 oil on canvas, 20" x 40" (51.0 x 101.7 cm) "Gift from A. Merlin and Alice Steed trust" 1982.001

Immigrant Train at the City of the Rocks, Idaho c. 1870 oil on board, 13 1/4" x 16 1/4" (33.5 x 41.2 cm) Museum Purchase 1987.015

Portrait of Eliza Thompson McAllister 1862 oil on canvas, 28 1/4" x 24" (71.5 x 60.5 cm) "Gift from Peter and Donna Crawley, Provo" 1985.036

Self-Portrait as Fire Chief c. 1877 oil on paper, 21 3/4" x 18" (55.0 x 46.3 cm) Museum Purchase 1986.001

Self-Portrait of the Artist c. 1869 oil on board, 5" x 4" (oval) (12.1 x 10.2 cm) "Gift from David and Karen Ericson, Salt Lake City" 1981.016

FAE CALVIN PACKARD (1927 -) Springville

A Pleasant Memory 1975 oil on canvas, 23 3/4" x 36" (60.0 x 91.4 cm) Museum Purchase from Spring Salon 1975.009

Winter in the Wasatch 1970 oil on canvas, 24" x 30" (61.0 x 76.4 cm) "Gift from LaPrele Makin, Provo" 1985.017

CATHY PARDIKE (1939 -) Salt Lake City

Untitled 1980 mixed media, 12 3/4" x 16" (32.5 x 40.6 cm) "Gift from Doug Muir, In memory of Grace Muir" 1989.039

WILLIAM JENSEN PARKINSON (1899 -) Salt Lake City

Crucifixion c. 1945 oil on board, 23 1/4" x 26" (59.0 x 66.0 cm) "Gift from Vern G. and Judy N. Swanson, Springville" 1990.030

House Wife 1961 oil on board, 16" x 20" (40.7 x 50.0 cm) "Gift from the Artist, William J. Parkinson" 1981.005

My Friend, Paul Smith Reading c. 1930 charcoal, 19" x 14" (48.1 x 35.5 cm) "Gift from F. Weixler Company, Salt Lake City" 1988.056

Self-Portrait pen & ink, 10 1/2" x 7 3/4" (26.6 x 19.7 cm) "Gift from Vern G. and Judy N. Swanson, Springville" 1989.014

Within the Ancient Underground Temple of Oude c. 1945 oil on board, 24" x 30" (61.0 x 75.8 cm) "Gift from the Artist, William J. Parkinson, SLC" 1988.062

CAROLYN K. PARRY (1885-1967) Salt Lake City

Bust of a Young Boy Scout n.d. plaster, 11" x 7 1/2" x 5 1/4" (28.2 x 19.4 x 14.5 cm) "Gift from Evelyn Vernon, Salt Lake City" 1991.028

DELWIN OLIVER PARSON (1848 -) Springville/Rexburg

Spirit of 76 1975 oil on canvas, 36" x 40 1/4" (91.3 x 101.9 cm) Museum Purchase from Spring Salon 1975.010

H. OLIVER PARSON (1916 -) Springville/Rexburg

Snow Patches c. 1948 oil on canvas mounted, 30" x 35 3/4" (76.2 x 89.3 cm) "Gift from Federated Aureole Clubs of Springville" 1982.004

THELMA BAGNELL PARSONS (1927 -) Murray

Morning at Capitol Reef 1983 watercolor, 18 3/4" x 24" (47.5 x 61.0 cm) "Gift from Greg Parsons, Murray, Utah" 1989.054

ESTHER ERIKA PAULSEN (1896 -) Utah

The Old Mill 1930s oil on canvas, 19 1/2" x 23 1/2" (49.5 x 59.5 cm) "Gift from F. Ed and Judy Bennett, Salt Lake City" 1981.031

HILMA MOLE PAYNE (1901 -1973) Utah

A Utah Morning 1946 oil on canvas, 28" x 30" (70.6 x 75.7 cm) "In Memory of Dr. & Mrs. Lyman Horne from Leonard & Harriet Arrington" 1988.042

ELLA GILLMER PEACOCK (1905 -) Spring City

In Nephi 1988 oil on canvas, 18" x 24" (46.0 x 61.1 cm) "Gift from A. Merlin and Alice Steed trust" 1989.052

WILLIAM J. PETERS (1916 -1963) Provo

Autumn 1940s oil on board, 24" x 30" (61.0 x 75.8 cm) "Gift from A. Merlin and Alice Steed collection" 1948.094

Portrait of A. Merlin Steed 1938 pencil, 19 1/2" x 14" (49.3 x 35.5 cm) "Gift from A. Merlin and Alice Steed collection" 1948.091

Portrait of Alice Wilcox Steed 1945 pencil, 19 1/4" x 14" (49.0 x 35.3 cm) "Gift from A. Merlin and Alice Steed collection" 1948.092

MARK BEVAN PETERSEN (1953 -) Salt Lake City

Grand Canyon 1982 oil on board, 6 1/2" x 16"

(16.5 x 40.5 cm) "Gift from David and Karen Ericson, Salt Lake City" 1983.016

BONNIE G. PHILLIPS (1942 -) Salt Lake City

Whole Wheat on Tuna 1981 watercolor on satin, 41 1/2" x 35 1/2" (105.6 x 90.3 cm) Museum Purchase 1981.055

DENIS RAY PHILLIPS (1938 -) Salt Lake City

Abstract Expressionism 1966 oil on canvas, 54 3/4" x 42 3/4" (139.1 x 108.8 cm) "Gift from Vern G. and Judy N. Swanson, Springville" 1981.033

Near St. Charles, Idaho August 1974 oil on canvas, 22" x 28" (56.1 x 71.0 cm) "Gift from the Geneva Steel, Orem" 1990.067

WAYNE "LUCKY" PICKERING (1910 -1981) Spanish Fork

Nude Female Figure c. 1960 bronze, 6" x 7" x 3 1/2" (15.0 x 17.7 x 9.0 cm) "Gift from the Artist's Family" 1985.033

PETE PLASTOW (1930 -) Moab

The Monitor and Merrimack 1989 oil on canvas, 30" x 60" (76.5 x 152.2 cm) "Gift from Al and Linda Switzler, Highland Utah" 1990.002

ELBERT H. PORTER (1917 -) Salt Lake City

Boy with Frog 1950 terra-cotta, 30" x 10 1/4" x 15 3/4" (76.2 x 26.2 x 40.0 cm) "Gift from the Artist, Elbert Porter" 1952.003

Negro Head 1930s bronze, 8" x 7" x 4 1/2" (3 x 18.0 x 11.5 cm) "Gift from the Grace Muir Collection Trust" 1989.080

BONNIE LEE BLAIR POSSELLI (1942 -) Sandy

Trees in Winter 1978 oil on canvas, 12" x 16" (30.5 x 40.5 cm) "Gift from Doug Muir, In memory of Grace Muir" 1989.042

LOUIS McLELLAN POTTER (1873 -1912) Utah

Portrait Bust of President Joseph F. Smith 1908 plaster, 26 1/4" x 18" x 9 1/4" (66.6 x 45.6 x 23.3 cm) Museum Purchase 1988.023

MYRA GROUT POWELL (1895 -1983) Ogden

Entanglement date unknown mixed media, 7 1/2" x 9 1/4" (19.1 x 23.4 cm) "Gift from Robert Stone, SLC" 1987.031

IRVIN T. PRATT (1891 -1955) Utah

Forest Stream 1930s watercolor, 9 3/4" x 13 1/4" (25.0 x 33.7 cm) "Gift from Grace Muir Collection trust" 1989.075 LORUS BISHOP PRATT (1855 -1923) Salt Lake City

Fishing along the Jordan 1916 oil on canvas, 16" x 28" (40.4 x 71.5 cm) "Gift from Blaine P. and Louise Clyde, Springville" 1984.012

Harvest Scene in France 1891 oil on canvas, 22" x 31" (56.4 x 78.8 cm) "Gift from Brent and Diane Pratt, Salt Lake City" 1986.085

Harvest Time in Cache Valley 1913 oil on canvas, 14" x 28" (35.4 x 71.2 cm) "Gift from Douglas and Afton Love trust, Dutch John, UT" 1985.032

Pioneer Portrait of Joseph Smith Bridge 1880s oil on canvas, 25" x 20" (63.5 x 50.9 cm) pair "Gift from David and Bea Glover, Bountiful" 1981.059

Pioneer Portrait of Mary Ann Walsh Bridge 1880s oil on canvas, 25" x 20" (63.5 x 51.0 cm) pair "Gift from David and Bea Glover, Bountiful" 1981.060

Shepherd and his Flock c. 1893 oil on canvas, 18" x 32" (45.5 x 82.0 cm) "Gift from A. Merlin and Alice Steed trust" 1984.008

GARY LEE PRICE (1955 -) Springville

Interlude 1989 bronze, 61 1/2" x 18" x 19 1/2" (155.5 x 45.7 x 49.5 cm) "Gift from Louise C. Clyde, Springville" 1990.017

The Christ 1985 bronze, 17 1/2" x 16" 8 1/2" (44.5 x 40.5 x 21.1 cm) "Gift from the Artist, Gary Price" 1989.084

CARL LEE PURCELL (1944 -) Manti

Barnyard 1981 intaglio/etching, 5 3/4" x 8 3/4" (14.9 x 22.5 cm) Museum Purchase 1983.010

IAN M. RAMSEY (1948 -) Salt Lake City

Farm in Winter, Centerville, Utah 1990 watercolor, 14" x 21" (35.9 x 53.5 cm) "Gift from Marcia C. Evans and Brent K. Evans, SLC" 1990.042

LEWIS A. RAMSEY (1875 -1941) Salt Lake City

Portrait of Grandfather, Thomas Steed 1905 oil on canvas, 30" x 25 1/4" (76.0 x 68.0 cm) "Gift from A. Merlin and Alice Steed collection" 1948.100

The Grand Canyon 1929 oil on board, 18" x 11 3/4" (45.7 x 30.2 cm) Museum Purchase 1981.013

HENRY NEIL RASMUSEN (1909 - ?) Salt Lake City

Allegory of War or *Mountain Landscape with houses* 1943 pastel, 19" x 26 1/4" (48.3 x 67.0 cm) "Gift from Mary Louise Kimball, In Memory of Ranch" 1988.002

Fish and Sails 1947 oil on board, 16" x 20" (40.5 x 51.0 cm) "Gift from Lund-Wassmer Collection" 1988.050

Still-Life with Fish, Fork and Spoon 1947 oil on board, 24" x 30" (61.0 x 76.1 cm) "Gift from Ranch Snow Kimball, Salt Lake City" 1983.016

ANTON JESSE RASMUSSEN (1942 -) Salt Lake City

Early Morning Beginning 1973 oil on canvas, 47 1/2" x 31 1/2" (120.0 x 79.5 cm) "Gift from David and Karen Ericson, Salt Lake City" 1984.041

Self Portrait 1984 oil on canvas, 24" x 30" (60.8 x 76.1 cm) "Gift from the Artist, Anthon Rasmussen" 1989.078

Study for Airport Mural 1981 mixed media, 9 1/4" x 14" (23.5 x 36.0 cm) Museum Purchase 1990.040

MICK REBER and DAVID HUNT (1942 -) Provo/Durango

You draw near unto Me with your lips, but your Heart is far from Me August 1987 ceramic sculpture, 20" x 19" x 3" (50.5 x 48.5 x 7.5 cm) "Gift from the Artists, Mick Reber and David Hunt" 1987.025

LURA REDD (1891 -) Utah

The Dam maybe Hungry Horse c. 1935 watercolor, 13" x 21 1/2" (32.5 x 54.0 cm) "Gift from Dr. Randal and Diane Gibb, Payson" 1986.084

H. REUBEN REYNOLDS (1898 -1974) Logan

Load of Hay, Logan 1941 oil on canvas, 24" x 30" (61.0 x 76.5 cm) "Gift from Mrs (Zina) H. Reuben Reynolds, Logan" 1981.037

LEE GREENE RICHARDS (1878 -1950) Salt Lake City

Big Cottonwood Stream 1932 oil on canvas, 39 1/2" x 32" (100.5 x 81.3 cm) "In Memory of Blaine P. Clyde from His Family & Friends" 1987.024

Bryce Canyon, Utah 1927 oil on board, 16" x 13" (40.5 x 32.6 cm)

"Gift from Lund-Wassmer Collection: Mrs. Roscoe A. Grover" 1986.077

Cenay de Ville France Aug. 11, 1902 pencil, 4 1/2" x 6 3/4" (11.2 x 17.3 cm) "Gift from Will and Allison South, Salt Lake City" 1983.038

Dreaming of Zion 1931 oil on canvas, 32" x 39 1/2" (100.5 x 81.5 cm) "Gift from Springville High School, Class of 1935 trust" 1988.008

The Girl in the Silk Dress 1904 oil on canvas, 29 1/4" x 21 1/4" (74.4 x 54.0 cm) "Gift from the artist, Lee Greene Richards, SLC" 1907.006

Grandma Eldredge's House, Salt Lake 1922 oil on canvas, 21 1/2" x 28 3/4" (54.5 x 73.0 cm) "Gift from Sheldon and Beverly Hyde, SLC" 1984.025

La Neige Fondante 1913 oil on canvas, 25" x 30" (63.6 x 76.2 cm) "Gift from David Dee, Salt Lake City" 1989.033

Landscape with Flowering Tree 1936 oil on board, 16" x 20" (40.5 x 50.5 cm) "Gift from Mrs. H. K. (Margaret) Richards, Santa Barbara" 1989.065

Portrait of Cyrus E. Dallin 1908 (16 July) oil on canvas, 24" x 20" (61.1 x 50.8 cm) "Gift from the artist, Lee Greene Richards, SLC" 1909.002

Portrait of the Poet, Alfred Lambourne 1920 oil on canvas, 24" x 20" (60.7 x 51.1 cm) "Gift from Margaret Cannon, SLC" 1987.026

Self-Portrait 1942 sanguine, 17 1/4" x 9 1/2" (43.8 x 24.0 cm) "Gift from Frederick C. and Sherry Ross, New Jersey" 1983.018

The Strength of the Hills or *Winter Night* 1920s oil on canvas, 20" x 24" (51.0 x 61.0 cm) "Gift from Lund-Wassmer Collection: Mrs. Roscoe A. Grover" 1986.078

Sunlight and Snow 1918 oil on canvas, 22" x 18" (55.8 x 45.5 cm) Museum Purchase 1922.004

Temple of the Sun, Zions 1927 oil on board, 13" x 16" (32.8 x 41.0 cm) "Gift from Lund-Wassmer Collection: Mrs. Roscoe A. Grover" 1986.076

HARRIETT RICHARDS-HARWOOD (1870 -1922) Salt Lake City

Lemonade Still-Life April 1888 oil on board, 12" x 18" (30.4 x 45.6 cm) "Gift from the Family, In Memory of Patrick O. Ward" 1988.064

CLESTON HOWARD RIGBY (1905 -1981) Provo

Red Maples 1947 oil on board, 24" x 30" (60.8 x 76.0 cm) "Gift from Maurine Fillmore Bryner, Provo" 1988.048

FRANK P. RIGGS (1922 -) Highland

Sentinel 1988 metal, 81" x 39 1/2" x 31" (205.0 x 100.5 x 79.0 cm) Museum Purchase from Spring Salon 1989.009

EDITH TAYLOR ROBERSON (1929 -) Salt Lake City

Channel Three 1981 oil on board, 24" x 36" (60.7 x 91.3 cm) "Gift from A. Merlin and Alice Steed trust" 1983.027

MARY LOU ROMNEY (1929 -) Salt Lake City

African Violet Tapestry 1984 watercolor, 19 3/4" x 27" (50.0 x 68.5 cm) "Gift from Mary Clark Kimball Johnson, SLC" 1991.015

DAVID HOWELL ROSENBAUM (1908 -1983) North Ogden

Boating on the Lake c. 1935 watercolor, 10 1/2" x 13 1/4" (26.7 x 33.4 cm) "Gift from David and Karen Ericson, Salt Lake City" 1988.037

Children at Play in Mantua, Utah c. 1937 oil on board, 22" x 30" (55.9 x 76.3 cm) "Gift from Paul Rosenbaum, North Ogden" 1983.017

Farmington Peak, Davis County 1935 oil on board, 30" x 36" (75.7 x 90.6 cm) "Gift from Lund-Wassmer Collection: Alton F. Lund, SLC" 1986.065

Fishing Village 1935 watercolor, 7 1/4" x 10" (18.4 x 25.4 cm) "Gift from Lund-Wassmer Collection" 1986.221

Self-Portrait 1940s oil on board, 14" x 17" (35.6 x 43.1 cm) "Gift from Vern G. and Judy N. Swanson, Springville" 1988.082

Workman c. 1935 watercolor, 17 3/4" x 23 3/4" (45.0 x 60.4 cm) "Gift from David and Karen Ericson, Salt Lake City" 1988.038

CORNELIUS SALISBURY (1882 -1970) Salt Lake City

Blue Mountain 1924 oil on board, 11 3/4" x 15 3/4" (29.8 x 40.0 cm) "Gift from Stan Salisbury, SLC" 1985.003

Curtain Time—Pioneer Theatre, Salt Lake 1947 oil on board, 24 1/4" x 33 1/4" (61.8 x 84.5 cm) "Gift from Springville Junior High School, 7th grade" 1947.011

Deep in the Woods 1938 oil on board, 12" x 16" (30.4 x 40.4 cm) "Gift from Mrs. H. K. (Margaret) Richards, Santa Barbara" 1989.066

Fishing Boats, Fisherman's Wharf, San Francisco 1949 oil on board, 24" x 31" (60.6 x 79.3 cm) "Gift from Stan Salisbury, SLC" 1985.002

The Source of Our Daily Bread 1926 oil on board, 16" x 20" (40.5 x 50.5 cm) "Gift from A. Merlin and Alice Steed trust" 1983.014

PAUL SALISBURY (1903 -1973) Provo

Hay Stacks 1965 oil on canvas, 30" x 36" (71.3 x 91.4 cm) "Gift from Springville High School, student body" 1966.007

Liberty Park Lake, Salt Lake City 1950s oil on board, 21 1/2" x 27" (54.7 x 68.3 cm) "Gift from J. Gerald Olpin" 1976.016

Mountain Solitude 1961 oil on canvas, 28" x 36" (71.0 x 91.5 cm) "Gift from Springville High School, Senior Class" 1962.002

Riders of the Range 1953 oil on canvas, 30" x 36" (76.5 x 91.6 cm) "Gift from Max and Kolene Knight, Springville" 1990.007

ROSE HOWARD SALISBURY (1887 -1975) Salt Lake City

Night Blooming Cereus 1930s oil on board, 22 1/2" x 28 3/4" (57.5 x 73.0 cm) "Gift from A. Merlin and Alice Steed trust" 1988.073

The Artist's Model or *Reclining Lady* 1936 oil on canvas, 18" x 24" (45.5 x 60.4 cm) "Gift from David and Bea Glover, Bountiful" 1981.007

SVEN BIRGER SANDZEN (1871 -1954) Kansas/Utah

Moonrise in the Canyon, Moab, Utah 1928 oil on canvas, 40" x 48" (101.2 x 122.1 cm) "Gift from Springville High School, Junior Class" 1928.003

JACK SEPTIMUS SEARS (1875 -1969) Salt Lake City/New York

Bum on a Bench or *Old Man Sitting* c. 1912 pen & ink, 16 1/2" x 13" (42.0 x 33.0 cm) "Gift from Robert N. and Peggy Sears, Salt Lake City" 1985.030

Chrysanthemums 1902 oil on canvas, 19" x 25" (48.2 x 63.5 cm) "Gift from Robert N. and Peggy Sears, Salt Lake City" 1984.028

Evening in June c. 1915 mixed media, 18 1/2" x 12" (47.0 x 30.5 cm) "Gift from Robert N. and Peggy Sears, Salt Lake City" 1986.304

G.O.P. Pres. timber 1916, carefully indexed by . . . 1916 charcoal, 13 3/4" x 13 3/4" (55.0 x 34.8 cm) "Gift from Robert N. and Peggy Sears, Salt Lake City" 1986.306

Old Man Eating 1967 pencil on paper, 4" x 4" (10.5 x 10.1 cm) "Gift from Lund-Wassmer Collection" 1986.230

One of Our Cats date unknown oil on board, 18" x 24" (45.5 x 60.6 cm) "Gift from Robert N. and Peggy Sears, Salt Lake City" 1986.308

Portrait of Robert Henri c. 1907 charcoal, 21" x 14 3/4" (53.3 x 37.5 cm) "Gift from Robert N. and Peggy Sears, Salt Lake City" 1985.028

Portrait of Rose Marie Young 1901 oil on canvas, 25" x 19" (63.4 x 48.2 cm) "Gift from Robert N. and Peggy Sears, Salt Lake City" 1986.009

Sunset, old Folsom Home, North of Salt Lake c. 1900 pen & ink, 4 3/4" x 6 1/2" (11.7 x 16.4 cm) "Gift from Robert N. and Peggy Sears, Salt Lake City" 1985.031

Violet Vendor 1905 oil on paper, 7 3/4" x 6" (20.1 x 15.5 cm) "Gift from Robert N. and Peggy Sears, Salt Lake City" 1986.303

Ysaye: from life-as he played at Concert, N.Y. 1912 pastel, 17" x 10 1/2" (42.8 x 26.9 cm) "Gift from Robert N. and Peggy Sears, Salt Lake City" 1985.027

H. FRANCIS SELLERS (1937 -) Salt Lake City

Park City Houses 1970s watercolor, 21 1/4" x 28 1/2" (54.0 x 72.0 cm) "Gift from Doug Muir, In memory of Grace Muir" 1989.051

ARCH D. SHAW (1933 -) West Valley City

Ego Trip: Self-Portrait 1986 oil on board, 28" x 22" (70.8 x 55.6 cm) "Gift from the Artist, A. D. Shaw" 1987.003

DOYLE DEWIS SHAW (1947 -) Springville

Manti Temple 1983 oil on canvas, 44" x 60" (112.2 x 152.3 cm) "Gift from Monte & Mary Lou Allman, Springville" 1985.006

ROBERT LORENZO SHEPHERD (1909 -) Santa Clara

Cape Royal, North Rim Grand Canyon 1987 watercolor, 34 1/4" x 60 3/4" (62.0 x 99.5 cm) "Gift from the artist, Robert Shepherd" 1988.013

On the Way to Church in Mexico 1980 watercolor, 16" x 11 3/4" (40.1 x 29.7 cm) "Gift from Janet McCoy, Orem, Utah" 1990.019

SUSAN GIFFORD SLADE (1943 -) Salt Lake City

Animal, Vegetable, Mineral Spring 1986 mixed media, 30" x 23" (75.8 x 58.1 cm) "Gift from Artist: In Memory of Ernest & Lenore Carroll" 1989.026

EMMA STOLTZ SMART (1862 -1924) Springville

A Bunch of Lilacs 1906 oil on canvas, 14" x 22" (36.0 x 55.8 cm) "Gift from the artist, Emma Stoltz Smart, Springville" 1907.007

Big Mountain (Mt. Timpanogas) 1906 oil on canvas, 24" x 36" (61.0 x 91.4 cm) "Gift from Dr. George L. and Emma Smart collection" 1925.045

Clay Banks 1905 oil on board, 9 1/2" x 13 1/4" (23.8 x 33.5 cm) "Gift from Dr. George L. and Emma Smart collection" 1925.046

Landscape c. 1910 oil on canvas, 18" x 22" (45.5 x 55.3 cm) "In Memory of Charles Lorenzo and Cora Harrison Daley" 1989.079

BRUCE HIXSON SMITH (1936 -) Springville

Aetatis L Self-Portrait 1986 oil on board, 14" x 15 1/2" (35.5 x 39.3 cm) Museum purchase 1987.014

Amanda 1981 oil on canvas, 48" x 51 1/2" (122.0 x 130.7 cm) Museum Purchase from Spring Salon 1981.057

Ode to Ad 1978 oil on canvas, 48" x 42" (122.3 x 107.0 cm) Museum Purchase from Spring Salon 1979.005

Pay Day 1983 intaglio/etching, 12 1/2" x 8 1/2" (31.5 x 21.4 cm) "Gift from Vern G. and Judy N. Swanson, Springville" 1990.010

DENNIS VON SMITH (1942 -) Utah

Aeroplane Contraption 1975 metal, canvas, 47 1/2" x 97 3/4" x 61" (120.6 x 247.9 x 154.9 cm) "Gift from Lund-Wassmer Trust Collection" 1990.005

The Binder 1984 bronze, 12 1/2" x 25 1/2" x 17" (31.7 x 64.7 x 43.2 cm) "Gift from Clayhill Corporation, Highland, Utah" 1985.018

Keeper of the Gate 1989 oil on canvas, 60" x 60" (152.4 x 152.4 cm) "Gift from David and Ingrid Nemelka, Mapleton" 1989.082

New Brother 1979 -80 bronze, 49 1/2" x 33" x 23" (125.7 x 83.8 x 58/5 cm) "Gift from Blaine P. and Louise Clyde, Springville" 1986.082

FRANK ANTHONY SMITH (1939 -) Salt Lake City

Coleus 1974 oil on canvas, 34" x 47" (86.5 x 119.5 cm) Museum Purchase from Spring Salon 1974.011

Cure 1988 acrylic on canvas, 48 1/2" x 70" (123.2 x 177.4 cm) "Gift from Louise C. Clyde, Springville" 1989.008

GARY ERNEST SMITH (1942 -) Highland

Degrees of Glory c. 1965 oil on canvas, 36" x 40" (91.2 x 101.6 cm) "Gift from James C. and Carol Christensen, Orem" 1988.081

Lamb to the Slaughter 1971 woodcut/blockprint, 12 3/4" x 23 3/4" (32.0 x 60.5 cm) "Gift from Vern G. and Judy N. Swanson, Springville" 1981.040

Point of the Mountain, Utah 19 May, 1973 oil on canvas, 24" x 32" (60.4 x 81.4 cm) "Gift from John and Gail Halgren, California" 1989.030

Self-Portrait 1972 1972 pencil, 11" x 8" (28.0 x 20.3 cm) "Gift from the Artist, Gary Ernest Smith" 1984.002

Self-Portrait: Divine Symmetry and Sacred Geometry 1970 oil on canvas, 23" x 19 1/2" (58.5 x 49.2 cm) "Gift from Ray Johnson, Scottsdale, Arizona" 1989.027

Steps of Conversion #1 1968 oil on canvas, 17 3/4" x 48" (45.0 x 122.0 cm) "Gift from David and Ingrid Nemelka, Mapleton" 1990.061

Up from the Dust 1972 oil on canvas, 44" x 48 1/4" (111.7 x 122.0 cm) "Memory of Ruth H. Nemelka from David and Ingrid Nemelka" 1987.038

Youthful Games 1984 oil on canvas 48" x 48" (121.7 x 121.7 cm) "Gift from Lund-Wassmer Collection: from Vern G. & Judy N. Swanson" 1986.010

JOEL SMITH (1929 -) Provo/Illinois

Random Orange 1986 watercolor, 15 1/2" x 21 3/4" (39.1 x 55.4 cm) Museum Purchase 1988.060

Root System 1986 watercolor, 18" x 25 3/4" (45.0 x 65.0 cm) Museum Purchase 1986.062

MOISHE SMITH (1929 -) Wisconsin/Hyde Park

Jewish Cemetery, Prague 1980 intaglio/etching, 17 1/2" x 25 3/4" (44.5 x 65.5 cm) Museum Purchase 1983.011

RUTH WOLF SMITH (1912 -1980) Salt Lake City

An Allegory of the 1960 Presidential Election 1960 oil on board, 38" x 28" (96.4 x 71.5 cm) "Gift from Geneva Steel, Orem" 1988.074

Floral Still-life with Figurines 1962 watercolor, 29" x 21" (73.5 x 53.2 cm) "Gift from David and Karen Ericson, Salt Lake City" 1988.005

SIDNEY PAUL SMITH (1904 -) Salt Lake City

Wilderness West of Salt Lake c. 1936 watercolor, 16" x 22" (40.5 x 56.0 cm) "Gift from the Artist, S. Paul Smith, SLC" 1981.006

V. DOUGLAS SNOW (1927 -) Salt Lake City

Cockscomb, near Teasdel 1985 oil on canvas, 68" x 83 1/2" (172.6 x 212.1 cm) "Anonymous Gift from Mapleton" 1989.069

Desert Landscape 1959 oil on canvas, 68" x 44" (172.9 x 112.0 cm) "Gift from Nathan Winters, SLC" 1988.055

The Reef 1976 oil on canvas, 44" x 68" (112.0 x 172.8 cm) Museum Purchase from Spring Salon 1976.017

WILLIAM R. SOUTH (1958 -) Bountiful

Self Portrait 1987 oil on paper, 19" x 25" (48.3 x 63.4 cm) "Gift from the Artist, William R. South" 1988.061

TREVOR JACK T. SOUTHEY (1940 -) Alpine

Eden Farm 1976 oil on board, 48" x 72" (121.9 x 182.8 cm) "Gift from Carole Hoffman, Lido Gallery, Park City" 1981.028

Full Bloom date unknown etching, 16 1/4" x 22 1/2" (41.3 x 57.0 cm) "Gift from Ellie Sonntage, Salt Lake City" 1990.060

Johnny's Apron 1974 pen & ink, 13 1/2" x 18" (34.5 x 45.5 cm) Museum Purchase from Spring Salon 1977.006

ULYSSES S. GRANT SPEED (1930 -) Lindon

Ropin' out the best ones 1984 bronze, 19 1/2" x 34 1/4" x 17" (49.7 x 86.5 x 43.0 cm) "Gift from A. Merlin and Alice Steed trust" 1985.034

KATE CLARK SPENCER (1946 -) Orem

Kate and Anne 1986 oil on board, 29 1/2" x 39 1/4" (74.7 x 99.6 cm) "Gift from the Artist, Kate Clark Spencer" 1989.053

NATHANIEL SPENS (1838 -1916) Utah

Embarkation from Scotland c. 1867 -68 oil on panel, 13 1/2" x 18" (34.4 x 45.7 cm) "Gift from Dr. George L. and Emma Smart trust" 1983.036

The Deacon Jones' Experience, Deacon's Prayer c. 1876 oil on paper, 16 1/2" x 22 3/4" (41.7 x 57.8 cm) "Gift from F. Ed and Judy Bennett, Salt Lake City" 1981.014

Wall-eyed Self-Portrait 1890s oil on board, 17" x 14" (43.1 x 35.6 cm) Museum Purchase 1984.010

ANNA ROBINSON SPIESS (1909 -1986) Bountiful

Park City late 1950s c. 1958 acrylic on board, 20" x 40" (50.8 x 101.6 cm) "Gift from William Spiess, Bountiful" 1987.034

Road to Grandma's House 1985 watercolor, 19 3/4" x 27 3/4" (50.5 x 70.5 cm) "Gift from William Spiess, artist's Husband" 1988.006

CHARLES CLYDE SQUIRES (1883 -) Salt Lake City/New York

Eighteenth Century Gentleman 1920s oil on canvas, 27" x 24" (68.8 x 61.5 cm) "Gift of Mark and Nancy Peterson, Alpine" 1988.024

Held by the Enemy 1930 oil on canvas, 30" x 24" (76.5 x 61.0 cm) "Gift from Mark and Nancy Peterson, Alpine" 1988.025

Mother with Child 1920s oil on board, 21" x 17" (53.3 x 43.2 cm) "Gift from Mark and Nancy Peterson, Alpine" 1988.026

HARRY SQUIRES (1850 - 1928) Utah

Artist's Lake Big Cottonwood 15 March, 1886 oil on board, 12" x 20" (30.3 x 50.8 cm) Museum Purchase 1982.009

LAWRENCE SQUIRES (1887 -1928) Salt Lake City

Alpine Cabin 1921 oil on board, 15 3/4" x 20"

(40.4 x 50.2 cm) "Gift from F. Ed and Judy Bennett, Salt Lake City" 1982.008

JOHN HEBER STANSFIELD (1878 -1953) Mt. Pleasant

Mt. Nebo Early Spring 1942 oil on board, 35" x 47 3/4" (88.5 x 121.4 cm) "Gift from Springville Junior High School, eighth grade" 1942.003

The West 1938 oil on board, 30" x 40" (76.4 x 101.6 cm) "Gift from Dr. Marian Merrill Brubaker estate" 1977.008

KATHRYN STATS (1944 -) Sandy

California Coast 1981 oil on canvas, 15" x 21" (38.1 x 53.3 cm) "Gift from Doug Muir, In memory of Grace Muir" 1989.040

LAURA LEE STAY (1958 -) Provo

Woman of Reverence Winter 1985 bronze, 35" x 12" x 9 1/4" (89.1 x 29.7 x 23.5 cm) "Gift from Lund-Wassmer Collection" 1985.007

KENT STEADMAN (1942 -) Utah

Sea Rocks 1966 acrylic on canvas, 24" x 30" (61.0 x 76.0 cm) Museum Purchase from Spring Salon 1967.005

LECONTE STEWART (1891 -1990) Kaysville

Farmington in Winter 1926 oil on board, 24" x 30" (61.0 x 76.2 cm) Museum Purchase 1986.003

Scrub Oaks, (large version) 1922 oil on canvas, 23 1/2" x 30" (59.8 x 76.0 cm) "Gift from David Dee, Salt Lake City" 1986.090

Snow, Steam, and Smoke 1932 lithograph, 11 3/4" x 8 3/4" (29.6 x 22.0 cm) "Gift from Lund-Wassmer Collection: 'Mrs. Roscoe A. Grover, SLC" 1986.079

The Corral at Grass Valley, Near Richfield 1978 oil on board, 21 3/4" x 30" (55.5 x 76.0 cm) Museum Purchase from Spring Salon 1978.011

Threshing Wheat in Porterville September 1948 oil on board, 21 1/4" x 30" (55.5 x 76.0 cm) "Gift from Springville High School, Junior Class" 1952.004

Thru the Eucalyptus Trees 1927 pencil, 7 1/4" x 10" (18.4 x 25.5 cm) "Gift from Russell and Jan Billings" 1983.019

RANDALL TODD STILSON (1961 -) Provo

Crucifixion Triptych 1990 watercolor on vellum, 2" x 5" each (5.1 x 12.5 cm) "Gift from David and Ingrid Nemelka, Mapleton" 1990.062

HELEN STOREY STONE (1907 -1987) Ogden

Collage c. 1980 mixed media, 17 1/2" x 24 1/2" (44.1 x 62.1 cm) "Gift from Robert Stone, Salt Lake City" 1987.028

Singing, 'Daddy' c. 1978 mixed media, 29 3/4" x 22" (75.3 x 55.4 cm) "Gift from Robert Stone, Salt Lake City" 1987.027

MARY H. TEASDEL (1863 -1937) Salt Lake City

Garfield Pier c. 1904 watercolor, 14 3/4" x 18" (37.5 x 45.8 cm) "Gift from David and Barbara Horne, Salt Lake City" 1989.003

MINERVA B. KOHLHEPP TEICHERT (1888 -1976) North Ogden/Cokeville

Indian Captives at Night 1939 oil on mounted canvas, 48" x 90" (122.2 x 228.6 cm) "Gift from Lund-Wassmer Collection trust" 1988.077

Jesus Christ is the God of that Land 1940s oil on board, 48" x 23 3/4" (122.0 x 60.5 cm) "Gift from David and Barbara Horne, Salt Lake City" 1985.037

BRIAN J. THAYNE (1956 -) Orem

Spring City 1985 1986 watercolor, 13 1/4" x 23 1/4" (33.6 x 59.1 cm) "Gift from the Artist, Brian Thayne" 1988.058

KARL THOMAS (1948-) Orem

Grand Canyon 1981 oil on board, 20" x 30" (50.5 x 75.8 cm) "Gift from David and Karen Ericson, Salt Lake City" 1991.030

EVERETT CLARKE THORPE (1907 -1984) Logan

Design in polymer, tempera, sand, clay, oil, metalics & wax 1954 mixed media on board, 30 1/4" x 16" (77.0 x 40.5 cm) "Gift from Gary Lewis of Providence, Utah" 1986.008

Line Down 1969 oil on canvas, 30" x 36" (76.4 x 91.5 cm) "Gift from Springville High School" 1969.001

MATILDA ANN EVANS THURMAN (1884 -1972) Utah

Cabbage Weeding in Utah County 1940 watercolor, 12" x 18" (30.5 x 45.7 cm) "Gift from J. Reed Tuft, Salt Lake City" 1990.013

Country Side in Utah County 1940s watercolor, 12" x 18" (30.5 x 45.7 cm) "Gift from J. Reed Tuft, Salt Lake City" 1990.012

House along the Jordan River, Salt Lake County 1940s watercolor, 18" x 12" (45.7 x 30.5 cm) "Gift from J. Reed Tuft, Salt Lake City" 1990.014

Playground 1950s watercolor, 14" x 10 1/4" (35.6 x 26.0 cm) "Gift from J. Reed Tuft, Salt Lake City" 1990.011

FRANCIS M. ("FRANK") TRESEDER (1853-1923) Salt Lake City

State Penitentiary Sugarhouse, Looking East November 1886 oil on canvas, 11" x 22" (28 x 56 cm.) "Gift from Stouffer Foods" 1991.031

State Penitentiary Sugarhouse, Looking West November 1886 oil on canvas, 11" x 22" (28 x 56 cm) "Gift from Nancy Roney and Collen Lund, Orem" 1991.032

L'DEANE MINOR TRUEBLOOD (1928 -) St. George

The Story Teller 1990 bronze, 17 3/4" x 15 3/4" x 14 1/2" (45.1 x 39.9 x 36.8 cm) "Gift from James and Barbara Jones, Salt Lake City" 1991.0

Waiting Her Turn 1990 bronze, 19" x 16 1/2" x 9 3/4" (48.3 x 41.9 x 24.7 cm) "Gift from James and Barbara Jones, Salt Lake City" 1991.0

Sarai 1986 bronze, 14 3/4" x 14 1/2" x 8 1/4" (37.4 x 37.0 x 21.0 cm) "Gift from Michael D. Hughes, St. George" 1989.029

JOHN ELLIOTT TULLIDGE (1836 -1899) Salt Lake City

Minnie Lake c. 1887 oil on canvas, 28" x 20" (70.8 x 50.5 cm) "Gift from Dr. George L. and Emma Smart collection" 1925.054

GLENN H. TURNER (1918 -) Springville

The Broken Windmill, Missouri 1948 oil on canvas, 24" x 30" (60.8 x 76.4 cm) "Gift from Springville High School, sophomore class" 1949.003

GEORGE ERNEST UNTERMANN (1864-1956) Vernal

Cretaceous Cauripods and Ornithopods 1952 oil on canvas mounted, 27 1/2" x 37 3/4" (70.4 x 96.4 cm) "Gift of Paul McFarlane, Salt Lake City" 1991.029

EDNA MERRILL VAN FRANK (1899 -1985) Salt Lake City

Ballet Dancer c. 1935 oil on board, 17 1/2" x 13 1/2" (44.0 x 33.9 cm) "Gift from Roger Van Frank, SLC" 1985.016

Dance Design c. 1935 oil on board, 20" x 16" (50.4 x 40.8 cm) "Gift from Roger Van Frank, SLC" 1985.015

Home for the Holidays: Centerville, Utah c. 1923 watercolor, 10" x 13 3/4" (25.5 x 34.8 cm) "Gift from Roger Van Frank, SLC" 1985.014

ADRIAN C. VAN SUCHTELEN (1941 -) Logan

The Dream 1989 intaglio/etching, 12" x 10" (30.2 x 25.0 cm) "Gift from David and Ingrid Nemelka, Mapleton" 1989.083

HAROLD "JACK" VIGOS (1914 -1983) Utah

Mountain Stream 1970 oil on board, 24" x 30" (61.0 x 76.0 cm) "Gift from Lund-Wassmer Collection: Ursel Allred, SLC" 1986.069

Roses 1955 oil on board, 29 3/4" x 23 3/4" (76.6 x 60.2 cm) "Gift from Lund-Wassmer Collection: Ursel Allred, SLC" 1986.072

Young Athlete 1960 oil on board, 30" x 24" (76.4 x 61.0 cm) "Gift from Lund-Wassmer Collection: Ursel Allred, SLC" 1986.071

MARCUS ALAN VINCENT (1956 -) Provo

Brother's Keeper 1984 oil on board, 36" x 36" (91.4 x 91.4 cm) "Gift from the Artist, Marcus Vincent" 1989.006

DAVID CHARLES WADE (1952 -) Salt Lake City

Dawn Patrol 1986 oil on board, 24" x 30" (76.2 x 98.7 cm) Museum Purchase from Spring Salon 1988.014

RANDI LYNN WAGNER (1952 -) Salt Lake City

Mist in the Mountains 1970s watercolor, 20 1/4" x 13 1/2" (51.5 x 33.5 cm) "Gift from Doug Muir, In memory of Grace Muir" 1989.047

RICHARD J. VAN WAGONER (1932 -) Ogden

Donor Bank 1990 oil on canvas/board, 48" x 71 3/4" (122.0 x 182.3 cm) "Gift from the Geneva Steel, Orem" 1990.066

White Volkswagen 1982 watercolor, 14" x 20" (35.5 x 50.7 cm) "Gift from A. Merlin and Alice Steed trust" 1983.028

CLAY WAGSTAFF (1964 -) American Fork

Landscape 125 1990 oil on canvas, 48" x 36 1/4" (122.0 x 92.2 cm) "Gift from David and Ingrid Nemelka, Mapleton" 1991.011

STANLEY GLEN WANLASS (1941 -) Utah

Broken Trusts 1981 bronze, 22 1/4" x 8" x 8" (56.5 x 20.3 x 20.3 cm) "Gift from the Butler Family of Lehi, Utah" 1982.022

FLORENCE ELLEN WARE (1891 -1971) Salt Lake City

At the Ceremonials, Gallup, New Mexico 1938 watercolor, 3 1/4" x 4 3/4" (8.0 x 12.2 cm) "Gift form Lund-Wassmer Collection" 1986.270

Autumn Leaves in the Snow 1948 oil on board, 30" x 23 3/4" (76.0 x 61.0 cm) "Gift from Lund-Wassmer Collection: Dr. Ernest King Family, SLC" 1986.020

Cherry Trees in Autumn 1949 oil on board, 22" x 30" (55.5 x 76.0 cm) "Gift from Lund-Wassmer Collection: Dr. Ernest King Family, SLC" 1986.021

Florence Ware and Student, Theodore M. Wassmer 1936 oil on board, 11" x 9" (28.0 x 22.8 cm) "Gift from Lund-Wassmer Collection: Judy Farnsworth Lund, SLC" 1986.274

Ibnin Lulien Mosque, Cairo, Egypt 1925 oil on canvas board, 10" x 7" (25.3 x 17.7 cm) "Gift from Lund-Wassmer Collection: Judy Farnsworth Lund, SLC" 1986.267

Indian Paint Brush 1946 oil on canvas board, 17 3/4" x 14" (45.0 x 35.4 cm) "Gift from Lund-Wassmer Collection: Dr. Ernest King Family, SLC" 1986.019

Laguna Beach, California 1925 oil on board, 12" x 19" (30.0 x 38.1 cm) "Gift from Lund-Wassmer Collection: Dr. Ernest King Family, SLC" 1986.016

Low Tide, Laguna Beach, California 1925 oil on board, 16" x 20" (40.0 x 50.5 cm) "Gift from Lund-Wassmer Collection: Dr. Ernest King Family, SLC" 1986.017

Moon Flowers in Wedgewood 1950 oil on canvas mounted, 23 1/2" x 20" (59.6 x 50.7 cm) "Gift from Lund-Wassmer Collection: Dr. Ernest King Family, SLC" 1990.034

Mt. Baldy and Lilly Pond Lake, High Uintahs 1930s oil on board, 20" x 16" (50.5 x 40.5 cm) "Gift from Mrs. H. K. (Margaret) Richards, Santa Barbara" 1989.067

Nature's Embroidery c. 1945 oil on board, 30" x 24" (76.1 x 60.7 cm) "Gift from Springville High School, freshman class" 1946.011

The Nose-Gay 1946 oil on canvas mounted, 14 1/2" x 18" (36.7 x 45.3 cm) "Gift from Lund-Wassmer Collection: Dr. Ernest King Family, SLC" 1990.035

Porlock, England 1926 watercolor, 5 1/2" x 3 1/2" (14.2 x 8.7 cm) "Gift form Lund-Wassmer Collection" 1986.273

Portrait of Theodore Milton Wassmer: Watching the Ski Meet 1936 oil on board, 30 1/4" x 24 1/4" (77.0 x 61.5 cm) "Gift from Lund-Wassmer Collection: Judy Farnsworth Lund, SLC" 1986.269

Sergeant Theodore Milton Wassmer 1942 oil on board, 26 3/4" x 24" (67.9 x 61.0 cm) "Gift from Lund-Wassmer Collection: Judy Farnsworth Lund, SLC" 1986.272

Shadeif on the Nile River, Egypt 1925 oil on board, 10" x 7" (25.3 x 17.7 cm) "Gift from Lund-Wassmer Collection: Judy Farnsworth Lund, SLC" 1986.268

Southern Utah 1955 oil on canvas, 24" x 18" (60.5 x 45.5 cm) "Gift form Lund-Wassmer Collection: Dr. Ernest King Family, SLC" 1986.023

Suey Sin Fah (Two Chinese Lilies) 1935 oil on canvas mounted, 30" x 24" (76.0 x 60.7 cm) "Gift from Lund-Wassmer Collection: Dr. Ernest King Family, SLC" 1990.033

Summac 1950 oil on board, 16" x 20" (40.4 x 50.6 cm) "Gift from Lund-Wassmer Collection: Dr. Ernest King Family, SLC" 1986.022

This is the Place 1942 watercolor, 5 1/4" x 5" (13.6 x 12.5 cm) "Gift from Lund-Wassmer Collection: Judy Farnsworth Lund, SLC" 1986.271

E. KIMBALL WARREN (1952 -) Pleasant Grove

Jordan Lake, High Uintahs 1988 oil on board, 12" x 16" (30.5 x 40.8 cm) Museum Purchase 1990.039

THEODORE MILTON WASSMER (1910 -) Salt Lake City/New York

Actors 1982 monoprint, 10" x 7" (25.3 x 17.8 cm) "Gift from Lund-Wassmer Collection" 1986.287

Adam and Eve 1941 oil on board, 30" x 24" (76.0 x 61.0 cm) "Gift from Lund-Wassmer Collection: Wallace Everton" 1983.042

Anemones 1960 oil on canvas, 22" x 18 1/4" (55.8 x 46.4 cm) "Gift from Lund-Wassmer Collection" 1986.285

At the Paleio-Siena, Italy 1965 glapasto, 19 1/2" x 15 1/2" (49.5 x 39.4 cm) "Gift from Lund-Wassmer Collection" 1986.280

Ballet Class 1960 oil on canvas, 16" x 12" (40.0 x 30.8 cm) "Gift from Lund-Wassmer Collection" 1986.279

Carol 1950 charcoal, 12 3/4" x 10" (32.5 x 25.4 cm) "Gift from Lund-Wassmer Collection: Judy Farnsworth Lund, SLC" 1986.276

Ceremony 1954 glapasto, 15" x 5" (38.1 x 12.6 cm) "Gift from Lund-Wassmer Collection: Mr. & Mrs. John W. Houser" 1984.032

Choices 1962 glapasto, 20" x 16" (50.3 x 40.4 cm) "Gift from the Artist" 1990.046

Dance Patterns or *Dance Compositions* 1968 oil on board, 24" x 48" (60.0 x 121.5 cm) "Gift form Lund-Wassmer Collection" 1986.289

Easter Bonnet 1950 oil on canvas, 24" x 20" (61.0 x 51.0 cm) "Gift from Lund-Wassmer Collection" 1986.277

Festival 1954 glapasto, 12" x 16" (30.5 x 40.6 cm) "Gift from Lund-Wassmer Collection: Mr. & Mrs. John W. Houser" 1984.033

Florence Ware swinging under a Willow Tree 1937 oil on board, 30" x 24" (76.1 x 60.8 cm) "Gift from Lund-Wassmer Collection" 1986.288

Golden October, Catskills 1970 oil on canvas, 24" x 30" (61.0 x 76.4 cm) "Gift from Grace Holmes Barbey" 1990.036

Helen 1960 glapasto, 15" x 11" (38.0 x 28.0 cm) "Gift from Lund-Wassmer Collection: Judy Farnsworth Lund, SLC" 1986.275

The Hunt 1954 glapasto, 8" x 12" (20.3 x 30.5 cm) "Gift from Lund-Wassmer Collection: Mr. & Mrs. John W. Houser" 1984.034

In Echo Canyon 1934 oil on canvas mounted, 20" x 16" (50.5 x 40.4 cm) "Gift from Lund-Wassmer Collection: Sheilla Woolley" 1990.047

In the Wings 1954 glapasto, 12" x 16" (30.5 x 40.6 cm) "Gift from Lund-Wassmer Collection: Mr. & Mrs. John W. Houser" 1984.035

Judy and Ted Wassmer at the Beaux Arts Ball 1986 oil on board, 23 1/2" x 35 3/4" (59.8 x 90.5 cm) "Gift from Lund-Wassmer Collection" 1990.031

Judy Lund Wassmer 1960 oil on board, 14" x 11" (27.9 x 36.0 cm) "Gift from Lund-Wassmer Collection" 1986.282

Labyrinth 1950 oil on board, 10 1/2" x 14 1/2" (26.4 x 36.8 cm) "Gift from Lund-Wassmer Collection" 1986.283

Logan Pass—Glacier Park 1940 oil on canvas, 24" x 29 3/4" (60.7 x 75.5 cm) "Gift from Lund-Wassmer Collection: Dorothy Benny Palmer, FL" 1990.037

Pearl Street, Provincetown, Mass. 1946 oil on canvas, 19" x 24" (48.0 x 60.8 cm) "In Honor of Floss Harmer from descendants of Lee Taylor" 1964.006

Persian Dancers 1969 glapasto, 9 1/4" x 7 1/4" (23.5 x 18.4 cm) "Gift from Lund-Wassmer Collection" 1986.281

Rain Dance, White Rocks, Utah 1933 oil on board, 5 3/4" x 7 3/4" (14.5 x 19.7 cm) "Gift from Lund-Wassmer Collection" 1986.286

Red Canyon of the Green River 1938 oil on board, 30" x 24" (76.0 x 60.6 cm) "Gift from Lund-Wassmer Collection: William Flower, SLC" 1986.087

Rehearsal 1975 glapasto, 11" x 8" (28.0 x 20.3 cm) "Gift from Lund-Wassmer Collection" 1986.278

Remembrance 1954 glapasto, 9" x 7" (22.9 x 17.7 cm) "Gift from Lund-Wassmer Collection: Mr. & Mrs. John W. Houser" 1984.036

Springtime Ballet 1949 oil on canvas, 24" x 30 1/4" (60.6 x 76.0 cm) "Gift from Springville Junior High School, eighth grade" 1951.005

Texas Blue Bonnets 1944 oil on canvas, 24" x 30" (61.0 x 76.5 cm) "Gift form Lund-Wassmer Coll: Mr. & Mrs. Kenneth Davidson, Ogden" 1990.025

Texas Sky 1943 watercolor, 8 3/4" x 8 3/4" (22.5 x 22.5 cm) "Gift from Lund-Wassmer Collection" 1986.284

Timpanogas Peak 1939 oil on board, 30" x 24" (76.3 x 61.0 cm) "Gift from Lund-Wassmer Collection: Mrs. Roscoe A. Grover, SLC" 1986.080

Woodstock Festival 1969 oil on canvas, 42" x 28" (107.3 x 71.0 cm) "Gift from Lund-Wassmer Collection" 1989.023

DOROTHY WATKINS (1911 -) Orem

Utah Lake, Near Goshen 1985 watercolor, 16" x 20 1/2" (40.6 x 52.0 cm) "Gift from the Artist, Dorothy Watkins" 1989.058 HARRIS T. WEBERG (-1980) Utah

Mountain Landscape date unknown watercolor, 19 1/2" x 23 1/4" (49.5 x 59.1 cm) "Gift from G. Ralph Bailey, SLC" 1990.022

DANQUART ANTHON WEGGELAND (1827 -1918) Salt Lake City

Bishop Sam Bennion Farm, Taylorsville c. 1879 oil on canvas mounted, 21" x 31" (53.3 x 79.0 cm) Museum Purchase 1986.002

Delivering the Mail 1910 oil on canvas, 12" x 18" (30.5 x 46.0 cm) "Gift from F. Ed and Judy Bennett, Salt Lake City" 1981.004

Ontario Mill Park City 1877 oil on paper, 15 3/4" x 23 1/2" (40.0 x 59.3 cm) "Gift from Neil and Jane Schaerrer, Salt Lake City" 1983.032

Pioneer Home 1880s oil on board, 9 3/4" x 13 1/4" (25.2 x 33.6 cm) "Gift from Edwin Evans, Salt Lake City" 1938.006

Portrait of Harriot Jacobsen 1905 October oil on paper, 4 1/4" x 2 3/4" (10.7 x 6.7 cm) "Gift from Will and Allison South, Bountiful" 1981.041

Still-Life with Apples 1911 oil on canvas, 12" x 16" (30.4 x 40.8 cm) "Gift from A. Merlin and Alice Steed trust" 1982.037

Temptation of Adam 1877 oil on canvas, 41 1/2" x 33" (105.3 x 83.5 cm) "Gift from Dan Weggeland II, Camp Hill, PA" 1984.019

Utah Lake View Near Lehi 1878 oil on board, 6 1/8" x 11 3/4" (15.8 x 29.9 cm) "Gift from A. Merlin and Alice Steed trust" 1984.013

View in American Fork Canyon 1878 1892 oil on board, 27" x 20" (68.7 x 51.3 cm) "Gift from Mr. and Mrs. Sterling Price trust" 1989.057

WILLIAM FERRIN WHITAKER (1943 -) Provo

Young Woman 1976 oil on board, 18" x 24" (45.6 x 60.7 cm) "Gift from Ray and Sue Johnson, Scottsdale, AZ" 1990.059

BENSON WHITTLE (1944 -) Provo

Sketch #1 Jackson 1980 pencil, 10 3/4" x 14 3/4" (27.3 x 37.5 cm) "Gift from the Artist, Benson Whittle, Provo" 1984.029

STEPHANIE WILDE (1952 -) Salt Lake City/Boise

Avenging Angels 1987 pen & ink, 13" x 22" (32.7 x 55.5 cm) "Gift from the Artist, Stephanie Wilde" 1988.016

NANCY LYNN DIEHL WILLIAMS (1936 -) Brigham City

The True Vine 1989 watercolor, 21 1/2" x 14" (54.2 x 35.9 cm) "Gift from the Artist, Lynn D. Williams" 1990.001

ROGER D. "SAM" WILSON (1943 -) Salt Lake City

A Tension to Detail 1982 watercolor, 22 1/2" x 29 3/4" (56.5 x 76.0 cm) Museum Purchase from Spring Salon 1983.029

Crow-Crowded or *I Myself* 1985 acrylic on canvas, 36" x 42" (91.5 x 106.8 cm) "Gift from Dr. George L. and Emma Smart trust" 1985.024

SHEILA WOOLSEY WOOLLEY (1926 -) Escalante

Old Cedars 1980 watercolor, 17 1/4" x 23 1/4" (43.5 x 59.1 cm) "Gift from Lund-Wassmer Collection" 1986.292

The Wasatch 1980 watercolor, 17 1/4" x 23 1/4" (43.5 x 59.0 cm) "Gift from Lund-Wassmer Collection" 1986.291

ALMA BROCKERMAN WRIGHT (1875 - 1952) Salt Lake City

Acquaduct 1904 pen & ink, 5 3/4" x 7 1/2" (14.2 x 19.0 cm) "Gift from David and Karen Ericson, Salt Lake City" 1981.021

Bend in the Jordan 1913 oil on board, 10" x 14" (25.3 x 35.5 cm) "Gift from the artist, Alma B. Wright, Salt Lake City" 1927.004

Dot 1912 pastel, 23 1/2" x 17 1/2" (59.6 x 44.5 cm) "Gift from Dr. George L. and Emma Smart collection" 1925.056

Female Figure Study c. 1902 -04 charcoal, 5" x 7 1/2" (12.5 x 18.8 cm) "Gift from David and Karen Ericson, Salt Lake City" 1981.022

Fishing on the Jordan 1913 oil on canvas, 17" x 24" (43.4 x 61.2 cm) "Gift from Dr. George L. and Emma Smart collection" 1925.057

From Piazzale Michelangelo, Florence April-04 1904 pen & ink, 6" x 9 1/4" (15.0 x 23.6 cm) "Gift from David and Karen Ericson, Salt Lake City" 1981.023

Head Study of a Man 1917 pastel, 15 3/4" x 13" (40.0 x 32.7 cm) "Gift from Dr. George L. and Emma Smart collection" 1925.059

The Jordan 1916 oil on canvas, 22" x 18" (56.7 x 46.0 cm) Museum Purchase 1921.003

Lady in Black 1919 oil on canvas, 36" x 28 1/2" (91.5 x 72.6 cm) "Gift from Springville High School" 1922.007

Landscape with Cows 1916 oil on canvas, l5" x 22" (38.0 x 55.9 cm) "Gift from Dr. George L. and Emma Smart collection" 1925.061

Myrtle: the Artist's Model c. 1937 oil on board, 10 3/4" x 16 1/4" (27.5 x 41.0 cm) "Gift from David and Karen Ericson, Salt Lake City" 1988.021

Old Farm in Coalville, Utah 1926 oil on canvas, 28 3/4" x 36 1/4" (73.0 x 91.1 cm) "Gift from A. Merlin and Alice Steed trust" 1985.023

Portrait c. 1937 charcoal, 19 1/2" x 14 1/2" (49.3 x 36.8 cm) "Gift from David and Karen Ericson, Salt Lake City" 1988.019

Portrait of Dr. George L. Smart 1926 oil on canvas, 28" x 22" (71.0 x 55.8 cm) "Gift from Ladies Home Culture Club, Springville" 1926.008

Portrait of George L. Smart's Father c. 1926 oil on canvas, 28" x 22" (71.0 x 56.0 cm) "Gift from Dr. George L. and Emma Smart collection" 1925.062

Portrait of Weston Vernon 1905 oil on canvas, 22" x 18" (55.2 x 45.6 cm) "Gift from the artist, Alma B. Wright, Salt Lake City" 1912.005

Profile of Young Girl c. 1902 -04 pencil, 7 3/4" x 6" (19.6 x 15.4 cm) "Gift from David and Karen Ericson, Salt Lake City" 1981.024

Quai Pontoise 1930 oil on canvas, 32" x 25 1/2" (81.0 x 64.8 cm) "Gift from Dr. George L. and Emma Smart trust" 1984.021

Reclining Female Nude c. 1937 crayon/conte, 8 3/4" x 13

3/4" (22.2 x 34.8 cm) "Gift from David and Karen Ericson, Salt Lake City" 1988.036

Seated Female Nude Model c. 1937 charcoal, 20 1/2" x 16 3/4" (52.0 x 42.8 cm) "Gift from David and Karen Ericson, Salt Lake City" 1988.020

Self-Portrait c. 1937 charcoal, 16 1/2" x 12 1/2" (41.9 x 31.5 cm) "Gift from David and Karen Ericson, Salt Lake City" 1988.029

Self-Portrait 1905 pencil, 6 3/4" x 4 3/4" (17.0 x 12.1 cm) "Gift from David and Karen Ericson, Salt Lake City" 1988.035

Standing Female Nude c. 1937 charcoal, 20 1/2" x 16 3/4" (52.3 x 42.8 cm) "Gift from David and Karen Ericson, Salt Lake City" 1988.018

Through the Pines, Balsams near Brighton 1917 oil on canvas, 24" x 17" (61.0 x 43.0 cm) "Gift from Dr. George L. and Emma Smart collection" 1925.064

DAVID BENNION YOUNG (1932 -) Provo/Wyoming

Desert Storm, Wyoming 1980 oil on canvas, 36 1/2" x 56 3/4" (92.5 x 144.1 cm) "Gift from Carol Ashworth, Provo" 1987.013

ERLA PALMER YOUNG (1917 -) Midway

Abandoned Homestead, Toward Dugway 1980 acrylic on board, 8 3/4" x 13" (22.5 x 33.5 cm) "Gift from the Artist, Erla Young" 1980.003

Winter's Garden, Fairview Canyon 1988 acrylic on canvas, 30" x 40" (76.1 x 101.5 cm) Museum Purchase from Spring Salon 1988.011

MAHONRI MACKINTOSH YOUNG (1877 -1957) Salt Lake City/New York

Bas-Relief Portrait of A. Lambourne 1908, August bronze, 9 1/4" circular (23.5 x 23.5 cm) "Gift from Vern G. and Judy N. Swanson, Springville" 1981.049

The Carpenter 1911 bronze, 16" x 11" x 12" (40.5 x 28.3 x 30.5 cm) "Gift from Robert N. and Peggy Sears, Salt Lake City" 1986.083

The El at Hudson River at 129th Street New York 1909 pencil, 7 1/2" x 10" (18.8 x 25.6 cm) "Gift from Robert N. and Peggy Sears, Salt Lake City" 1986.309

The Factory Worker c. 1938 bronze, 45 1/2" x 26" x 14" (115.5 x 66.0 x 35.3 cm) "Gift from Blaine P. & Louise Clyde & W.W. Clyde Co." 1984.006

Farm in Utah August 1941 mixed media, 9" x 14" (22.6 x 36.0 cm) "Gift from Margaret Cannon trust" 1990.024

Frontier Scout c. 1932 bronze, 19" x 19" x 7" (48.5 x 48.5 x 18.0 cm) "Gift from A. Merlin and Alice Steed trust" 1983.039

Pig Pens at Palacca date unknown intaglio/etching, 8 3/4" x 12" (22.1 x 30.5 cm) "Gift from Lund-Wassmer Collection: Mrs. Roscoe A. Grover, SLC" 1986.081

Portrait of John Hafen 1906 oil on canvas, 17" x 14" (43.3 x 36.0 cm) "Gift from the artist, Mahonri M. Young, Salt Lake City" 1907.008

Seated Brigham Young c. 1947 bronze, 21 1/4" x 9 1/2" x 13 1/2" (54.0 x 24.0 x 33.9 cm) "Gift from Peter and Donna Crawley, Provo" 1983.044

The Stone Mason c. 1907 bronze, 16" x 12 1/2" x 12 1/2" (40.7 x 32.1 x 31.8 cm) "Gift from Robert N. and Peggy Sears, Salt Lake City" 1985.026

Two Animal Sketches with Self Portrait 1926 pen & ink, 4 1/4" x 7" (10.8 x 17.9 cm) "Gift from Lund-Wassmer Collection" 1986.294

FRANCIS HUBERT ZIMBEAUX (1913 -) Salt Lake City

Nymphet in Open Field 1982 oil on canvas, 36" x 60" (92.0 x 152.9 cm) "Gift from the Artist: Francis Zimbeaux, Salt Lake City" 1990.043

Evening on Mystic Lake when the Nymphs Came to Dance 1980 watercolor, 13" x 18 1/2" (33.0 x 47.0 cm) "Gift from Lund-Wassmer Collection" 1986.295

Self Portrait 1950 oil on canvas, 22" x 16" (55.9 x 41.2 cm) "Gift from the Artist, Francis Zimbeaux, SLC" 1987.002

FRANK IGNATIUS ZIMBEAUX (1860 -1935) Salt Lake City

Catholic Mass, Decoration Day at the Salt Lake Cemetery 1928 oil on board, 8 1/2" x 13" (21.7 x 32.9 cm) "Gift from Francis Zimbeaux, SLC" 1991.0041

Main Street Salt Lake City September 1928 pencil drawing, 11" x 13 3/4" (27.5 x 34.4 cm) "Gift from Francis Zimbeaux, SLC" 1991.005

252